MW01134469

BALLOT BLOCKED

STANFORD STUDIES IN LAW AND POLITICS

Edited by Keith J. Bybee

BALLOT BLOCKED

The Political Erosion of the Voting Rights Act

Jesse H. Rhodes

Stanford University Press
Stanford, California

Stanford University Press
Stanford, California

©2017 by the Board of Trustees of the Leland Stanford Junior University.
All rights reserved.

No part of this book may be reproduced or transmitted in any form or by any
means, electronic or mechanical, including photocopying and recording, or in any
information storage or retrieval system without the prior written permission of
Stanford University Press.

Printed in the United States of America on acid-free, archival-quality paper

Library of Congress Cataloging-in-Publication Data

Names: Rhodes, Jesse H., author.
Title: Ballot blocked : the political erosion of the Voting Rights Act / Jesse H. Rhodes.
Description: Stanford, California : Stanford University Press, 2017. | Series: Stanford
 studies in law and politics | Includes bibliographical references and index.
Identifiers: LCCN 2017018234 (print) | LCCN 2017021934 (ebook) | ISBN 9781503603530
 (e-book) | ISBN 9780804797597 (cloth : alk. paper) | ISBN 9781503603516 (pbk. : alk.
 paper)
Subjects: LCSH: Suffrage—United States—History—20th century. | Suffrage—United
 States—History—21st century. | United States. Voting Rights Act of 1965. |
 Minorities—Suffrage—United States—History—20th century. | Minorities—
 Suffrage—United States—History—21st century.
Classification: LCC JK1846 (ebook) | LCC JK1846 .R46 2017 (print) |
 DDC 324.6/20973—dc23
LC record available at https://lccn.loc.gov/2017018234

Cover design: Matt Tanner
Typeset by Motto Publishing Services in 10/14 Minion

To my wife, Megan, and my children, Jacob and Julia,
who are always there to remind me of what is truly important.

Contents

Acknowledgments

WHILE WRITING THIS BOOK I INCURRED MANY PERSONAL and intellectual debts. My deepest gratitude goes to:

My wife, Megan, who has been a constant source of love and support throughout the research and writing of this book. She has also been boundlessly understanding through the many research trips, conferences, and long nights at the office that are part and parcel of the writing process;

My kids, Jacob and Julia, who have always provided moments of levity and joy, especially when I needed them. It was always a great pleasure, as well as a relief, to be able to come home to them at the end of the day;

My parents, Sam Rhodes and Frances Hessler, who were happy to talk about the project when things were going well or to offer condolences when they weren't. Mom and Dad were also able and willing to provide much-appreciated help around the house when two sets of hands weren't enough;

My colleagues at the University of Massachusetts, Amherst, especially Scott Blinder, Paul Collins, Justin Gross, Rebecca Hamlin, Raymond La Raja, Tatishe Nteta, Meredith Rolfe, Brian Schaffner, and Elizabeth Sharrow, for providing encouragement for the project as well as generous comments on chapter drafts;

Good friends and family, especially my brother Eliot Rhodes and sister-in-law Anna Buss, and my friends Angelica Bernal and Toby Barnes, Lauren McCarthy and Dan Kost, and Paul and Lisa Collins for providing welcome diversion in the form of food, beer, and music;

Olivier Richomme, whose invitation to write an article responding to the *Shelby County v. Holder* decision for a special issue of *TransAtlantica* inspired me to write this book;

Nicole Mellow and Justin Crowe for organizing the lovely miniconference at Williams College at which I first presented material from this book; and Sid Milkis, Jeff Tulis, and Emily Zackin for providing generous feedback on that manuscript;

Tom and Susan McElroy, for being great parents-in-law, for allowing me to stay at their home during research trips to Washington, DC, and for being willing to share their bourbon;

Keith Bybee, the editor for the Stanford Studies in Law and Politics Series at Stanford University Press, for taking an early interest in the project and providing continued enthusiasm as it developed;

Michelle Lipinski, the senior acquisitions editor for anthropology and law at Stanford University Press, for always being willing to answer my calls, providing consistent reassurance, and fielding my endless questions about the publication process;

David Barney, Kaylee Johnson, and Bryce McManus, for providing outstanding research assistance as well as coauthorship on related conference papers and articles;

Avi Green, who coauthored with me an op-ed in *Talking Points Memo* outlining some of my early thinking on the development of federal voting rights politics;

And the archivists and librarians at the United States Library of Congress, the LBJ Presidential Library, the Richard Nixon Presidential Library and Museum, and the Ronald Reagan Presidential Library and Museum, for answering my questions and helping me to find invaluable documents.

Without all of you, this book would not have been possible.

BALLOT BLOCKED

Introduction

Explaining the Puzzling Evolution of the Voting Rights Act

ON JUNE 25, 2013, THE SUPREME COURT ANNOUNCED ITS decision in *Shelby County v. Holder*. The landmark ruling overturned a central provision of the Voting Rights Act (VRA), known as the "coverage formula," that identified jurisdictions with records of racial discrimination in elections and thereby made their proposed election rules subject to preapproval by the federal government. By striking down the coverage formula, the Court made it much easier for these jurisdictions to instate stringent election rules that raise significant obstacles to voting, particularly among younger, poorer, and nonwhite citizens.

While Democrats sharply criticized the ruling as an assault on the right to vote, prominent Republican politicians cheered the decision for recognizing putative improvements in race relations and returning political authority to the states. Senator Charles Grassley of Iowa declared, "What [the ruling] tells me is after 45 years, the Voting Rights Act worked, and that's the best I can say. It just proves that it worked." Jeff Sessions, a Republican senator from Alabama, endorsed the decision in an almost identical fashion, asserting that "the world has changed since 1965. . . . It was raw discrimination in 1965. . . . That's why the act passed, and it has been pretty darn successful."[1] Republican senator Lindsey Graham lauded the ostensible benefits of the ruling for American federalism: "As a South Carolinian, I'm glad we will no longer be singled out and treated differently than our sister states."[2]

At first blush, the celebration of the Court's decision by Grassley, Sessions,

and Graham—all conservative Republicans—seems unsurprising. After all, the conventional wisdom is that today's Democrats support vigorous enforcement of minority civil and voting rights by the federal government, whereas contemporary Republicans prefer granting deference on these matters to state and local governments and the private sector. But there is just one small problem with this simple narrative. All three Republican senators—along with virtually all of their colleagues in the GOP—voted in 2006 to reauthorize for a twenty-five-year period the provision struck down by the Court. In lauding the *Shelby County* ruling, Grassley, Sessions, and Graham were celebrating the judicial demolition of a policy they had recently voted to entrench in law.

Why would they do such a thing? Ironically enough, insight into this puzzling behavior can be found in the remarks of late conservative justice Antonin Scalia, a strident critic of federal voting rights enforcement. During oral arguments in *Shelby County*, Scalia claimed that consistent bipartisan support in Congress for the Act—which had been reauthorized repeatedly between 1970 and 2006—was attributable to the tendency of conservative legislators to vote for the legislation in spite of their better judgment, out of the cynical desire to better position themselves for electoral success. As Scalia explained,

> I don't think there is anything to be gained by any Senator to vote against continuation of this act. . . . Even the Virginia Senators, they have no interest in voting against this. . . . They are going to lose—they are going to lose votes if they do not reenact the Voting Rights Act. Even the name of it is wonderful: The Voting Rights Act. Who is going to vote against that in the future?[3]

In Scalia's mind, the failure of conservative members of Congress to oppose continuation of the coverage formula justified judicial intervention to prevent the indefinite extension of the constitutional wrong of subjecting states to federal oversight of their election systems. "I am fairly confident [the coverage formula] will be reenacted in perpetuity unless—unless a court can say it does not comport with the Constitution," the conservative justice declared. "*It's—it's a concern that this is not the kind of a question you can leave to Congress*" (emphasis added).[4]

Scalia's normative argument that the Supreme Court was obligated to rid the nation of what he characterized as an unconstitutional "racial entitlement" was both misleading and self-serving. But his interpretation of the motivations and behaviors of Republican elected officials (and their allies on

the Supreme Court) contained an important kernel of truth. Scalia's remarks unintentionally illuminated the political logic that encouraged conservative members of Congress to acquiesce to the repeated expansion of the VRA and then to cheer when their conservative judicial allies weakened the very legislation they ostensibly endorsed.

As I show in this book, conservative elected officials who opposed the expansion of federal voting rights enforcement—but were unwilling to do so openly for fear of alienating both people of color and moderate white voters and thereby harming their party's electoral prospects—adopted a sophisticated long-term strategy to weaken the Act while maintaining a positive public reputation on voting rights matters. In high-profile legislative debates, many Republicans (and conservative southern Democrats) acceded to expansive reauthorizations of the Act, despite their opposition to much of its content, in order to burnish their civil rights credentials. At the same time, however, they adopted lower-profile strategies to limit the scope of voting rights enforcement.

Republican presidents, with the support of many congressional Republicans, empowered conservative justices on the Supreme Court to weaken the Act on their behalf. They also crafted esoteric administrative rules and exploited obscure bureaucratic procedures to limit implementation without running the risk of adverse public scrutiny.

Over time, this strategy enabled critics of the VRA in the elective branches of government to weaken federal voting rights enforcement while obscuring their culpability for doing so. More broadly, this approach advanced the long-term Republican project of eroding the authority of Congress, the most representative branch of the federal government, to protect vulnerable Americans under the Fourteenth and Fifteenth Amendments to the Constitution. Far from strengthening the democratic process, as Justice Scalia suggested, the developments described in this book eroded the promise of American democracy by rendering the voting rights of people of color and minority-language speakers more vulnerable and hobbling the capacity of Congress to preserve their rights.

This book provides a compelling answer to two questions that have puzzled observers of federal voting rights politics: Why did key conservative Republican officials consistently adopt administrative and judicial decisions that undermined the very legislation they previously endorsed? And why have the legislative text, administrative implementation, and judicial interpretation

of the VRA so frequently worked at cross-purposes? As I show, these coun-
terintuitive developments derive from persistent efforts by key Republican
elected officials to limit federal voting rights enforcement while simultane-
ously maintaining the electorally useful appearance of fealty to the ideal of
racial equality. Only by promoting (low-profile) judicial and administrative
decisions that controverted their (high-profile) legislative choices could con-
servative Republican officials advance both of these contradictory goals. The
repeated execution of these discordant maneuvers determined the fractious
character of federal voting rights enforcement.

This book offers broader payoffs for our understanding of how partisan
coalitions manipulate the characteristics of different governing institutions to
achieve controversial objectives without eroding their political support. It is
now widely understood that partisan coalitions attempt to shape the person-
nel and behavior of the executive and judicial branches so that these advance
elected officials' policy goals.[5] More subtly, scholars have recognized that par-
tisan coalitions ascending to power in the elective branches of government
sometimes pass along to allies on the Supreme Court or within the federal
bureaucracy responsibility for deciding controversial matters that they feel
constrained from resolving themselves due to fear of backlash from constitu-
ents.[6] Researchers have even posited that, in extreme circumstances in which
elected officials grudgingly acquiesced to legislation they deplored in order to
placate some constituents, they may invite unelected allies to overrule their
own choices so as to surreptitiously accomplish their preferred goals.[7] Yet
the empirical evidence for these stronger claims—especially the fairly radi-
cal proposition that partisan coalitions sometimes encourage administrative
and judicial allies to overturn choices made under duress—remains limited
due to the methodological and evidentiary challenges of documenting this
behavior.[8] Drawing on thousands of archival and primary sources, dozens of
oral histories, hundreds of contemporary newspaper articles, and numerous
scholarly works, this book demonstrates through a detailed analysis of the
evolution of the nation's most effective civil rights law that elected officials
may deliberately and repeatedly invite (indeed, empower!) unelected allies to
weaken or overturn legislation they abhorred but were unwilling to block.

The case of voting rights politics offers further insights on the use of ad-
ministrative and judicial institutions by partisan coalitions to advance cher-
ished but controversial programmatic objectives. The canonical works in this
literature have focused on the efforts of "lawmaking majorities" or "domi-
nant national coalitions" to achieve controversial ends by nonlegislative (and

especially judicial) means.[9] In these studies, dominant coalitions take full advantage of their ascendancy, authoritatively entrenching their preferred outcomes in administration and jurisprudence. What is notable about federal voting rights politics, however, is that conservative political actors, primarily but not exclusively within the Republican Party, sought with considerable success to advance their preferred policies by administrative and judicial means despite lacking a durable "lawmaking majority" or "dominant national coalition" during the 1965–2015 period.[10] As this book shows, conservative leaders in the Republican Party exploited periods of control of one or more branches of the federal government to *incrementally advance* the project of limiting federal voting rights enforcement via the executive branch or the judiciary. Each step in this process provided a firmer institutional foundation on which similarly minded Republican officials could build, if and when they reclaimed political power. Yet, because critics of federal voting rights enforcement were simultaneously acquiescing to legislative expansions of the VRA in order to maintain a positive reputation on voting rights matters, their entrenchment efforts were always fragmented and incomplete. These observations point to a distinctive, incremental pattern of institutional manipulation by partisan actors to effectuate preferred objectives by subterranean means.

My study also adds nuance to our understanding of the role national governing institutions play in extending or retarding the realization of civil rights for vulnerable groups in society. Scholars have long debated whether the elective branches of government or the federal courts offer greater opportunities for the advancement of civil rights.[11] In my view, however, this question is somewhat misplaced. Rather than thinking about the various branches of the federal government as possessing relatively stable characteristics that make them more or less effective in promoting civil rights in general, we should instead imagine them as fairly fluid institutions whose influence on civil rights policy making can vary dramatically depending on who is occupying them and for what purposes.[12] This perspective brings partisan coalitions to the forefront, focusing on the ways in which these coalitions manipulate the frequently ambiguous characteristics of institutions to advance diverse—and even conflicting—programmatic objectives.[13]

The Development of the VRA: Puzzles

Well into the 2000s, the expansion of the Voting Rights Act was largely taken for granted.[14] The Act's reputation as the "most effective civil rights law ever

TABLE 1.1. The Puzzling Evolution of the Voting Rights Act

	Consistently expansive *Legislative politics*	Increasingly fragmented *Administrative politics*	Increasingly conservative *Supreme Court politics*
1965–1968 (Chapter 1)	Enactment of the Voting Rights Act of 1965	Deployment of voting registrars and election monitors only to areas with worst records; failure to implement preclearance in serious fashion	Vindication of constitutionality of VRA; expansion of preclearance to cover vote dilution as well as denial of the ballot
1969–1980 (Chapter 2)	Extension of VRA to enfranchise 18–21-year-olds (1970); expansion of VRA to protect rights of language-minority citizens (1975)	Effort to limit preclearance to instances of "proven" discrimination (in contravention to text of Act); acceptance of discriminatory voting changes; lax use of registrars and monitors provisions	Narrowing of preclearance "effects" standard to instances of "retrogression" of minority voting power; acceptance of annexation plans that dilute minority voting power
1981–2000 (Chapter 3)	Extension of preclearance coverage and other "temporary" provisions for 25 years; expansion of Section 2 to permit legal challenges to voting rules with "discriminatory effects"	(During Reagan presidency) Use of hiring and promotion to advantage conservative attorneys; serious limitations on staff influence in administration of preclearance; major deceleration of preclearance	Imposition of substantial constitutional limitations on majority-minority redistricting; narrowing of preclearance "intent" standard to instances of "retrogressive intent" on part of officials
2001–2013 (Chapter 4)	Extension of preclearance coverage and other "temporary" provisions for 25 years; overturning of several conservative statutory decisions by Supreme Court	(During Bush presidency) Use of questionable personnel practices to advantage conservative attorneys and punish liberal lawyers; alteration of administrative procedures to eliminate staff influence in voting rights cases; possible politicization of preclearance to advance GOP interests	Narrowing of meaning of "vote dilution" to further disadvantage minority interests; invalidation of Section 4 "coverage formula," with effect of paralyzing federal preclearance of proposed voting changes in jurisdictions with records of racial discrimination
2009–2016 (Chapter 5)	No major decisions (Republican obstruction of legislative response to Supreme Court decision striking the coverage formula and obstructing preclearance)	Use of personnel policies to advantage liberal attorneys and staff; strenuous efforts to limit "voter ID" policies and other stringent election rules; ongoing bureaucratic warfare between liberal and conservative attorneys	No major Supreme Court decisions 2014–2016 (Court split 4–4 after death of Justice Antonin Scalia)

enacted" seemed to render it virtually impervious to retrenchment.[15] Even in 2006, when some legal scholars expressed serious concerns that the Supreme Court was prepared to strike down portions of the VRA, these voices were largely drowned out by popular celebration of the renewal of the legislation.[16] But with the Supreme Court's ruling in *Shelby County*—and the attendant rush by states throughout the nation to adopt restrictive voting requirements—the vulnerability of the right to vote became strikingly evident.[17]

That decision also brought into sharp relief the many puzzles surrounding the evolution of federal voting rights policy. Since 1965 the VRA has been renewed and expanded in four major legislative overhauls (in 1970, 1975, 1982, and 2006), always by overwhelming margins and always during periods of Republican control of the presidency.[18] Why has Congress repeatedly voted on a nearly unanimous basis to extend and strengthen the provisions of the Act, even as rising conservative influence in national politics has hamstrung other causes favored by liberals and minority-rights advocates? And why have very conservative Republican members of Congress as well as conservative Republican presidents such as Richard Nixon, Ronald Reagan, and George W. Bush consistently celebrated renewal of the law? When we look beyond the legislative politics surrounding the VRA, other puzzles emerge. Republican presidents have repeatedly undertaken actions in the administrative and judicial arenas to limit the scope of the VRA, despite their previous endorsement of the Act. If these officials consistently backed renewal of the VRA in Congress, however, why did they routinely adopt decisions in these other arenas that weakened the Act? Alternatively, if conservative Republicans' administrative and judicial maneuvers reflected their true preferences, why did they not also aggressively advocate them in the legislative domain, especially in the repeated instances in which control of the presidency or at least one house of Congress offered them real opportunities to limit the scope of the Act's protections?

These questions point to broader developmental puzzles. The Court's ruling in *Shelby County* is illustrative of a general pattern in which legislative and judicial voting rights decisions have, since the early 1970s, consistently marched in different directions. As summarized in table I.1 and described in the following chapters, in repeated reauthorizations since 1965, the text of the VRA has provided ever-more expansive voting rights safeguards for racial and language minorities; the Court's voting rights jurisprudence, however, has gradually moved further and further to the right. In similar fashion,

the repeated reauthorization and expansion of the Act's statutory guarantees have been attended by an increasingly fragmented voting rights bureaucracy characterized by declining expertise and deteriorating professional comity. How can these divergent patterns be reconciled?

Explaining the Evolution of the VRA

At present, we do not possess the means to resolve these puzzles. Alexander Keyssar has provided a magisterial history of the expansion of the right to vote from the founding of the United States to the dawn of the twenty-first century.[19] But there is surprisingly little research focused on the development of federal voting rights policy over the last five decades.[20] And although legal scholars have extensively studied the evolution of the Supreme Court's voting rights jurisprudence since the 1960s, they have generally declined to place these rulings in broader partisan and institutional context.[21] Most other related scholarship focuses on specific empirical questions, such as whether the Act has led to better representation of racial minorities or stimulated turnout among African American and Latino voters.[22]

In recent years, a few intrepid analysts—most notably legal historian J. Morgan Kousser and journalist Ari Berman—have examined the evolution of the VRA over time.[23] Yet, although both Kousser and Berman make invaluable contributions to our understanding of voting rights politics, both fail to provide the clear, theoretically informed narrative that links repeated congressional choices, administrative decisions, and Supreme Court rulings and thereby illuminates the peculiar development of the Act from 1965 to the present.

Kousser's objective is to highlight the "strange, ironic" features of the evolution of the VRA, which he believes will "help us both to understand a crucial civil rights policy and . . . devise workable solutions to the problems in voting rights that are sure to arise in the future."[24] He takes previous studies to task for "smoothing out informative kinks, telescoping complex and often paradoxical developments, and misleadingly characterizing motives." He also calls on scholars to pay greater attention to the "complicated minuets involving courts, Congress, and bureaucracy."[25] Kousser's detailed historical analysis highlights several puzzling developments: the repeated reauthorization of the VRA during conservative Republican presidential administrations; the frequently confused if not lackluster implementation of the VRA by the De-

partment of Justice (DOJ), especially during conservative Republican administrations; and the often tortured reasoning of voting rights decisions handed down by Republican appointees to the Supreme Court. Although Kousser's argument is difficult to summarize, the main takeaway appears to be that the evolution of the VRA defies simple narrative explanation—especially a triumphalist explanation that predicts the inevitable victory of minority voting rights. Indeed, he concludes, "the jerky, often-reversed course of modern voting rights history reminds us never to count on present trends, rely on the inevitable success of truth or right principles, or forget that justice is a self-conscious political construction."[26]

Kousser's research is impeccable, his analysis is richly detailed, and his characterization of the troubled development of the Act is sound. What his study lacks, however, is an overarching argument that makes sense of the disparate "strange" and "ironic" developments he so ably describes. Kousser clearly recognizes that the increasing vulnerability of the Act is linked to the ascendance of modern Republican conservatism in American political life. But he does not explain how the VRA's peculiar evolutionary course is tied to this development. If, as Kousser suggests, key political actors in the Republican Party successfully obstructed implementation of the VRA through the bureaucracy and the courts, why did they always acquiesce to the expansion of provisions of the Act in Congress, even when they seemed to possess the votes to force major changes in the content of the statute? Given that the simultaneous development of expansive legislation, fragmented administration, and restrictive judicial interpretation is arguably *the* most puzzling feature of the evolution of the federal voting rights regime, the failure to explain it is unsatisfactory.

Ari Berman has recently provided a detailed narrative history of the evolution of the VRA from its enactment in 1965 through its post–*Shelby County* struggles in 2015. The core thesis of Berman's book and other writings is that bipartisan commitment to minority voting rights sustained the VRA until very recently, when ideological extremism and anxiety about demographic shifts favoring the Democrats led Republicans to abandon their support of the Act in favor of stringent rules that shrink the electorate and thereby enhance Republican prospects. As Berman suggests, "For decades after the 1960s, voting rights legislation had strong bipartisan support in Congress. Every reauthorization of the VRA—in 1970, 1975, 1982 and 2006—was signed by a Republican president and supported by an overwhelming number of Re-

publicans in Congress."[27] But "elements of the Republican Party have since [the 2006 renewal of the Act] become more hostile to the law, especially following President Barack Obama's election," ultimately leading to the "collapse" of "a five-decade bipartisan consensus" on the VRA.[28] For Berman, Republican opposition to much of the VRA was a recent development spearheaded by a small cadre of conservative ideologues at the fringes of the GOP establishment. This movement is personified in the figures of Chief Justice John Roberts and entrepreneurial litigator Edward Blum, who, in Berman's telling, made it their personal mission to limit the scope of the Act.[29]

Berman's study offers compelling portraits both of civil rights activists such as John Lewis and of conservative "revolutionaries" such as John Roberts. Berman's inability to account for crucial historical patterns, however, renders his central argument unconvincing. Berman correctly observes that the repeated appointment by Republican presidents of conservative jurists to the Supreme Court and lower federal courts enabled the judicial erosion of federal voting rights protections. But if (as Berman asserts) Republican elected officials genuinely supported renewal of the VRA until very recently, why, beginning in the late 1960s, did they consistently back the appointment of jurists who were expected by most contemporary observers to weaken federal voting rights safeguards? The administrative obstructionism that Berman documents—which, again, dates to the late 1960s—is likewise very difficult to square with his presentation of the GOP as broadly supportive of the VRA until very recently. Why would Republican presidents routinely limit federal voting rights enforcement by administrative means if they and their allies endorsed the core purposes of the Act?

An Alternative Explanation

Both Kousser and Berman end up restating—rather than resolving—the central questions surrounding the evolution of the Act. In this book, I develop an alternative argument that foregrounds the interplay between party coalition and ideological demands, electoral imperatives, and institutional politics in a polity in which racial conflict is fierce but also (at least since the 1960s) constrained by proequality norms.

Race has always been the central fault line of American politics. Throughout United States history, proponents of racial equality have continuously struggled for preeminence in American politics with those who advocated

white supremacy—or, at least, who opposed federal measures designed to re-
duce racial inequalities.[30] Battles over racial equality, which have involved a
wide range of participants within both government and civil society, have
mapped onto national party politics in a variety of ways. Since the civil rights
revolution of the 1960s, however, the partisan alignment over race has been
clear. The members of the Democratic Party have more consistently supported
federal efforts to reduce racial inequalities while Republican Party members
have tended to oppose such measures.[31] To be sure, both parties have con-
tained dissident factions: a dwindling number of conservative, white Demo-
crats continued to object to civil rights reforms into the 1980s, and moderate-
to-liberal Republicans remained an important, if minority, force within the
GOP into the same decade.[32] But although the partisan divide on civil and
voting rights matters was clearly evident in the 1960s, it has intensified dra-
matically since that time.[33]

Partisan polarization over race had roots in the New Deal realignment,
which set the parties on very different ideological and interest trajectories. To
be sure, the New Deal party system was initially organized around economic
issues, to the general exclusion of racial concerns. Nonetheless, the coalitions
and ideological commitments it institutionalized within each party rendered
partisan polarization on racial matters all but inevitable. With the New Deal,
African Americans, left-wing workers and labor unions, liberal intellectuals
and activists, and progressive Christians and Jews became core Democratic
Party constituencies.[34] Because all these groups held liberal views on racial
matters, their incorporation rendered the party's traditional conservative
stance on civil rights—rooted in the party's alliance with the white suprema-
cist "Solid South"—increasingly untenable. Moreover, the New Deal and Fair
Deal cemented a new Democratic ideology of "rights-based universalism,"
the central pillar of which was equal rights for all Americans regardless of
race, creed, or national origin.[35] These new coalition partners and ideological
commitments moved the national Democratic Party slowly but inexorably to-
ward support of minority civil rights so that, by 1964, national party leaders
were forced to adopt the cause.[36] This process also gradually pushed racially
conservative southern Democrats toward the margins of influence.[37]

Meanwhile, the Republican Party's evolving coalition partners and ide-
ological commitments gradually impelled the "party of Lincoln" to adopt
more conservative positions on civil rights issues during and after the New
Deal era.[38] The party's core constituencies, large- and small-business own-

ers, opposed federal efforts to increase economic opportunities for people of color in the 1940s and 1950s on the grounds that such initiatives interfered with managerial prerogatives and private-property rights.[39] The inclination of many rank-and-file Republican voters toward racial conservatism—already clearly evident in public opinion polls from the 1940s—only intensified as the party began to compete (at least at the presidential level) for the support of some southern whites in the 1950s.[40] Finally, the GOP's embrace of an ideology of antistatism and free-market capitalism during the New Deal meant that it was disinclined to support federal civil rights efforts that increased regulations and imposed on the traditional prerogatives of state and local governments.[41]

The partisan divide on civil rights accelerated after the enactment of the Civil Rights Act (CRA) of 1964 and of the VRA.[42] The clear and divergent signals sent by Democratic and Republican elites on civil rights matters—especially in the 1964, 1968, 1972, and 1980 presidential campaigns—reinforced the coalitional dynamics at play before 1965. In response to these signals, ordinary citizens increasingly sorted themselves into the party that best represented their economic and racial views, with economically *and* racially liberal Americans moving into the Democratic Party and economically *and* racially conservative citizens filing into the Republican ranks.[43] Meanwhile, Democratic and Republican members of Congress increasingly adopted polarized positions on both economic and civil rights matters. These developments culminated in realignments in the parties' respective geographic bases of power. Generally, the Democratic Party gradually achieved predominance in states in the liberal Northeast, upper Midwest, and Pacific coast, where Republicans had once enjoyed considerable success; and the GOP slowly gained ascendancy in the staunchly conservative and formerly Democrat-dominated South.[44] With this realignment, liberal northern Republicans and conservative southern Democrats became practically extinct species in Congress and in national politics more generally.

The growing partisan racial cleavage was accompanied by the emergence of a novel set of norms governing public discussion of racial issues. Before the 1960s, explicitly racist messages—"racial nouns or adjectives to endorse white prerogatives, to express antiblack sentiment, to represent racial stereotypes, or to portray a threat from African Americans"—were acceptable, even commonplace, in American politics.[45] But gradually changing public attitudes, the ascendance of the modern civil rights movement, and the enact-

ment of the CRA and the VRA established a new system of norms in which explicit racist rhetoric was redefined as unacceptable in legitimate political discourse. Although racism and opposition to racial equality remained potent forces, these sentiments were driven underground as both political parties and all major players in national politics renounced the doctrine of "white supremacy." Arising in its stead was a new "norm of racial equality" in which all Americans, regardless of race and ethnicity, were entitled to fair and equal consideration before the law.[46] The norm of racial equality diffused widely in American politics and society, as evinced by a dramatic increase in white support for equitable access to economic and political opportunities (despite the persistence of negative racial stereotyping by many whites).[47] Meanwhile, both the CRA and the VRA attained the cultural status of "super-statutes," enjoying widespread veneration and near-constitutional significance.[48]

The ascendance of the norm of racial equality in the context of partisan polarization on racial issues transformed the politics surrounding voting rights policy making after 1965. In the post-1965 period, federal voting rights policy making revolved around questions of *how far* federal authority should reach and for *how long*. Should nonblack racial and ethnic minorities and individuals with limited English proficiency be afforded protections under the Act? Should people of color be able to challenge election rules with racially disparate effects, even in the absence of evidence of intentional discrimination? Should state and local governments be required to construct majority-minority districts to ensure that nonwhites enjoy the same opportunity as whites to elect candidates of choice to office? How long should provisions mandating federal review of changes in election rules in jurisdictions with histories of racial discrimination remain in operation?

Many Democratic elected officials (with the exception of conservative, white southern Democrats) naturally gravitated toward a very expansive view of each of these matters, both because it was popular with powerful party constituencies and because it resonated with core party commitments. In contrast, many Republican elected officials faced conflicting imperatives. On one hand, core Republican coalition partners and ideological commitments inclined many Republican elected officials toward a relatively narrow view of federal voting rights enforcement. Business groups, although not opposed to minority voting rights per se, feared the redistributive implications of expanded turnout and political power by racial-, ethnic-, and language-minority citizens; racially conservative whites opposed federal efforts to enhance the

political power of African Americans and Latinos; and Republican votaries of limited government disputed the VRA's impositions on state and local authority. Moreover, Republicans' growing post-1965 partnership with middle- and upper-class whites disinclined them toward modes of voting rights enforcement—such as race-conscious districting—that offended this group's belief that civil rights enforcement was legitimate only to the extent that it was "colorblind."[49] Finally, as people of color moved overwhelmingly into the Democratic ranks, some Republican elected officials calculated that measures to make voting more difficult for these groups would enhance GOP electoral prospects.[50] In short, a relatively narrow vision of federal voting rights enforcement served as a "common carrier" (to use Eric Schickler's term) of distinct but overlapping interests and values within the Republican coalition.[51]

On the other hand, in an era in which the norm of racial equality was ascendant and the VRA was accorded near-constitutional status, Republican officeholders understood that efforts to limit federal voting rights protections were fraught with political danger. Republican elected officials with large nonwhite constituencies could not aggressively challenge the VRA without outraging these groups and thus potentially putting their own electoral careers at risk.[52] In the post-1965 period, many Republican senators and a nontrivial number of Republican representatives faced the imperative to achieve a respectable (if usually modest) showing among nonwhite voters. For these Republican officeholders, electoral demands imposed limitations on their willingness to attempt to circumscribe the scope of the VRA, despite other coalitional and ideological pressures to do so.

More subtly, even those Republicans who did not need minority voter support to ensure their own reelections were nonetheless restrained from directly and aggressively pursuing limits on the scope of the VRA. For these elected officials, an interest in maintaining the GOP's collective reputation on civil rights issues with people of color *and* moderate whites discouraged them from forcefully seeking a reduction in the breadth of the Act's protections.

As Gary Cox and Mathew McCubbins have argued, individual elected officials place a high value on the collective reputation of their party. The party's collective reputation is valuable because voters—many of whom lack information about specific candidate traits and achievements—rely heavily on their understanding of the party's public standing in making choices at election time.[53] Through its impact on voters' choices, the party brand affects "the member's personal probability of reelection" and "the party's probability of

securing a majority" and thus of advancing cherished policy objectives.[54] Importantly, because voters regularly update their views of the parties' reputations in light of the parties' recent public performance, elected officials must make ongoing efforts to maintain their parties' public brands.

The imperative of party-brand maintenance imposed strong pressure on Republican elected officials to appear supportive of federal voting rights enforcement. As Republican officeholders understood, the ascendance of the norm of racial equality and the enshrinement of the VRA as a quasi-constitutional law endowed the Act with great symbolic as well as practical importance among people of color and moderate whites. Thus, aggressive and visible efforts to weaken the VRA risked alienating these groups. This prospect—especially the possible estrangement of potentially pivotal moderate white voters—threatened Republican electoral fortunes and in turn risked undermining Republican programmatic objectives in areas of greater concern to core party constituencies (such as tax reductions, cuts in domestic spending, and increases in defense spending). Concerns about party-brand maintenance with people of color and moderate whites thus imposed restraints on the behavior of Republican elected officials who might otherwise have sought limitations on the scope of the Act's protections.

In short, many Republican officeholders faced a serious conflict between the demands of core coalition partners and ideological commitments and the requirements of party-brand maintenance. For many Republican elected officials, then, the task was to find ways to limit the scope of the VRA in order to satisfy coalitional and ideological demands while also preserving the party's public reputation by maintaining the appearance of fidelity to the norm of racial equality. Ultimately, key Republican Party leaders (presidents, members of the party leadership, and influential senators and representatives) adopted a solution to this political problem that involved exploiting the varying political characteristics of decision-making processes within the different branches of the federal government.

Scholars have recognized that policy-making venues and processes vary considerably in *visibility* (meaning conspicuousness to interested parties, the media, and the public), *traceability* (that is, the extent to which responsibility for decisions can be linked back to elected officials), and *openness* (the degree to which venues and processes are amenable to popular participation and influence).[55] These differences in turn affect both the character of policy making within these domains and the likely outcomes of political struggles.

Voting rights politics have varied dramatically in visibility, traceability, and openness across the three branches of government, with these factors generally achieving their highest levels during *legislative* consideration of enactment or renewal of the VRA and reaching much lower levels when decisions have been confined to *administrative* and *judicial* venues. A rough empirical indication of the dramatic differences in the visibility and traceability (although not openness) of voting rights politics across institutional venues can be gleaned from the observation of over-time variation in mainstream media attention to the Act.[56] Figure 1 provides a basic illustration of this variation as revealed in the frequency of front-page articles mentioning the "Voting Rights Act" in the *New York Times* and the *Washington Post*—the nation's two papers of record—between 1965 and 2012 (the point at which comparable archival newspaper data is no longer available).[57] Broadly speaking, attention to the VRA declined substantially over time as the Act became institutionalized within American politics. But as the plots show, attention in these two newspapers exhibits several spikes: in 1965, 1969–1970, 1974–1975, 1981–1982, 1984, 1989, 1991–1992, and 2005–2006. With the exceptions of 1984 and 1989, *all of these spikes occurred in periods in which Congress was engaged with reauthorizing provisions of the VRA.* In other years, media attention was usually much less intense—despite the fact that judicial rulings and administrative decisions with profound implications for federal voting rights enforcement were rendered in many of those intervening years.[58] These patterns provide an indication of how, at least in the realm of voting rights politics, visibility and traceability have been closely tied to legislative struggles.

Over time—and with fits and starts—leading Republican officeholders exploited these dynamics to their advantage in crafting voting rights policy.[59] In Congress, where decision-making on voting rights matters was highly visible to the media and the public, easily traceable to the choices of decision makers, and attended by extensive popular participation—and thus most likely to affect the party's public brand—these Republican elected officials grudgingly acquiesced to expansions of the scope of the VRA in order to maintain the party's reputation of support for minority voting rights. At the same time, however, in the administrative and judicial arenas, where there was much less media and public scrutiny of voting rights matters, responsibility for decisions was more difficult to pin on elected officials, and public participation was sharply circumscribed—and thus decisions were less likely to affect public impressions of the party's brand—these officeholders pursued the narrow

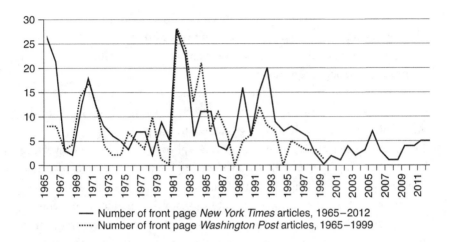

— Number of front page *New York Times* articles, 1965–2012
‥‥‥ Number of front page *Washington Post* articles, 1965–1999

FIGURE 1. Attention to voting rights politics in the *New York Times* and *Washington Post*, 1965–2012.

SOURCE: Author's analysis of data from *ProQuest Historical Newspapers*.

vision of federal voting rights enforcement they and their core constituent groups preferred.[60] Over time, their actions strengthened the capacity of allies in the bureaucracy and judiciary to countermand (or at least dilute) the legislative choices Republican elected officials deplored but were unwilling to block.

As Republican critics of the VRA quickly learned, Congress was not an auspicious venue in which to pursue a narrowing of the scope of the Act. Because sunset provisions required Congress to review and reauthorize important features of the Act on a routine basis, legislators could not avoid taking public positions on the law. As figure 1 suggests, the debates attending these reauthorization processes were subject to extensive public and media attention. Proposals and choices by conservative Republican officials thus came under intense public scrutiny. Furthermore, because reauthorizations of the VRA required the recording of public votes, responsibility for decisions was easily traceable to the choices of elected officials. With Democrats relentlessly framing these votes as referenda on basic citizenship rights, many Republicans were eager to appear supportive of the statute, especially on final-passage votes. Finally, legislative struggles over voting rights were comparatively open processes, involving broad participation by civil rights activists and minority-language advocates. Consequently, initiatives to limit the scope of the Act

were subjected to ceaseless public criticism by civil rights groups. Unwilling to suffer the reputational costs of voting on the record against the VRA, many Republicans repeatedly acquiesced to expansive reauthorizations of the Act despite their strong reservations.[61]

At the same time, Republican critics of the VRA found that administrative politics offered an effective means for circumscribing the scope of the Act while simultaneously avoiding damage to the party's reputation.[62] Unlike decisions pertaining to legislative renewal of the Act, choices involving the application of Supreme Court doctrines, the implementation of administrative regulations, or the disposal of particular cases rarely received extensive attention from the media or the public (or, for that matter, from members of Congress).[63] Republican presidents thus enjoyed considerable freedom to limit the scope of federal voting rights enforcement through administrative mechanisms without fear of eliciting adverse media or public scrutiny. Furthermore, because restrictive administrative decisions on voting rights matters were formally rendered by obscure bureaucrats within the Department of Justice, responsibility was less directly traceable to the choices of Republican elected officials.[64] Finally, administrative decisions on voting rights matters were not characterized by the same broad participation as were legislative choices—due to the high cost of monitoring bureaucratic determinations and the limited diffusion of legal expertise, they tended to be negotiated by a relatively narrow circle of bureaucrats, lawyers, and interest-group representatives. The narrow scope of conflict surrounding most administrative decisions often allowed Republicans who took a restrictive view of federal voting rights enforcement to prevail on implementation matters without generating broad public outcry.

Judicial appointments also proved highly successful as a means for limiting the effectiveness of the VRA without exposing Republican critics to public disapprobation. As a general matter, political parties can use Supreme Court appointments to "institutionalize their substantive policy agendas [and] insulate them from electoral politics."[65] Party leaders have especially strong incentives to empower the Court when the members of their party are cross-pressured in ways that prevent them from making authoritative decisions through the legislative process. Under such conditions,

> the Court as a policymaker [can be] a potential strategic resource for overcoming a fragmented coalition and achieving policy outcomes desired by

some constituents. At the same time, the independence of the judiciary from explicit political control allow[s] politicians to distance themselves from judicial actions greatly disliked by other constituents.[66]

Republican elected officials who preferred a more modest role for the VRA exploited these characteristic features of the judicial-appointments process to circumscribe federal voting rights enforcement while minimizing the risk of damage to the party's public reputation. Although judicial confirmation hearings were fairly visible, the views of conservative candidates on voting rights cases generally were not; and even in the few instances in which such opinions received considerable scrutiny, they competed with many other jurisprudential and political considerations for public and senatorial attention. (Overall, evidence presented in the following chapters suggests that many—if not most—Americans paid limited attention to hearings pertaining to the appointment of pivotal justices.) In any case, except in a few extraordinary circumstances, senators followed confirmation-process norms by acquiescing to the nominees of the president. Thus, as long as conservative Republican presidents did a thorough job of vetting their choices, they could be fairly confident that their nominees would advance their preferred agenda on the Court for years or decades following their appointments.[67]

Furthermore, because judicial appointees made the controversial programmatic decisions, Republican elected officials retained "plausible deniability" of responsibility for the Court's choices. Many of the most important conservative voting rights decisions were rendered by justices whose Republican presidential sponsors had long since retired from office, further attenuating the chain of responsibility and accountability linking elected officials and judicial outcomes.[68] Last but not least, life tenure enabled the Court's conservative justices to resist the popular pressures that constrained the choices of Republican elected officials on voting rights matters.

Of course, due to variation in both individual (especially presidential) preferences and skill in implementing this strategy, the intensity and thoroughness of Republican institutionalization of a relatively narrow view of federal voting rights enforcement varied somewhat over time. Yet, when the 1965–2015 period is considered as a whole, a fairly consistent political and institutional pattern comes into focus. Over the long run, the repeated use of administrative and judicial decisions by key Republican leaders to circumscribe federal voting rights enforcement had the effect of limiting the expan-

sive voting rights legislation that Republican elected officials ostensibly endorsed in Congress.

A Few Notes on Method and Data

Although the chapters that follow are presented in narrative format, I use a variety of methods and sources of evidence to substantiate the major arguments in this book. Here, I briefly describe these methods and sources so that the reader has a clear sense of the logic of the analysis that appears in subsequent chapters.

In substantial part, I adopt a "process-tracing" approach as a method to assess my argument. Process tracing involves leveraging historical information to permit observation of the various steps of the overarching argument in specific historical cases.[69] I have made strenuous efforts to acquire information that will support this approach. I have collected thousands of primary documents from numerous presidential libraries, the Library of Congress, and other archives, and I have reviewed hundreds of recorded telephone conversations between presidents, members of Congress, and representatives of civil rights groups. These sources provide an inside look at private deliberations among presidents, party leaders, and members of Congress about electoral strategies and tactics, legislative maneuvers, administrative politics, and judicial appointments. They also allow an examination of the decisions and actions of these figures. Because these sources record private conversations and events at the approximate time they occurred, they are generally less guarded and biased by ex-post interpretations, and thus they provide especially valuable insights on actors' motivations and behaviors.[70] Additionally, I have consulted dozens of oral histories from presidential advisors and staff, members of Congress, and interest-group representatives that appear in the oral-history projects of the Kennedy, Johnson, Ford, Reagan, and Bush I administrations. These documents, although somewhat less reliable than primary sources, still provide valuable insight on the thought processes and strategies of elite political actors. I have supplemented the archival evidence and oral-history interviews with thousands of articles drawn from contemporary newspapers and journals as well as with a very large number of relevant secondary sources, such as published books, articles, and monographs. This extensive, diverse array of documents allowed me to cross-check inferences across multiple sources and thereby derive firmer conclusions.[71]

To an important degree, these documents provide smoking-gun evidence

in support of key steps in my argument, directly illuminating the motivations of key Republican (and Democratic) elected officials and linking them to important decisions and actions in relation to the formation of voting rights legislation, the administration of voting rights law, and the selection of Supreme Court justices.[72] For example, I have acquired considerable direct evidence that, on multiple occasions, key Republican officials abandoned support for conservative voting rights proposals due to fear of the negative impact that these initiatives would have on the party's public reputation and electoral chances. I have also acquired direct evidence that Republican presidents appointed Supreme Court justices at least in part with an eye toward limiting the capacity of Congress to expand federal protections of minority voting rights.

Smoking-gun evidence of actors' intentions or deeds is sometimes unavailable, however. I thus supplement process tracing with assessment of the "observable implications" of my argument. This approach involves generating expectations about various observable patterns that should be present if the argument is correct and determining whether these expectations are in fact validated by the weight of accumulated evidence.[73] Although no single observation provides definitive proof, the presence of many observations consistent with the argument provides powerful support.[74] This approach is analogous to the strategy of the criminal detective who solves the crime by accumulating many disparate observations that—once integrated with an overarching "theory of the crime"—all point to the same culprit.[75]

Each part of my argument entails several observable implications. If key Republican actors were motivated by coalition partners and ideological commitments to circumscribe federal voting rights protections, they should do the following: initiate legislative proposals to limit the scope of the VRA; express hostility toward or vote against expansive voting rights proposals in such lower-profile legislative settings as committee hearings, markup sessions, and floor votes on amendments; and express support for and vote for proposals that would narrow the scope of the VRA in these low-profile settings. To investigate these implications and determine whether they are borne out, I analyze a wide range of relevant information, including the texts of legislative proposals, quantitative data describing cosponsorship of voting rights legislation and key votes in committees and on the chamber floors, and qualitative descriptions of legislative processes from archival sources and contemporary newspaper accounts.

But if fear among key Republican elected officials of the political costs of

following through with efforts to circumscribe federal voting rights protections ultimately led them to acquiesce to expansive voting rights bills, they should also do these two things: abandon conservative positions in the face of civil rights mobilization and public criticism and eventually endorse expansive voting rights proposals (including proposals they initially criticized). To document civil rights mobilization on voting rights measures—and pressure on Republican officials—I draw heavily on archival documents from the collections of the NAACP and Leadership Conference on Civil Rights (LCCR). I also examine patterns of change in the public position-taking of Republicans over the course of legislative debate using the texts of bills, public statements from officials, and roll-call votes. I pay special attention to qualitative and quantitative indicators of shifts from opposition to support of expansive voting rights legislation—such as when Republican members of Congress vote for final passage of the VRA despite previously supporting failed amendments that would have seriously weakened the Act—as well as the timing of these shifts in relation to civil rights mobilization. To provide additional circumstantial evidence of electoral motives as the basis for these maneuvers, I make use of contemporary public-opinion polls pointing to the popularity of the VRA, the salience of civil rights matters, public disapproval of Republican positions on voting rights and civil rights, and so forth.

If Republicans sought to use administrative maneuvers as a means for weakening federal voting rights protections out of the view of the public and the media, they should repeatedly do the following: appoint officers within the Department of Justice and the Civil Rights Division (CRD) with conservative attitudes on voting rights matters; establish bureaucratic processes and rules that have the effect of narrowing the scope of federal enforcement; and instate hiring, promotion, and recognition practices that favor attorneys and support staff with narrow views of federal voting rights enforcement. Moreover, the substantive effects of these decisions should be observable in relaxed patterns of federal voting rights enforcement. To assess these implications, I use primary documents from within administrations, public statements by administration officials and political appointees, reports of federal administrative activities and investigations of official malfeasance, and contemporary news reports.

Finally, if Republicans used judicial appointments as a way to advance conservative voting rights objectives, they should repeatedly nominate jurists whose known positions on voting rights matters, federalism, and congressional power point to a narrow view of voting rights enforcement. Fur-

thermore, we should see indications of the effectiveness of Republican efforts to institutionalize conservative voting rights views on the Supreme Court in the behavior of Republican appointees. Republican nominees should do the following: tend to vote on the conservative side of voting rights cases before the Supreme Court, jettison liberal precedents on voting rights issues in the process of reaching conservative rulings, establish new statutory interpretations or constitutional doctrines congenial to conservative claimants in voting rights cases, and adopt normative or legal language echoing the major themes of the administrations that appointed them. I evaluate the intentions of Republican presidents with a variety of data. Statements by presidents and top officials pointing to conservative positions on constitutional matters pertaining to voting rights issues provide circumstantial evidence of presidential intentions to nominate justices with similar views. Qualitative information on the voting rights records of Supreme Court nominees also provides important circumstantial evidence of intentions of the presidential patrons. Further indications of Republican presidents' intentions can be found in the postappointment voting records on voting rights issues of Republican appointees to the Court, which can be assessed with quantitative data assembled by social scientists. A final means that I use to illuminate linkages between justices' arguments and the interests and ideologies of the officials who appointed them is the careful qualitative reading of the texts of key opinions written and/or supported by Republican appointees.

Plan for the Book

Chapter 1 traces the paths by which the Voting Rights Act was, during the administration of Lyndon B. Johnson (1963–1969), established in law, administered in the federal bureaucracy, and extended through generous statutory construction by a liberal Supreme Court. Chapters 2, 3, and 4, which respectively cover the 1969–1980, 1981–2000, and 2001–2013 periods, turn to subsequent struggles over the scope of the VRA, concentrating much more on Republicans' strategic efforts to weaken the Act while maintaining the public appearance of support for the norm of racial equality. Chapter 5 (2009–2016) completes the history with an examination of the contentious politics surrounding voting rights during the presidency of Barack Obama. The conclusion reviews the evidence to draw out the broader theoretical and empirical implications of the book and contemplates the future of voting rights in the age of Donald Trump.

1 Liberal Ascendance and Enactment of the Voting Rights Act of 1965

THE WINDS OF CHANGE ARE FRESHENING IN THE DEEP SOUTH, where hundreds of Negroes are being allowed this week, for the first time, to register to vote," the *Boston Globe* grandly announced on August 12, 1965. "The segregationists scowl and mutter darkly; but their hands, which have so often interfered in the past, are stayed by the knowledge that the might of the Federal government is solidly on the side of the Negroes."[1] Setting aside the purple prose, the conclusions of the anonymous editorialist were broadly correct. The Voting Rights Act of 1965, which President Lyndon B. Johnson had signed into law only days earlier, marked a decisive break with past federal civil rights laws that attempted, albeit feebly, to address the problem of widespread black disenfranchisement in the South.

Whereas previous acts of Congress had established litigation as the sole method of federal voting rights enforcement, the VRA authorized executive branch officials to intervene in southern states without the prior blessing of the federal courts. The Act suspended literacy tests in jurisdictions with low black registration and electoral participation, and it empowered the Department of Justice both to register African Americans frustrated by local registrars and to monitor the conduct of elections in jurisdictions in which racial discrimination was rampant. More radically, the VRA called for advance federal approval—or "preclearance"—of changes in election rules and regulations in jurisdictions with histories of low black electoral participation.

Enactment of the VRA resulted from the confluence of three critical de-

velopments: intense frustration among civil rights activists and, increasingly, executive branch officials with the transparent failures of existing voting rights law; the ascendance of an organized and militant civil rights movement with the capacity to dramatize the nation's worst racial injustices; and the election to the federal government of a coalition of civil rights liberals—based primarily but not exclusively within the northern Democratic Party—with the political will to carry through strong civil rights reforms in the face of strident resistance from southern Democrats and conservative Republicans. The convergence of these three developments finally permitted the transcendence of the political, legal, and institutional obstacles that had long thwarted effective federal voting rights enforcement.

Even as the cause of civil rights liberalism surged to full tide, however, institutions with more limited exposure to the pressures of social movement activism and electoral politics played a critical—if contradictory—role in shaping the VRA. Away from the gaze of the public, officials within the Johnson administration made conscious choices that blunted the transformative potential of the Act. The Department of Justice limited the scope of federal registration and election-monitoring efforts to areas with the worst civil rights records and declined to exercise vigorous oversight of changes to election regulations in southern jurisdictions covered by the Act. Yet at almost the same time, the liberal justices of the Supreme Court ratified the major provisions of the VRA and—more radically—interpreted the preclearance provisions of the Act to apply to a broader range of election changes and structures than was clearly contemplated in the text of the statute. These crosscutting developments altered the meaning of the law in unforeseen ways, establishing important gaps between what the VRA seemed to require on its face and the way it operated in practice.

At a broader level, the enactment of the VRA gave rise to a new voting rights politics. Before 1965, national Democratic Party officials sought to suppress ever-expanding conflict over civil rights between the party's northern-based coalition of African Americans, left-leaning workers, and progressives and its traditional center of power in the segregated "Solid South."[2] But the party's embrace of the VRA in 1965 signaled a new era in Democratic politics, in which the northern wing and civil rights liberalism became permanently ascendant. As national Democratic Party officials publicly embraced the cause of civil rights, Republican elected officials increasingly adopted conservative positions on racial matters, both to better reflect the preferences of ex-

isting coalition partners and to appeal more effectively to whites alienated by the Democrats' racial liberalism. Ironically, just as the VRA was beginning to transform southern electoral politics, shifting party alignments threatened to destabilize the foundations of political support that had made adoption of the Act possible.

The Kennedy-Johnson Years and the Limitations of Voting Rights Enforcement

The modest achievements of a massive southwide registration drive conducted by civil rights organizations between 1962 and 1964—and the increasing incidence of white violence against organized voting rights campaigns—drew mounting public attention to the suppression of black citizenship and clearly established the necessity of more effective federal machinery to protect minority voting rights. Although both the Kennedy and Johnson administrations delayed voting rights reforms to avoid outraging southern Democrats, Johnson (under overwhelming pressure from pro–civil rights coalition partners and liberal members of Congress) belatedly adopted the cause as his own.

The Kennedy Administration's Approach to Voting Rights Enforcement

The waning years of Republican Dwight Eisenhower's presidency witnessed the passage of the first two civil rights measures since the end of Reconstruction—the Civil Rights Acts of 1957 and 1960. The 1957 Act protected the right to vote in federal, state, and local elections against obstruction by both state and private action, and it authorized federal civil suits against individuals who sought to hinder registration or voting because of "race, color, or previous condition of servitude." It also created both the United States Commission on Civil Rights (USCCR), which was authorized to study racial matters and investigate civil rights violations, and the Civil Rights Division, a new unit within the Department of Justice with the power to scrutinize and prosecute alleged abuses. Under the Act, the Department could seek injunctions in federal court against actions intended to "interfere with the right to vote in any election in which a federal official is to be elected."[3]

The 1960 Act modestly strengthened its predecessor. To check obstruction of federal investigations by recalcitrant southern officials, it required localities to maintain voter registration records and make them available for review

by federal officials. The 1960 Act also authorized federal district courts to appoint voting referees to review rejected registration applicants in jurisdictions in which county registrars engaged in patterns or practices of discrimination.[4]

Relatively cautious in its approach to racial matters, the Eisenhower administration declined to enforce the 1957 and 1960 Acts in a vigorous fashion.[5] The election of Democrat John F. Kennedy, who had campaigned actively for black votes, to the presidency in 1960 raised expectations among civil rights activists that progress on the voting rights front would be forthcoming.[6] But these hopes were soon dashed. Convinced that a push for further civil rights advances would shatter the Democratic Party and obstruct his reelection, Kennedy insisted "that new civil rights legislation was neither needed at the present time nor feasible," recalled James Farmer of the Congress on Racial Equality (CORE).[7] (Kennedy and top administration allies went so far as to insist that proscription of the use of poll taxes in federal elections, which everyone knew were used by southern states to deny African Americans the ballot, could be accomplished only by *constitutional amendment*, even though the Fourteenth and Fifteenth Amendments seemed to provide ample basis for eliminating them by statutory means.)[8] As an alternative to new legislation, Kennedy prioritized litigation and executive action, which he hoped would permit incremental progress without infuriating southern whites.[9] Civil rights activists scoffed at this piecemeal approach; Roy Wilkins of the NAACP charged the administration with "smooth[ing] Unguentine on a stinging burn even though for a moment (or for perhaps a year) it could not bind up a joint."[10]

Wanting to forestall the escalation of racial disturbances in southern states instigated by the 1961 Freedom Rides, however, the Kennedy White House sought new means to advance African American voting rights. Kennedy's assistant attorney general for civil rights (and later attorney general) Nicholas Katzenbach explained that administration officials privately cherished the notion that if they could "get [African Americans] voting fast enough [they would] not have these other [civil rights] problems."[11] With this objective in mind, Kennedy administration officials connected major civil rights organizations, including the NAACP, Southern Christian Leadership Conference (SCLC), Student Nonviolent Coordinating Committee (SNCC), and CORE, with private philanthropic funding to finance suffrage campaigns in southern states.[12] Although some activists feared that collaboration with the administration would undermine the independence of the movement, the

major civil rights organizations eventually agreed that the risk was worth it. SCLC officials argued that this approach could transform scattered registration drives into "well-oiled machinery in voter registration" that could help relieve "our Southern dilemma."[13]

Thus, in early 1962 these organizations joined forces under the aegis of the Southern Regional Council's Voter Education Project (VEP) to organize "greatly enlarged registration programs in the South," according to civil rights lawyer Wiley Branton, who directed the Project.[14] At least twenty-seven VEP campaigns—led by professional staff but energized by thousands of youthful volunteer "shock troops"—were in the field by September 1963. Under the watchful gaze of hostile whites, campaigners organized citizenship training schools, distributed political literature, orchestrated registration rallies, and attempted to register voters in communities throughout the Deep South.[15] Whereas Kennedy administration officials treasured the naïve belief that these projects would supplant more provocative tactics, some movement leaders hoped they would ignite serious racial confrontations that would force the federal government to intercede on behalf of black would-be voters.[16]

The Limitations of Federal Voting Rights Laws

Despite the heroic efforts of voting rights activists, however, the accomplishments of the registration drives were modest. To be sure, as the *Baltimore Afro-American* reported in late 1964, "the numbers of registered voters in 11 Southern states . . . doubled, from 1.1 million to more than 2 million since the 1960 presidential election," so that black registration in that region reached approximately 43 percent.[17] But as Harvard Sitkoff, David Garrow, and others have shown, this good news was tempered by the continuing disenfranchisement of millions of African Americans in the conservative strongholds of the Deep South. Indeed, black registration rates for Alabama, Louisiana, Mississippi, and South Carolina were 23 percent, 32 percent, 6.7 percent, and 39 percent, respectively.[18]

These discouraging results were attributable to the intensity of ongoing white resistance to black enfranchisement in the Deep South, the unwillingness of the Kennedy and Johnson administrations to aggressively enforce the law, and the structural deficiencies of the 1957 and 1960 Acts. In many southern counties, both subtle and blatant obstruction of black registration and voting continued unabated. States throughout the South enforced prerequisites to voting—such as rules that voters exhibit the ability to read, write, and provide a "reasonable interpretation" of provisions from the US Constitution

or state constitutions—that were difficult for many disadvantaged black (and white) citizens to attain. These rules also invested white county registrars with enormous discretion to determine whether applicants passed or failed their assessments, and registrars employed this power in aggressive fashion to deny African American applicants access to the ballot.[19]

The discriminatory administration of election laws was frequently accompanied by threats—and execution—of economic coercion and physical violence against African Americans seeking to exercise their rights as citizens. Because the economic circumstances faced by the vast majority of southern blacks were precarious, the mere threat of economic retaliation by white business owners, creditors, and government officials often sufficed to keep them from seeking the vote.[20] When blacks attempted to assert their citizenship rights, retribution was swift. The Council of Federated Organizations (COFO)—a coalition of civil rights groups—reported in mid-1964 that in Mississippi, "large numbers of Negro workers have been fired from jobs on the plantations and in the towns because of involvement with the civil rights movement. . . . To add further pressure, some county authorities have on occasion ended Federal Welfare programs, denying displaced Negroes unemployment relief."[21]

White violence against African Americans who dared assert their citizenship rights also increased in frequency and savagery. Between January 1961 and March 1963, SNCC activists counted no fewer than "64 acts of violence and intimidation against Negroes in Mississippi [alone]," almost all of which were "directly related to efforts by Negroes to register to vote."[22] Voter registration efforts in other states met with similar fates. A major 1963 voter registration campaign organized by CORE in Plaquemine, Louisiana, was cruelly suppressed by what James Farmer described as "mounted troopers with their prod rods, [who] rode down the marchers like cowboys on a fearsome roundup."[23] In Selma, Alabama, hundreds of local voting rights activists were assaulted or imprisoned between 1962 and early 1965.[24]

Yet Kennedy refused to deploy federal authorities to guarantee activists' safety. The official position of the administration was that "the federal government has no police type organization to enforce the law," as Kennedy's assistant FBI director Courtney Evans explained, and that state governments were responsible for maintaining public order within their respective borders.[25] Since state governments throughout the South were either active participants or complicit partners in violence and coercion against aspiring black

voters, the position of the White House was patently absurd. In truth, Kennedy's subdued reaction reflected his deep ambivalence about the civil rights movement. "Until the end of 1963 [when the crisis in Birmingham, Alabama, finally pushed Kennedy to advocate a new civil rights act], every big demonstration or turmoil that Martin King led was a problem for the president," explained assistant attorney general for civil rights Burke Marshall, insofar as it exacerbated the very racial and regional tensions within the Democratic coalition that Kennedy desired to suppress.[26]

The existing system of federal civil rights laws further hamstrung the capacity of the Kennedy administration to advance African American voting rights in the face of entrenched white resistance. Under the 1957 and 1960 Acts, the chief means available to the Department of Justice of combatting voting rights violations was to file suit in federal court to enjoin perpetrators of discrimination against continuation of unconstitutional practices. Given the scale of southern intransigence, however, this "was just an impossible system of law enforcement," Nicholas Katzenbach explained. "The courts had been very, very slow on this; people obviously were qualified to vote who were being turned down; then we had to bring a lawsuit; then we had to go through all the appeals and another election would go by. . . . It would take forever in terms of personnel and work and everything else."[27]

Due to the limits of federal law, enforcement problems would have been endemic under the most auspicious of circumstances. But conditions were hardly ideal. Jurisdictions targeted by the CRD obstructed federal investigations at every turn, necessitating additional litigation.[28] Once cases were brought to trial, segregationist southern judges—some of whom Kennedy appointed in order to placate powerful southern Democratic senators—often frustrated enforcement through adverse decisions or intentional delay of rulings.[29] And when federal courts sided with the Department of Justice, officials in the Department noted that state and local officials routinely flouted their rulings, "requir[ing] further attention to see if court orders are being complied with."[30]

Civil Rights Mobilization and the Origins of the Selma Crisis

Despite the abject failure of the 1957 and 1960 Civil Rights Acts—and the limited improvements brought about by the 1964 Civil Rights Act—prospects for

effective voting rights legislation remained uncertain in late 1964 and early 1965. Only with the violent suppression of a voting rights crusade in Selma, Alabama—fortuitously captured in gory detail by television news camera operators and broadcast to a large, national television audience—did favorable conditions for new legislation emerge.

Rising Frustration with National Leaders

Despite rising conflict throughout the South over access to the ballot, President Kennedy declined to press hard for legislation that would be effective in enfranchising African American citizens. Brutal police repression of the Birmingham, Alabama, desegregation movement in spring 1963 and obstruction of the integration of the University of Alabama by Democratic governor George Wallace that summer had shocked the nation and finally awakened a somnolent administration to the moral imperative of civil rights.[31] But it was doubtful that the Civil Rights Act proposed by the administration would have changed much on the voting rights front. The legislation presumed that litigation would remain the chief instrument of voting rights enforcement and thus marked a modest improvement over existing law. In any case, at the time of Kennedy's assassination in November 1963, it was still far from certain that the measure would be enacted.[32]

Frustrated with the status quo, some civil rights activists called for more radical action. In the wake of the September 1963 bombing of the 16th Street Baptist Church in Birmingham, which killed four African American girls as they were preparing for choir practice, SCLC activists Diane Nash and James Bevel lobbied Martin Luther King Jr. to mount a massive civil disobedience campaign in Montgomery, the seat of the state government. The duo proposed to bring the city to a halt through the peaceful disruption of air, automobile, and rail traffic in order to force the "removal of George Wallace from the governorship of Alabama" and spur enactment of new laws ensuring that "every 21 year old resident of Alabama can register to vote."[33] Skeptical of the project's chances of success, however, King demurred. Instead, he threw himself into an antisegregation campaign in St. Augustine, Florida, designed to "get [the Civil Rights Act] through Congress," explained King's trusted SCLC associate, C. T. Vivian.[34]

The shocking murder of President Kennedy put responsibility for passing the Civil Rights Act in the hands of his successor, vice president and former Senate majority leader Lyndon B. Johnson. Although Johnson had amassed a modest civil rights record during his Senate tenure, rising sensitivity to the

horrors of Jim Crow and growing awareness of the importance of African Americans to Democratic electoral fortunes had gradually convinced him that it was necessary to fundamentally reform the nation's civil rights laws.[35] (Indeed, in the days and weeks following the Birmingham crisis, Johnson had emerged as a forceful advocate of the Civil Rights Act within the administration, urging unenthusiastic Kennedy aides to encourage the president to barnstorm the country in order to mobilize public support for passage of the Act.)[36] On assuming the presidency, Johnson used all the powers at his disposal to secure passage of the Civil Rights Act; and he worked hand in glove with civil rights leaders on matters of lobbying and legislative strategy. "It was Johnson [not Kennedy] who felt deeply about black people," averred Bayard Rustin, chief architect of the August 1963 March on Washington. "It was Johnson who had the skills to get through Congress the bills."[37]

Despite his growing commitment to racial equality, however, Johnson's relationship to the civil rights movement was fraught with tension. Whereas civil rights activists insisted that "we can't wait" (in the words of Martin Luther King) for equal citizenship, Johnson's view of the movement was marked by a paternalism that subordinated civil rights demands to the leadership of the president, the electoral interests of the Democratic Party, and the normal workings of the political system.[38] As close Johnson advisor Harry McPherson put it, "[We were] Southern liberals. . . . [W]e believe in integration, we believe in reason, we believe that things are going to be fine if men of goodwill get together and if we put down the racists."[39] The philosophical gulf between the radical egalitarianism of the civil rights movement and the liberal condescension of the president set the stage for conflict, even though the two sides shared many of the same ultimate objectives.[40]

Indeed, as the Civil Rights Act wended its way through Congress toward eventual passage in July 1964, the disturbing events of that summer laid bare the bankruptcy of federal voting rights protections and raised new questions about the commitment of the president to the civil rights cause. The Mississippi Freedom Summer Project (MFSP)—a massive SNCC-led effort designed to draw attention to "the need for enforcement of federal guarantees of basic human and political rights," including voting rights—unleashed horrific violence from white racists (punctuated by the brutal murders of James Chaney, Andrew Goodman, and Michael Schwerner) without producing significant gains in black enfranchisement.[41] Meanwhile, Johnson proved all too willing to subordinate civil rights concerns to personal and party interests. At the Democratic National Convention in Atlantic City, New Jersey, Johnson en-

gineered the seating of Mississippi's lily-white segregationist delegation over the strenuous protests of the integrated delegation of the Mississippi Freedom Democratic Party (MFDP) in an ultimately futile effort to keep deep southern states in the Democratic column for the 1964 presidential election.[42]

Although Johnson privately defended his actions at the convention as necessary to ensure a strong Democratic showing in the general election, many activists felt betrayed by the president's high-handed treatment of the MFDP.[43] Even moderate leaders, such as Martin Luther King Jr., who had grudgingly accepted the resolution of the controversy warned Johnson and other national politicians that "[the African American's] cry for justice has hardened into a palpable, irresistible force. He is unwilling to retrogress or mark time."[44]

The Origins of the Selma Movement

These setbacks spurred civil rights activists to resume the confrontational tactics they had abandoned during the 1964 presidential campaign in deference to Johnson's request for a moratorium on demonstrations. In mid-November 1964, King accepted an invitation from Amelia Boynton Robinson and other Selma, Alabama, leaders to help reenergize their flagging registration drive. Given the anticipated violent response from Selma police and white vigilantes, the decision represented a partial adoption of the proposal advocated by Bevel and Nash the previous September to escalate confrontations with recalcitrant Alabama officials as a means to advance black voting rights.[45]

In private conversations with King, Johnson had counseled against the Selma project, arguing that the nation needed time to digest the 1964 Civil Rights Act before it would accept further civil rights reforms.[46] Emboldened by his overwhelming victory over staunch racial conservative Barry Goldwater in the 1964 election, however, the president began mulling over how to extend voting rights to southern blacks. Johnson pressed Nicholas Katzenbach (who had recently been promoted to attorney general) to "try to figure out . . . what I can do to get 100 percent of people to vote," even raising the possibility that federal postmasters might be enlisted as registrars in counties in which local examiners refused to enroll African American voters.[47] Throughout the early months of 1965, administration officials also quietly exchanged voting rights proposals with civil rights activists and opened clandestine discussions with Senate Republican minority leader Everett Dirksen of Illinois, whose cooperation was necessary if new voting rights legislation was to receive the Republican support necessary to overcome an expected Senate filibuster by southern Democrats.[48]

As his aides struggled to develop a proposal that could pass constitutional muster and win sufficient support from congressional Republicans, Johnson surprised King by encouraging him to dramatize the injustices of southern electoral practices.[49] "If you can find the worst condition you can run into. . . . If you can take that one illustration, get it on the radio, get it on the television, get it in the pulpits, get it in the meetings—every place you can—then pretty soon the fellow who didn't do anything but drive a tractor would say, 'Well, that is not right, that is not fair,'" Johnson counseled King in a mid-January call.[50] Although Johnson obviously failed to anticipate the brutal suppression of the Selma movement or the national outcry that would follow, the exchange indicated that the president supported King's aims, if not his timetable for legislative action.

Bloody Sunday and the Origins of the Voting Rights Act

On January 2, 1965, the SCLC kicked off what King described as a "determined, organized, mobilized campaign to get the right to vote everywhere in Alabama."[51] Over the following six weeks, activists executed an escalating series of confrontations with Selma registrars and police, hoping to provoke a violent outburst that would catapult the registration drive into the national consciousness and thereby force enactment of effective voting rights legislation. Although the demonstrations did win some attention from the media and liberal members of Congress—and King another visit with a nonplussed President Johnson, who believed that the growing pressure on Congress was premature given the state of behind-the-scenes negotiations with Dirksen— they did not achieve a major breakthrough.[52] The stalemate in Selma led to a change in tactics. Andrew Young (King's SCLC lieutenant) later explained that activists understood that "Selma needed a break" and thus "stepped up [their] demonstrations in [nearby] Lowndes, Perry, Wilcox, and Marengo Counties."[53]

The geographic shift yielded tragic results, setting the stage for what would go down in history as "Bloody Sunday." During a vicious attack on a peaceful night demonstration, police officers in Marion, Alabama, mortally wounded a young marcher named Jimmie Lee Jackson. Inspired by the book of Esther, King's close associate James Bevel proposed that activists honor Jackson by "go[ing] to Montgomery and see the king"—Alabama governor George Wallace—to present their grievances.[54] "Bevel's idea of a march on Montgomery caught fire" in the imaginations of local activists, according to SNCC national chairman John Lewis, leading to a belated SCLC endorsement.[55]

The March 7 demonstration unleashed an orgy of violence that earned the "Bloody Sunday" moniker. As marchers, led by Lewis and Hosea Williams of SCLC, attempted to cross the Edmund Pettus Bridge on their way out of downtown Selma, they were confronted by a large assemblage of city police, volunteer posse-men organized by Sheriff Clark, and Alabama state troopers sent by Governor Wallace. When the marchers knelt to pray, the law-enforcement officials "bombarded [them] with tear gas . . . and then waded into them with clubs, whips and ropes," chasing "screaming, bleeding marchers nearly a mile back to their church, clubbing them as they ran."[56] A SNCC volunteer on the scene provided a visceral image of the carnage, reporting that "police are beating people on the streets. Oh, man, they're just picking them up and putting them in ambulances. People are getting hurt pretty bad."[57]

The horrific events—captured on film by intrepid journalists—finally provided the Selma movement with the media bonanza it had sought, without success, for more than two months. That night, ABC interrupted its broadcast of *Judgment at Nuremberg*, a dramatization of the war crimes trials of Nazi officials with an estimated audience of more than 48 million people, with fifteen minutes of footage from Bloody Sunday, and the other major networks aired similar bulletins during their regular programming.[58] The televised bloodshed prompted a massive, if belated, public outcry against the violent suppression of black citizenship. "What the public felt on Monday [the day after Bloody Sunday]," Harry McPherson privately warned the president, "was the deepest sense of outrage it has ever felt on the civil rights question."[59] As northern Democrats and Republicans in Congress took to the floor to "voice disgust at [the] Selma violence," thousands of protestors sympathetic to the movement staged rallies in cities around the country and hundreds more hurried to Selma to join the demonstrators.[60] The subsequent murders of two white Selma demonstrators—pastor James Reeb and homemaker Viola Liuzzo—by white Alabama thugs only reinforced public pressure for a federal solution to the injustice of black disenfranchisement.

Facing a swelling tide of public opinion, the president finally made an irrevocable commitment to voting rights reform. Despite privately grumbling that "it looks like [King's] in charge of the country and taking it over," Johnson maneuvered Wallace into negotiations to ensure the safety of participants in a march from Selma to Montgomery.[61] The president also publicly announced that he would send to Congress a bill to "secure [the right to vote] for every American" in short order.[62]

The legislative proposal, hammered out in negotiations between Katzen-bach and Dirksen, provided for the suspension of literacy tests in states and localities with low registration or voting rates, federal registration of voters and monitoring of elections in these jurisdictions, and federal court review of proposed changes to election rules and regulations.[63] The plan marked a dramatic departure from previous voting rights legislation insofar as it sus-pended state election rules long understood as permissible under the Consti-tution, empowered executive officials to register voters and monitor elections absent prior judicial authorization, and required federal court preclearance of new election regulations in jurisdictions covered by the Act. As Katzenbach acknowledged, the proposal was radical, but given the almost certain failure of more modest legislation that would have left "control of voting machinery in state hands and depend[ed] upon judicial enforcement . . . I [saw] no real alternative."[64]

As a further show of resolve, the president requested and received permis-sion from House and Senate leaders to address a joint session of Congress to (in Johnson's words) "tell the country what we recommend" to redress black disenfranchisement.[65] With these fateful steps, Johnson ensured that the na-tional attention garnered by the Selma movement would be harnessed in the service of enacting legislation to safeguard African American voting rights.

Liberal Political Power and Passage of the Voting Rights Act of 1965

Johnson's electrifying address to Congress introducing the Voting Rights Act—punctuated by his declaration that "we shall overcome" the "crippling legacy of bigotry and injustice" that had tarnished the nation's history—helped translate the general moral outrage sparked by the violence at Selma into pub-lic determination to secure black voting rights via federal legislation.[66] After the 1964 elections, the president also enjoyed supermajority Democratic con-trol in the House (with the party holding 68 percent of seats) and the Senate (with 67 percent of seats) as well as the support of many liberal Republicans, thus making prospects for new legislation particularly auspicious.[67]

Still, administration officials and their congressional allies faced chal-lenging circumstances on the route to enactment of the president's initiative. The proposal faced staunch criticism, both from liberals in both parties who wanted the legislation to implement an outright ban on the use of poll taxes in state and local elections and from southern Democrats and conservative

Republicans who opposed the forceful measures contemplated in the bill.[68] Successful negotiation of these difficulties required all of the president's legislative prowess as well as compromise on the part of civil rights activists and liberals who had desired stronger legislation.

Conflict between the Administration, Congressional Liberals, and Congressional Conservatives

The difficulty of enacting voting rights legislation that was sufficiently strong and politically palatable to a broad swath of Congress was apparent from the moment the administration bill was enrolled. A bipartisan contingent of senators passed an unusual motion, on a 67–13 vote, requiring the Judiciary Committee to report the legislation in a matter of weeks, stripping virulent racist and Democratic committee chairman James Eastland of Mississippi of his power to bottle up the measure in committee.[69] But the bill that came to the floor in early April 1965 included the sweeping poll-tax amendment that administration officials and many senators believed was unconstitutional.[70] The "revolt of the liberals" on the Judiciary Committee thus threatened to "shatter the bipartisan coalition that [administration allies] had carefully constructed and perhaps give the southerners their only chance to block the bill."[71] (Notably, the civil rights community fought especially hard for retention of the amendment, putting it at odds with its ostensible allies in the Johnson administration.)[72] Finally, after extensive negotiations failed to produce a compromise, the amendment was stricken from the bill on a dramatic 49–45 floor vote in mid-May 1965.[73] In an early indication of growing partisan polarization on voting rights matters, support for the failed amendment came overwhelmingly from liberal northern Democrats: of northern Democrats casting votes, 77 percent favored it, compared with 25 percent of northern Republicans, 23 percent of southern Democrats, and 0 percent of southern Republicans.[74]

Meanwhile, Senate conservatives, led by North Carolina Democrat Sam Ervin, sought to lard the bill with a series of weakening amendments or, barring that, delay a vote until liberals lost the will to fight.[75] These amendments generally attempted to weaken the VRA by either reducing its focus on southern states, limiting jurisdiction in voting rights complaints to courts in states in which the complaints arose, or raising the legal standard for claims of voting rights violations. Many of these amendments enjoyed support among both a supermajority of southern Democrats and a significant fraction of northern and southern Republicans, as table 1.1 shows.[76] Reflecting their especially

TABLE 1.1. Senate Roll Calls on Weakening Amendments, 1965

Roll call N	Description	% Rep. support (all)	% northern Rep. support	% southern Rep. support	% Dem. support (all)	% northern Dem. support	% southern Dem. support
51	Strike coverage formula	25	21	50	26	7	74
53	Remove exclusive jurisdiction of US dist. court for DC in actions for declaratory judgments or injunctive relief	31	29	50	28	4	81
54	Provide that examiners appointed under Act apply state law respecting qualifications of voters	16	11	50	26	2	76
56	Limit actions against enforcement of poll tax to situations of denial of vote "on account of race or color"	78	79	75	25	5	68
57	Retain state literacy tests if applied without discrimination	10	4	50	26	2	83
59	Strike preclearance in states where literacy tests have been suspended	16	11	50	26	2	80
64	Give discretionary authority to US dist. court in state where case arose to remove action for declaratory judgment from dist. court for DC	48	48	50	32	5	90
65	Eliminate coverage formula and base appointment of registrars on complaints from applicants in districts	53	50	75	26	2	80
66	Require prior determination by district court for DC before triggering mechanism for literacy tests is effective	39	37	50	26	2	77

68	Require applicant seeking to register before federal registrar to allege denial under color of law of opportunity to vote on account of race	22	18	50	28	4	77
69	Specify that suspension of literacy tests not apply in jurisdictions where 95% of persons of voting age applying for registration in 1964 election were adjudged literate and were registered	23	22	25	25	0	77
70	Allow attorney general to exonerate jurisdictions without requiring state to seek declaratory judgment	38	36	50	28	2	82
71	Terminate retention of jurisdiction of dist. court of DC when declaratory judgment ends in favor of jurisdiction	31	29	50	26	2	77
72	Terminate coverage formula in jurisdictions that prove in dist. court for DC that they are not violating 15th amendment	28	25	50	27	2	77
73	Strike coverage formula	41	36	75	28	2	82
74	Authorize judicial review of attorney general rejection of petition to end further action of federal registrars	13	11	25	31	7	82
75	Strike requirement that only dist. court for DC or courts of appeals have jurisdiction to issue judgments against enforcement	13	11	25	26	2	81
76	Require attorney general to seek injunctions against civil rights protestors	6	4	25	28	2	77

SOURCE: "Democrat and Republican Party Voting Splits Congresses 35–113 (31 May 2015)," accessed July 18, 2016, available from VoteView.com, http://voteview.com/partycount.html.

strong backing of minority voting rights, northern Democrats were by far the least supportive of each of these weakening amendments.

For much of April and May 1965 it was uncertain whether backers of the administration bill could defeat all the amendments and muster the super-majority needed to invoke cloture on debate. As the coalition of liberal Democrats and liberal Republicans beat back amendment after amendment, however, "sentiment for a cloture move to cut off debate [began] building up," the *Washington Post* reported.[77] After twenty-four days of deliberation, "a cloture tally of 70–30 in the Senate formally ended the Southern blockade against consideration of the voting rights bill" in late May 1965, paving the way to easy passage of the legislation in that chamber.[78]

But significant obstacles to enactment of strong voting rights legislation remained in the House of Representatives. The House Judiciary Committee finished work expeditiously, but its bill (known as the Celler bill, after Democratic Judiciary chairman and staunch civil rights advocate Emanuel Celler of New York) included the controversial amendment invalidating the poll tax. When the measure entered the House Rules Committee, unrepentant segregationist and Democrat Howard W. Smith of Virginia, who chaired the committee, "show[ed] his customary skill at impeding the enactment of civil rights legislation" by holding the measure without hearings for several weeks.[79]

In the meantime, House Republican leaders Gerald Ford of Michigan and William McCulloch of Ohio sought to burnish the GOP's civil rights credentials by promoting an alternative—but much weaker—voting rights bill that threatened to peel away precious Republican votes from the plan offered by the Johnson administration. The proposal circulated by the Republican leadership would have eliminated the formula triggering federal intervention, substituting a process in which federal registration of black voters would have been initiated in any jurisdiction in which twenty-five meritorious complaints of discrimination were made. Additionally, it would have permitted the retention of literacy tests in southern states until such tests were shown to discriminate on the basis of race. Most importantly, the Republican alternative did not provide for federal preclearance of proposed alterations in election rules.[80] These developments endangered passage of voting rights legislation by risking House-Senate differences that could lead to "another round of delaying action, if not a second Southern filibuster in the Senate," if and when that chamber was presented with a conference report.[81]

Under heavy pressure from Celler, Smith finally relented in early July

1965, sending the Judiciary chairman's eponymous bill to the floor with an open rule permitting unlimited amendments. As House debate on the legislation began, "the crucial question [was] whether [the voting rights bill] should include a flat ban against poll taxes," the *Hartford Courant* reported.[82] But the plan put forward by the Republican leadership also remained "very dangerous," in the estimation of President Johnson, because it provided moderate and conservative representatives with an opportunity to appear supportive of black voting rights while avoiding major changes to the racial status quo in southern states.[83] Fortunately for proponents of the VRA, public endorsement of the Ford-McCulloch measure by southern Democrats as "far preferable to the [Celler] bill" (in the words of Virginia congressman William Tuck) ultimately discredited it in the eyes of some liberal Republicans who might otherwise have been inclined to accept it out of party loyalty.[84] In the end, the Ford-McCulloch bill failed on a 171–248 vote, despite receiving support from 84 percent of voting Republicans. (Democrats opposed the measure 57–227, with opposition coming overwhelmingly from the party's northern members.)[85] With the Ford-McCulloch substitute defeated, the Celler measure passed that chamber in mid-July 1965 on a 333–85 vote.[86]

Liberal Compromise and Passage of the Voting Rights Act

As the president anxiously explained in an early July 1965 phone conversation with Martin Luther King Jr., the House-Senate divide over the poll-tax issue raised the specter that delegates to the conference tasked with sorting out the differences between the bills might "get in an argument . . . that [could] delay it and maybe nothing [would] come out."[87] Conference negotiations over the poll-tax amendment dragged on despite intense lobbying from the White House, with neither House advocates nor Senate opponents willing to give ground.[88] At his wits' end, Attorney General Katzenbach put in a desperate plea to King requesting that he bless a compromise in which the poll-tax ban would be removed from the bill in exchange for legislative language condemning the tax and directing the Department of Justice to institute legal challenges in states in which it was still in use. Despite his strong aversion to the poll tax, King publicly endorsed the compromise based on the "overriding consideration" that the legislation be enacted into law.[89] The testimonial broke the logjam, enabling the conference committee to report out a bill excluding the troublesome provision.[90]

With the public still strongly favoring voting rights legislation, overwhelming bipartisan endorsement of the bill in both chambers followed hard

on the heels of the issuance of the conference report. On August 6, in a Capitol Rotunda ceremony attended by King, Roy Wilkins, James Farmer, Rosa Parks, and other civil rights dignitaries, President Johnson signed the Voting Rights Act into law, declaring that the measure would "strike away the last major shackle" of the "ancient bonds" that restrained African Americans from full citizenship.[91]

Although the president may have been guilty of excessive optimism, there was no doubt that the Voting Rights Act of 1965 represented a profound expansion of federal, and especially executive, authority to protect the voting rights of African Americans and other citizens of color. The Act suspended literacy tests in jurisdictions in which fewer than 50 percent of persons of voting age were registered to vote on November 1, 1964, or in which fewer than 50 percent of eligible voters voted in the 1964 presidential election (these criteria, collectively known as the coverage formula, were contained in Section 4 of the Act); it also empowered the Department of Justice to send federal examiners to register eligible citizens in these jurisdictions. Further, the Act authorized federal observation of elections in localities designated for federal registration efforts. In accordance with the compromise worked out during the House-Senate conference, the Act directed the attorney general to challenge the constitutionality of poll taxes still in use by some states. The voting rights of other citizens (primarily Hispanics) were safeguarded through a provision prohibiting denial of the ballot to persons illiterate in the English language if they had at least a sixth-grade education in another language in an "American-flag" school. Finally, and most radically, Section 5 of the Act required preclearance by the federal courts or the Department of Justice of all proposed changes in election rules and regulations in jurisdictions identified by the coverage formula.

The statute marked a dramatic improvement over previous law. Yet how the Act, which was untested and ambiguous in many of its particulars, would perform in practice depended in significant part on the political will of the president and the officials charged with implementing the law within the Department of Justice.[92]

Voting Rights Enforcement in the Johnson Administration

On signing the VRA into law, President Johnson vowed to "not delay or hesitate, or turn aside, until Americans of every race and color and origin have

the same right as all others to share in the process of democracy."[93] But the idealism of the president was tempered both by awareness of the limited capacity of the bureaucracy charged with enforcing the law and by a pragmatic desire to moderate political backlash from aggrieved southern whites and their representatives in Congress. This balancing act led Johnson and his advisors to allocate considerable attention to some areas of voting rights enforcement, such as the registration of voters in counties with the worst voting rights records, while neglecting others, especially the review of alterations to election rules and regulations in covered southern states and localities. The partial implementation of the VRA by the Johnson administration inaugurated a pattern of voting rights enforcement—embellished in subsequent administrations—in which implementation decisions were heavily informed by, if not subordinated to, broader political considerations.

Administrative and Political Obstacles to Full Enforcement

Enactment of the VRA created a new—and massive—set of responsibilities for civil rights administrators within the Department of Justice. Even setting aside the formidable mandate to review proposed changes to election rules in covered jurisdictions, guaranteeing that African Americans throughout the South could register and participate freely in elections was a task of monumental proportions. Administration officials knew, however, that resources within the DOJ were inadequate to fully enforce the provisions of the Act. Want of administrative capacity predated the VRA; indeed, Ramsey Clark, who succeeded Nicholas Katzenbach as attorney general in 1966, frankly admitted that they had "*never* secured enough personnel and money to enforce [civil rights] laws on the books, or even a fraction of enough" (emphasis added).[94] But the enormous expectations embedded in the Act made the problem much more acute. The administration thus faced unavoidable choices in allocating scarce resources as it implemented the new law.

Other concerns further complicated efforts by the administration to enact the sweeping mandates contained in the VRA. The unprecedented powers granted by the Act to the Justice Department elicited anxiety even from those charged with wielding them. Because administration officials recognized that the provisions of the Act were (in the words of Stephen Pollak, a Civil Rights Division chief) "radical . . . in terms of the formula and the suspension of the normal state authority to set conditions for registration," they felt some responsibility to move gingerly in implementing them.[95] Much more importantly, administration officials could not avoid taking into consideration the

political ramifications of enforcement decisions. Vigorous enforcement of the VRA risked massive backlash from southern whites and their elected representatives in Congress, which would inevitably produce political problems for the White House. Administration officials thus had to find a way to enforce the law without excessively antagonizing southern Democrats. Johnson advisor Morris Abram provides a telling description of the philosophy informing the administration's approach to federal voting rights enforcement: "Having the act on the books, [African Americans] thought it could be enforced all across the country immediately. . . . [But the processes of America], unless you destroy them, are in place and eventually they will prevail if you don't kick them down or assault them."[96]

The Johnson Administration's
Partial Implementation of the VRA

Faced with limited resources and conflicting demands, the implementation strategy of the Johnson administration revealed a delicate equipoise of idealism and pragmatism. Given that the protests at Selma had riveted national attention on formal and informal barriers to voter registration, the Department of Justice focused considerable effort on registering African American voters in the jurisdictions with the worst voting rights records. The administration deployed hundreds of federal examiners to recalcitrant counties in Alabama, Georgia, Louisiana, Mississippi, and South Carolina in which, in defiance of federal law, registrars were still requiring literacy as a qualification for registration or in which they failed to provide adequate facilities or working hours to accommodate the surge of black applicants.[97] Between enactment of the VRA in August 1965 and December 1967 alone, "[federal] examiners had been sent to 58 counties in five Southern States . . . [and] Examiners in these counties had listed as eligible to vote a total of 158,094 persons, including 150,767 nonwhites and 7,327 whites."[98] These efforts were extremely effective. In fact, a 1966 VEP study of Alabama, Mississippi, and South Carolina concluded that counties to which federal examiners were assigned experienced a fifteen- to twenty-point surge in the registration rate compared with counties in which no federal officials were on the scene.[99]

But as the VEP analysis underscored, the reach of federal registrars did not extend to every county in which African American registration substantially lagged that of whites. In fact, the report noted, there were nearly two hundred counties in covered states with African American registration rates below fifty percent to which not a single federal examiner was assigned. Given

the recent violence against aspiring black registrants, many African Americans in these jurisdictions were understandably reluctant to attempt to register to vote in the absence of a protective federal presence.[100] Nonetheless, when confronted with demands for "affirmative" federal efforts to register African American voters in all counties with low black registration, the administration demurred. "We can't take cattle trucks and haul people to the polls," President Johnson bluntly informed an irate Roy Wilkins of the NAACP in late November 1965. "That's not part of the concept [of the registrars' program] at all."[101] Although a plausible argument could be made that the Department was doing the best it could with limited resources, it is also probable that Johnson sought to limit intervention to those jurisdictions in which violations of federal law were most egregious in order to manage tensions with southern whites and their congressional representatives. Indeed, the White House had been appraised that the presence of federal registrars was an issue that conservative white candidates were exploiting on the campaign trail in the run-up to the 1966 elections, undoubtedly reinforcing the prevailing view within the administration that enforcement powers needed to be exercised prudently.[102]

Even as the Department struggled to devise a federal registrar program that was both administratively feasible and politically sustainable, it was simultaneously attempting to establish an effective process for monitoring the conduct of elections in southern jurisdictions. As was the case with federal registrars, the use of election observers by the Department was targeted, focusing on the subset of southern counties "shown [by departmental investigations] to be most susceptible to attempts to obstruct or delay voting by Negroes," the New York Times explained.[103] In these jurisdictions, "the Department of Justice [. . .] made extensive use of the observer provisions of the Act," according to the United States Commission on Civil Rights, with approximately 1,500 observers attending elections in counties within Alabama, Georgia, Louisiana, Mississippi, and South Carolina in 1966 and 1967 in which white resistance to black enfranchisement was especially virulent. An additional 618 observers assessed elections in twenty-four counties or parishes in the same states in 1968.[104]

Department officials were pleased with the success of the election observer program, finding only scattered instances of irregularities at polls at which observers were present in the 1966 and 1968 elections.[105] But leaders in the civil rights movement worried that the program suffered from signifi-

cant limitations, which could plausibly be linked to the desire of the admin-
istration to curb political controversy. Echoing complaints about the limited
reach of the federal registrar program, activists protested that observers were
deployed too sparingly and only to the jurisdictions with the very worst vot-
ing rights records. Another serious concern was that the lack of clear insignia
differentiating federal observers from local officials—a further indication of
the administration's desire to make the observers inconspicuous so as to min-
imize intergovernmental conflicts—created the impression that federal offi-
cials were buttressing the intimidating circumstances they were ostensibly
sent to counteract. The United States Commission on Civil Rights noted that
"some Negro voters, primarily in the Deep South, reportedly are deterred
from voting because they associate the unidentified Federal observer[s] . . .
with the local election and registration officials who have been so hostile to
Negro voting in the past."[106]

If the implementation of the federal registrar and election observer pro-
grams by the Department reflected a pragmatic mix of assertiveness and cau-
tion, its administration of the preclearance provisions of the Act represented
an almost complete abdication of responsibility. Fearful of backlash from
southern jurisdictions, the Civil Rights Division declined to establish formal
processes for evaluating preclearance submissions from covered states. "All of
the several hundred changes submitted [under Section 5] to the present have
gone to the Attorney General . . . [but] *the Department of Justice has dealt with
these since 1965 without any set of procedures,*" League of Women Voters activ-
ists complained in 1971, more than two years after Johnson had retired from
office (emphasis added).[107] In fact, the Division even failed to ensure that cov-
ered states, which were by all accounts extremely reluctant "to defer to the
power of the federal government to scrutinize their electoral processes," com-
plied with the legal obligation to submit proposed changes for review.[108]

Due in no small part to the laxity of federal oversight, only 260 proposed
voting changes were submitted by covered jurisdictions to the Department
of Justice between 1965 and 1969, with the preponderance coming from just
two states, Georgia and Virginia. Federal review of these submissions ap-
pears to have been cursory. Of the submissions assessed by the Department,
all but ten were approved.[109] As a practical matter, this meant that changes in
election rules or regulations that had the purpose or effect of discriminating
against African American voters may well have been enacted between 1965
and 1968 in dozens, if not hundreds, of jurisdictions covered by Section 5.

John W. Gardner, chairman of the Urban Coalition Action Council and a former high-ranking official in the Johnson administration, claimed in July 1969 that "too many legislatures and local officials have worked energetically to neutralize the effectiveness of the Voting Rights Act." This charge was amply confirmed by an extensive report by the United States Commission on Civil Rights.[110]

By the time of Johnson's retirement from office in January 1969, the Voting Rights Act had produced achievements almost unimaginable at the start of the decade. Throughout the South, the estimated black registration rate reached 62 percent in 1968, and it exceeded 55 percent in each of the Deep South states.[111] And self-reported voter turnout among southern blacks exploded from around 46 percent in 1964 to just over 60 percent in 1968.[112] But as the NAACP asserted in early 1969, due to uneven implementation by federal officials, "the full potentialities of [federal civil and voting rights] laws have not been realized."[113] Indeed, the Johnson years revealed that the scope of federal voting rights enforcement under the Act was susceptible to readjustment—if not diminution—in the service of the broader political agenda of the White House. In subsequent decades, Republican presidents further developed the example set by Johnson, using low-profile administrative maneuvers to instate an even more limited understanding of voting rights enforcement.

The Warren Court's Construction of the VRA

Because both the constitutionality and the textual meaning of the central provisions of the Act were subject to considerable debate, the scope of federal voting rights enforcement depended heavily on how the VRA fared in litigation before the Supreme Court. Proponents of vigorous federal voting rights enforcement thus had the great good fortune of passing the Act just as the Warren Court's "rights revolution" was reaching its apex.[114] The staunchly liberal majority not only vindicated the constitutionality of the new law but also interpreted the statute very generously, allowing Section 5 to reach a much broader array of election regulations than clearly contemplated in the legislation. In the end, however, this period yielded conflicting legacies. Even as they expanded the reach of the VRA, the liberal rulings of the Warren Court legitimized the use of extremely flexible constitutional and statutory reasoning in the field of voting rights law—an intellectual bequest that could cut in

either a liberal or a conservative direction depending on the ideological pre-
dilections of the majority of justices. Over the long run, much more conser-
vative justices appointed by Nixon, Reagan, and the Bushes appropriated this
second legacy in order to attack—and substantially weaken—the first.

The Warren Court and Johnson's Limited Judicial Legacy

Enactment of the VRA raised profound matters of constitutional law and
statutory interpretation. A fundamental question was whether Congress had
the power under Section 2 of the Fifteenth Amendment to enact the sweeping
provisions contained in the legislation.[115] Assuming this query was answered
in the affirmative, subtler but vitally important questions of statutory inter-
pretation remained. What counted as a "voting qualification or perquisite to
voting, or standard, practice, or procedure with respect to voting" under Sec-
tion 5 of the Act? How should one determine whether an alteration to a "vot-
ing qualification or perquisite to voting, or standard, practice, or procedure
with respect to voting" had the purpose or effect of "deny[ing] or abridg[ing]
the right to vote on account of race or color"?[116] Beyond their immediate im-
pact on the implementation of the VRA, the Court's answers to these ques-
tions had major implications for how authority over voting rights enforce-
ment was to be apportioned among the branches of the federal government.

While undoubtedly sympathetic to the jurisprudence of the Warren
Court, President Johnson made only modest contributions to its subsequent
development. Arguably, this was attributable both to the president's tradi-
tional view of judicial appointments, in which nominations to the federal
bench were more matters of patronage and symbolism than substantive pol-
icy making, and to subsequent changes in the Court's personnel that diluted
the impact of Johnson's choices.[117] Johnson's first appointee to the Court,
close advisor Abe Fortas, replaced outgoing associate justice Arthur Gold-
berg, who Johnson had convinced in 1965 to leave the Court in order to serve
as US ambassador to the United Nations.[118] From the perspective of the pres-
ident, Fortas's main value was as "one of [his] great friends" who would keep
Johnson appraised of the Court's inner workings and possibly help head off
adverse rulings pertaining to Great Society programs.[119] But because For-
tas's jurisprudence was similar to that of Goldberg in many respects, his ap-
pointment had little noticeable impact on the tenor of the deliberations of the
Court. Fortas also had limited opportunity to make his mark. Following rev-
elations of questionable dealings with financier Louis Wolfson, Fortas retired
in 1969 after only four years of service.[120]

Johnson's second nominee to the Court—solicitor general and former NAACP attorney Thurgood Marshall—made a similarly limited impact on the trajectory of the Court following his appointment in late 1967, albeit due to no fault of Marshall's own. Although President Johnson nominated the legendary attorney in large part to symbolize the nation's racial progress, Marshall was a committed liberal with extensive knowledge of the field of civil rights law and thus might have further advanced the Court's expansive jurisprudence in this area.[121] Unfortunate timing thwarted the promise of his appointment, however. The departure over the decade after Marshall's appointment of Earl Warren, William O. Douglas, and Abe Fortas—and their replacement by more conservative justices nominated by Republican presidents Richard Nixon and Gerald Ford—meant that "Marshall relatively quickly found himself placed on the margins of the Court's work by many of his colleagues."[122]

Despite the failure of President Johnson to establish an enduring judicial legacy, the Warren Court proved a particularly hospitable venue during the VRA's crucial early years. Of six cases pertaining directly to the Act that came before the Court during Warren's chief justiceship, the Court issued a liberal ruling in all but one.[123] In crafting its most important voting rights opinions, the Court's jurisprudence in relation to the Act was strikingly flexible, exhibiting either extensive deference to Congress or an impressive degree of judicial assertiveness, depending on which best advanced the cause of African American voting rights.

Judicial Deference to Congress and the Vindication of the VRA's Constitutionality

The Court's first opportunity to influence the scope of the VRA emerged when South Carolina—with amici support from the states of Alabama, Georgia, Louisiana, Mississippi, and Virginia—challenged the constitutionality of the Act. The complaint lodged in *South Carolina v. Katzenbach* (1966) was comprised of three major claims. First, the state charged that the coverage formula established in Section 4—the lynchpin of the entire Act insofar as it designated particular areas of the country for special federal attention—was unconstitutional because it unfairly included unoffending southern jurisdictions while excluding nonsouthern political units guilty of racial discrimination. Second, South Carolina contended that the federal examiner and election monitor provisions, in assigning quasi-judicial functions to the attorney general, violated the separation of powers.[124] Finally, South Carolina argued

that the establishment of federal preclearance under Section 5 of the Act—
which amounted to a "prophylactic measure" against *potentially* unlawful ac-
tions—exceeded Congress's powers under the Fifteenth Amendment.[125]

Within the legal and political context of the day, these were serious
charges.[126] But in an 8–1 decision (with associate justice Hugo Black dis-
senting in part), the Court upheld all of the challenged portions of the Act.
The majority opinion, authored by Chief Justice Warren, was characterized
throughout by great deference to the authority of Congress to advance mi-
nority voting rights. Although the majority contended that "the constitu-
tional propriety of the Voting Rights Act of 1965 must be judged with refer-
ence to the historical experience which it reflects," it acceded entirely to the
"historical experience" as construed by Congress.[127] The ready acceptance of
the congressional presentation of the facts paved the way for the Court's en-
dorsement of the constitutionality of the VRA. Indeed, given that Congress
had uncovered an extensive history of discrimination and resistance to fed-
eral law, the Court pronounced, it was entitled to employ "*any rational means
to effectuate the constitutional prohibition of racial discrimination in voting*"
(emphasis added).[128]

This "very flexible and forgiving" standard clearly gave the remarkable
provisions of the Act the benefit of the doubt.[129] Addressing South Caroli-
na's contention that the coverage formula unfairly targeted southern states,
the majority breezily responded that "these arguments . . . are largely beside
the point. Congress began to work with reliable evidence of actual voting dis-
crimination in a great majority of the States and political subdivisions af-
fected by the new remedies of the Act. The formula eventually evolved to de-
scribe these areas *was relevant* to the problem of voting discrimination, and
Congress was therefore entitled to infer a significant danger of the evil in the
few remaining States and political subdivisions covered by Section 4 of the
Act" (emphasis added).[130]

The majority's disposal of the complaint that the coverage formula irra-
tionally excluded jurisdictions with histories of discrimination against Af-
rican American voters was similarly forgiving to the discretion of the leg-
islative branch. "It is irrelevant that the coverage formula excludes certain
localities which do not employ voting tests and devices but for which there
is evidence of voting discrimination by other means," the majority argued.
"[Through Section 2 of the VRA] Congress strengthened existing remedies
for voting discrimination in other areas of the country. Legislation need not

deal with all phases of a problem in the same way, so long as the distinctions drawn have *some basis* in practical experience" (emphasis added).[131] Even the most radical provision of the Act—federal preclearance of proposed changes in election rules—was ratified without extensive argument. "This may have been an uncommon exercise of congressional power," the Court conceded. "[B]ut the Court has recognized that exceptional conditions can justify legislative measures not otherwise appropriate." Because congressional interpretation of recent experience suggested that states and localities might devise new discriminatory measures again and again in order to continually thwart adverse court decisions, "Congress responded in a permissibly decisive manner" to prevent such chicanery in the future.[132]

The readiness of the Warren Court to accord great latitude to the congressional exercise of authority to advance civil rights reached new heights in *Katzenbach v. Morgan* (1966). *Morgan* presented a much tougher test of the powers of Congress. As legal scholar William Eskridge notes, the complaint "involved a provision [Section 4(e) of the VRA] preempting New York's literacy requirement [as a prerequisite to voting], *as to which there were no congressional findings of invidious racial operation*" (emphasis added).[133] Because the Court had recently upheld the nondiscriminatory use of literacy tests in *Lassiter v. Northampton County Board of Elections* (1959), it was far from certain whether "Congress [could] strike down a state literacy test devoid of any indicia of racial intent."[134]

The majority (with only Justices Harlan and Stewart dissenting) ruled that Congress possessed the power to invalidate literacy tests even in the absence of evidence of intentional discrimination. In an unprecedented move, it declared that Section 5 of the Fourteenth Amendment granted Congress the "same broad powers expressed in the Necessary and Proper Clause" in Article I of the Constitution to institute all appropriate means of advancing equal protection of the law as Congress understood it.[135] This remarkable line of argumentation effectively "conceded to Congress the task of interpreting the meaning of the constitutional text," a function the Court had traditionally claimed, quite jealously, for itself.[136] As a practical matter it allowed the majority to sidestep the *Lassiter* ruling to focus on the narrower question of whether Congress could "prohibit the enforcement of the state law by legislating under Section 5 of the Fourteenth Amendment."[137]

With the constitutional issue framed this way, the only matter left to determine was whether Section 4(e) was "appropriate legislation" to enforce the

Equal Protection Clause, "plainly adapted to that end" and in accordance with "the letter and spirit of the Constitution."[138] The majority set a low bar for adjudicating whether Congress's enactment of Section 4(e) was appropriate. The Court need only be able to "perceive a basis" on which Congress might judge that "this need of the Puerto Rican minority for the vote warranted federal intrusion upon any state interests served by the English literacy requirement."[139] In the view of the majority, this basis was easy to establish: Congress *might well have judged* that Section 4(e) was an appropriate exercise of its power under the Equal Protection Clause as a means to the constitutionally permissible end of "gaining nondiscriminatory treatment in public services for the entire Puerto Rican community."[140]

Furthermore, the provision was, in the majority's view, "plainly adapted" to this end because its enfranchisement of Spanish speakers empowered these citizens to use the electoral process to achieve equal protection under the laws.[141] Finally, the majority averred that the provision was consistent with the "letter and spirit of the Constitution," even though it effectively discriminated against non-English speaking citizens who were educated in schools outside the United States or its territories, because Congress was entitled to make reasonable distinctions among classes of persons based on policy considerations such as the maintenance of particular international relationships or the promotion of specific immigration objectives.[142] In making this evaluation, the majority opinion reaffirmed the principle of deference to the legislature by acknowledging that Congress could, if it so chose, advance minority civil rights in an incremental fashion.

Judicial Activism and Expansion of the Meaning of Section 5

Deference to Congress in these two constitutional cases did not indicate, however, that the Warren Court had adopted a general posture of submission to congressional authority. Properly understood, the deference of the Court in both cases was an instrumental means to advance the cause of racial justice. When the promotion of black voting rights required the vigorous assertion of judicial clout, the Court seized the opportunity.

The chance came in *Allen v. State Board of Elections* (1969), a statutory interpretation decision probing the meaning of the text of Section 5. The controversy in *Allen* arose from challenges by African American plaintiffs to the implementation by the states of Mississippi and Virginia of assorted changes in election rules without prior approval by the federal courts. The "reforms," including shifts from district-based to at-large elections, changes in particular

government positions from an elective to an appointive basis, and alterations in rules regulating independent political campaigns, all tended to dilute the influence of black voters and make it more difficult for African American candidates to win elections.[143] The move from district-based to at-large elections allowed white voters to overwhelm black ones (as long as African Americans were in the minority within the at-large jurisdiction); the transformation of elective offices to appointive ones allowed incumbent white officeholders rather than newly enfranchised black voters to select powerful officials; and the alteration of rules governing independent campaigns made it more difficult for black candidates—who were still largely prevented from winning Democratic nominations in southern states—to run effective independent campaigns. Other southern states adopted similar stratagems to undermine black political power, protect white Democratic incumbents, and forestall potentially momentous changes in policy.[144] The major question at hand in *Allen* was whether such alterations counted as "voting qualifications or perquisites to voting, or standards, practices, or procedures with respect to voting" under Section 5 of the VRA and thus fell subject to federal preclearance.[145]

The stakes of the interpretation of the meaning of the relevant language were enormous. If Section 5 addressed only rules and regulations pertaining directly to registration and voting, its effect would be limited to ensuring that African Americans and other racial minorities were given equal opportunity to participate in elections. But if Section 5 also covered alterations in rules and regulations affecting the structure of election systems, it might enable Justice officials or the federal courts to implement preclearance so as to ensure African Americans a fair share of substantive political power in jurisdictions historically dominated by white supremacists.[146]

In a 7–2 decision authored by Chief Justice Warren, the Court declared that Section 5 applied to changes to rules regarding the organization and structure of election systems as well as to those pertaining to the process of voting. "The Voting Rights Act was aimed at the subtle, as well as the obvious, state regulations which have the effect of denying citizens their right to vote because of their race," the majority pronounced. "Moreover, compatible with the decisions of this Court, the Act gives a broad interpretation to the right to vote, recognizing that voting includes 'all action necessary to make a vote *effective*'" (the internal quotation comes directly from the statute, with emphasis added).[147] By interpreting the phrase "make a vote effective" broadly to mean "make a vote capable of exercising substantive political power" rather

than simply "make a vote legally valid," an understanding grounded in the Court's recent reapportionment decisions, the majority established a jurisprudential rationale for reading the statute to require Section 5 coverage of rules not pertaining directly to the process of voting.[148]

But the majority opinion also relied heavily on the historical claim that "in passing the Voting Rights Act, Congress *intended* that state enactments such as those involved in the instant cases be subject to the Section 5 approval requirements" (emphasis added).[149] The bulk of the opinion was a defense of this construction of congressional intent. First, the majority noted that, in response to concerns expressed in Senate hearings that the words *qualification or procedure* might not cover some practices with the potential to deny African Americans the vote, Attorney General Katzenbach emphasized that the phrase was "intended to be all-inclusive of any kind of practice." The final text of the bill contained the additional terms *standard* and *practice* in the relevant text, which the majority interpreted to signify congressional intent to "give the Act the broadest possible scope."[150]

Second, the majority pointed to testimony by Katzenbach emphasizing that the purpose of Section 5 was to overcome the tendency of recalcitrant southern legislatures to "outguess the courts of the United States or even to outguess the Congress of the United States" in order to frustrate black political participation. This, the majority argued, provided further evidence of the drafters' intent that "Section 5 was to have a broad scope."[151] Finally, the majority noted that Katzenbach testified that "precious few" types of rule changes should be excluded from preclearance "because there are an awful lot of things that could be started for purposes of evading the Fifteenth Amendment if there is the desire to do so"; they also observed that Congress subsequently declined to list any exceptions to Section 5 coverage in the text of the section. The majority concluded that this omission was deliberate, "indicating an intention that all changes, no matter how small, be subjected to Section 5 scrutiny." [152]

Based on these observations, the majority argued that "the weight of the legislative history and an analysis of the basic purposes of the Act indicate that the enactment [in each of the cases before the Court] constitutes 'a voting qualification or prerequisite to voting, or standard, practice, or procedure with respect to voting' within the meaning of Section 5."[153] But the evidence presented in the majority opinion—although strongly suggestive—was not definitive, bolstering the impression that the majority adopted a generous in-

terpretation of the record at least in part due to its strong substantive commitment to African American civil rights.

At the broadest level, the majority's interpretation of the legislative record obscures the fact that there was a "lack of extended discussion of vote dilution in the 1965 legislative history."[154] Given that African American voting rights activism in Selma had riveted national attention on the denial of access to the ballot, it is understandable that congressional debate focused intently on the immediate imperative to ensure that African American citizens were able to register and vote.[155] But the dearth of discussion about vote dilution precludes an authoritative determination that members of Congress intended Section 5 to require federal review of election rules that might have the purpose or effect of curtailing black voting power. Furthermore, although the quotations supplied by the majority provided indications that members of Congress and the administration desired Section 5 to have broad scope, none of these individuals stated explicitly that preclearance was intended to cover changes in election rules and regulations not pertaining directly to registration and voting. This was problematic, because it is difficult to understand why the framers of the Act would have failed to generate an authoritative record if they definitely intended Section 5 to address changes of the type in question in *Allen*.[156]

Finally, the majority opinion dismissed as inconclusive a quotation by Assistant Attorney General Burke Marshall that raised questions about the Court's expansive construction of the intent of the statute. In his testimony, Marshall declared, "The problem that the bill was aimed at was the problem of registration . . . If there is a problem of another sort, I would like to see it corrected, *but that is not what we were trying to deal with in the bill*" (emphasis added).[157] This statement seemed to indicate that the Johnson administration did not envision Section 5 to require federal review of changes to election rules not pertaining directly to registration and voting. Although Marshall's statement need not be taken as definitive, it does not provide a ringing endorsement of the construction of the text embraced by the majority of the Court, either.[158]

Allen thus bequeathed a complex legacy to the VRA. On one hand, the expansion of the meaning of the language of Section 5 arguably reflected the Court's continuing work in partnership with liberals in the elective branches to advance African American civil rights, ensuring that preclearance would have continuing relevance even after formal barriers to black voting had been demolished. Indeed, approximately three-quarters of all Section 5 objections

between 1970 and 2013 (1,102 out of 1,523) were made on the basis of the vote dilution grounds judicially sanctioned in *Allen,* suggesting that the Court ruling played a central role in maintaining the vitality of Section 5.[159] On the other hand, the ruling represented a major exercise of judicial power and thus a significant departure from the deference typically accorded by the Warren Court to Congress on civil rights issues. Judicial muscle flexing worked in favor of African American voting rights in *Allen* only because of the sympathy of the justices in the majority with this cause. If and when the ideological predilections of the Court's majority changed, similar assertions of authority would have quite different consequences.

Conclusion

Enactment of the VRA and its subsequent ratification and expansion by the Supreme Court were transformative moments in civil rights history, finally establishing federal machinery capable of safeguarding the voting rights of African American citizens. These dramatic changes originated in the convergence of three auspicious developments: intense dissatisfaction among civil rights activists and, increasingly, executive branch officials with existing federal voting rights laws; the cresting of a powerful civil rights movement capable of dramatizing racial injustices; and the emergence of liberal majorities across all three branches of the federal government with the political will to advance minority voting rights.

Ironically, however, "the victory of Selma gave way to crisis, not fulfillment," historian Adam Fairclough has written.[160] Even as the civil rights movement intensified its advocacy, the cause of racial justice was increasingly frustrated by adverse political developments. The urban riots of 1965–1968 and the increasing militancy of some factions of the civil rights movement— which conservative activists and politicians ruthlessly exploited to discredit the entire movement—alienated more and more white Americans from the cause of racial equality. White anxiety was undoubtedly amplified by the growing realization that African Americans intended to use their newfound political power to achieve a more equitable redistribution of opportunities in areas such as education, housing, and employment.[161] Republicans increasingly sought to benefit politically from the growing controversy surrounding civil rights conflicts, vocally criticizing both the Johnson administration and civil rights leaders for encouraging law breaking and social disorder. Many Democrats responded by distancing themselves from the civil rights

movement and insisting that civil rights advances be balanced with respect for "law and order."[162] By early 1967, *Newsweek* reported with some hyperbole that "Congress itself stood transformed at least in party by the white backlash—and less hospitable than ever to the cause of the Negro American."[163]

To make matters worse, the widening gulf between many civil rights activists and the Johnson administration over increasing American involvement in Vietnam undermined the working relationship between the movement and the presidency that had made possible the stunning achievements of 1964 and 1965.[164] Viewing support for the war as a matter of patriotism, many ordinary Americans likewise judged harshly those civil rights leaders who opposed the conflict. In April 1967, a poll indicated that 59 percent believed King's criticism of American involvement in Vietnam hurt the civil rights cause.[165]

Even as civil rights politics were roiled by the developments of the late 1960s, bureaucratic maneuvers and judicial pronouncements played a central role in shaping the evolution of federal voting rights policy. The cautious implementation of the VRA by the Johnson administration circumscribed enforcement of the Act in ways that could not have been anticipated by a reading of the text of the statute. Nearly simultaneously, however, a liberal Supreme Court not of Johnson's making provided a resounding endorsement of the constitutionality of the VRA and expanded the scope of Section 5 by means of statutory interpretation. Institutions insulated from the pressures of civil rights activism and electoral politics played a pivotal, if often obscured, role in determining the ambit of the VRA, introducing unanticipated tensions into the structure of the federal voting rights regime that influenced its subsequent development.

Johnson's dramatic March 1968 announcement that he would not run for reelection, and King's tragic assassination only weeks later, announced the demise of the liberal era of the 1960s. The return of conservative Republican Richard Nixon to national prominence—and his elevation to the presidency in 1968 on promises to restore "law and order" and to roll back federal civil rights enforcement—raised serious questions about the durability of the federal voting rights regime established during the period of Democratic ascendancy in national politics. Would a president with Nixon's ideological commitments and coalition partners support extension of the Voting Rights Act, which was up for reauthorization in 1970? And how would Nixon's administration of the executive branch and appointments to the federal courts affect the development of the Act?

2 Conservative Backlash and Partisan Struggle over Voting Rights, 1968–1980

W HEN THE VRA WAS ENACTED IN 1965, THERE WAS LITTLE reason to anticipate that the renewal of the temporary provisions of the Act (which were due to expire in August 1970) would provoke much in the way of conflict. Indeed, believing that the "Dixie bloc [had been] buried by Congress," as the *Chicago Defender* crowed in October 1965, many liberals anticipated that the full might of the federal government would finally be deployed to dismantle segregation in southern states.[1] Others argued that the time had come to refocus federal attention on pervasive racial injustices in the North. Senator Robert Kennedy of New York went so far as to suggest in September 1965—just a month after riots rocked the Watts neighborhood of Los Angeles—that "the racial problems of the Northern cities now were more urgent than those of the South."[2]

But the optimism of mid-1965 was soon shattered. By 1968, the civil rights agenda seemed in terminal decline, the victim of rising racial antagonism, internecine conflict over Vietnam, and the waning of the civil rights movement. In November, Democratic presidential candidate and staunch civil rights supporter Hubert Humphrey was defeated by Republican standard-bearer Richard Nixon, ending the creative partnership between civil rights activists and a Democratic presidency that had facilitated passage of the major civil rights legislation of the 1960s. Indeed, because Nixon had pledged on the campaign trail to amend civil rights legislation that—like the VRA—concentrated federal enforcement efforts in southern states, an Act that had so recently seemed inviolable now appeared vulnerable to retrenchment.

Yet the events that followed were both more complicated and more puzzling. Far from suffering diminution, the extraordinary provisions of the VRA were renewed in 1970 and again in 1975. The Act was also extended to preserve the rights of voters who spoke English as a second language. But this was not the full story. Administrators within the Department of Justice not only continued to decline to make full use of the authority at their disposal but also, in some instances, appeared to go out of their way to thwart effective implementation of the Act. Meanwhile, as a direct result of Nixon's appointments, the voting rights jurisprudence of the Supreme Court began to drift to the right. In a series of rulings with profound consequences for the development of federal voting rights enforcement, the Court began to limit the conditions under which the federal government could object to proposed voting changes under Section 5 of the Act.

These crosscutting developments were attributable to the different political logics governing voting rights struggles waged in conspicuous legislative environs as well as those conducted in relatively obscure administrative and judicial venues. Although conservative Republican influence in national politics was on the rise, it could not be harnessed to check the scope of the VRA as readily within Congress as within the bowels of the federal bureaucracy or the halls of the Supreme Court. Unwilling to accept the public disapprobation that would ensue if they voted publicly to circumscribe the Act, Republican critics swallowed their reservations and twice acquiesced to the extension of the extraordinary provisions of the law. Rather than spelling the end of Republican resistance, however, legislative defeats merely diverted it into less visible, traceable, and participatory institutional channels. President Nixon led the way, demonstrating that administrative maneuvers and judicial appointments offered less politically conspicuous means for circumscribing federal voting rights enforcement.

Nixon's Assault on the VRA and the 1970 Renewal

Seeking to advance his "southern strategy" to court resentful whites, Republican president Richard Nixon proposed a plan—initially endorsed by most congressional Republicans and southern Democrats—that would have substantially diminished the scope of the VRA. In response, civil rights activists and their allies initiated a furious campaign to preserve the Act, featuring claims that Nixon sought a return to the status quo prior to enactment of the 1965 law. They also attached to the legislation a popular amendment to en-

franchise eighteen- to twenty-year-old Americans. These developments dras-
tically raised the political stakes, turning the debate over the reauthorization
into a referendum on the right to vote. Loath to shoulder the public's blame
for diminishing the right to vote, many congressional Republicans, and even-
tually the president himself, abandoned the Nixon plan in favor of an initia-
tive that enhanced the VRA's protections.

Nixon's Racialized Campaign and
Prospects for Renewal of the VRA

The year 1968 was a cruel one for the Democratic Party and the civil rights
movement. Declaring that "I do not believe that I should devote an hour or
a day of my time to any personal partisan causes or to any other duties other
than the awesome duties of this office [to bring the war in Vietnam to suc-
cessful conclusion]," President Lyndon B. Johnson unexpectedly bowed out
of the 1968 presidential contest in late March of that year.[3] In truth, Johnson's
surprise announcement reflected the sober realization that public backlash
against his war leadership had rendered a second elected term impossible.
Days later, Martin Luther King Jr. was assassinated in Memphis, Tennessee,
traumatizing the nation and sparking urban riots in dozens of American cit-
ies. These shocking events threatened to permanently cripple a civil rights
movement already reeling from ideological factionalism, fatigue at the grass-
roots, and the adverse effects of federal surveillance and repression.[4]

The impression that the cause of liberalism was slackening received fur-
ther confirmation as the year progressed. The Democratic National Conven-
tion, held in August 1968 in Chicago, was a debacle that exposed the party's
deep divisions to a national television audience. Within the convention hall,
liberal activists and party regulars split bitterly over the selection of vice pres-
ident and Vietnam hawk Hubert Humphrey as the party's presidential nomi-
nee. Outside, police brutally dispersed demonstrators protesting the Vietnam
War. Meanwhile, feeding on white resentment against mid-decade civil rights
advances, the independent presidential campaign of former Alabama gover-
nor George Wallace threatened to detach much of the South from the Demo-
cratic coalition.[5]

Sensing that victory was at hand, Republican presidential nominee Richard
Nixon ruthlessly exploited "the awesome political problems that confront[ed]
the . . . Democratic ticket."[6] Nixon adopted as his central campaign theme a
phrase, "law and order," that signaled his opposition to civil rights agitation,
urban protests, and antiwar radicalism and thereby reassured moderate white

voters throughout the nation who were frightened by the political turmoil. "I believe in civil rights," the Republican candidate intoned on the campaign trail. "But the first civil right of every American is to be free from domestic violence, and we are going to have an administration that restores that right in the United States of America."[7] To reinforce his political appeal among whites in southern states, especially, Nixon also "stressed his belief that the South had been discriminated against too long, and that a century after the Civil War it was time to begin treating the South once again as a full-fledged part of the union."[8] While Nixon was most vocal in criticizing judicially mandated busing as a means for desegregating southern schools, his repeated exclamation that "I don't believe you should use the South as a whipping boy," also seemed to convey a tacit promise to reassess recent civil rights legislation that leveraged the might of federal authority to dismantle Jim Crow.[9]

Given the tone of the campaign, Nixon's narrow victory in the fall election set the stage for a major confrontation over federal voting rights enforcement. Believing that, as Representative Emanuel Celler of New York bluntly explained in early 1969, "there has been no significant change in the states affected [by the temporary provisions of the VRA] to bring Negroes into the election process," civil rights activists and their congressional allies argued that it was necessary to continue to focus voting rights enforcement efforts in southern states.[10] After Celler introduced legislation that would reauthorize the temporary provisions of the Act for five years, Clarence Mitchell of the NAACP and Roy Wilkins of the Leadership Conference on Civil Rights journeyed to the White House to seek the president's approval of the plan.[11] But Nixon demurred, offering only the bland response that "the actual impact of the present legislation was being studied by the Justice Department . . . [and] if these studies indicated that the Act needed to be renewed that it will be."[12] Nixon's equivocal message created the impression that, in the words of the *New York Times*, he was "seeking a course that would not destroy the Negro voter registration work done in the South . . . [but] would assuage the continuing anger of white Southern politicians who believe they have been singled out for special, punitive attention."[13]

Belatedly announced in late June 1969, Nixon's proposal largely confirmed this impression. The bill combined measures apparently calibrated to appeal to conservative whites with provisions that seemed designed to reassure civil rights moderates and liberals. Consistent with Nixon's campaign promise to end "discrimination" against southern states, the legislation struck from the

Act the sections requiring federal preclearance of proposed voting changes in the South. If adopted, this proposal would have "permit[ted] states to enact discriminatory laws and put them into effect until the Justice Department discovered and challenged such laws and the courts held them unconstitutional," the Leadership Conference on Civil Rights observed.[14] Additionally, the bill would have established a new federal commission to study *both* voting restrictions *and* voter fraud, implying that the latter was as serious a problem as the former. This provision was popular among congressional Republicans who believed that large-scale fraud by Democratic Party machines disadvantaged Republican candidates.[15]

Yet, at the same time, Nixon's plan would have ostensibly expanded the federal role in safeguarding voting rights *outside* the South. In addition to banning all literacy tests until January 1, 1974, and loosening residency requirements for voting in presidential elections, it authorized the DOJ to send voting examiners and observers to all parts of the nation and empowered the attorney general to challenge in federal court the voting regulations of any state or locality.[16] Attorney General John N. Mitchell thus maintained that the legislation was a progressive plan intended to address a "national concern . . . which must be treated on a nationwide basis."[17]

But there were good reasons to question the accuracy of this claim. The strongest congressional advocates of the Nixon plan were the conservative Republicans and southern Democrats who had consistently opposed effective federal voting rights legislation in the past. "If we have to have some voting rights bill," South Carolina Republican Strom Thurmond candidly declared, "I hope it would be the administration's."[18] Democratic senator Sam Ervin of North Carolina, who led the conservative attack against the VRA in 1965, expressed similar sentiments.[19] Claims by the attorney general notwithstanding, the enthusiasm of the harshest critics of the VRA for Nixon's proposal did not engender confidence among supporters of the Act.

The substance of the proposal also raised serious administrative and constitutional concerns. Since the plan did not call for any new personnel or appropriations, it would have had the practical effect of redirecting limited federal resources for enforcement away from the South, where voting rights violations were most pervasive.[20] The heavy emphasis of the Nixon proposal on litigation to secure voting rights also troubled civil rights forces because it seemed willfully ignorant of the problems that had plagued this approach to enforcement prior to 1965. Finally, while the VRA had already withstood

repeated constitutional challenges, Nixon's proposal had not, engendering doubts about its suitability as an alternative to the Act.[21]

The Rise of the "Conservative Coalition"
and the Advance of the Nixon Plan

Clarence Mitchell vowed that civil rights organizations "shall make [their] fight [against the Nixon proposal] in the committees of Congress and [they] shall make [their] fight on the floor of Congress."[22] Given the disorganized state of civil rights forces, an approach that leveraged the personal influence of sympathetic liberal Democratic and Republican legislators made considerable tactical sense.[23] Along with the LCCR—a coalition of dozens of civil rights and ally organizations founded in 1950 by civil rights luminaries A. Philip Randolph, Roy Wilkins, and Arnold Aronson to coordinate legislative campaigns—the NAACP played a central role in the 1970 legislative struggle over the VRA.

At first, the insider strategy seemed to pay dividends. Liberal Democrats (with an assist from liberal Republicans who "[were] not real enthusiastic about the Administration's voting rights proposal," as Nixon aide Lamar Alexander candidly reported) pushed Celler's rival proposal through the House Judiciary Committee in late July 1969.[24] But the bill then entered the traditional graveyard of civil rights legislation—the House Rules Committee. There, Chairman William Colmer, a Mississippi Democrat and staunch conservative on racial matters, exercised his prerogative by "refus[ing] . . . to move the measure toward the House floor." When Colmer finally relented in late November 1969 in response to intense pressure from the Democratic leadership, he exacted a heavy price, passing the bill along with a rule that would, as the *Washington Post* explained at the time, "mak[e] it in order to offer as an amendment the administration's voting rights proposals."[25]

As the *Post* presciently noted, Colmer's crafty maneuver paved the way for a new bipartisan conservative alliance on voting rights matters in the House: "Southerners [still primarily Democrats] favor the administration bill. Republicans will be under heavy party pressure to support it. A Republican-Dixie coalition . . . could get together and push through the administration bill."[26] This is precisely what happened. Unmoved by a telegram to the House GOP from Roy Wilkins, Whitney Young, Ralph Abernathy, A. Philip Randolph, and Bayard Rustin warning that any amendments to the Celler bill "will strike a blow at the nation's black voters" and "must be interpreted as opposition to civil rights," 152 Republican legislators (85 percent of all voting

Republicans) joined with 82 southern and western Democrats to pass Nixon's proposal in early December 1969.[27] In a reflection of the party's much stronger pro-VRA stance, 65 percent of all voting Democrats (and 87 percent of northern Democrats) opposed Nixon's proposal.[28] The racial subtext of the vote was clear to all: while liberals sat in stunned silence, "cheers and applause burst from the southern members as the result . . . was announced."[29]

Civil Rights Countermobilization and
the Emergence of a Liberal Alternative

Following the House vote, consideration of the VRA moved to the Senate, where conservatives, led by Senator Ervin, seemed to hold even greater sway. At this point, however, opponents of Nixon's plan benefited from a fortuitous coincidence of scheduling. Introduction of the House bill in the Senate interrupted ongoing consideration of Nixon's nomination of controversial Florida judge Harrold Carswell to the Supreme Court. Taking heed of the recent defeat of Nixon's previous nominee to the Court, Clement Haynsworth, Senate conservatives were anxious to vote on Carswell's nomination before burgeoning liberal opposition overwhelmed it as well.[30] Supporters of the VRA extension exploited this situation to their advantage. As Arnold Aronson of the LCCR explained, the Conference, "working closely with Senate Republican leader Hugh Scott, and one of the Democratic stalwarts on civil rights, Senator Philip Hart . . . backed a substitute to the House bill" that extended the VRA for five years, albeit with additional language incorporating the administration's proposed ban on literacy tests and state residency requirements for voting in presidential elections.[31] (In truth, the selective additions from the administration bill made the VRA even more progressive than it had been previously while at the same time enabling Senate liberals to claim that they were promoting "compromise" legislation that incorporated Nixon's proposals.) Then, Senate liberals prevailed upon Democratic majority leader Mike Mansfield of Montana to adjust the Senate calendar to require completion of business on the voting rights bill prior to a floor vote on the Carswell nomination.

This maneuver put considerable pressure on Senate critics of the VRA to support—or at least not obstruct—timely passage of the expansive Scott/ Hart voting rights bill. If they sought to filibuster the legislation, the *Washington Post* explained, "it [would] only further delay the Carswell nomination. . .[giving] Carswell critics more time to develop new arguments against him."[32] The gambit worked. As J. Francis Pohlhaus of the NAACP later re-

called, "For once time worked in our favor, as some Senators who would nor-
mally oppose us went along with the leadership on the bill and on cloture in
order to get a chance to vote for Carswell."[33] During the struggle, the Senate
rejected, 47 to 32, "an attempt by Southerners and pro-Administration Re-
publicans to table, and thus kill," the legislation favored by civil rights activ-
ists and their congressional allies.[34] Several additional amendments to dilute
the strength of the coverage formula, limit the role of the (liberal) US District
Court for the District of Columbia and weaken preclearance were also de-
feated due to virtually unanimous opposition from northern Democrats and
majority opposition from northern Republicans (see table 2.1).

Senate passage of the Scott/Hart bill added a new wrinkle to the reautho-
rization, however: an amendment sponsored by Mansfield (and strongly fa-
vored by liberal Senate Democrats) to grant all eighteen-, nineteen-, and
twenty-year-olds the right to vote in all federal, state, and local elections.[35] In-
spired by the desire to enfranchise young Americans—the majority of whom,
not coincidentally, were expected to vote Democratic—the proposal intruded
into an area that the Constitution seemed to reserve for state governments,
and thus it stretched congressional authority to the limit. The amendment,
which appeared to have strong public support, passed the Senate easily, but
Nixon opposed it for both constitutional and partisan reasons.[36] In a state-
ment implying that he might veto the VRA if it contained the eighteen-year-
old vote rider, the president called on Congress to "secure the vote for the Na-
tion's eighteen-, nineteen-, and twenty-year-olds in the one way that is plainly
provided for in the Constitution . . . Constitutional amendment."[37] Nixon's
willingness to draw a line in the sand on the nation's premier piece of vot-
ing rights legislation provides an indication of the president's ambivalence
toward the federal role in enforcing minority voting rights. The veto threat
raised the possibility that House Republicans, encouraged by the president,
could insist on a conference to strike the youth enfranchisement provision
from the legislation, thereby granting Senate conservatives a second oppor-
tunity to filibuster the bill once the conference report reached that chamber.[38]

Electoral Interests and Abandonment of
the Nixon Plan by Many Republicans

In actuality, however, these circumstances strengthened the hand of propo-
nents of the Senate bill in the House of Representatives. It was one thing for
critics of the VRA in the House to prefer Nixon's proposal to a simple re-
newal of the 1965 legislation; it was another thing altogether to embark on a

TABLE 2.1. Support for Proposals to Weaken the Scott/Hart Bill, 1970

Roll call N	Amendment	% Rep. support (all)	% northern Rep. support	% southern Rep. support	% Dem. support (all)	% northern Dem. support	% southern Dem. support
321	Eliminate requirement that fewer than 50% of voters actually voted in 1964 presidential election as prerequisite for suspending literacy tests	13	6	50	33	3	89
322	Exclude certain groups from count of adult persons in calculating percentage of citizens voting in 1964 presidential election	42	38	67	35	6	89
323	Reject requirement that violations of VRA be heard in US dist. court for DC	46	41	80	37	6	95
324	Permit states that repeal literacy tests to be exempt from coverage of VRA	34	30	60	33	3	84
325	Change method of enforcement of Section 5	39	34	75	33	3	84
326	Change from 1964 to 1968 the election for triggering suspension of literacy tests	32	30	40	30	3	83
328	Suspend literacy tests in all jurisdictions in which fewer than 50% of eligible voters were registered on November 1, 1968	63	61	80	38	43	28
332	Strike certain sections of enforcement provision	23	20	40	28	0	79
339	Repeal formula for suspension of literacy tests	18	15	33	27	0	72
340	Provide that coverage formula and preclearance expire August 7, 1975	37	33	60	29	3	81

SOURCE: "Democrat and Republican Party Voting Splits Congresses 35–113 (31 May 2015)," accessed July 18, 2016, available from VoteView.com, http://voteview.com/partycount.html.

course of action that could undermine federal voting rights enforcement in the South, antagonize millions of young American citizens during a period of youth militancy and campus unrest, and thwart what was an apparently popular expansion of the franchise.[39] Of particular note to members of Congress up for reelection in 1970 was that public attention to civil rights matters ran high in that year, with more Americans identifying "civil rights" as the most important problem facing the nation than at any point since 1965 (the year the VRA was enacted into law).[40] Many House Republicans and southern Democrats appear to have become increasingly anxious to avoid the negative electoral repercussions of supporting Nixon's proposal. Indeed, Nixon advisors warned in early April 1970 that "the House of Representatives [now] shows clear signs of willingness to accept the Senate Amendments to the House passed extension of the Voting Rights Act." This despite the fact that the Senate bill was far stronger than what the House had recently passed.[41]

Civil rights activists and their congressional allies made the most of representatives' queasiness to bolster the case for the Senate bill. Following a "National Emergency Assembly" to rally their forces, the LCCR and NAACP redoubled their behind-the-scenes lobbying efforts, "campaigning hard to win [House] approval for a Senate-okayed revision" of the VRA.[42] The LCCR also "launched an appeal to the public to write or call members of the House to urge their support of the Senate version of the Voting Rights Bill," according to the *Baltimore Afro-American*.[43]

This rhetorical onslaught came just as public-opinion surveys were indicating that the GOP was in for a painful 1970 election campaign. Indeed, polls from May and June 1970 revealed that Americans favored Democratic congressional candidates over Republican ones by a wide margin. More importantly, while Nixon was fairly popular, fully 58 percent of Americans viewed his handling of race and civil rights unfavorably.[44] Consequently, many Republican senatorial and congressional candidates who needed to appeal to moderate whites or people of color had little incentive to follow Nixon's lead on civil rights matters. The president received messages from worried Republican leaders expressing the fear that GOP representatives' chances of reelection would be undermined if the VRA were not renewed and "Republicans [were] blamed for [the] disaster."[45]

These considerations help explain why the Scott/Hart bill passed the House by such a wide margin (272 to 132) despite the chamber's previous endorsement of Nixon's much weaker proposal.[46] Consistent with their gener-

ally stronger support for civil rights in the post-1965 era (with the exception of the shrinking southern delegation), Democrats voted for the legislation at a much higher rate: 75 percent of Democrats supported the bill (compared with 57 percent of Republicans), and Democrats provided 63 percent of the total votes in favor. But enactment of the Scott/Hart bill was facilitated because many House Republicans joined their Democratic colleagues in voting for the legislation. An analysis of the voting behavior of House Republicans provides indications that an important fraction of GOP representatives felt considerable pressure to vote in favor of the more expansive Scott/Hart bill despite contrary coalitional interests and ideological commitments. Of the 169 Republicans who voted on both bills, 69 (or 41 percent) voted for the enhanced VRA in June 1970 despite having voted for the much narrower Nixon plan the previous December. (Voting only for the more expansive bill were 23 Republicans [14 percent], while 75 [44 percent] supported only the Nixon proposal and 2 [1 percent] opposed both measures.) The dramatic shift in Republican voting behavior suggests that many members, facing difficult campaigns in a context of extensive public attention to civil rights, were unwilling to accept the partisan blame for scuttling the nation's "most effective civil rights law."[47]

The House vote put the president in an extremely awkward position. To sign the legislation would require Nixon to renege on positions held firmly since his campaign, but vetoing the bill would send an unmistakable—and highly visible—signal of hostility to the aspirations of both African Americans and the nation's youth. While a few of Nixon's advisors—most notably, Assistant Attorney General (and future Supreme Court Justice) William H. Rehnquist—urged him to veto the legislation, others maintained that the president could not afford to create the appearance of sacrificing the interests of African American and youth voters for the sake of constitutional propriety or partisan pique. "To veto the Voting Rights Act would be taken as a gross and gratuitous slap in the face of black America," speechwriter Raymond K. Price cautioned the president. "It would offend and outrage not only the blacks, but also millions of others who identify, in greater or lesser degree, with black aspirations." Leonard Garment agreed that Nixon must sign the legislation, warning the president:

> I cannot emphasize how harmful [a veto] would be. . . . There are underway a number of careful, potentially successful, efforts to close the gap with the black leadership, to reduce some of the polarizing language, to minimize the hazards of racial violence this summer and next fall (when major school de-

segregation under Administration direction must take place). A veto would at least interrupt these efforts, probably end them for the foreseeable future. At worst, it could produce the most bitter reaction from blacks, youth, and others, since the President took office.[48]

Even Harry Dent—Nixon's liaison to the white South—suggested that Nixon would be wise to sign the bill so as to best position himself with moderate voters in anticipation of a close 1972 presidential campaign.[49]

In the end, Nixon abandoned his more limited voting rights initiative and signed the expansive plan favored by congressional liberals into law. It seems clear that the president's actions were motivated primarily by a desire to maintain the GOP's positive reputation on voting rights matters, especially when those actions are viewed in light of the considerations raised by his advisors. As Nixon's advisors emphasized, given the strong resonance of the Act with the norm of racial equality, any effort to limit the scope of the law risked offending not only African Americans and liberals but also moderate whites "to whom the right to vote sounds like it should be inviolate," as John Price explained.[50] With many Republicans congressional candidates facing difficult elections in 1970 (and the president potentially facing a tough race in 1972), Nixon needed to avoid actions that would undermine the party's public reputation and concomitant ability to achieve pressing policy objectives. These considerations explain why the president repudiated prominent public stands against legislation that "discriminated" against the South and enfranchised young citizens by "unconstitutional" means and instead signed into law legislation that did not reflect the preferences of either core Republican coalition members or the white southern Democrats he was attempting to woo.

Ford's Flip-Flop and the 1975 Renewal of the VRA

Because the 1970 amendments only renewed the coverage formula and preclearance provisions of the Act for a period of five years, Congress was due to revisit the measure in 1975. By that time, the Watergate fiasco had shifted the political winds in the favor of proponents of minority voting rights. Nixon had left office in disgrace, a president who had never won a national election had come to occupy the White House, and dozens of liberal "Watergate babies" had flooded the halls of Congress. Civil rights activists sought to make the best of these auspicious circumstances, pressing for the expansion of the terms of the Act to safeguard the voting rights of non-English-speaking citi-

zens. Rather than risk open war with the civil rights movement over minority voting rights in the opening stages of what promised to be a brutal 1976 campaign season, critics of the Act again acquiesced—albeit unenthusiastically—to demands for expanded voting rights protections. The immediate upshot was a substantially liberalized law covering a greater portion of the nation and offering a wider array of protections to minority voters. But the legislative struggle also pointed to growing Republican antagonism toward vigorous federal voting rights enforcement.

The Addition of Minority-Language Protections to the Voting Rights Agenda

The story of how protections for minority-language speakers rose to the forefront of the voting rights agenda is also the tale of how Latino civil rights organizations joined what previously had been a cause spearheaded by African American, labor, and progressive activists. These groups had initially excluded minority-language concerns from the legislative agenda, instead seeking to establish a permanent ban on literacy tests and reauthorize the coverage formula and preclearance requirements for another ten to fifteen years.[51]

Over the winter of 1974–1975, civil rights activists secured commitments from key legislators for this agenda—an easy job, given liberal Democrats' overwhelming influence in both chambers.[52] "Once we got the House and Senate nailed down on [the renewal]," Clarence Mitchell later explained, "then we started working on Justice."[53] The initial response of the Gerald Ford administration to these efforts suggests that the president had taken the political lessons of the 1970 renewal to heart. Despite his advocacy of much more modest voting rights legislation in 1965, Ford immediately endorsed the expansive plan offered by civil rights activists and their liberal allies.[54] Although subsequent actions raised questions about the sincerity of Ford's commitment, civil rights leaders believed the president's ostensible support meant they were "riding a good tide" (in Clarence Mitchell's words) to an easy reauthorization.[55]

During hearings on the legislation in February and March 1975, however, negotiations hit an unexpected snag. Insurgent Latino civil rights organizations led by the Mexican American Legal Defense and Education Fund (MALDEF) and the National Council of La Raza (NCLR) sought, in the words of J. Francis Pohlhaus of the NAACP, to "latch onto our bill" in order to "extend coverage to Spanish speaking voters and other minority groups."[56] For minority-language activists, who were experiencing a swell of consciousness raising and political organizing in the mid-1970s, this strategy made perfect

sense. An investigation by the United States Commission on Civil Rights disclosed "widespread discrimination against . . . minorities, principally Spanish-Americans" in the administration of elections in areas in which non-English speakers were prevalent.[57] Believing "federal statutes are inadequate to resolve problems encountered by Chicanos," language-minority organizations sought to amend the VRA to extend preclearance coverage to areas with concentrations of non-English speakers and require jurisdictions to provide election materials in voters' native languages.[58] Two separate bills advancing these objectives were introduced in the House by liberal Democratic legislators.

Many members of the LCCR and NAACP sympathized with the concerns raised by minority-language advocates. But they viewed proposals to amend the VRA to address these issues with considerable ambivalence. As J. Francis Pohlhaus later recalled, given the increasingly conservative makeup of the Supreme Court (a development spurred by Nixon's judicial appointments), "[They] did not want a constitutional attack on these new provisions to cause the Court to reconsider previous decisions [on the constitutionality and scope of the VRA] or to be forced to consider parts of the 1965 Act or amendments thereto on which it had not ruled in tandem with the new language provisions."[59] Fearing that the proposed amendments would, in Clarence Mitchell's biting words, improve the present law "out of existence," African American civil rights leaders initially insisted that they be quarantined under a separate title of the Act. [60] Under this arrangement, the rest of the VRA would almost certainly survive an unfavorable Court ruling against the novel provisions. But minority-language activists rejected this approach out of hand. "The problem with a separate title is that it's easier to knock us out (in the congressional deliberations)," Al Perez, associate counsel for MALDEF, explained.[61]

Minority-language activists eventually emerged victorious in this struggle, in no small part because many liberal Democrats represented districts with significant Spanish-speaking constituencies and thus appreciated the political wisdom of attaching minority-language protections to the legislation.[62] Moreover, despite their misgivings, most African American civil rights organizations within the LCCR preferred endorsing the expanded bill to adopting a course of action that could undermine renewal of the core provisions of the Act. By June 1975, an accord had been reached so that "the AFL-CIO, UAW, Friends Committee on National Legislation, Leadership Conference on Civil Rights, Mexican-American Legal Defense and Education Fund,

TABLE 2.2. Support for Weakening Amendments in the House of Representatives, 1975

Roll call N	Amendment	% Rep. support (all)	% northern Rep. support	% southern Rep. support	% Dem. support (all)	% northern Dem. support	% southern Dem. support
182	Trigger federal presence in elections when fewer than 50% of Hispanic/black citizens voted in previous election only in districts where Hispanics/blacks make up 5% of population (and limit federal presence to 10 years)	61	53	93	21	2	63
183	Loosen requirements for "bailout" from preclearance coverage	60	53	89	19	2	59
184	Repeal preclearance procedures	47	37	89	16	2	48
185	Limit ban on voter qualifications/devices to 10 years	38	29	75	14	4	37
186	Strike provisions providing for protection of language minority groups	47	40	75	15	4	41
187	Delete Alaskan natives from definition of language minorities	79	75	93	14	6	33
189	Exclude from definition of "language-minority group" persons of ethnic origin whose dominant language is English	64	57	90	12	3	33
191	Extend definition of "language-minority group" to all persons whose principal language is one other than English	40	32	69	38	29	57

SOURCE: "Democrat and Republican Party Voting Splits Congresses 35–113 (31 May 2015)," accessed July 18, 2016, available from VoteView.com, http://voteview.com/partycount.html.[i]

[i]Although the amendment offered in House Vote 191, 94th Congress, 1st Session appears expansive on its face, the facts that southerners strongly supported it and northerners generally opposed it suggest that the amendment was likely intended to undermine enforcement of the minority-language provision by making it overbroad and thus vulnerable to constitutional challenge. Individuals' votes on the amendment can be found at GovTrak.us, accessed September 6, 2016, https://www.govtrack.us/congress/votes/94-1975/h191.

and the National Congress of Hispanic American Citizens are among those groups that support the bill and oppose all anticipated amendments."[63]

Republican and Southern Democratic Resistance
to the 1975 Reauthorization

Action on the renewal began in the House, where Democrats held a commanding advantage following the 1974 elections. The House legislation reauthorized the temporary provisions of the 1970 Act for another ten years while requiring jurisdictions with sizeable language-minority populations to submit proposed voting changes for preclearance. The bill also provided for bilingual ballots and oral voting assistance in jurisdictions with significant non-English-speaking populations. The legislation thus marked a major expansion of the VRA, suggesting, in the words of New York Democrat Herman Badillo, that "the spirit of the 1960's still exists, and for everybody."[64]

As the bill wended its way through the committee system to the House floor, the fragile unity holding the civil rights organizations together helped ensure that the raft of hostile amendments offered by conservative legislators would be sunk. Buoyed by civil rights lobbying and strong backing from congressional liberals, the bill was approved in that chamber by an overwhelming 341–70 margin in early June 1975. Yet the unfriendly amendments championed by Republican representatives Charles Wiggins of California and M. Caldwell Butler of Virginia—which sought to strip coverage for language minorities, time-limit the proposed ban on literacy tests, permit southern jurisdictions to "bail out" of the preclearance process, and shorten the renewal to a period of five years, among other things—were notable insofar as they provided further evidence of the changing racial and partisan politics surrounding federal voting rights enforcement.[65] As the *Washington Post* observed, "[Southern Democrats] had led the fierce fights against civil rights legislation in the 1960s, but this time it was Republicans ... offering the softening amendments."[66] Table 2.2, which summarizes these votes, shows that Republicans were in fact noticeably more supportive of these weakening amendments than were Democrats (although regional differences within each party were also apparent). The party differences pointed to nascent partisan polarization over federal enforcement of minority voting rights.

Senate consideration of the VRA—delayed until early July by Democratic Judiciary Committee chairman James Eastland's illness and absence from the Senate—provided yet further evidence that resistance to federal voting rights enforcement was increasingly becoming a Republican phenomenon. During

committee consideration, southern Republican legislators not only repeatedly
attempted to water down the legislation but also, in cooperation with south-
ern Democrats, sought to delay the report of the bill to the floor, even though
the temporary provisions of the Act were set to expire in a matter of weeks.[67]
"Facing a bitter dispute with Southern legislators," Democratic leaders (with
the support of the major civil rights organizations) engaged in aggressive par-
liamentary tactics of their own, "unexpectedly call[ing] up the House-passed
voting rights bill for [immediate] action" in order to avoid having to wait for
the Senate Judiciary Committee report.[68] (The maneuver was supported by
86 percent of voting Democrats and 81 percent of voting Republicans.) They
then secured a strong vote for cloture on debate, apparently paving the way
for swift passage of the House legislation and transmission of the bill to the
White House without the need for a time-consuming conference.

Ford's Strategic Embrace of—and Awkward Retreat from— Racial Conservatism

An awkward moment of racial pandering by the president followed. Having
previously endorsed a straightforward extension of the law, Ford suddenly re-
versed course, declaring his preference that Congress "make the voting rights
act applicable nationwide."[69] With this unexpected announcement, the pres-
ident apparently endorsed an amendment offered by conservative Missis-
sippi Democrat John Stennis to require every state in the Union to submit
proposed voting changes for preclearance. Given Stennis's long history of
opposition to civil rights—he had signed the "Southern Manifesto" in sup-
port of school segregation, supported Republican Barry Goldwater for pres-
ident in 1964, and opposed both the Civil Rights Act of 1964 and the Vot-
ing Rights Act of 1965—the amendment was viewed by civil rights activists
and their congressional allies as a tactically sophisticated effort to under-
mine Section 5 by "mak[ing] it generally applicable . . . rather than [focusing
on] those states and localities where the problem of minority voter registra-
tion is most pronounced."[70] Ford's announcement thus appeared to put him
squarely on the side of conservative critics of the VRA. The presidential en-
dorsement breathed new life into what had been a moribund amendment, po-
tentially imperiling renewal of preclearance.

The surprise maneuver must be placed in the broader context of Repub-
lican presidential politics. Since the inauspicious beginning of Ford's presi-
dency, conservative activists and party notables had harshly criticized him
for allegedly hewing to a moderate ideological line and had openly discussed

drafting conservative star and California governor Ronald Reagan to contest the Republican presidential nomination in 1976. As Ford's campaign manager James Baker later recalled, top administration officials "certainly were concerned about [a challenge from Reagan] in May or June of '75," just as the VRA was wending its way through Congress.[71] In this context, Ford's request appeared calibrated to signal he was "following Nixon's civil rights footsteps," thereby enabling him to shore up support among conservative Republican voters.[72]

But the president's sudden embrace of the Stennis amendment also rendered him vulnerable to the charge that he was willing to sacrifice minority voting rights for the sake of political expediency. Liberal Democrats and civil rights activists pounced on this theme, accusing Ford of "playing politics" with voting rights in order to position himself for the presidential campaign.[73] Democratic senator Edward Kennedy of Massachusetts sarcastically announced that Ford's request "in the final hours" of Senate debate "[did] a great deal to confuse" the position of the administration on voting rights matters.[74]

These charges came just as public opinion polls were indicating that Ford's support for the Stennis amendment actually represented bad presidential politics. In 1975, overall public opinion was extremely favorably disposed on civil rights issues, achieving the highest level of support it had attained since the breakthroughs of 1963–1965.[75] Strikingly, a June 1975 survey revealed that 59 percent of Americans believed that the government should be making a "major effort" to "solve the problems caused by ghettos, race, and poverty" and an additional 29 percent thought "some effort" should be made.[76] In this context, Ford had electoral incentives to support expansive voting rights legislation despite his past record. Furthermore, polls revealed that Ford was much more popular with Republican voters than was Reagan, suggesting that the president did not need to follow Reagan's lead in order to capture the 1976 GOP nomination.[77]

These electoral considerations provide a plausible explanation for Ford's subsequent—and otherwise puzzling—abandonment of the Stennis amendment. The president appears to have belatedly realized that his support for the Stennis amendment was a detriment to his electoral interests and thus contacted Republican leaders to clarify that passage of the amendment "took third place [in his list of priorities] behind either extension for five years or passage of the House measure."[78] In truth, Ford seemed to be making a cyn-

ical attempt to have it both ways. As the *New York Amsterdam News* argued with considerable justification,

> Whereas President Ford let it be known by letter that he approved of the Stennis amendment to the Voting Rights Act, he also let it be known that he did not want his personal approval to the 50-state extension to stand in the way of the highest priority: passing the Voting Rights Act itself. By so doing, the President let the Southerners know he was on their side, while at the same time dooming any chance the Stennis amendment had of being written into law.[79]

Conservatives' Grudging Embrace of the VRA

Following the president's flip-flop, the Stennis amendment was defeated 38–58 due to overwhelming Democratic opposition and disapproval of half of the Republican delegation. (Whereas 69 percent of voting Democrats opposed the amendment, only 50 percent of Republicans disapproved.)[80] Numerous other hostile amendments were tabled—some on fairly close votes—due to very strong Democratic and majority Republican opposition. (Across all of the roll calls, an average of 79 percent of Democrats and 55 percent of Republicans supported tabling the hostile amendments.)[81] The Senate finally passed the House bill 77–12 (with 91 percent of Democrats and 82 percent Republicans in support).[82]

Significantly, however, a notable fraction of the votes in favor of final passage came from Republicans and southern Democrats who had previously supported amendments that would have crippled the VRA. These striking reversals in voting behavior provide important circumstantial evidence that, at the end of the day, a significant fraction of conservative senators did not want to be on the "wrong side" of a final-passage vote, and thus they voted for legislation they did not really support. So, for example, nine Republicans (27 percent of Republicans who voted on both measures) and thirteen Democrats (25 percent of Democrats voting) voted for final passage despite having previously supported the hostile Stennis amendment.[83] (Notably, 55 percent of Republicans and 66 percent of Democrats voted to both table the Stennis Amendment and pass the expanded VRA, pointing to the relatively greater Democratic support for muscular voting rights enforcement.) Eleven Republicans and five Democrats voted for final passage even though they previously supported an amendment that would have crippled the minority-language provisions of the Act by rendering them inapplicable in states with substantial representation of non-whites in the state legislature.[84] And eleven Republicans and twelve Democrats voted for enactment of the VRA despite supporting an amendment that would

have granted local—and presumably much more jurisdiction-sympathetic—federal district courts jurisdiction over matters arising from the Act.[85]

After Senate passage, the legislation returned to the House, where it was reauthorized on a resounding 346–56 vote.[86] The bill thus came to Ford's desk with overwhelming—indeed, veto-proof—support in both chambers of Congress. This fact, coupled with the unfavorable attention Ford had received due to his brief support of the Stennis amendment, ensured presidential approval of the measure. And on August 6, 1975—the tenth anniversary of the enactment of the VRA—Ford signed the reauthorization into law, blandly intoning that "the right to vote is at the very foundation of our American system, and nothing must interfere with this very precious right."[87]

The 1975 amendments to the VRA were an even more momentous expansion of minority voting rights than were those enacted in 1970. In addition to permanently banning literacy tests and extending the provisions of the Act for another seven years, the 1975 renewal brought under its protection millions of minority-language voters. The amendments also heralded the emergence of a new alliance between different segments of the civil rights community that could help buttress the VRA in future legislative struggles over the scope of the Act.

Although the political dynamics were muted somewhat by the tenuous legitimacy of Ford's presidency and the overwhelming strength of the Democratic Party in Congress following the 1974 elections, the underlying forces at work in 1975 were the same as those present in 1970. The high visibility, easy traceability, and broad participation attending legislative consideration of the VRA once again provided a decisive advantage to those who sought to expand the scope of the Act. Conservative critics of the VRA—a growing proportion of whom hailed from the Republican ranks—sought to thwart its renewal. When push came to shove, however, they were disinclined to subject themselves to public condemnation for weakening the Act, as both the vacillation of President Ford over the Stennis amendment and the reversals in many senators' voting behavior from amendment votes to the final-passage vote vividly illustrated.

The Nixon/Ford Administrative Presidency and Federal Voting Rights Enforcement

Both Nixon and Ford were foiled in their respective efforts to weaken the nation's preeminent voting rights law by legislative means. Yet their actions

pointed to the possibility of a new voting rights politics, in which Republicans might challenge federal efforts to protect minority voters in order to advance their conservative political views, appeal to various factions within their party coalition, and woo disaffected southern white Democrats. The question was how these objectives might be accomplished without creating the public impression that Republicans were abandoning the norm of racial equality and seeking to disenfranchise minority voters. Richard Nixon, the first Republican president to appreciate the conservative potential of the administrative presidency, employed obscure—and seemingly neutral—bureaucratic procedures to circumscribe federal voting rights enforcement. These subterranean maneuvers shielded the GOP from the public outcry that would have attended legislative evisceration of the Act, providing a blueprint for conservative resistance to the VRA in the 1980s and beyond.

Nixon's Administrative Presidency and Voting Rights

Nixon entered office determined to exert White House control over the sprawling federal bureaucracy.[88] Although he believed that a strong presidential hand was necessary to bring recalcitrant civil servants into line, Nixon's core motive was "to attempt to accomplish administratively what [he] could not do legislatively" due to lack of popular and congressional support.[89] Nixon intended to use all of the tools at his disposal—executive orders and directives, presidential appointments, administrative routines, and personnel policy—to accomplish programmatic goals by administrative means.

The Department of Justice—which had raised the ire of southern whites for its central role in enforcing federal civil and voting rights laws—was targeted by the president for special attention. (Indeed, during the 1968 campaign, Nixon promised a secret gathering of southern politicians that he would take personal control of the Department, implying that his stewardship would alleviate the burden of federal enforcement in southern states.)[90] To establish White House authority over the Department, Nixon appointed his campaign manager and former law partner, John N. Mitchell, to serve as attorney general. Since Mitchell was the chief architect of Nixon's campaign strategy to court racially resentful whites through appeals to "law and order," the move provided a fairly clear indication that Nixon intended to employ administrative maneuvers as a means to align civil and voting rights enforcement with his conservative ideological commitments, the demands of core constituencies, and the administration's strategy of allying white southerners with the GOP.[91]

Administrative Politics as a Means to
Dilute Voting Rights Enforcement

Indeed, in the realm of voting rights administration the actions of Mitchell and his subordinates suggest deliberate efforts to circumscribe enforcement by administrative means, despite the president's ostensible endorsement of the 1970 VRA. Mitchell began by assembling an administrative team better known for its links to the GOP than for its experience on civil rights matters.[92] To lead the Civil Rights Division, Mitchell selected a close confidante, Jerris ("Jerry") Leonard, a former Wisconsin state senator and Republican Party official with no previous experience in the field of civil rights law. By all accounts, Leonard was Mitchell's "team man in Justice's Civil Rights."[93]

Under Leonard's direction, the CRD employed a variety of administrative practices—some held over from the Johnson administration—that seemed intentionally calibrated to limit the scope of federal voting rights enforcement. As a first step, the CRD failed to exploit the full potential of the federal registrar program to expand black registration. Although federal registrars continued to operate in the most problematic jurisdictions, "examiners have rarely been used [in other counties] . . . despite persistent disparities in minority and white registration in many counties of covered States," the United States Commission on Civil Rights reported a year after Nixon's departure from office.[94] In a period in which the hostility of local election officials toward African American voting remained strong in many localities, the refusal of the CRD to send examiners to additional counties meant that growth in black registration in these jurisdictions almost certainly trailed what it might have attained with the benefit of federal assistance.[95]

Nixon officials also initially continued the practice begun during the Johnson administration of soft-pedaling federal preclearance of changes in election rules and regulations in covered jurisdictions. In 1970, Leonard gave his blessing to a Mississippi state law requiring candidates to receive a majority of the vote in order to be elected to office—even though it was well-known within the state that the measure was implemented to prevent African Americans from exploiting a divided white vote in order to elect independent black candidates to office.[96] (The move outraged career attorneys within the Division who had counseled Leonard to object to the measure.)[97] Then, ignoring the protests of civil rights leaders, CRD signed off on plans submitted by twenty-six Mississippi counties requiring all citizens to reregister to vote, despite the fact that the schemes were almost certainly intended to drop otherwise eligible African American voters from the rolls.[98]

Moreover, following the 1970 reauthorization of preclearance Mitchell and Leonard seemed intent to "accomplish by administration what [they] were unable to do through legislation," as the Leadership Conference on Civil Rights charged in April 1971.[99] They promulgated a new proposed rule interpreting Section 5 that declared (in Leonard's words) "it is not the Attorney General's function to enter objections to the submitted laws of sovereign states unless he is persuaded that there is a prohibited racial purpose or effect."[100] The proposed rule inverted the standard of proof required by the VRA, which placed the burden on covered jurisdictions to demonstrate that proposed changes did *not* discriminate against minority voters. If adopted, the alteration would have substantially narrowed the conditions under which objections could be interposed and thus would have seriously limited the effectiveness of preclearance. In the end, and in the face of vocal criticism from civil rights activists and liberal members of Congress, the CRD belatedly reversed course.[101] Given the circumstances, it is probable that the administration's awkward reversal represented an effort to avoid what Leonard Garment described as "another major civil rights controversy . . . involving the 'guttiest' of all the civil rights issues—voting rights."[102]

The Nixon Department of Justice began after the 1971 dustup over the Section 5 guidelines to administer preclearance in a more conscientious fashion. (Between 1971 and 1974 Justice Department officials examined 4,211 proposals from covered jurisdictions and objected to 183.)[103] Yet the DOJ still failed to achieve robust implementation of Section 5. To the great frustration of civil rights activists, liberal members of Congress, and covered jurisdictions, the Division did not maintain consistent criteria for determining whether proposed adjustments in election rules discriminated against minority voters and thus ran afoul of the VRA. Although the standards of the Supreme Court were in flux at the time, the CRD introduced further confusion by shifting its benchmarks in response to often-conflicting decisions issued by lower federal courts. This not only heightened uncertainty about the meaning of the law but also ensured, as voting rights authority J. Morgan Kousser has written, that "civil rights forces [sometimes] suffered unadvertised reversals at the hands of a faceless bureaucracy."[104] In an extreme example of this dynamic, in 1973 the DOJ declined to exercise preclearance review of South Carolina's reapportionment plan on the flimsy grounds that a lower federal court upheld the constitutionality of the plan—even though the court specifically noted that it lacked the authority to preclear the plan as required by the VRA.[105]

Furthermore, the Nixon administration made no serious efforts to ensure that southern states and localities obeyed the requirement to submit proposed voting changes for review, holding the door wide open to resistance by recalcitrant local officials. Later studies by the federal government and independent observers found that states and localities refused to submit hundreds of rules changes between 1971 and 1975, with untold consequences for minority voters residing in these jurisdictions.[106] In truth, there are indications that—through inaction and poor communication—the Nixon administration enabled efforts by covered jurisdictions to skirt preclearance requirements. A 1978 General Accounting Office review of a random sample of 271 preclearance decisions—which drew data primarily from the Nixon and Ford administrations—found that while 55 percent of Section 5 submissions received comments from interested parties, these individuals and groups were informed of review decisions in less than 1 percent of cases. The GAO concluded that this breakdown in the transmission of important information to stakeholders enabled jurisdictions to flout the law, because "minority groups and individuals may not have adequate information to detect changes implemented despite the Department's objections."[107]

The foregoing patterns suggest that Nixon administration officials engaged in a sophisticated, if limited, effort to circumscribe federal voting rights enforcement via administrative maneuvers. Crucially, with the exception of the struggle over the Section 5 implementation guidelines, these machinations largely avoided public scrutiny. Compared to the relatively high levels attained during the legislative struggle over the VRA in 1969–1970, both media and public attention to voting rights matters was quite modest between 1971 and 1974.[108] These patterns pointed to the effectiveness of the administration's bureaucratic politics as a means to simultaneously limit federal voting rights enforcement and avoid damaging charges of insensitivity on voting rights issues.

Watergate and Administrative Reform
during the Presidency of Gerald Ford

Believing that the politicization of administration during the Nixon years contributed both to his predecessor's downfall and to heightened public cynicism about government, Gerald Ford made rebuilding the reputation of the executive branch a primary objective of his presidency. The Department of Justice—a previous chief of which, John Mitchell, was facing criminal proceedings for his participation in the Watergate break-in and cover-up—was

viewed as especially in need of rehabilitation.[109] To lead the Department, Ford sought a person "of unquestioned integrity and impeccable legal abilities and background . . . [who] came from outside the traditional political arena," ultimately settling on renowned legal scholar and former University of Chicago president Edward H. Levi.[110]

Levi presented the image of "the Attorney general as scholar, not [as was the case with Mitchell] enforcer," the *New York Times* explained.[111] The attorney general's commitment to professionalism was reflected in a more vigorous implementation of important sections of the VRA. Under the leadership of Division chief J. Stanley Pottinger, the rate of CRD objections under Section 5 to voting changes proposed by southern states increased dramatically, indeed, peaking according to some measures. And in a significant departure from the practices of the Nixon administration, the Division began "cracking down selectively on states, counties, and even cities that have violated the Voting Rights Act by failing to submit laws for federal approval."[112] Even as the Division evaluated measures passed in Arizona, Georgia, Louisiana, Mississippi, New York, North Carolina, South Carolina, and Virginia for evidence of failure to comply with Section 5, the FBI conducted an in-depth probe of decisions in thirty-two counties and fifteen cities in Alabama.[113] The investigations led to the discovery of numerous instances in which jurisdictions failed to submit proposed changes for preclearance; and in some cases the Justice Department filed suit to enjoin implementation of policies enacted in defiance of the law.[114]

The CRD also began implementing the language requirements of the 1975 VRA in a fairly vigorous fashion. It ruled that hundreds of counties in twenty-seven states would be required to conduct bilingual elections beginning in fall 1975, and it sent more than one hundred observers to oversee implementation of bilingual balloting in Texas the following year. By 1976, 513 cities and counties in 30 states were determined by the CRD to be required to hold bilingual elections—a count embracing more than one-third of the entire US population.[115]

At the same time, however, significant enforcement problems evident during the Nixon presidency continued on Ford's watch. Despite increased efforts to assess compliance, the CRD still failed to guarantee that covered jurisdictions submitted proposed changes for preclearance review and adhered to Section 5 rulings.[116] The Division also made limited use of its litigation authority to promote minority voting rights, imposing a heavy burden on private litigants to enforce the law.[117]

The Nixon Administrative Legacy:
A Blueprint for Republican Voting Rights Enforcement

As was the case during the administration of Lyndon B. Johnson, implementation of the VRA under Nixon and Ford was a case of a cup that was both half-full and half-empty. But the Nixon years witnessed the emergence of subterranean administrative tactics deliberately designed to thwart full and effective enforcement of the VRA. Nixon's sophisticated use of bureaucratic mechanisms to obstruct federal voting rights enforcement out of the public spotlight foreshadowed the administrative strategies that Republican presidential successors Ronald Reagan, George H. W. Bush, and George W. Bush employed to much greater effect.

Nixon/Ford Supreme Court Appointments
and the Evolution of the VRA

If the Nixon years revealed that sub rosa administrative tactics could be employed to curtail the expansive tendencies of the VRA without exposing the Republican Party to public censure, they also provided preliminary indications that judicial appointments could be made to serve the same purpose. Nixon's appointees were particularly important in advancing the conservative approach that the president had favored in the struggle over the 1970 amendments to the VRA but ultimately abandoned in order to buttress his party's political reputation.

The Judicial Strategies of Nixon and Ford

The gradual transformation of the Court's voting rights jurisprudence had its origins in the 1968 presidential campaign. Nixon charged that the Court's liberal decisions had encouraged demonstrations, rioting, and crime by sending the message that disrespect for law was socially acceptable. "As I look over the decisions of [the Supreme Court] and other courts in recent years," he avowed on the campaign trail, "I have reached the conclusion that some of our courts have gone too far in their decisions in weakening the peace forces as against the criminal forces in this country, and we must restore that balance."[118] Nixon promised to strengthen the "peace forces" by appointing jurists who would "interpret the laws" but not "move further than that and attempt basically to write laws, write social legislation."[119]

In fact, as domestic policy advisor John Ehrlichman candidly explained, Nixon's real objective was to "change the domestic situation through the cre-

ation of a long-lived, strict-constructionist Supreme Court, composed of young justices who would sit and rule in Nixon's own image."[120] At the programmatic level, Nixon likely anticipated that this strategy would shift the Court's civil and voting rights jurisprudence to the right and thereby limit the scope of federal intervention in race-related matters that the president thought were best left to state and local governments, the private sector, or voluntary action by individuals. After all, as Nixon's assistant attorney general and appointee to the Court, William H. Rehnquist, candidly observed, "A judge who is a 'strict constructionist' in constitutional matters will generally not be favorably inclined toward claims of either criminal defendants or civil rights plaintiffs."[121] For this reason, Nixon likely anticipated that his appointment strategy would also help him politically, allowing him to shore up support among racially conservative white voters, especially (but not exclusively) in southern states, while maintaining the allegiance of more moderate whites.[122]

Nixon selected Warren Burger, a well-respected "law-and-order" judge from Minnesota, to replace Earl Warren as chief justice when Warren announced his retirement in 1969.[123] To replace departing justice Abe Fortas, however, Nixon tasked Attorney General Mitchell with identifying a "strict constructionist Southerner who was Republican" (in the words of advisor William Safire).[124] Although both South Carolina judge Clement Haynsworth and Florida jurist G. Harrold Carswell were defeated in the Democrat-controlled Senate—the first due to damaging allegations of rulings biased by financial conflicts of interest, the second on the basis of embarrassing revelations of past racist actions and underwhelming qualifications for office—administration officials believed that the failed nominations scored important political points with racially conservative whites.[125]

Following these apparent "setbacks," Nixon decided to avoid further controversy by nominating distinguished jurists to fill the seats vacated by retiring justices Fortas, Hugo Black, and John Harlan. Nonetheless, the president was quite successful in appointing to the Court nominees who took a more conservative approach than their predecessors on civil and voting rights issues. Indeed, using data from Harold Spaeth's Supreme Court Database, it is possible to provide a rough quantitative comparison of the voting behavior of Nixon's appointees with the justices they replaced on these matters.[126] Table 2.3 presents the voting behavior of Nixon's appointees and the justices they replaced on all civil rights issues (desegregation, employment discrim-

TABLE 2.3. Voting Behavior of Nixon Appointees on Civil and Voting Rights Cases

	Retiring justice	Nixon replace-ment	Retiring justice	Nixon replace-ment	Retiring justice	Nixon replace-ment	Retiring justice	Nixon replace-ment
	Warren	Burger	Fortas	Blackmun	Black	Powell	Harlan	Rehnquist
N of votes (all civil rights cases)	308	550	81	660	447	469	345	780
Proportion liberal votes	84%	38%	85%	61%	74%	40%	46%	26%
N of votes (voting rights cases)	6	21	5	28	6	20	7	38
Proportion liberal votes	83%	67%	100%	89%	17%	55%	57%	37%

SOURCE: Supreme Court Database, "Justice-Centered Data: Cases Organized by Supreme Court Citation," accessed July 21, 2016, available at http://scdb.wustl.edu/data.php.

ination, affirmative action, immigration, rights of women, disabled people, gay people, and so on) and voting rights issues in particular. The table shows the number of total votes, as well as the proportion of those votes that could be categorized as "liberal" (that is, votes in favor of civil rights claimants), on these sets of issues.

As table 2.3 reveals, Nixon's appointees were much more conservative than the justices they replaced on all civil rights issues. With the exception of Justice Blackmun, they amassed moderate-to-conservative records on voting rights issues as well. Burger cast liberal votes in voting rights cases much less frequently than did Warren (67 percent versus 83 percent), and he also partic-ipated in more voting rights cases. Powell amassed a moderate record on vot-ing rights cases (casting a liberal vote 55 percent of the time), although it was to the left of that of the stridently anti-VRA Hugo Black (who cast liberal votes in only 17 percent of cases). Finally, Rehnquist's record on voting rights issues was noticeably more conservative than Harlan's. (They cast liberal votes in 37 and 57 percent of cases, respectively.) Rehnquist also cast many more votes and later served as chief justice, so his influence was arguably much greater.

The evidence thus suggests that Nixon was fairly, although incompletely, successful in appointing justices who would be more likely than their predeces-sors to vote against the interests of voting rights claimants. But, despite Nixon's ostensible support for the 1970 VRA, did he deliberately appoint justices with

an eye toward retrenchment on voting rights issues? Although smoking-gun evidence is lacking, circumstantial evidence pertaining to Nixon's appointment of Rehnquist is very suggestive. First of all, the president made the nomination even though he was well aware that Rehnquist viewed the VRA with a skeptical eye, as he had been urged by Rehnquist to veto the 1970 renewal of the Act.[127] Equally important, Nixon stood by Rehnquist even after it was revealed during confirmation hearings that the nominee had helped organize efforts by Arizona Republicans to dispute the credentials of black and Hispanic Democratic voters in the late 1950s and early 1960s and had possibly participated in these activities himself.[128] Based on these considerations, it is reasonable to conclude both that Nixon understood Rehnquist's conservative position on voting rights issues and that he anticipated that Rehnquist would advance them while on the Court.

Unlike Nixon, Gerald Ford was not focused on attempting to use appointments to transform the Court. In the wake of Watergate, Ford's chief concern was to convey his commitments to professionalism and nonpartisanship in public service.[129] These considerations account for his "safe and respectable choice" of well-regarded federal judge John Paul Stevens—widely viewed as a moderate conservative who would occupy the political center of the Court—over more conservative but controversial candidates such as former solicitor general Robert Bork.[130] Over the long run, Stevens would disappoint Ford—and Republican conservatives more generally—by migrating toward the Court's liberal wing on civil and voting rights issues. But because Stevens replaced William O. Douglas, who was arguably the Court's most liberal justice at the time, his appointment contributed (at least in Stevens's early terms) to the rightward shift in the Court's jurisprudence.

The Voting Rights Legacy of Nixon/Ford Appointees

The infusion of more conservative justices came at a pivotal moment in the development of the Court's voting rights jurisprudence. By the early 1970s, the VRA had succeeded in removing the most egregious government-imposed obstacles to registration and voting. Consequently, as voting rights scholar Richard Engstrom noted, the focus of voting rights litigation spearheaded by civil rights organizations "shifted . . . from *vote denial* to *vote dilution*, the practice of reducing the potential effectiveness of the new black voting strength through such devices as gerrymanders, at-large elections, and annexations."[131] And for good reason: in response to rising participation by African Americans in elections, white power brokers had exploited these subtler

tools to limit African American influence in southern politics and preserve the careers of conservative, white Democratic politicians.[132]

But although the Warren Court had made clear in *Allen v. State Board of Elections* (1969), *Perkins v. Matthews* (1971), and *Georgia v. United States* (1973) that alterations by covered jurisdictions of electoral arrangements with the potential to dilute minority voting power were subject to review under Section 5, it had not articulated precise standards to aid federal courts and the Department of Justice in determining whether particular changes should be denied preclearance. It thus fell to the more conservative Burger Court to determine the content of these standards. In a pair of influential cases—*City of Richmond v. United States* (1975) and *Beer v. United States* (1976)—Nixon appointees provided the decisive votes establishing a relatively narrow standard that limited the ability of the federal government to reject proposed election rules that threatened to dilute the voting power of nonwhite citizens. Both rulings contained arguments and patterns of reasoning that resonated with the ideology and interests of the president and party coalition whose appointees enabled them, providing further evidence of the influence of Republican politics on the Court's voting rights jurisprudence.

City of Richmond involved a dispute over the acceptability of a Richmond, Virginia, annexation that decreased the black population in the enlarged city from 52 percent to 42 percent. A federal district court had ruled that the original annexation violated Section 5, both because it was adopted with the purpose of maintaining Richmond's working white voting majority and because it had the effect of diluting African American voting power.[133] In response, Justice attorneys and Richmond officials developed a compromise plan that maintained the annexation but changed the election format from an at-large system to a ward-based system. The new arrangement featured four majority-black wards, four majority-white wards, and one mixed ward. When the federal district court again refused to grant approval—arguing that the new system continued to promote a discriminatory purpose and to dilute black voting strength—both the city and the Department appealed to the Supreme Court.[134]

In a 5–3 decision made possible by the support of three of Nixon's four appointees (Justice Powell did not participate in the case), the Court held that the revised annexation must be precleared. The majority argued that the revised Richmond system did not impermissibly dilute black voting strength because, in the words of Justice White's opinion, it "fairly reflects the strength

of the Negro community as it exists *after the annexation*" (emphasis added). As White explained,

> It is true that the black community, if there is racial bloc voting, will command fewer seats on the city council; and the annexation will have effected a decline in the Negroes' relative influence in the city. But a different city council and an enlarged city are involved after the annexation. Furthermore, Negro power in the new city is not undervalued, and Negroes will not be underrepresented on the council.[135]

The majority argued that the ruling was necessary to preserve the authority of local communities to annex territory. "To hold otherwise," the majority opinion warned, "would be either to forbid all such annexations or to require, as the price for approval of the annexation, that the black community be assigned the same proportion of council seats as before, hence perhaps permanently overrepresenting them and underrepresenting other elements in the community, including the nonblack citizens in the annexed area."[136] The majority was not willing to sanction either of these alternatives.

As a practical matter, even though *City of Richmond* diluted the voting power of resident African Americans, it provided localities with greater freedom to annex territory so long as annexation decisions were not racially motivated and jurisdictions softened the blow to minority voting strength through adoption of fairer (that is, ward-based) election systems.[137] The decision thus seemed poised to "encourage annexation in other cities where the restoration of a white majority might be achieved under the guise of legitimate governmental consolidation."[138] Although research on the racial implications of annexations is limited, there is some empirical evidence that some communities may practice "strategic" annexations that are likely to dilute minority voting strength. In a context of declining urban populations and falling tax revenues, nonwhite citizens in urban areas have faced considerable pressure to accept diminished political power in exchange for a broadened tax base and greater prospects for economic development.[139]

The ruling was also profoundly important from a jurisprudential perspective, signaling a much more conservative balancing of the interests of black voters against those of southern jurisdictions than would have transpired under the Warren Court. By choosing to base its evaluation of the acceptability of Richmond's annexation on whether African Americans received a "fair share" of representation *after* the annexation rather than whether they expe-

rienced a substantive dilution of voting power relative to what they had enjoyed *prior* to it, the Court appeared willing to trade away substantive representation for African Americans in order to increase localities' flexibility to annex territory.[140] All told, *City of Richmond* represented a significant move to the right of the position adopted by the Court in *Perkins v. Matthews*—decided before Rehnquist and Powell joined the Court—which seemed to weigh the threat of minority vote dilution more heavily than other policy considerations.[141]

Beer v. United States, a 5–3 decision written by Justice Stewart but enabled by the unanimous support of Nixon's appointees, played an even more significant role in circumscribing the scope of Section 5 over the long run.[142] The question at hand was whether New Orleans's 1970 reapportionment should be precleared. In 1961, the apportionment plan had provided for one district in which African Americans represented a majority, four in which whites were a majority, and two other seats elected at-large; the 1970 plan provided for two African American–majority districts, three majority-white districts, and two at-large seats. (The two at-large seats present in both the 1961 and 1970 apportionments had been mandated by the municipal charter adopted in 1952, almost certainly as a means to reinforce white domination of city politics.)[143] At the time of the 1970 reapportionment, African Americans comprised about 45 percent of the city population. A federal district court had held that the reapportionment violated Section 5 by diluting African American voting power.

The conservative Court majority took the opposite view. It dismissed concerns about the dilutive effects of the at-large seats required by the 1952 charter on the grounds that the VRA provided that "discriminatory practices . . . instituted prior to November, 1964 . . . are not subject to the requirement of preclearance" under Section 5.[144] Much more consequential was the reasoning explaining why the apportionment of the five "councilmanic" districts—which failed to provide African Americans with representation approaching proportionality—did not dilute black voting power and thus run afoul of Section 5. According to the majority, "the purpose of Section 5 has always been to insure that no voting procedure changes would be made that would lead to a *retrogression* [essentially, backsliding] in the position of racial minorities with respect to their effective exercise of the electoral franchise" (emphasis added).[145] Consequently, any reapportionment that maintained existing African American voting strength or enhanced it—even if the scheme fell far short of giving African Americans voting power commensurate with their

numbers—must be precleared "unless the new apportionment so discrimi-
nates on the basis of race or color as to violate the Constitution."[146] Applying
this "retrogression" standard, the majority concluded that because New Or-
leans's 1970 reapportionment did not leave African Americans worse off in
terms of representation than they were under the 1961 reapportionment, it did
not violate Section 5.

Coming just as the preclearance process was, at long last, being imple-
mented in a serious fashion, the decision gravely limited the potential of Sec-
tion 5 to promote African American voting power. Henceforth, the effects
clause of Section 5 could not be used to ensure that voting changes maxi-
mized—or even enhanced—minority voting strength. To the contrary, as
voting rights scholar Pamela Karlan later argued, under *Beer* "changes that
merely perpetuate a preexisting level of exclusion are not objectionable [un-
der Section 5] for having a discriminatory *effect*," although they could still be
rejected if they were motivated by a discriminatory *purpose*.[147] Moreover, the
retrogression standard established in *Beer* appeared to reward jurisdictions
that had discriminated most egregiously prior to enactment of the VRA by
allowing them to receive preclearance for new submissions so long as these
did not further diminish black voting power.[148] In a recent comprehensive
analysis of CRD enforcement activities, J. Morgan Kousser has shown that
the Court's ruling in *Beer* was associated with a 50 percent decline in Sec-
tion 5 objections and more information requests (from seventy-six to thirty-
eight) between 1976 and 1981. Section 5 enforcement remained depressed rela-
tive to pre-*Beer* levels into the mid-1990s, during the presidency of Democrat
Bill Clinton.[149] In short, *Beer* circumscribed preclearance in ways that reso-
nated with the interests of conservative Republicans and southern Democrats
as expressed during the 1965, 1970, and 1975 legislative debates over the VRA
and tied the hands of more liberal presidential administrations.

What made *Beer* controversial as well as consequential was the limited na-
ture of the evidence supplied by the majority to support its narrow "retrogres-
sion" interpretation of the effects prong of Section 5. The sole source of ev-
idence presented by the *Beer* majority to justify the retrogression standard
came from an obscure House report accompanying the 1975 extension of the
VRA. The relevant paragraph from the House report read:

> The standard [under Section 5] can only be fully satisfied by determining on
> the basis of the facts found by the Attorney General [or the District Court] to
> be true whether the ability of minority groups to participate in the political

process and to elect their choices to office is augmented, diminished, or not effected by the change affecting voting.[150]

As the basis for a new and restrictive interpretation of the statute, this was not an ideal piece of evidence. The text of Section 5 of the VRA (as of 1976) did not limit objections to instances in which changes in election rules threatened to *further* disadvantage people of color. Rather, it prohibited *all* changes that "have the purpose [or] . . . effect of denying or abridging the right to vote on account of race or color," implying that alterations in arrangements that maintained existing levels of discrimination would also fall subject to preclearance. Furthermore, in *South Carolina v. Katzenbach*, which upheld Section 5, the Warren Court elaborated on this phrase, suggesting that the section required the DOJ (or the US District Court for the District of Columbia) "to determine whether [new voting regulations'] use would *perpetuate* voting discrimination" (emphasis added). This elaboration suggested that nonretrogressive voting changes could be deemed objectionable if they maintained existing discriminatory arrangements.[151] Because the Court's adoption of the House report language as authoritative allowed it to circumvent more expansive interpretations of Section 5 available in the text and in past precedent, the move underscored the Court's conservative shift on voting rights matters.

Additionally, the majority opinion excluded evidence contained in the Senate report on the 1975 VRA that contradicted the information in the House report used as the basis for the decision. Whereas the majority argued that the at-large districts in New Orleans's reapportionment plan were beyond the purview of Section 5, the Senate Report took the opposite view, holding that "[when] a change in the voting practice or procedure may also retain some features of the previous system . . . *all* aspects of such a change are within the reach of Section 5" (emphasis added). The Senate report also explicitly praised the exact lower-court decision that the Court was overturning.[152] Although neither report presented a definitive portrait of congressional intent, the majority's exclusion of evidence that challenged its interpretation of the statute reinforced the impression that the Court was moving decisively toward a much more conservative understanding of voting rights enforcement.

Indeed, in both *City of Richmond* and *Beer*, the outcome and reasoning of the decision pointed to the increasing conservatism of the Court on voting rights issues. More broadly, the evidence suggests that these rulings were decisively shaped by the influence of Republican president Richard Nixon. The majorities backing these decisions not only consisted primarily of Nixon ap-

pointees but also adhered to a circumscribed understanding of preclearance that was consistent with—if not as extreme as—the position advocated by Nixon during the struggle over the 1970 renewal of the Act.

Conclusion

On December 26, 1976, Democratic senator and stalwart voting rights advocate Philip Hart passed away at the age of sixty-four, a victim of cancer. Obituary writers lavishly praised the Michigan senator, describing him as a "fighter for civil rights," a "champion of change," and a "soft-spoken man with a voice loud enough to lead the battle for an end to bigotry."[153] The death of Hart deprived the Senate of one of its most forceful and effective voices on behalf of the voting rights of the nation's racial and ethnic minorities. His replacement, Donald W. Riegle, was a much more moderate Democrat, with interests inclining toward finance, banking, and commerce concerns.

Hart's passing also marked a transition in the politics of federal voting rights enforcement. Increasingly, efforts to strengthen protections for minority voters faced energetic resistance from Republican (and southern Democratic) elected officials as well as from Republican administrative and judicial appointees, leading to growing partisan and institutional conflict over the terms of the Act.

Expanding institutional combat over the scope of federal voting rights enforcement reflected a new logic of voting rights policy making during a period of growing Republican influence in national politics. Such logic would continue to structure the development of the federal voting rights regime in the decades that followed. The high publicity and extensive activist participation attending congressional consideration of the renewal of the VRA combined with the easy traceability of political responsibility for legislative decisions provided a decisive advantage to proponents of strong federal voting rights protections during legislative struggles over the terms of the Act. Seeking to avoid the charge of racism they feared would hurt their chances with moderate voters and people of color, many Republicans (and southern Democrats) acquiesced to the expansion of the scope of the VRA despite their intense opposition to its most important features. Meanwhile, however, critics of the VRA, led by President Nixon, learned that they could circumscribe the scope of the Act via administrative stratagems and judicial appointments, which were effective and less likely to generate public disapproval. By 1976,

this strategy had already begun to bear fruit, in particular with the substantial judicial narrowing of the scope of the effects clause of Section 5 of the Act. The example set by Nixon provided a blueprint for conservative political action that his Republican successors—Ronald Reagan, George H. W. Bush, and George W. Bush—would both emulate and elaborate on during their presidencies.

3 The Growing Struggle over Voting Rights in the 1980s and 1990s

A S PRESIDENT RONALD REAGAN SIGNED THE HISTORIC EXTEN-sion of the Voting Rights Act into law on June 29, 1982, he presented the reauthorization as evidence of enduring bipartisan support for federal voting rights enforcement. "Yes, there are differences over how to attain the equality we seek for all our people," the president conceded. "And sometimes amidst all the overblown rhetoric, the differences tend to seem bigger than they are." Nevertheless, Reagan continued, the words and actions of elected officials on both sides of the partisan aisle demonstrated conclusively that consensus reigned when it came to protecting the voting rights of the nation's racial and language minorities. "This legislation proves our unbending commitment to voting rights," he declared. "It also proves that differences can be settled in the spirit of goodwill and good faith."[1]

Voting rights activists remembered the events preceding the president's endorsement of the legislation very differently. Georgia state senator (and future NAACP board chairman) Julian Bond contested the veracity of administration claims of steadfast support for the VRA, recalling a history of strident presidential resistance to expansive voting rights legislation:

If President Reagan wasn't against the Voting Rights Act, why did no one from the administration testify for it during 18 days of hearings in the House? Why did the president and Attorney General William French Smith favor a 10-year extension, not the 25 years suggested by House and Senate? Why did Smith say the House-passed version would guarantee proportional represen-

tation when the bill's language said it wouldn't? Why did it take 17 months for the administration to agree to a bill that 389 House members and 85 percent of the Senate thought fair? Come on.[2]

Bond's rendition of events was closer to the mark. The 1982 amendments to the VRA emerged from a charged political and racial struggle involving very different views of federal voting rights enforcement. On one side of this conflict were civil rights activists and their congressional supporters, who favored the expansion of federal efforts to promote the voting rights of citizens of color. On the other was a coalition of conservative elected officials and activists, led by the president, that sought to circumscribe the major provisions of the VRA in the name of constitutional color blindness and local control of political affairs. The vitality of the law as a safeguard of minority voting rights ultimately hinged on the outcome of what the *New York Times* described as a "major fight" in Congress—a fight that, to an even greater degree than in previous episodes, pitted Democrats against Republicans.[3]

As with the 1970 and 1975 struggles over the reauthorization of the Act, the high visibility, traceability, and accessibility characteristic of the legislative process ultimately played to the advantage of the civil rights movement and its congressional allies. That coalition engaged in an unprecedented legislative and grassroots mobilization, casting the 1982 reauthorization as a referendum on the right to vote. This crusade attracted broad public and media attention and forced the president and members of Congress to take public stands on the racially charged subject of minority voting rights. Loath to accept political responsibility for limiting the scope of the Act in the early stages of a difficult election campaign, both the president and his Republican allies acquiesced to the reauthorization of a law whose main stipulations they did not support.

Yet in the wake of this defeat, the president and his allies worked in a systematic fashion through less visible, traceable, and accessible political venues to contain the expansive tendencies of the renewed law. Elaborating the example set by Richard Nixon, both Ronald Reagan and George H. W. Bush employed subterranean administrative practices to shift the tenor of voting rights enforcement within the DOJ to the right. Much more importantly, both presidents accelerated the rightward march of the Supreme Court on voting rights issues through their judicial appointments. By 2000, a conservative Court majority comprised of Nixon, Reagan, and Bush appointees had sharply circumscribed the ambit of Section 5 of the VRA and es-

tablished precedents that put the future of the preclearance regime in doubt. That these developments occurred beneath the political radar—and long after the presidents who set them in motion had retired from office—obscured Republican culpability for their origins and thereby permitted the GOP to escape the blame for diminishing what remained an extremely popular piece of legislation.

Escalating institutional combat over the interpretation and scope of the major provisions of the Act during the 1980s and 1990s expanded the gulf between the broad understanding of federal voting rights enforcement embedded in the statute, the increasingly fragmented implementation of the law, and the increasingly circumscribed judicial interpretation of the Act. This period also witnessed the dramatic growth of judicial authority to determine the extent of federal involvement in protecting the voting rights of racial minorities—a development (long advocated by Reagan officials) that came at the expense of the powers of Congress. The ascendance of the Supreme Court as the chief arbiter of the meaning of the VRA allowed conservative positions that had previously been rejected in the legislative arena to prevail. Indeed, the Court's decision in *Reno v. Bossier Parish II* (2000), which required the Civil Rights Division to preclear deliberately discriminatory election rules so long as the intentions of officials were not also "retrogressive," provided eloquent testimony to the growing centrality of Supreme Court rulings in advancing the objectives of conservative critics of the Act.

Mobile v. Bolden and the Challenge to Section 2 of the Voting Rights Act

The continuing rightward drift of the voting rights jurisprudence of the Supreme Court set the stage for the 1982 renewal of the VRA. The Court's plurality decision in *Mobile v. Bolden* (1980), supported solely by the appointees of Republican presidents Eisenhower, Nixon, and Ford, threatened to undermine Section 2 by establishing an extraordinarily high bar for plaintiffs seeking to prove discrimination in vote dilution cases. Because the plurality decision evinced disdain for past liberal precedents and for the factual determinations of the lower courts, it also revealed nascent conservative efforts to concentrate authority over voting rights policy making in the Supreme Court.

The question at hand was whether the maintenance by Mobile, Alabama, of an at-large system for electing city commissioners violated the Voting Rights Act, the Fourteenth Amendment, and the Fifteenth Amendment on

the grounds that (under conditions of racially polarized voting) the system effectively excluded blacks from serving as commissioners and thereby diluted African American influence in Mobile politics. Both the district court and the court of appeals reviewing the case found that it did. But a plurality on the Supreme Court, in an opinion authored by Justice Stewart and joined by Chief Justice Burger, Justice Powell, and Justice Rehnquist, disagreed. (Justices Stevens and Blackmun, each writing separately, concurred in the judgment of the Court.)[4] According to the plurality, because the at-large system was not *deliberately* maintained by local whites in order to perpetuate racial discrimination there was no abridgement of the rights of African American voters. As the plurality decision declared, Section 2 and the Reconstruction Amendments "[do] not entail the right to have Negro candidates elected, but prohibit only purposefully discriminatory denial or abridgement by government of the freedom to vote 'on account of race, color, or previous condition of servitude.'"[5]

Although the outcome of the case was a disappointment to civil rights activists, the legal reasoning employed by the plurality imparted the decision with much broader significance. The plurality argued that its Fourteenth and Fifteenth Amendment jurisprudence made clear that state actions that were racially neutral on their face were unconstitutional *"only if motivated by a discriminatory purpose"* (emphasis added).[6] In fact, however, and contrary to these claims, the Court had previously struck down facially neutral laws as violations of the Fourteenth and/or Fifteenth Amendments on findings that these acts had racially disparate *effects*.[7] Moreover, the Court had recently invalidated a multimember districting scheme (in *White v. Regester* [1973]) because it impermissibly diluted minority voting power. In light of this history, the insistence by the plurality on evidence of discriminatory intent was widely viewed as greatly increasing the burden of proof on litigants making vote dilution claims.[8]

The plurality not only demanded evidence of deliberate discrimination but also apparently established a new, much more stringent test for determining intent. Although the Court had previously endorsed a "totality of the circumstances" approach in *White v. Regester* (1973) and *Washington v. Davis* (1976) that permitted inference of discriminatory intent from indirect and circumstantial evidence, the plurality opinion in *Mobile v. Bolden* denied that pertinent facts—for example, that Mobile had never elected a black commissioner—provided circumstantial evidence that discriminatory motives were behind its maintenance of an at-large system.[9] This created the distinct im-

pression that only smoking-gun evidence of racial bias—an extremely high (and perhaps unattainable) standard of proof—would satisfy the plurality. As the *Washington Post* noted at the time, "In voting cases similar to Mobile's, [proof of intent] is especially difficult to find. Actions leading to the exclusion of minorities often occurred generations ago . . . and relevant documents and testimony may no longer exist."[10]

In an angry dissent, Justice White—who authored the majority opinions in *White v. Regester* and *Washington v. Davis* on which the plurality opinion in *Mobile v. Bolden* ostensibly rested—argued that the plurality opinion was disingenuous, cloaking its departure from previous doctrine with misleading appeals to precedent. As White charged,

> Without questioning the vitality of *White v. Regester* and our other decisions dealing with challenges to multimember districts by racial or ethnic groups, the Court today inexplicably rejects a similar holding based on meticulous factual findings and scrupulous application of the principles of these cases by both the District Court and the Court of Appeals. The Court's decision is flatly inconsistent with *White v. Regester*, and it cannot be understood to flow from our recognition, in *Washington v. Davis*, that the Equal Protection Clause forbids only purposeful discrimination.[11]

White's dissent pointed out other inconsistencies in the plurality opinion that seemed to signal important shifts in the voting rights jurisprudence of the Court. Whereas *White v. Regester* and *Washington v. Davis* had accorded considerable deference to assessments by lower courts of whether the facts warranted inference of discriminatory intent, the *Mobile v. Bolden* plurality decision did not.[12] The plurality opinion thus suggested that recent conservative appointees to the Court—condemnations of "judicial activism" by presidents Nixon and Ford notwithstanding—were comfortable concentrating power in the Supreme Court when it came to limiting the scope of federal voting rights enforcement. This apparent contradiction—which in fact represented the inevitable result of Republican efforts to circumscribe civil and voting rights enforcement via judicial appointments—only intensified in the ensuing decades.

Civil Rights Activism and the Enactment of the Voting Rights Act of 1982

Conservative influence in national politics reached new heights in 1980, with the election of the staunchly conservative Republican Ronald Reagan to the

presidency and the capture of the Senate by the GOP. Nonetheless, despite strong initial support from the president and many congressional Republicans for amendments that would have seriously weakened the VRA, these figures again acquiesced to a renewal that significantly strengthened the Act. Faced with an unprecedented mobilization by civil rights activists that threatened to pin the party with a reputation of indifference to minority voting rights, Republicans retreated from conservative legislative proposals to salvage their party's brand in time for the 1982 elections.

Conservative Threat and Civil Rights Mobilization

Mobile v. Bolden dealt a devastating blow to a civil rights movement already reeling from the political and legal setbacks of the 1970s. Indeed, in the months following the decision there was an "outpouring of legal commentary" that "demonstrated the concern of many civil rights advocates" with the implications of the ruling.[13]

The election of conservative Republican Ronald Reagan to the presidency in 1980 further shook the confidence of those who favored an expansive reading of federal voting rights protections. Reagan had vocally opposed the enactment of the VRA in 1965 and in subsequent years had repeatedly criticized the preclearance provisions of the Act for their alleged imposition on the "rights" of southern states. At a broader level, Reagan's 1980 campaign was widely perceived as catering to whites aggrieved by the recent advances enjoyed by African Americans—an assessment reinforced by Reagan's fulsome praise of "states' rights" at a campaign stop in Philadelphia, Mississippi, close to the site of the 1964 murder of voting rights activists James Chaney, Andrew Goodman, and Michael Schwerner.[14]

Fear among civil rights leaders that Reagan intended to weaken federal voting rights protections only intensified in the months following his election. When a delegation of activists obtained a private audience with Reagan in early December 1980, they "[took] issue with the President-elect on issues such as states' rights, minimum wage, public education, and voting rights."[15] Meanwhile, "the White House . . . avoided a public stand on the pending states' rights issue of greatest racial sensitivity—the renewal of the Voting Rights Act of 1965," the *New York Times* reported.[16] Reagan's caginess on voting rights matters did little to dispel the impression that the president sympathized with conservative calls—articulated most forcefully by arch-conservative Republican senator and incoming Judiciary Committee chairman Strom Thurmond—to restructure the Act. (Thurmond argued that Sec-

tion 5 should either be stricken from the Act or be extended to every state in the nation, and conservative activists demanded that Republican officials reaffirm the interpretation of Section 2 established in *Mobile v. Bolden* and make it easier for jurisdictions to "bail out" of preclearance coverage.)[17] Walter E. Fountroy, DC delegate to Congress and chairman of the Congressional Black Caucus, warned that "there are people who do not support the Voting Rights Act. . . . Those who oppose the Act are organizing Now to convince Congress to weaken the Act so it will be ineffective."[18]

The major civil rights organizations gathered at a series of meetings between January and March 1981 to chart a course for "defend[ing] the gains made in the civil rights field in the last two decades," as John Shattuck of the ACLU explained.[19] As LCCR executive director Ralph Neas described in a memorandum to participating organizations, the main priorities of civil rights organizations were to "retain Section 5"; "extend the bilingual provisions to 1992"; and "amend Section 2 with respect to standards of evidence for proof of voting discrimination" so that it clearly prohibited election practices with discriminatory effects (whether or not plaintiffs proved a discriminatory purpose).[20]

Civil rights leaders vowed, in Reverend Jesse Jackson's words, to "use whatever means necessary—litigation, agitation, confrontation, [or] cogitation" to shore up the VRA's major provisions.[21] Working under the aegis of the LCCR, activists organized "a coalition of 150 organizations representing civil rights, labor, church and civic groups" to "convince members of Congress that folks back in their home districts and states support an extension of the Voting Rights Act," as the NAACP Washington Bureau explained to its affiliates.[22]

This effort advanced on multiple fronts. As a first step, civil rights leaders attempted to head off conservative legislation by advancing a muscular voting rights bill in Congress. A legislative drafting committee comprised of prominent voting rights lawyers worked closely with sympathetic legislators to develop satisfactory legislative language. Their strategy was to exploit the Democrats' majority in the House, in which sympathetic members could employ their prerogatives in committee and on the floor to "establish clearly the need for extending the VRA," as Neas explained. Once favorable legislation was passed in the House—a virtual certainty given Democrats' commanding advantage in that chamber—civil rights activists and their Democratic allies would leverage this momentum to push the bill through the Republican-controlled Senate.[23] Democratic congressman Don Edwards of Califor-

nia (whose subcommittee enjoyed jurisdiction over the legislation) agreed to give civil rights organizations pride of place during legislative hearings in order to promote a strong evidentiary record that would bolster prospects for the renewal.[24] Edwards kept his promise: during seven weeks of committee hearings, which took place in the late spring and early summer of 1981, "dozens of witnesses testified that there was a need to retain the law in basically its present form [that is, according to its meaning prior to *Mobile v. Bolden*]," the *New York Times* reported.[25]

Meanwhile, civil rights organizations mobilized grassroots activists to pressure rank-and-file Democrats and Republicans to back the legislation. Beginning in April 1981, Jackson's Rainbow-PUSH Coalition, along with the Southern Christian Leadership Conference, organized a series of large marches in districts throughout the United States, culminating in a massive reenactment of the 1965 march from Selma to Montgomery.[26] At the same time, the NAACP encouraged local affiliates to start "grassroots 'feedback' projects to get people in your Congressional District and/or state to meet with, write or wire your Congressperson or Senator urging support for the Act's extension."[27] Other LCCR-affiliated civil rights organizations with local units, such as MALDEF, the National Urban League, and the League of Women Voters, organized parallel grassroots activities, fostering the establishment of "Save the VRA" coalitions in all 50 states and 435 congressional districts.[28]

Complementing the grassroots campaign was a major media blitz orchestrated by the LCCR, the NAACP, and labor unions such as the AFL-CIO and the UAW. Members of a media steering committee disseminated fact sheets, talking points, news clippings, and copies of testimony to print- and broadcast-media outlets to encourage favorable coverage of the campaign to renew the law, and they also worked to place sympathetic op-eds in prominent news sources. The pressure from civil rights organizations was intense, involving "daily ongoing communication between members of the Steering Committee and the press."[29]

Republican Backtracking from Proposals to Weaken the VRA in the House

By focusing public and especially media attention on the racial implications of the renewal, the "Save the VRA" campaign deterred public opposition to the reauthorization from coalescing among Republicans in the House. As Republican representatives were painfully aware, careful cultivation of public

and media interest by civil rights activists engendered a political context in which "any Republican who raises a question [about the VRA] look[s] like a racist," as one Hill aide explained.[30] Administration officials quickly came to the same conclusion. Republicans were hesitant to push for alterations to the Act, one memo warned, because they knew they would be "hotly attacked by the civil rights community as anti-minority."[31] "Everyone agrees that there is no way the Republicans can win on this issue," another memo concluded.[32] Rather than confront the Democrats on voting rights issues, as many GOP activists wanted, a substantial fraction of Republican elected officials—particularly the growing number in southern states—hoped to project a relatively positive position on minority voting rights to "avoid putting the GOP leaders in the position of appearing to be against blacks and other minorities that the party is trying to attract."[33]

These considerations help explain House Republicans' apparent lack of interest in a proposal floated by Illinois Republican Henry Hyde to significantly weaken Section 5 of the Act, despite the fact that Republican representatives were, on average, even more conservative on both economic and racial issues in 1981 than they had been in the 1970s (at least as measured by their roll-call voting behavior).[34] Describing the VRA as an "outrage" to the dignity of southern states, Hyde had called for the replacement of mandatory preclearance with a new procedure in which federal courts would have to redesignate jurisdictions for preclearance coverage based on findings of patterns or practices of discrimination in elections.[35] But with few Republicans willing to publicly support his proposal, the Illinois Republican abruptly abandoned the amendment, endorsing the renewal of preclearance, albeit with a provision to allow jurisdictions with histories of good behavior to "bail out" of coverage.[36]

Perhaps more importantly, intense pressure from the Save the VRA campaign appears to have dissuaded President Reagan from entering the fray, even though the president's campaign promises and previous public statements indicated that he preferred major alterations to the terms of the Act. Behind the scenes, the president's aides urged him to avoid taking a position on the VRA prior to completion of House deliberations.[37] The president could only lose politically by becoming involved, his advisors warned, because

> regardless of the intentions on how the issue should be phrased when presented to Congress in particular and the public in general, the issue will nonetheless be debated on the level of abridging and abusing someone's right to vote, rather than the administrative arguments that favor eliminating the

temporary provisions. . . . The issue is going to continue to be one of extreme sensitivity.[38]

In his subsequent actions, Reagan behaved in a manner that suggested he sought to avoid the impression of "abridging and abusing someone's right to vote." Rather than inject himself into House deliberations, the president avoided the controversy, directing Attorney General William French Smith to study whether the Voting Rights Act was "the most appropriate means of guaranteeing" the suffrage rights of racial and language minorities.[39]

Reagan's reticence left conservative critics of the VRA bereft of their most persuasive spokesman during the crucial period in which the legislation was being formulated and debated in the House. With the president on the sidelines, legislation embodying the main priorities of civil rights activists moved swiftly through Edwards's subcommittee and the full House Judiciary Committee and onto the House floor. There, bolstered by a massive LCCR-based lobbying campaign that "crowded the corridors" of House office buildings, the House turned aside a series of weakening amendments that would have limited the scope of the minority-language protections and made it much easier for covered jurisdictions to bail out of preclearance requirements.[40] Notably, support for each of these amendments (shown in table 3.1) was much greater among Republicans than among Democrats, pointing to the ever-growing gap between the parties on voting rights issues. Indeed, across five votes on weakening amendments, Republican support averaged 55 percent (with, on average, 48 percent of northern Republicans and 78 percent of southern Republicans voting in favor); Democratic support, however, averaged 8 percent (with an average of 3 percent of northern Democrats and 20 percent of southern Democrats voting in favor).

Following the defeat of each of these amendments, the House voted to pass the reauthorization of the VRA by a wide 389 to 24 margin. In the aftermath of the vote, Reagan aide Mel Bradley pointedly argued that "the 389 to 24 vote for the House Bill . . . suggests that except for a very few, *the majority of the elected representatives of both parties believe it to be politically wise to support the House Bill*" (emphasis added).[41] In fact, analysis of relevant roll-call votes reveals that a large fraction of Republicans (and a much smaller share of Democrats) voted to renew the VRA despite having previously supported failed amendments that would have significantly circumscribed the scope of the Act. For example, 47 percent of Republicans (and 10 percent of Democrats) voting "yea" or "nay" on both bills voted for passage of the VRA

TABLE 3.1. Support for Weakening Amendments in the House of Representatives, 1981

Roll call N	Amendment	% Rep. support (all)	% northern Rep. support	% southern Rep. support	% Dem. support (all)	% northern Dem. support	% southern Dem. support
223	Eliminate provision making signing of consent decree a bar to bailing out from coverage of Act if consent decree was signed within 10 years of petition to bail out	48	39	76	7	2	18
224	Permit bailout cases to be heard in federal district court in geographic jurisdiction rather than in District of Columbia	58	49	88	13	3	34
225	Allow covered state to bail out from coverage if 2/3 of counties are eligible to bail out	43	34	76	8	1	21
226	Eliminate provisions requiring certain areas of country to provide bilingual elections materials	63	58	80	7	3	14
227	Require certain areas of country to provide bilingual election materials but not bilingual ballots	61	58	70	7	6	10

source: "Democrat and Republican Party Voting Splits Congresses 35–113 (31 May 2015)," accessed July 18, 2016, available from VoteView.com, http://voteview.com/partycount.html.

despite previously voting to ease preclearance by allowing bailout proceedings to occur in local federal courts rather than in the US District Court for the District of Columbia. And of those voting "yea" or "nay" on both bills, 53 percent of Republicans (and 4 percent of Democrats) supported renewal of the VRA even though they had previously voted to eliminate rules requiring certain jurisdictions to provide bilingual election materials. Plus, 51 percent of Republicans (and 5 percent of Democrats) endorsed the reauthorization even though they had voted to end the requirement that certain jurisdictions provide bilingual ballots to non-English-speaking voters.[42] These patterns lend credence to Bradley's interpretation, suggesting that a significant proportion of representatives (especially Republicans) believed that it was politically desirable to project an image of support for minority voting rights when the proverbial cards were on the table.

Republican Abandonment of Conservative Proposals to Weaken the VRA in the Senate

The passage of the legislation in the House meant that "the [Republican-led] Senate was faced with an amended Voting Rights Act proposal that, *from the perspective of the conservative leadership of the Senate Judiciary Committee,* was far worse than anything anticipated" (emphasis added).[43] Given the tremendous momentum behind the House bill, it "seem[ed] likely that a similar measure [would] be passed by the Senate, and that there [would] ultimately be a House-Senate compromise on the final details" notwithstanding Republican control of the Senate, Reagan aide Elizabeth Dole explained to top advisor Richard Darman.[44] The apparent inevitability of Senate passage of liberal-friendly legislation was in no small part due to the unwillingness of Senate critics to appear publicly opposed to minority voting rights. Indeed, Mississippi Republican Trent Lott reported to President Reagan in early October 1981 that given the intensity of civil rights mobilization conservatives feared that "anyone who seeks to change [the House bill] in any respect will risk being branded as a racist."[45] Small wonder, then, that senators Edward Kennedy of Massachusetts and Charles Mathias of Maryland easily secured a filibuster-proof sixty-one cosponsors for a bill identical to that passed in the House.[46] Efforts to limit the scope of the Act via amendments ultimately received only modest support from senators. Notably, however, support across eight amendments eventually offered on the Senate floor was clearly stronger among Republicans (with an average of 37 percent voting favorably) than among Democrats (with an average of 10 percent voting in favor),

providing further reaffirmation of the growing partisan divide over voting rights.[47]

Under the circumstances, conservative Republican senators warned, only "active Presidential support" for a conservative alternative could forestall enactment of an expansive voting rights bill.[48] Thus, during the early months of 1982, administration officials—most notably CRD chief William Bradford Reynolds—gamely pressed for removal of the "discriminatory effects" language from Section 2 of the Senate bill. Reynolds argued that the language in question would inevitably lead to proportional representation by race, because proportionality was the only logical way to ensure that electoral arrangements did not generate racially disparate outcomes. Reynolds also warned that enactment of the House bill would result in "widespread restructuring by the federal courts of electoral procedures and systems at all levels of government . . . on no more than a finding that the election system is not designed to avoid disproportionate election results."[49]

Even as Reynolds pressed the administration's case, however, political aides renewed their warnings that the fight over Section 2 was tarring the president with a reputation for hostility to the fundamental rights of minority voters.[50] Reagan also heard from worried Republican officials who argued privately that the GOP was losing the public relations battle over the reauthorization.[51] In fact, a January 1982 survey indicated that 57 percent of Americans believed Reagan was doing an "only fair" or "poor" job of handling civil rights issues.[52]

Faced with the prospect of a major embarrassment to the party, which could have harmed GOP chances in the fall elections, the president appears to have made a strategic retreat from his opposition to the "discriminatory effects" language in the Senate bill. When a "compromise" amendment sponsored by Republican senator Robert Dole of Kansas received strong bipartisan support in the Senate in late April 1982, Reagan quickly gave his blessing to the deal, which aimed to clarify the proposed language of Section 2 with a statement that the provision did not mandate proportional representation. Following a desultory filibuster (crushed by an 86–8 cloture vote) by archconservative North Carolina senator Jesse Helms, the bill passed the Senate 85–5; a few days later, the House approved the Senate legislation by voice vote. Despite his previous opposition to many of its major provisions, the president lauded the reauthorization for preserving "the crown jewel of American liberties" and signed it into law in a Rose Garden ceremony on June 29, 1982.[53]

Enforcement of the VRA under Reagan and Bush

The 1982 renewal of the VRA was a milestone in the development of the Act. Section 5—long the *bête noire* of racial conservatives—was renewed for a twenty-five-year period, ensuring ongoing federal oversight of alterations to election rules in covered jurisdictions. The minority-language provisions, loathed by conservatives for their alleged adverse effects on national unity (and state and local administrative budgets), were extended until 1992, when they were again renewed until 2007.[54] Meanwhile, Section 2 was significantly enhanced by clearly permitting legal challenges to election arrangements with discriminatory effects. This was a legislative achievement with major consequences for subsequent voting rights enforcement: a comprehensive study of published Section 2 lawsuits between 1982 and 2005 found that of 331 complaints advanced by civil rights plaintiffs under the revised section, an impressive 123 (37.2 percent) obtained a favorable judicial ruling.[55]

Given Reagan's desire to weaken each of these features of the law, the 1982 reauthorization was a serious political defeat. Ultimately, this setback was attributable to the unwillingness of both the president and his Republican congressional allies to publicly position themselves, in the run-up to congressional elections, on the unpopular side of a prominent—and broadly participatory—legislative struggle over minority voting rights. As Senator Edward Kennedy later explained, in the end "the Republicans don't want to re-fight these battles on the floor of the United States Senate. . . . No one's for repealing the Voting Rights Act or the Fair Housing Act or the Employment Discrimination Act."[56]

But conservatives' ambition to limit federal involvement in protecting the voting rights of citizens of color did not abate in the aftermath of the 1982 struggle over the renewal of the Act. Administration officials sought to recoup their losses in the realm of bureaucratic politics, in which comparatively modest public attention, reduced traceability of political decisions, and limited public participation facilitated the advancement of conservative objectives at a lower risk of public backlash. Through appointments, changes in administrative procedures, and alterations in personnel management, Reagan imprinted a distinctly conservative stamp on enforcement of the Act that partly countered the progressive implications of the 1982 law. George H. W. Bush, Reagan's political successor, pursued similar ends, although by much subtler means.

Reagan's Administrative Presidency and
Federal Voting Rights Enforcement

President Reagan grudgingly endorsed renewal and expansion of the VRA in 1982. At the same time, however, "Justice Department officials . . . moved to control the politically sensitive civil rights division" in order to bring CRD activities into alignment with the conservative objectives of the administration.[57] Attorney General Smith selected William Bradford Reynolds, a former corporate lawyer, to lead the Division, a position Reynolds held until the waning days of Reagan's presidency. Reynolds was hired not because of his track record as a civil rights attorney—indeed, he "readily admitted that he had no background or experience in the field"—but rather because he was both a staunch Reagan loyalist and a tireless administrator and thus could be trusted to bring what was viewed by administration officials as a thoroughly liberal—and recalcitrant—Division to heel.[58] For his part, Reynolds relished the opportunity to imprint conservative values on federal voting rights enforcement. Believing that liberal approaches to racial issues were both profoundly misguided and politically ineffective, Reynolds aimed to rein in federal enforcement of civil rights protections when and where he could.[59]

Reynolds instituted major changes in CRD operations in order to imbue the Division with a more conservative cast. In Reynolds's view, Division staff attorneys were insufficiently loyal to the Reagan administration's conservative agenda. As he put it, "there are a lot here who, if left to their own devices, would do things differently than I would like to see them done." To address this perceived problem, Reynolds instituted a new system of centralized decision-making, which he described as "far more extensive" than was undertaken in previous administrations, that enabled him to closely monitor staff work and reverse decisions that did not accord with administration objectives.[60] Under this new system, "almost all the work of the career attorneys was reviewed by politically appointed special assistants or by Reynolds himself," with these figures having final say in implementation decisions.[61] To make this system feasible, Reynolds greatly expanded the number of Schedule C political appointments within the Division, filling these positions with Reagan loyalists and charging them with the day-to-day oversight of the careerists.

The new system of centralized decision-making had important implications for the tenor of voting rights enforcement during the Reagan era. Reynolds proved more than willing to countermand staff attorney decisions with

which he disagreed, resulting in a more lenient application of federal voting rights law. For example, in the realm of Section 5 administration, between 1981 and 1985 alone "there were at least thirty instances in which Reynolds overruled staff attorneys who urged him to object to a voting law change which they considered discriminatory," according to civil rights attorney Lani Guinier.[62] More generally, Reynolds's hands-on management inevitably decelerated the pace of Division work, with the result of hindering ongoing enforcement actions and discouraging new projects. Indeed, according to an important study of Division activities during the Reagan era, Reynolds's complete domination of decision-making ultimately led to "less arguing, less activism, and fewer initiatives by the careerists."[63]

Reynolds' restructuring of decision-making was reinforced by a confrontational approach to personnel management that gradually altered the Division so that it more closely resembled the administration. Through actions and statements intended to antagonize liberal attorneys, Reynolds and like-minded political appointees within the CRD made clear that dissidents were (in the words of a DOJ spokesperson) "welcome to leave" their jobs.[64] Indeed, confronted by an attorney who suggested that Reynolds's combative approach was rendering him "a general without an army," Reynolds replied, "If that happens, so be it. I'll get another army."[65] (In fact, Reynolds occasionally "hired non-civil service attorneys and authorized them to act independent of the normal Department structure" in order to accomplish administration goals, according to longtime staff attorney Brian Landsberg.)[66] Over time, Reynolds's caustic personal style and unpopular micromanagement of career staff led to a dramatic turnover in personnel: according to Drew Days III, a former Division chief, Reynolds's tenure was associated with "the departure of a host of able career lawyers who had found it possible, until Reagan left office, to work under Democratic and Republican Administrations alike." At least twenty-five career attorneys (or approximately one-seventh of all positions in the division) left CRD during the Reagan years in protest of the agency's rightward lurch on civil rights matters.[67]

Reynolds's forceful personal involvement in voting rights administration and combative interactions with career staff corresponded with important shifts in federal voting rights enforcement during Reagan's two terms in office. With Reynolds exercising tight control over the preclearance review process, CRD objections to proposed alterations in election rules as a proportion of all submissions from covered jurisdictions fell to a historic low be-

tween 1981 and 1988.[68] There is also evidence that CRD applied more lenient standards in some high-profile Section 5 cases during this period. A number of important post-1980-Census submissions precleared by CRD at Reynolds's insistence—including North Carolina's legislative reapportionment, Montgomery, Alabama's council apportionment, and Louisiana's congressional reapportionment—were later overturned by federal courts because they diluted minority voting strength and thereby violated Section 2 of the VRA.[69]

At the same time, the Division's litigation activity slowed to a crawl. While CRD duly continued suits held over from the Carter administration, it exhibited little energy in initiating new challenges to discriminatory voting arrangements. Between 1982 (when the new Section 2 language was approved) and 1985, the Division filed only ten new voting rights suits, even though private groups and individuals initiated scores of Section 2 complaints during this period.[70] At the same time, Reynolds "to an unprecedented degree . . . sided with covered jurisdictions in litigation aimed at enforcing the VRA," according to Frank Parker, longtime head of the Mississippi office of the Lawyers' Committee for Civil Rights Under Law.[71] In perhaps the most notable instance of this trend, Reynolds allied with the state of North Carolina in *Thornburg v. Gingles* (1986), an ultimately unsuccessful suit before the United States Supreme Court that sought to challenge the scope of Section 2 as amended during the 1982 reauthorization of the Act so as to permit the state to implement a redistricting scheme that effectively diluted the votes of the state's black voters.[72]

Through administrative maneuvers, Reynolds advanced many of the objectives that the Reagan administration had initially embraced during the 1982 debate over renewal of the VRA but ultimately abandoned out of fear of damage to the party's reputation. Given the administration's strong conservative preferences on voting rights issues, this pattern is highly suggestive of its strategic decision to divert to the administrative arena the controversial agenda that it was unwilling to champion too aggressively in the legislative process.

The Subtle Administrative Politics of George H. W. Bush

During his single term in office, George H. W. Bush seemed to adopt a more pragmatic stance on voting rights matters that in some respects harkened back to the approach embraced by Gerald Ford.[73] Seeking to avoid the high-profile struggles over voting rights that had created political embarrassment for his immediate predecessor, Bush directed his attorney general, Richard

Thornburgh, to pursue a less confrontational approach. As Thornburgh later explained,

> Brad Reynolds had been the head of the civil rights division under Meese and . . . created a horrible gulf between the administration and the civil rights community. I came out of a tradition [as former governor of Pennsylvania] that had always worked very closely with the civil rights community and I saw an opportunity to really build some bridges there that would have helped the administration.[74]

According to Thornburgh, this shift served both the administration's political interest in maintaining a positive civil rights image and (what Thornburgh viewed as) the principled commitment of President Bush to civil rights. As Thornburgh put it, "I want to lean over backward to present an *image* of an administration that is sensitive on civil rights and a *reality* of responsiveness to the civil rights community on its concerns without undercutting bedrock beliefs" (emphasis added).[75]

Thus, under Thornburgh's leadership, reporters noted, "the nation's chief law-enforcement agency, so recently Washington's locus of political plotting and conservative ferment, suddenly grew mouse-quiet. . . . One-time lightning-rod political appointees became model bureaucrats, or, more commonly, vanished altogether."[76] Bush's CRD chief, former New York lawyer John R. Dunne, was generally perceived by members of Congress as an "independent-minded public servant" who guided the CRD in an even-handed fashion.[77] And in fact, the voting rights enforcement activities of the Division became noticeably more vigorous under Dunne's tutelage. The Section 5 objection rate increased considerably between 1989 and 1992, and Division attorneys began the practice (unthinkable during the Reagan administration) of refusing preclearance in cases in which governing entities failed to enhance minority representation in their redistricting plans.[78] Additionally, the Division resumed its historic practice of advocating a broad reading of the Voting Rights Act in litigation before the Supreme Court. Thus, for example, in *Pressley v. Etowah County* (1992), in which a conservative Court ultimately ruled that changes in the budgetary authority of a county commission were not subject to preclearance, the Bush administration sided with the unsuccessful African American plaintiffs.[79]

But closer scrutiny reveals these measures as less impressive than they initially appear. Under the leadership of Thornburgh—whose interests and ex-

perience centered on criminal justice concerns—the Department's agenda drifted away from civil rights matters toward enforcement of federal crime, drug, and securities fraud statutes. As a result, the *New York Times* noted in early 1991, even as "the Justice Department has grown in manpower and budget," it has "lost its pre-eminence as the driving force for social change and the center of legal thinking in the Government."[80] It is also possible—even likely—that the Bush administration's apparent reinvigoration of voting rights enforcement was calibrated to advance the long-term electoral prospects of the Republican Party in southern states. Critics, including some conservative intellectuals who viewed majority-minority districting as a betrayal of the principle of "color blindness," charged that the Division pressured southern states engaged in redistricting after the 1990 Census to maximize black representation largely because Bush administration officials calculated that this would pack minority voters within a small number of safe districts and thereby enhance GOP chances in adjoining districts. Although Dunne dismissed the circumstances as "coincidental," this view was lent credence by the fact that federal voting rights enforcement in the Bush administration reinforced the Republican National Committee's transparent strategy of encouraging racialized redistricting in states in which the party expected to pick up seats.[81] Subsequent research indicates that racial redistricting in the early 1990s likely cost Democrats seats in Congress and state legislatures in southern states.[82]

To be fair, this struggle also exposed tensions within the Democratic coalition (which, of course, Republicans were happy to exploit). Many black Democrats in southern states desired descriptive representation by African American legislators. But the creation of majority-minority districts to accomplish this goal often rendered the election of moderate-to-conservative white Democrats—who had previously dominated southern politics—untenable.[83] In many cases, the creation of majority-minority districts rendered many adjacent districts both very white and very conservative and thus (especially given the leftward march of the national Democratic Party) particularly receptive to appeals by conservative white Republican candidates. Over the long run, majority-minority districting likely reinforced the rise of Republicanism in the South by eroding the biracial coalitions that had facilitated the election of white Democratic representatives in the 1970s and 1980s.[84]

On the whole, however, the Reagan-Bush years revealed Republican administration of federal voting rights law as the continuation of legislative

struggle by other means. Especially during Reynolds's tenure at CRD, political objectives that could not be achieved legislatively were advanced through administrative processes. For both presidents, however, Supreme Court appointments provided a more effective means for exercising conservative influence over federal voting rights enforcement while at the same time minimizing the political and electoral repercussions of racially charged decisions.

Conservative Judicial Appointees and the Diminution of the VRA

While Ronald Reagan ultimately endorsed reauthorization and expansion of the VRA, it seems fairly clear that this decision reflected a calculated effort to spare the administration and the GOP the blame for weakening the Act. Indeed, in legal-guidance documents and statements on constitutional matters, his administration envisioned a drastically reduced federal role in voting rights enforcement and advocated a new form of judicial activism that would protect state and local governments from "excessive" congressional efforts to promote civil rights. The evidence strongly suggests that Reagan pursued a judicial policy intended to enact this conservative vision via constitutional decisions and thereby check the expansive implications of the 1982 revisions to the Act. In a series of wide-ranging decisions, Reagan appointees (with an assist from George H. W. Bush appointee Clarence Thomas) substantially advanced this agenda, employing language and ideas incubated in Reagan's Department of Justice to justify its rulings.

Reagan's Constitutional Critique of the VRA and Republican Judicial Nominees

Reagan and his top aides—especially Edwin Meese, the "architect of the president's legal policy" who served as attorney general during Reagan's second term—expounded novel constitutional arguments that presumed a sharply circumscribed understanding of federal voting rights enforcement and set tight limits on the scope of congressional authority to protect minority voters.[85] In important legal documents prepared by the Department of Justice, they castigated the Court's vindication of the 1982 amendments to the VRA in *Thornburg v. Gingles*, portraying it as tantamount to a judicial mandate for proportional representation. In the administration's view, only instances of intentional discrimination in elections—and not decisions with discriminatory effects—should be actionable under Section 2 of the Act.[86] Reagan offi-

cials also maintained that the Court's entire line of Section 5 decisions since *Allen v. State Board of Elections* (1969) was inimical to the Constitution, because it "judicially transformed [the provision] from a guarantee that jurisdictions identified by Section 4 will not reinstate discriminatory barriers to minority *voting* into a guaranteed minimum floor for minority electoral success."[87] To prevent the VRA from becoming a vehicle for "affirmative action" in elections, administration officials argued, preclearance review should be limited to changes in rules that hindered voting (and not those that diluted minority political power).

More broadly, Reagan administration legal-guidance documents stridently criticized the deference of the post–New Deal Court to congressional assertions of power under the Fourteenth and Fifteenth Amendments to protect people of color. The administration contended that Congress had illegitimately transfigured "the authority to *enforce* the guarantees of these amendments into the power to *expand* the nature and breadth of these substantive guarantees."[88] This had upset the separation of powers and denigrated the traditional authority of state and local governments. In public speeches and law-review articles, Meese contended that the Court should serve as the "bulwark of a limited Constitution" by curbing congressional authority under the Reconstruction Amendments.[89]

For Reagan administration officials, appointing judges—especially Supreme Court justices—who shared their views on these matters was a top priority, as that was a principal means for "institutionaliz[ing] the Reagan revolution so it can't be set aside no matter what happens in future presidential elections," as Meese explained in a candid moment.[90] To this end, the president empowered Attorney General Smith—and, later, Meese—to institute a process for identifying and vetting conservative jurists for vacancies on the Court. Reagan's advisors established an elaborate, highly bureaucratized procedure for evaluating candidates, involving extensive review of each candidate's record and speeches and thorough in-person interviews, to ensure that nominees adhered to the constitutional vision of the president. Notably, William Bradford Reynolds—whose narrow view of federal voting rights enforcement was well known within the administration—oversaw the vetting of judicial candidates.[91] In the end, "the president's influence over the process was maximized by his Committee on Federal Judicial Selection—a group including the White House chief of staff, one or more presidential counselors, the president's assistant for legislative affairs, the attorney general, and a

handful of other Justice Department appointees—which centralized the final decision process."[92]

In light of the administration's clearly articulated positions on voting rights issues, Reagan's elevation of William H. Rehnquist to the chief justiceship following the retirement of Warren Burger in 1986 provides strong circumstantial evidence that the president intended to use judicial appointments to advance these views. As the 1971 hearings on his appointment to the Court had revealed, Rehnquist had overseen efforts to challenge voter credentials in predominantly minority precincts and may have personally participated in these activities during his career as an Arizona lawyer and Republican activist. Tellingly, Reagan administration officials minimized concerns about this aspect of Rehnquist's record, insisting that "there is nothing improper about a party seeking to prevent electoral fraud by monitoring the bona fides of potential voters."[93] Moreover, during his tenure as associate justice, Rehnquist had consistently exhibited a cramped view of the major provisions of the VRA: out of sixteen suits directly involving the Voting Rights Act between his appointment to the Court and his elevation to the chief justiceship, Rehnquist had cast a conservative vote in all but three cases.[94] Rehnquist's position on voting rights matters thus hewed quite closely to that of the administration.

Reagan's choice for the chief justiceship also shared the president's restricted view of the powers of Congress under the Reconstruction Amendments. In his dissenting opinion in *City of Rome v. United States* (1980), Rehnquist argued at length both that Congress enjoyed only the power to enforce but not define the terms of the Fourteenth and Fifteenth Amendments and that (in order to maintain a proper separation of powers) the Supreme Court had the obligation to strike down congressional actions that exceeded these stipulations as the Court interpreted them.[95] "In all areas of constitutional law . . . Rehnquist's jurisprudence has been scrupulously premised on the principles of federalism and separation of powers and he has resisted any attempt to engage in unwarranted judicial evisceration of traditional values or democratic choices through the invention of 'rights' discerned in 'penumbras' emanating from a 'living' Constitution," Reagan advisor Arthur Culvahouse approvingly concluded in a memo detailing the work of the prospective chief justice.[96]

Crucially, even though Rehnquist had already served on the Court for more than a decade, a large proportion of Americans remained poorly in-

formed about his record and paid only modest attention to his confirmation hearings. Around the time of Reagan's selection of Rehnquist for the chief justiceship, fully 66 percent of the public had no opinion on his nomination.[97] Even though the confirmation hearings were televised, a large fraction of the public (43 percent) reported not having followed them, and around the time of his confirmation between 30 and 37 percent still expressed no opinion of his nomination.[98] It thus seems very likely that a fairly large proportion of Americans had limited—if any—knowledge of Rehnquist's views on voting rights (and other) matters. Limited public knowledge meant that Rehnquist's nomination did, perhaps counterintuitively, represent an opportunity for the administration to advance racially conservative positions on voting rights matters without attracting excessive adverse attention from the public.

In short, Rehnquist represented the perfect choice to lead the Reagan administration's crusade to circumscribe the scope of the VRA and limit congressional authority to enforce the Reconstruction Amendments while at the same time deflecting criticism from the GOP. Rehnquist not only largely shared the narrow view of the VRA outlined in the administration's legal-guidance documents but also enjoyed a low public profile that would ease confirmation despite his conservative views on voting rights matters. Further circumstantial evidence that the Reagan administration selected Supreme Court justices at least in part with an eye toward judicial advancement of its conservative voting rights commitments can be found in the subsequent voting behavior of Reagan's appointees. Using the Supreme Court Database, it is possible to investigate the ideological tenor of voting by Reagan appointees on civil rights issues in general and voting rights issues in particular.[99] As table 3.2 shows, of Reagan's four appointees—Rehnquist, Sandra Day O'Connor (to replace Justice Potter Stewart), Antonin Scalia (to fill Rehnquist's vacated seat), and Anthony Kennedy (to replace Justice Lewis Powell)—all but O'Connor amassed records on civil and voting rights issues that were both very conservative in general and, in a rough sense, more conservative than the justices they replaced. Given the clarity of the administration's positions on voting rights matters and the intensity of its judicial screening process, it is difficult to view the almost uniformly conservative voting record of Reagan appointees on voting rights issues as anything but a reflection of administration strategy to advance its programmatic objectives by judicial means.

In the twelve years between Reagan's departure from the presidency and George W. Bush's victory in the contested 2000 presidential election, the con-

TABLE 3.2. Voting Behavior of Reagan Appointees on Civil and Voting Rights Cases

	Retiring justice	Reagan replace-ment	Retiring justice	Reagan replace-ment	Vacating justice	Reagan replace-ment	Retiring justice	Reagan replace-ment
	Burger	Rehnquist	Stewart	O'Connor	Rehnquist	Scalia	Powell	Kennedy
N of votes (all civil rights cases)	550	780	647	474	780	455	469	423
Proportion liberal votes	38%	26%	53%	42%	26%	29%	40%	40%
N of votes (voting rights cases)	21	38	20	25	38	23	20	22
Proportion liberal votes	67%	37%	50%	56%	37%	35%	55%	41%

SOURCE: Supreme Court Database, "Justice-Centered Data: Cases Organized by Supreme Court Citation," accessed July 21, 2016, available at http://scdb.wustl.edu/data.php.

servative bloc comprised of Reagan appointees—further emboldened by the elevation by George H. W. Bush of Clarence Thomas (arguably the Court's most conservative justice following his elevation)—achieved a revolution in the Court's voting rights jurisprudence.[100] In a series of sweeping decisions, this bloc constricted the federal government both in its authority to check discriminatory actions by state and local governments and in its capacity to expand representation for minority voters.[101] The Court's constitutional arguments on key voting rights questions—analyzed in detail below—echoed the positions established by the Reagan administration in its seminal legal-guidance documents, providing further indications of the linkages between the administration's programmatic objectives, its judicial appointments, and the Court's decisions.

In this way, judicial appointments allowed the Reagan administration to carry on its failed 1982 legislative campaign by judicial means while at the same time shielding the GOP from public censure for curtailments of minority voting rights. The Republican judicial legacy also blunted the impact of subsequent elections—which placed Democrats in control of the presidency—on the character of voting rights enforcement. Democratic president Bill Clinton, who served between 1993 and 2001, possessed a much more robust understanding of the authority of the federal government to protect mi-

nority voting rights and sought to use the enforcement powers of the De-partment of Justice to enhance minority influence in elections and expand officeholding by citizens of color.[102] Under the leadership of Deval Patrick—a former NAACP staff attorney and private civil rights lawyer—Division staff made voting rights enforcement a top priority.[103] Most notably, the Division attempted to exploit the preclearance process to require southern states to adopt majority-minority districts in their districting plans; and when conser-vative activists challenged these schemes in federal court, the Division law-yers joined legal efforts to defend them.[104] But the conservative Court ma-jority, which held a 5–4 advantage despite Clinton's two appointments to the Court (Justices Ruth Bader Ginsburg and Stephen Breyer), obstructed this policy through a series of rulings that progressively narrowed the authority of the Division in implementing preclearance.[105]

The "Wrongful Districting" Cases and the Court's Policing of Race-Based Representation

Following the 1982 amendments and the Supreme Court's decision in *Thorn-burg v. Gingles*, many states sought to comply with Section 2 (and, in covered states, Section 5, as interpreted by the DOJ under Bush and, especially, Clin-ton) by creating majority-minority districts in which nonwhites constituted electoral majorities and thus possessed opportunities to elect candidates of color to office.[106] Almost immediately, however, conservative white residents brought suit to challenge the constitutionality of these arrangements, spark-ing litigation that quickly made its way to the Supreme Court.

The controversy in *Shaw v. Reno* (1993)—the leading case in the Court's "wrongful districting" jurisprudence—arose from efforts by the state of North Carolina to construct two minority-opportunity districts following the 1990 Census in order to comply with DOJ requests. Initially, the state pro-posed to create only one such district, but the DOJ refused to preclear the proposal. The state legislature then drew a new plan featuring two majority-black districts (the 1st and 12th districts) with highly irregular boundaries. The ungainly district contours reflected the reality that establishing minority-opportunity districts often requires crossing traditional jurisdiction bound-aries—especially when legislators are also attempting to maximize parti-san advantage and protect incumbents at the same time. In the view of the conservative majority, however, the irregularity of these district bound-aries indicated that North Carolina was taking race too much into account in redistricting, at the expense of "traditional districting principles" such as

contiguity, compactness, and the preservation of traditional communities of interest. As Justice O'Connor explained for the majority

> Reapportionment is one area in which appearances do matter. A reapportionment plan that includes in one district individuals who belong to the same race, but who are otherwise widely separated by geographical and political boundaries, and who may have little in common with one another but the color of their skin, bears an uncomfortable resemblance to political apartheid.[107]

This, the conservative majority argued, threatened to reinforce negative racial stereotypes, exacerbate racially polarized voting, and heighten feelings that government was unresponsive to the needs of citizens.[108] The potential for this "expressive" injury, which was discovered for the first time in *Shaw*, created standing to sue under the Equal Protection Clause of the Fourteenth Amendment for opponents of noncompact majority-minority districts.[109]

With *Shaw*, the Court's conservative members profoundly altered the politics of redistricting, recasting it in the mold envisioned by Reagan and his supporters. The elaboration of standing doctrine under the Fourteenth Amendment to incorporate novel claims based on "expressive injuries" provided a powerful legal mechanism for aggrieved whites—backed by well-financed conservative legal foundations—to check the putative "affirmative action" in the electoral process that Reagan administration officials had so maligned.[110]

Indeed, the *New York Times* reported that, as soon as the opinion of the Court was announced, conservative voters and well-funded legal advocacy organizations began planning how to "challenge electoral districts from North Carolina to California, from hospital boards to Congressional seats."[111] A major player in this movement—indeed, arguably *the* primary force behind the legal challenges—was Edward Blum, a stockbroker and frustrated congressional candidate who recruited top conservative lawyers with prior service in Republican presidential administrations to bring the suits.[112] The central role played by conservative attorneys seasoned in previous Republican administrations in challenging majority-minority districts pointed directly to Republicans' strategy of diverting to the federal courts the politically treacherous task of eroding federal voting rights protections.

In the wake of *Shaw*, Clinton's CRD created a special *Shaw v. Reno* task force to "defend[] racially fair redistricting plans against unjustified claims that they are unconstitutional 'racial gerrymanders.'"[113] But these efforts

proved unable to prevent further conservative challenges to majority-minority districts from reaching a sympathetic Supreme Court. *Miller v. Johnson* (1995), another of the leading cases to reach the Court, severely circumscribed states' authority to create majority-minority districts as a means for satisfying obligations under Section 5 of the VRA and the Fifteenth Amendment. In *Miller*, the majority opinion, written by Justice Kennedy, struck down a Georgia redistricting plan featuring three majority-minority districts created by the state in order to receive federal preclearance for its redistricting following the 1990 Census.[114] While *Miller* followed *Shaw* by arguing that majority-minority districting imposed expressive harms on white district residents, the decision made it even easier for aggrieved whites to challenge majority-minority districts on Equal Protection grounds by downgrading the emphasis on district appearance that provided the primary rationale for the earlier ruling.[115] Instead, according to *Miller, whenever* race was the "predominant factor" in redistricting—trumping other "traditional race-neutral districting principles [such as] compactness, contiguity, and respect for political subdivisions or communities"—the resulting districts were to be reviewed by the Court with the highest degree of scrutiny.[116] *Miller* thus extended the scope of Equal Protection claims to a much greater number of majority-minority districts than those contemplated in *Shaw*, further expanding opportunities for conservative legal organizations to challenge gains in the descriptive representation of racial minorities in government.[117]

Beyond its immediate implications for the politics of redistricting, the decision further advanced the objective of the Reagan administration to judicially limit the authority of the political branches of the federal government to remedy racial inequalities. First, *Miller* directly challenged the prerogatives of the DOJ and President Clinton in implementing Section 5 of the VRA. The majority opinion harshly criticized Attorney General Janet Reno and CRD chief Deval Patrick for "accept[ing] nothing less than abject surrender" to the agenda of maximizing descriptive representation of African Americans.[118] To the conservative justices, the DOJ's actions were "not required by the Act under a correct reading of the statute"; consequently, Georgia could not sustain its redistricting by claiming it was necessary to comply with federal law. More pointedly, the conservative bloc maintained, it was "inappropriate for a court . . . to accord deference to the Justice Department's interpretation of the Act." Instead, the Court was obliged to make an independent assessment of whether the Department's interpretation of the statute was "correct." By serv-

ing notice that the conservative justices would not countenance a broad read-
ing of the VRA by the Justice Department to promote minority officeholding,
Miller circumscribed the authority of the president to implement the VRA
in order to remedy the persistent descriptive underrepresentation of African
American voters.[119]

Although the conservative justices portrayed *Miller* as an effort to rein in
a runaway Department of Justice, the decision also struck directly at the au-
thority of Congress to authorize and oversee administrative remedies under
the VRA and the Fifteenth Amendment. The majority opinion argued that
absent explicit congressional authorization for majority-minority redistrict-
ing, the actions of the Department of Justice were clearly inconsistent with
the terms of the Act.[120] But the conservative justices went even further, inti-
mating that if Congress *had* intended to authorize race-based redistricting
under the VRA, the Act might run afoul of the Fourteenth Amendment. As
the majority opinion warned,

> The Justice Department's implicit command that States engage in presump-
> tively unconstitutional race-based districting brings the Act, once upheld
> as a proper exercise of Congress's authority under Section 2 of the Fifteenth
> Amendment, into tension with the Fourteenth Amendment. . . . Congress's
> exercise of its Fifteenth Amendment authority even when otherwise proper
> must still consist with the letter and spirit of the constitution [internal cita-
> tions omitted].[121]

Because (in the view of the conservative justices) Congress had not intended
to authorize race-based redistricting, it was unnecessary at the time to ad-
dress the "troubling and difficult constitutional questions" of whether Con-
gress had the authority to do so.[122] Politically, however, this was a shot across
the bow, warning elected representatives that the conservative justices would,
as Reagan had hoped, closely police the scope of congressional authority un-
der the Fifteenth Amendment.

Clinton administration spokespersons sharply criticized *Miller* as "a set-
back in the struggle to ensure that all Americans participate fully in the elec-
toral process" and vowed that they remained "firmly committed to full en-
forcement of the Voting Rights Act."[123] Nonetheless, by the late 1990s, "court
challenges to minority districts [were] shifting the odds for blacks," the *Wash-
ington Post* reported.[124] Most frequently, the opinions of the Court—usually
in 5–4 votes pitting the conservative majority against its liberal members—

served to curtail majority-minority districting and check the powers of the DOJ to implement federal voting rights law in ways that benefited minority candidates. It struck down congressional redistricting schemes featuring majority-minority districts in North Carolina (*Shaw v. Hunt* [1996]) and Texas (*Bush v. Vera* [1996]) and, in *Abrams v. Johnson* (1997), upheld a court-ordered congressional districting plan for the state of Georgia that provided for only a single majority-minority district (down from three contained in the state's 1982 apportionment plan). These rulings encouraged lower federal courts— on which Reagan and Bush appointees were heavily represented—to void a large number of other majority-minority districts contained in state and local redistricting plans. The Court often summarily affirmed these decisions on appeal.[125]

To be sure, not all of the "wrongful districting" decisions completely prohibited the consideration of race in redistricting. In *Easley v. Cromartie* (2001), for example, a majority upheld a revised majority-minority district in North Carolina, although on the grounds that the district was created primarily for partisan, rather than racial, reasons.[126] Setting aside the details of specific cases, however, *Shaw* and its progeny revealed a conservative Supreme Court majority intent on curbing, if not eliminating, the consideration of race in redistricting. This directly advanced the conservative objective (voiced repeatedly during the debate over the 1982 amendments to Section 2 of the VRA and attested to in subsequent Reagan administration publications) of restricting group-based—and, especially, racially proportional—voting power in American electoral politics. Moreover, because the policing of racial redistricting by the conservative justices necessarily entailed imposing constraints on the powers of the president and Congress to assist minority voters, they further advanced the Reagan administration's vision of a "limited Constitution" in which the authority of the elected branches to remediate racial inequalities was held in close check by the Supreme Court.

The Bossier Cases and the Narrowing of Section 5

In a pair of decisions, *Reno v. Bossier Parish I* (1997) and *Reno v. Bossier Parish II* (2000), that related to the redistricting of the Bossier Parish school district in Louisiana, the Court accelerated the ascendance of the Reagan voting rights agenda by narrowly construing the scope of Section 5 to the extent that it required preclearance of intentionally discriminatory adjustments to election rules and regulations so long as these were not also retrogressive. The circumstances of *Bossier I* arose from the refusal of the Clinton administra-

tion Civil Rights Division to preclear a redistricting plan proposed by Bossier Parish Schools. Bossier Parish had a long and sad history of discrimination against its African American citizens, which extended to their lack of representation on local government bodies. Although 20 percent of the parish's residents were African American, no people of color had ever been elected to serve on the parish school board prior to 1995. Notably, the parish declined in its 1990 redistricting plan to create any majority-black districts.[127] The DOJ charged that the redistricting plan was objectionable because its failure to include two majority-minority districts effectively diluted the *potential* voting power of African American residents. The objection by the Department to the parish plan raised the legal question of whether the DOJ could make vote dilution—a violation of Section 2 of the VRA as amended in 1982—the basis for denial of preclearance under Section 5.[128]

A majority of the Supreme Court—comprised of the conservative majority of O'Connor, Rehnquist, Kennedy, Scalia, and Thomas, along with Clinton appointees Ginsburg and Breyer—ruled that it could not. In the view of the majority, a contrary decision would contravene the Court's holding in *Beer* that "a plan has an impermissible 'effect' under Section 5" *only* if it would "lead to a retrogression in the position of racial minorities" relative to their condition under the previous electoral scheme, *not* if it would merely dilute their voting strength compared to some hypothetical arrangement.[129]

In reaching this decision, the majority adopted a reading of *Beer* and the relevant legislative history that resonated with the narrow understanding of Section 5 advocated by the Reagan administration.[130] Although the majority argued that the reasoning of *Beer* compelled the decision in *Bossier I*, in fact the situation was far murkier. At the time *Beer* was decided, prevailing Court doctrine (evinced in *White v. Regester*) held that "unconstitutional" voting practices—then understood as actions with discriminatory effects—should not be precleared. But with *Washington v. Davis* and *Mobile v. Bolden*, the Court shifted position on what constituted unconstitutional racial bias, holding that only intentionally discriminatory decisions were impermissible from a constitutional standpoint. In response, Congress changed the *statutory* definition of discrimination under the VRA to vote dilution during the 1982 renewal. They did this in order to limit the impact of *Mobile* on litigation under Section 2 of the Act that challenged voting arrangements with discriminatory consequences.[131]

These developments, which transpired after *Beer* was handed down, cre-

ated a situation in which the constitutional definition of impermissible dis-
crimination (intentional racial bias) differed from the statutory definition
(decisions with racially disparate effects, regardless of intent). Because these
circumstances were not anticipated at the time of *Beer*, they made *Beer's* ap-
plication to the facts of *Bossier I* far from straightforward.[132] The majority
sought to avoid these complexities with the following argument: "Given our
longstanding interpretation of Section 5, which Congress has declined to alter
by amending the language of Section 5, *we believe Congress has made it suffi-
ciently clear that a violation of Section 2 is not grounds in and of itself for deny-
ing preclearance under Section 5*" (emphasis added).[133] In point of fact, how-
ever, the legislative history provided indications that members of Congress
may indeed have intended to make Section 2 violations grounds for denial
of preclearance. The Senate report on the legislation declared that "in light
of the [1982] amendment to section 2, it is intended that a section 5 objection
also follow if a new voting procedure itself so discriminates as to violate sec-
tion 2"; the House report contained analogous language.[134]

Only by finessing the interpretive challenges surrounding *Beer* and down-
playing contrary historical evidence could the majority reach its decision,
which had the consequence of advancing the narrow view of preclearance
long advocated by Reagan conservatives. Along the way, the decision accorded
limited deference to the congressional record and thus further accelerated the
Reagan/Bush constitutional vision by elevating the authority of the Court
over voting rights policy at the expense of that of Congress.[135] As might be ex-
pected, conservative legal activists were elated. Michael Carvin, a former as-
sistant attorney general for civil rights who served under William Bradford
Reynolds during the Reagan administration and managed the plaintiffs' suit
in *Bossier I*, delightedly concluded that the decision would terminate federal
efforts "to engage in affirmative action on behalf of minority voters."[136]

Bossier I had left open the question of whether adoption of arrangements
resulting in the dilution of minority voting strength provided circumstantial
evidence of objectionable intentional discrimination on the part of Bossier
Parish officials, setting the stage for further litigation and Court review.[137]
But the conservative justices framed the issue in a manner that departed from
past precedent and signaled their ambition to further restrict the scope of
Section 5. They proposed the novel theory that preclearance could be denied
on discriminatory purpose grounds only if the racist intentions of Bossier
Parish officials were also *retrogressive* (that is, intending to make racial mi-

norities even worse off than under present arrangements).[138] Since a retrogressive purpose was a much more stringent standard than a mere discriminatory one, adoption of this new theory by a majority of the Court would have rendered it even more difficult for federal officials to establish a basis for denying preclearance on purpose grounds.

The conservative justices adopted the "retrogressive intent" standard as the authoritative statutory construction in *Bossier II*. The crux of the majority opinion was that since the Court had already determined in *Beer* that evidence of retrogressive consequences was required for denial of preclearance based on the expected racial *effects* of proposed election rules, evidence of retrogressive intentions must also be required to justify denial of preclearance on the grounds of the suspected racial *purposes* of the officials proposing the changes. Otherwise, interpretation of the two prongs of the test for denying preclearance (that a proposed electoral scheme "must not have the *purpose* and will not have the *effect* of denying or abridging the right to vote on account of race or color") would entail application of different standards to each prong.[139]

The reasoning of the conservative justices seems compelling at first blush. But it actually departed in important respects from rulings—most notably, in *City of Richmond v. United States* (1975)—issued by more liberal Courts that embraced a much broader understanding of discriminatory purposes in the context of preclearance determinations and thereby enabled a more expansive application of Section 5.[140] The majority opinion distinguished *City of Richmond* on the basis that the focus of that case on annexations made its holding less applicable to the facts of *Bossier II*. But the majority opinion in *City of Richmond* had explicitly stated that the principles it announced were to have broad applicability beyond annexation cases. As the opinion had pronounced, "An official action, *whether an annexation or otherwise*, taken for the purpose of discriminating against Negroes on account of their race has no legitimacy at all under our Constitution or under the [VRA]. Section 5 forbids voting changes taken with the purpose of denying the vote on the grounds of race or color" (emphasis added).[141] Furthermore, the Court had subsequently reaffirmed this principle, most importantly in *City of Pleasant Grove v. United States* (1987).[142] These decisions seemed to make clear that *any* discriminatory purposes—not just retrogressive ones—violated Section 5. The Court's sidestepping—without overruling—of these important precedents to reach a decision that substantially narrowed Section 5 provided a powerful illustration

of the impact of Reagan/Bush appointees on the tenor of the Court's voting rights jurisprudence.

Indeed, *Bossier II* dealt a severe setback to the preclearance regime. As the *New York Times* reported, the DOJ was henceforth required to "approve districting changes, even those adopted with a discriminatory purpose, as long as the changes left minority voters in no worse a position than before."[143] Moreover, by requiring retrogressive intent, the majority effectively rendered the effects prong of Section 5 redundant, because only "incompetent retrogressors" would attempt—but fail—to implement electoral changes that had the effect of retrogressing minority voting strength.[144] As a practical matter, the decision contributed to the precipitous decline in the rate of objections to proposed voting changes in the 2000s.[145]

Boerne v. Flores *and the Prospect of* Increased Judicial Scrutiny *of Section 5*

These conservative voting rights decisions were reinforced by broader doctrinal shifts limiting congressional authority under the Reconstruction Amendments, as heralded in *Boerne v. Flores* (1997). Ostensibly, *Boerne* was a religious freedom case, addressing the scope of congressional authority under the Fourteenth Amendment to protect religious liberties against incidental infringement by state or local government actions. The constitutional question was whether Congress, in enacting the Religious Freedom Restoration Act (RFRA) of 1993, exceeded its authority by adopting statutory language that expanded the meaning of the Fourteenth Amendment beyond that interpreted by the Supreme Court and in ways that imposed on traditional state and local prerogatives. Most progressives, along with the Clinton administration, pushed for an expansive understanding of congressional authority under the Fourteenth Amendment, arguing that "Congress has the authority to encompass fundamental rights with an additional statutory layer of protection."[146] But the majority opinion (written by Justice Kennedy and joined by Chief Justice Rehnquist, Justice Stevens, Justice Scalia, Justice Thomas, and Justice Ginsburg) held that it did not, because "[Congress] has been given the power 'to enforce,' not the power to determine what constitutes a constitutional violation."[147]

Although the immediate effect of the decision was to invalidate the RFRA, astute observers recognized that the decision had potentially devastating implications for Section 5 of the VRA.[148] The reason was the new test established in *Boerne* for determining whether an application of congressional enforce-

ment authority was constitutionally valid, which effectively constitutional-
ized the conservative opinion (often voiced by Reagan administration offi-
cials) that there should be strict limits on the authority of Congress under
the Reconstruction Amendments. In *Boerne*, the majority held that Congress
must produce a strong evidentiary record of intentional discrimination in
order to justify enforcement actions that burdened states and localities and
also must demonstrate that imposed burdens were congruent and propor-
tional to the extent of the violations.[149] Given the profound skepticism toward
the VRA exhibited by the conservative justices, it was doubtful whether they
would continue to view Section 5 as a "congruent and proportional" remedy
to the suppression and dilution of voting by racial minorities and other vul-
nerable groups.[150]

Conclusion

After the 1982 extension of the VRA was signed into law, civil rights activists
celebrated. But their enthusiasm was tempered by an acute awareness that the
powers to interpret and enforce the major provisions of the Act were in the
hands of those who had long opposed the progressive vision of federal voting
rights enforcement. Jesse Jackson used pungent language to describe the feel-
ings of many civil rights activists: "We're glad, we celebrate the extension of
the Voting Rights Act, but if it is extended and not enforced, it is merely an
Indian treaty."[151]

There is no question that the 1982 renewal marked an important chap-
ter in the development of the VRA. The 1982 amendments ensured that the
preclearance and minority-language provisions would remain in effect, and
they strengthened the language of Section 2 to enhance the ability of civil
rights plaintiffs to challenge electoral practices that diluted minority voting
strength. Over the long run, the reauthorization contributed directly to an in-
crease in successful challenges to dilutive voting practices as well as to an ex-
pansion of officeholding by citizens of color. The substantial increase in mi-
nority officeholding likely stimulated greater political participation on the
part of at least some African American and Latino voters.[152]

By 2000, however, it was clear that recent events had justified the concerns
raised by Jackson. Conservative control of the implementation and interpre-
tation of the VRA not only prevented the law from achieving its full poten-
tial but also gradually undermined the political and constitutional founda-

tions of the Act. Largely beneath the political radar, both Reagan and Bush used administrative maneuvers and appointments to the Supreme Court to refashion the VRA so that it was a shadow of the statute Reagan had ostensibly endorsed. In the end, administrative practices and appointments served as effective subterranean means for eroding the substance of decisions made in more transparent and participatory venues. This sub rosa strategy was of great political consequence, because it enabled Republican elected officials to advance controversial racial purposes without facing direct electoral accountability for their actions. Indeed, the conservative legacy substantially outlasted the Republican administrations that brought it into being, constraining federal voting rights enforcement by a substantially more liberal Democratic president during the 1990s.

At the end of the twentieth century, pundits and reporters indicated that the VRA was "on the endangered list."[153] The ascendance of conservative Republican George W. Bush to the presidency along with tightened Republican control of Congress after the contested 2000 election thus raised urgent questions about the future of federal voting rights enforcement. How would the VRA weather the ascendance of Republican conservatism in the federal government? Would primary responsibility for establishing the parameters of federal voting rights enforcement remain in the hands of elected officials, especially those in Congress? Or had their authority been eclipsed by that of the conservative majority on the Supreme Court?

4 Voting Rights Politics in an Era of Conservative Ascendance, 2001–2013

T HIS IS A GRAND DAY OF CELEBRATION AND TRIUMPH FOR ALL Americans, not just minorities," declared Wade Henderson, executive director of the Leadership Conference on Civil Rights, on July 27, 2006.[1] Henderson was describing President George W. Bush's endorsement of the Fannie Lou Hamer, Rosa Parks, and Coretta Scott King Voting Rights Reauthorization and Amendments Act of 2006 in a major ceremony on the South Lawn of the White House. Surrounded by civil rights leaders such as Julian Bond of the NAACP, the Reverend Jesse Jackson of the Rainbow-PUSH Coalition, and the Reverend Al Sharpton, Bush signed the bill into law with great fanfare while promising (in his words) "to continue to build on the legal equality won by the civil rights movement to help ensure that every person enjoys the opportunity that this great land of liberty offers."[2]

Henderson appeared to have considerable cause to celebrate. The 2006 reauthorization renewed the provisions of the Act pertaining to preclearance, minority language assistance, and election monitors for twenty-five years, until 2031, and contravened several conservative Supreme Court decisions that had eroded the legal authority of the Department of Justice to protect the voting rights of citizens of color. At first blush, the reauthorization also seemed to reaffirm the predominant influence of the major civil rights organizations in the politics of voting rights policy making. Civil rights activists put enormous organizational resources into lobbying on behalf of the renewal, and they overcame significant resistance in the Republican-controlled House and

Senate to achieve their major policy objectives. On its face, then, the reauthorization was a civil rights achievement of historic proportions.

Considered in light of broader developments in federal voting rights policy making during Bush's tenure in office, however, the renewal represented a far more ambiguous victory. Although the text of the renewed statute presumed energetic federal enforcement, administrative will and capacity to accomplish this objective had been steadily declining for some time. Between 2001 and 2008 the Division was seriously weakened by budget cuts and the departure of dozens of experienced career attorneys, which corroded the capacity of the agency to administer the provisions of the law. Behind the scenes, the Bush administration politicized Division operations to an unprecedented degree, authorizing political appointees to bend both hiring and enforcement activities to advance the interests of the Republican Party. With the competence and integrity of the Division in doubt, many Democrats and civil rights activists questioned whether the CRD possessed the wherewithal to enforce the statute in a vigorous fashion.[3]

Changes in the attitude of the Supreme Court toward voting rights matters—again a result of deliberate administration strategy—reinforced these developments. The appointment by President Bush of two very conservative justices—John Roberts, as chief justice, and Samuel Alito, as associate justice—all but ensured that the Court would travel further down the conservative road it had traversed since the presidency of Richard Nixon. The selection of Roberts was especially troubling, because documents disclosed during Roberts's confirmation hearings indicated that the prospective chief justice held a very narrow view of the scope of the VRA.[4]

By the end of 2013, these developments in the administrative and judicial arenas overwhelmed the expansive tendencies of the 2006 reauthorization. The political upheaval at the CRD sharply divided the Division on ideological lines and undermined its ability to complete its business in a professional manner.[5] More consequentially, the Roberts Court moved expeditiously to limit the authority of the federal government to protect minority voting rights. In *Shelby County v. Holder*, issued on June 26, 2013, the conservative majority struck down the coverage formula determining which jurisdictions must submit proposed changes to voting rules or elections systems to the Department of Justice (DOJ) or the federal courts for preclearance.[6] The decision effectively dismantled the preclearance regime, freeing previously covered jurisdictions to implement new voting rules and regulations without prior federal approval. In the aftermath of the ruling, states previously covered by Sec-

tion 4 swiftly adopted restrictive new election laws that seemed consciously designed to make voting more difficult for young, poor, and nonwhite voters.

The evisceration of the preclearance regime by the conservative justices finally brought to fruition a political project that many Republican and white southern Democratic elected officials had advocated since the early days of the Nixon administration. The means by which this occurred likewise reflected a vintage Republican strategy calibrated to circumscribe federal voting rights enforcement while at the same time obscuring the culpability of Republican elected officials for this development.

In the legislative arena, Republican critics of the VRA continued their strategy of acquiescing to expansive renewals of the Act in order to maintain the electorally valuable façade of party support for vigorous federal enforcement of minority voting rights. Even though many Republicans clearly wanted to impose serious limits on the scope of federal voting rights enforcement, their overriding desire to avoid a public clash over the right to vote in an election year ultimately drove them to yield to a reauthorization that many within the party abhorred. At the same time, however, Republican critics of vigorous federal enforcement again leveraged compensating advantages in the relatively low-profile domains of administrative politics and judicial appointments to curtail the expansive features of the Act. The deliberate enervation of the CRD by Bush administration officials transpired largely out of public view, coming to light only after the most serious damage had been done. By that point, the president no longer faced reelection, allowing him to escape democratic accountability for the enfeeblement of federal voting rights enforcement. Meanwhile, appointments to the Supreme Court once again provided a means to advance views that had been thoroughly repudiated in the legislative arena. Insulated by life-tenure appointments, conservative Republican appointees to the Court imposed decisions limiting the scope of the VRA that could have never survived open contestation in the legislative process. The vocal celebration by prominent congressional Republicans of the *Shelby County* decision, which undid legislative work for which they had previously voted, pointed directly to the party's strategic delegation to the Court of the unpopular business of weakening federal voting rights safeguards.

The Politicization of the Civil Rights Division

"We must actively and vigorously enforce the laws that protect the voting rights of ethnic and racial minorities, of citizens who do not speak English

fluently, and of the elderly and persons with disabilities," President George W. Bush announced during a July 31, 2001, ceremony in the White House Rose Garden celebrating his receipt of the final report of the National Commission on Federal Election Reform, a panel charged with proposing improvements to the nation's ramshackle election-administration system.[7] Speaking just months after the disputed 2000 election—the results of which were sullied by the widespread discard of African American and Latino ballots—Bush was keen to rebrand himself as a staunch defender of voting rights.[8] In public statements, Bush advocated robust efforts to reform American elections, supporting the Help America Vote Act of 2002, which set minimum federal standards designed to forestall disputes over the counting of ballots in future elections.[9] Behind the scenes, however, Bush and his close advisors quietly and deliberately implemented major changes that eroded the will and capacity of the Civil Rights Division to defend the voting rights of people of color and of minority-language citizens. These decisions undermined the competence of the Division to accomplish the lofty objectives Bush trumpeted in his public pronouncements.

The Infusion of Conservative Ideologues within the Justice Department

Through his appointments to leadership positions within the CRD, Bush sought to remake the Division in his conservative image. This entailed adoption of an extreme version of the administrative politics practiced by the Reagan administration. This initiative began at the top, with the appointment or promotion of figures with very conservative views on voting rights matters. Attorney General John Ashcroft—who, along with other Missouri Republicans, blamed his defeat in the 2000 Missouri Senate race on alleged voter fraud by Democratic operatives—set the tone for the administration's approach to voting rights enforcement.[10] Ashcroft signaled this rightward shift in October 2002, with the announcement of his Voting Access and Integrity Initiative, which required all US attorneys' offices to coordinate with local officials in combatting voter fraud, an issue that was becoming an ever more prominent concern among Republican Party officials and operatives despite a dearth of hard evidence pointing to fraud as a problem. (Indeed, the Department of Justice's own extensive investigation, concluded in 2007, yielded scant evidence of voter fraud by impersonation).[11] The scheme departed from the traditional voting rights enforcement paradigm employed by the Depart-

ment by elevating deterrence of voter fraud to the same, if not a greater, level of importance as prevention of racial discrimination against minority voters. As Ashcroft put it, "The strength of our democracy demands that we fulfill the rights of *both* ballot access and ballot integrity—to guarantee every citizen, in accordance with the law, the right to vote, and to every voter the right to be counted" (emphasis added).[12] As civil rights activists presciently cautioned at the time, however, Ashcroft's plan raised fears that "overly aggressive 'voting integrity' efforts, instead of reducing fraud, tend to intimidate lawful voters and ultimately suppress voter turnout."[13]

Civil rights activists had every reason for trepidation: if the appointment of Ashcroft as attorney general raised concerns, some of the figures elevated to leadership positions within the Civil Rights Division were even more problematic. An especially dubious appointee was Deputy Assistant Attorney General Bradley Schlozman, who served as acting head of the Division for much of Bush's tenure in office. A self-proclaimed protégé of William Bradford Reynolds, Schlozman had no experience in the field of civil rights law but was familiar in political circles as a hard-charging Republican loyalist.[14] Another administration favorite was Hans von Spakovsky, a former litigator and insurance-industry lawyer, who was tapped to serve as legal counsel for Assistant Attorney General for Civil Rights R. Alexander Acosta but acted as de facto chief of the Voting Section during Bush's first term in office.[15] Prior to his stint within the Justice Department, von Spakovsky had distinguished himself primarily as a vocal advocate of stringent voter identification requirements to (in his own words) "prevent imposters from voting."[16] In addition to embracing Ashcroft's crusade against alleged voter fraud, Schlozman and von Spakovsky were united in the conviction that "the Voting Rights Act needs to be applied in a race-neutral manner" rather than "as a way of helping only minority voters, and in particular, helping one political party," as von Spakovsky put it.[17] To say the least, the belief that the obstacles to participation in elections facing whites were equivalent to those experienced by African American and Latino voters—and thus demanded equal attention from the Civil Rights Division—represented a strikingly conservative view of federal voting rights enforcement. The notion that routine enforcement of the VRA served to benefit the Democratic Party was also troubling insofar as it suggested that administration officials viewed implementation of federal voting rights law and enforcement of the United States Constitution as detrimental to Republican interests.

Corruption of Personnel Practices within the Civil Rights Division
Bush authorized political appointees to exploit personnel policies to bring the
Division into alignment with the conservative objectives of his administra-
tion.[18] Division chief Schlozman, who privately derided voting rights attor-
neys as "commies," "pinkos," and "mold spores," embraced this task with rel-
ish.[19] Some senior attorneys who disagreed with the enforcement priorities
of the Bush White House were enticed into early retirement with generous
buyout packages. But others were effectively pushed out of office through the
diminution of professional responsibilities and the creation of a hostile work-
place environment. Indeed, following a thorough investigation, the Office of
Inspector General (OIG) concluded that Voting Section Chief Joseph Rich
was subjected to inappropriate and unfair treatment at the hands of politi-
cal appointees that likely contributed to his decision to take early retirement
in 2005.[20] Over time, aggressive tactics like those used on Rich resulted in a
mass exodus of experienced civil rights attorneys—including nearly all of the
CRD's African American lawyers—from the Division.[21] By 2006, former Di-
vision trial attorney William Yeomans later estimated, "some 55–60 percent
of career attorneys had left the Division, including many of its most experi-
enced litigators."[22] The departure of experienced attorneys deprived the Divi-
sion of legal and institutional knowledge essential to achievement of its tradi-
tional civil rights mission.

Bush appointees replaced outgoing voting rights attorneys with a new
cadre of lawyers who lacked experience litigating civil rights matters but
were overwhelmingly "affiliated with conservative groups like the Feder-
alist Society, the Heritage Foundation, or the Republican National Lawyers
Association." Indeed, sixty-three of the sixty-five lawyers hired by Bradley
Schlozman whose political or ideological affiliations were evident in the hir-
ing process identified with the Republican Party or a conservative interest
group.[23] Of considerable note for a Division focused on fighting racial dis-
crimination, Schlozman declined to hire a single African American candi-
date even though well-qualified applicants were available.[24] These patterns re-
flected a deliberate policy on the part of Schlozman to (in his own words)
"gerrymander all of those crazy libs right out of the [Voting Rights] section"
in order to make way for "right-thinking Americans."[25] The Department of
Justice inspector general later concluded that Schlozman's politicized hiring
practices violated federal civil service laws prohibiting consideration of parti-
san and ideological affiliations in employment.[26]

By all accounts, Schlozman's hiring practices wrought dramatic changes within the Division. This transformation is best encapsulated by the replacement of Joseph Rich with John Tanner as chief of the Voting Section. Whereas Rich was a believer in strong federal voting rights enforcement, Tanner echoed the sentiments of Schlozman and von Spakovsky, celebrating the proliferation of stringent voter qualification requirements by state and local governments as an effective response to the specter of voter fraud. He was also infamous within the Section for his questionable use of Department funds as well as for his racially insensitive remarks and behavior.[27] (Tanner once quipped by e-mail to Schlozman that he liked his coffee "[former United States Commission on Civil Rights chairwoman] Mary Frances Berry style—black and bitter." Schlozman delightedly forwarded the remark to conservative colleagues.)[28] Hounded by controversy, Tanner was finally forced to resign from office in 2007 following a public uproar over his grotesque claim that a Georgia law requiring prospective voters to present photo identification would affect whites much more than blacks because "minorities don't become elderly [and thus fail to maintain photo identification] the way white people do: They die first."[29]

Centralization of Decision-Making within the "Front Office"

Hiring practices were only the most obvious means by which Bush's political appointees refashioned the operations of the Civil Rights Division. William Bradford Reynolds had famously centralized decision-making in his office, but Schlozman and von Spakovsky went even further in centralizing control. To limit the influence of career attorneys who disagreed with the administration's approach to voting rights enforcement, administration officials transferred them on an involuntary basis to other sections where they could no longer influence voting rights cases.[30] Robert Berman, the long-serving deputy chief of the Voting Section, was transferred out of the Section against his will shortly after he concurred with the staff recommendation that the Georgia photo identification proposal not be precleared.[31] The Office of Inspector General later concluded that "the perceived ideology or the positions Berman took in Voting Section matters were likely among the motivating factors in [Bradley] Schlozman's decision to transfer Berman involuntarily out of the Section."[32] The involuntary transfer of Berman and several other attorneys for ideological reasons violated federal civil-service laws governing reassignment of career employees.[33]

Beyond removing disfavored attorneys from their posts, Division lead-

ers altered procedures in voting rights cases to insulate decisions from influence by those liberal attorneys remaining in office. As William Yeomans notes, "[Schlozman] interfered in the regular case assignment process to dictate the assignment of important cases based on whether an attorney was sufficiently conservative."[34] Conservative attorneys were handed important voting rights cases, while, as legal scholar Peter Margulies notes, "long-term employees who had incurred the wrath of political appointees were given assignments having nothing to do with their experience, such as defending immigration appeals," so that they would be unavailable to comment on voting and civil rights matters.[35]

Schlozman and von Spakovsky also made a routine practice of overruling staff attorney recommendations on voting rights matters, particularly when Republican Party interests were at stake. Thus, for example, they ignored the 2001 recommendations of career staff attorneys evaluating a Mississippi redistricting plan ordered by a state court. This had the direct consequence of ensuring that an alternative plan favoring the GOP was adopted instead.[36] These figures also approved the state of Texas's controversial 2003 redistricting plan—which substantially increased Republican congressional representation in part by diluting Latino voting strength—despite the fact that career staff unanimously recommended that an objection be interposed. This part of the plan was later struck down by the Supreme Court in *LULAC v. Perry* (2006). In yet another example of this dynamic, Schlozman and von Spakovsky precleared Georgia's voter identification plan even though career staff warned that the requirements would likely lead to the disenfranchisement of African American voters, and four staff members who had opposed preclearance of the Georgia plan "were reprimanded while the one dissenting staff member received a bonus for his work in the case."[37] A federal court later enjoined enforcement of the plan on the grounds that it amounted to a poll tax that imposed severe restrictions on the right to vote.[38]

The Georgia case provided the strongest indication of the efforts by administration loyalists to bend enforcement decisions to suit Republican interests. Hans von Spakovsky had endorsed Georgia's photo identification plan as an effective ballot-security measure in an anonymous law-review article published before Georgia submitted its proposal for review by the Division, a fact that—when it was revealed *after* the Division's approval of the proposal—contributed to the impression that the CRD leadership made decisions about voting rights matters based on preconceived notions rather than examination of

the facts of cases.[39] This affair was symptomatic of a broader institutional development in which voting rights decisions by CRD leaders were uncoupled from the professional judgment of career staff. By mid-2005, in fact, the Division's politicized front office had completely banned opinions from staff attorneys on voting rights cases.[40]

Consequences of Bush's Management of CRD

The politicization of personnel policy and decision-making had adverse consequences for Division operations. Based on dozens of interviews and analysis of thousands of documents, the Department of Justice's inspector general concluded that these developments had poisoned the working environment within the Division, eroding its capacity to fulfill its basic responsibilities.[41] With Division operations in disarray, key provisions of the Act went into administrative hibernation during Bush's tenure in office. Especially after 2003, the administration put the brakes on Section 2 enforcement: while 121 Section 2 matters were filed by the Voting Section between 2001 and 2003, only 41 additional cases were filed between 2004 and 2007.[42] Section 5 enforcement suffered a similar decline between the last year of Clinton's presidency and the first four years of Bush's tenure. Both the total number of preclearance objections (36) and the proportion of objections relative to submissions (.0008) fell precipitously between 2000 and 2005 compared to the previous decade (356 and .002, respectively).[43]

High-Level Support for Schlozman and von Spakovsky

Far from being the handiwork of rogue bureaucrats, the efforts of Schlozman and von Spakovsky appear to have been met with approval at the very highest levels of the administration. These figures eventually received more prestigious positions within the administration, from which they continued to politicize voting rights matters. Thus, for example, when Thor Hearne (another official within the administration focused on the issue of voter fraud) complained to the White House in late 2005 that Missouri US attorney Todd Graves was not, in his view, investigating allegations of fraud within that state with sufficient vigor, Graves was sacked and Schlozman was given his job, despite the fact that Schlozman lacked any prosecution experience.[44] Schlozman then brought criminal voter-fraud charges against four Missouri activists from the liberal-leaning group ACORN just days before the 2006 elections, even though Department of Justice guidelines recommended against timing enforcement actions in the closing days of campaigns due to the risk of influ-

encing election outcomes.[45] Schlozman's announcement of charges was espe-
cially questionable because it came in the midst of a hard-fought Senate cam-
paign between freshman Republican senator James Talent and Democratic
challenger Claire McCaskill that observers believed could tip the balance be-
tween the parties in that chamber, and thus the announcement created the
impression that Schlozman was using his authority to influence the election
to benefit the GOP.[46] Despite this breach of protocol, Schlozman was later
assigned to a position in the US Attorneys' executive office, from which he
helped supervise branch offices around the country.[47]

In similar fashion, the White House rewarded von Spakovsky with a re-
cess appointment to the Federal Election Commission (FEC).[48] From that
post, von Spakovsky may well have played an important role in yet another
Bush-era voting rights controversy—the alteration of a bipartisan report to
the Election Assistance Commission (EAC), prepared by Democratic voting
rights scholar Tova Andrea Wang and Republican election lawyer Job Sere-
brov. The report was altered to suppress the authors' questions about the va-
lidity of Republican voter-fraud claims and their criticism of the Depart-
ment of Justice's handling of voter-intimidation cases.[49] The precise role of
von Spakovsky in this affair is murky. By his own account, von Spakovsky
objected to Wang's participation in the study because of what he viewed as
her "inexperience as either a prosecutor of election crimes or as an election
official, and because of her outspokenly-biased belief that voting fraud was
a myth." Wang also alleged (although von Spakovsky denied) that von Spa-
kovsky sent an email to EAC commissioners expressing his desire to "kill the
[voting-fraud] project."[50] After conducting a thorough investigation, the EAC
inspector general concluded that it could not confirm whether von Spakovsky
exercised undue influence over the content of the final EAC report. But the in-
spector general found that von Spakovsky attempted to pressure Republican
EAC commissioner Paul DeGregorio to (in DeGregorio's words) "use his po-
sition (on the EAC commission) to advance the Republican Party's agenda."[51]
Outrage among Democratic senators over this affair forced von Spakovsky to
withdraw his nomination for full appointment to the FEC in 2008.[52]

The exploits of Schlozman and von Spakovsky—and the plum positions
they were granted as rewards for their service—pointed to the unprecedented
politicization of federal voting rights enforcement during the Bush adminis-
tration. Considered in broader perspective, however, the conscious demoli-
tion of administrative capacity within the CRD during Bush's tenure in office

represented the logical culmination of efforts undertaken by a succession of conservative presidents to limit the scope of federal voting rights enforcement via administrative maneuvers. Like his Republican forebears, Bush exploited political appointments, staffing practices, and administrative routines to circumscribe federal voting rights enforcement. During Bush's tenure in office, however, the administrative tactics employed by previous conservative presidents were pushed to—and even beyond—the limits of the law. By the time these activities finally came to light, Bush had already won reelection, allowing him to escape electoral accountability for his actions.

The Rightward Drift of Voting Rights Jurisprudence in the Early 2000s

Meanwhile, the conservative majority on the Supreme Court continued its project of limiting the authority of the Department of Justice and the lower federal courts to promote officeholding by citizens of color. This jurisprudential trend in turn reflected the success of conservative Republican presidents Richard Nixon, Ronald Reagan, and George H. W. Bush in appointing justices who were expected to further the political purpose—repeatedly frustrated in the legislative arena—of circumscribing the capacity of the federal government to safeguard the rights of minority voters.

Following on the heels of the *Bossier I* (1997) and *Bossier II* (2000) decisions, the conservative majority further narrowed the administration of preclearance in *Georgia v. Ashcroft* (2003). Stemming from a controversy arising from the 2001 redistricting in Georgia, the case was the most recent in a series involving questions about the circumstances under which preclearance could be denied on the grounds that a proposed plan reduced minority political representation. The controversy at hand was whether Georgia's redistricting plan, which replaced some majority-minority districts with a greater number of "minority-influence districts" (in which minorities would constitute less than a majority—but still an important part—of the district population), represented an unacceptable retrogression in minority voting power that justified the denial of preclearance by a federal court.[53]

The Court's majority opinion, authored by Reagan appointee Sandra Day O'Connor and joined by fellow Reagan appointees Antonin Scalia and Anthony Kennedy, George H. W. Bush appointee Clarence Thomas, and Nixon appointee William Rehnquist, determined that it did not. What made the case

truly significant, however, was the reasoning employed in the majority opin-
ion in reaching the decision. Prior to *Georgia*, redistricting in jurisdictions
covered by Section 5 were evaluated according to the *Beer* standard, which
held that Section 5 prohibited changes in electoral arrangements that brought
about retrogression in the ability of minority voters to exercise the franchise
effectively.[54] In this context, "effective exercise of the franchise" had tradition-
ally meant the ability of minority voters to *elect a candidate of their choice*. The
majority opinion in *Georgia*, however, made a dramatic departure from this
standard, demoting the ability of minority voters to elect a candidate of choice
to only one of a number of factors to be evaluated in determining whether a
redistricting plan was retrogressive. As O'Connor wrote in her opinion for the
Court, "any assessment of the retrogression of a minority group's effective ex-
ercise of the electoral franchise depends on an examination of all the relevant
circumstances, such as the ability of minority voters to elect their candidate of
choice, the extent of the minority group's ability to participate in the electoral
process, and the feasibility of creating a nonretrogressive plan."[55]

According to the *Georgia* majority, ensuring minority voters' "effective
exercise of the electoral franchise" did not require maintaining their abil-
ity to elect a candidate of choice. Consequently, states could eliminate some
majority-minority districts without being guilty of retrogressing minority
voting power, and states could adopt "coalition" districts in which racial mi-
norities would comprise a minority of the district population but still elect
candidates of choice through voting alliances with whites. What's more,
the opinion also sanctioned the creation of "minority-influence" districts,
in which minority groups would not enjoy the ability to elect candidates of
choice but might "influence" elections and governance in other ways. The
opinion thus fundamentally altered nearly thirty years of judicial and admin-
istrative interpretation of Section 5.[56]

The ruling potentially had profound implications for the administration
of preclearance as well. Consistent with the broader deference of the conser-
vative majority to state prerogatives, the opinion granted states extensive lee-
way in deciding how to ensure that racial minorities could exercise the vote
effectively. Indeed, O'Connor emphasized in the majority opinion that "Sec-
tion 5 does not dictate that a State must pick one of these methods [majority-
minority districts, coalition districts, or influence districts] of redistricting
over the other. . . . Section 5 gives States the flexibility to choose one theory
of effective representation over the other."[57] Since it was likely that majority-

white legislatures in covered states would often choose to do away with ma-jority-minority districts if allowed the opportunity, the decision of the con-servative justices made it more probable that minority voters in these states would be subjected to the dilution of their voting power, at least as tradi-tionally understood.[58] In this sense, the decision furthered the conservative project—articulated most forcefully by the Reagan administration in legal-guidance documents and statements during the 1981–1982 legislative debate over amendments to Section 2 of the VRA—of limiting the potential of the Act to promote majority-minority districting and more racially proportional representation in politics.

Electoral Strategy and Republican Acquiescence to the Voting Rights Act of 2006

Even as Republican political fortunes surged to high tide after the 2004 elec-tions, voting rights remained an extremely delicate subject for Republican elected officials. Although congressional Republicans had, as a general mat-ter, moved far to the right on both economic and racial issues, the extensive publicity, ready traceability, and considerable political openness surrounding legislative debate over reauthorization of the VRA continued to make public opposition to vigorous federal voting rights enforcement politically risky for those Republican elected officials who needed to appeal to moderate whites (and, potentially, a fraction of minority voters). Additionally—and especially in light of the racially charged human and political disaster presented by Hurricane Katrina—all Republican elected officials were anxious to present a moderate civil rights image so as to best position the party brand going into the 2006 elections.

Thus, despite extensive opposition within the Republican caucus to re-newal of the preclearance and minority-language assistance provisions of the Act, Republicans in both chambers ultimately voted in favor of the reauthori-zation by an overwhelming margin once it became clear that failing to do so would seriously compromise the party's reputation. The stark divergence in behavior between Republican elected officials acting in high-profile and po-litically open arenas and Republican political and judicial appointees operat-ing in more opaque and impermeable venues underscored the central roles of transparency and accessibility in shaping Republican positioning on voting rights matters.

Civil Rights Mobilization and the Racial Stakes
Surrounding the Reauthorization

As in previous episodes in the history of the development of the Act, the impetus for the 2006 reauthorization originated in a pervasive sense of crisis within the civil rights movement. The politicization of federal voting rights enforcement and the rightward lurch of the Court's voting rights jurisprudence were merely two among numerous factors that heightened fears among civil rights activists that the VRA faced unprecedented threats. Foremost in the minds of many within the civil rights movement was the disproportionate discarding of African American and Latino ballots for Democratic candidates in recent federal elections. They believed this discarding contributed directly to Bush's election victories and thus revealed the frailties of existing law. "All we need to do is look at the elections of 2000 and 2004 to see that VRA violations are still a persistent feature of our political landscape," LCCR director Wade Henderson insisted.[59]

Civil rights activists also perceived that conservative legal activists were mobilizing for a frontal assault on the federal preclearance regime. This was by no means paranoid thinking: conservative public intellectual Abigail Thernstrom (who became vice chair of the United States Commission on Civil Rights during Bush's tenure in office) and Edward Blum, head of the Project on Fair Representation, a legal organization closely tied to Republican donors that played a lead role in challenging the constitutionality of majority-minority districts, argued repeatedly in newspaper editorials and conservative journals that "Congress should let these emergency provisions [Sections 4 and 5 of the VRA] expire: They're not needed, they've lost their logic, and they create mischief."[60]

An early January 2005 meeting with President Bush did little to allay the concerns harbored by civil rights activists. Speaking with members of the Congressional Black Caucus (CBC), Bush claimed he was "unfamiliar" with the VRA and would have to review a specific legislative proposal before he would be willing to endorse renewal of the Act.[61] In actuality, conservative Justice Department officials were advocating at the time that Sections 4 and 5 be discarded. Bush and his close advisors were "dubious" about the coverage formula and preclearance provisions of the Act, top aide Karl Rove later admitted, but kept this opinion to themselves.[62]

The unwillingness of the president to pledge public support for the reauthorization was both unexpected and deeply disturbing to CBC members.

As Democratic representative Elijah Cummings of Maryland recalled, "I was shocked. I thought he was going to say that [renewing the law] is something that we need to do to make sure everyone's right to vote is guaranteed."[63] The exchange convinced civil rights leaders that the president intended to permit conservative Republicans in Congress to "torpedo the [VRA]," as Jesse Jackson explained.[64]

Given firm Republican control of Congress after the 2004 elections—the GOP held a 55–44 advantage in the Senate and a 231–202 lead in the House—this scenario was not out of the question. Indeed, by 2005, the gradual polarization of the parties on both economic and racial issues (which had increasingly become intertwined and thus understandable in terms of a single "dimension" of political conflict) had led congressional Republicans to adopt very conservative positions on civil rights matters while Democrats moved to the left.[65] Moreover, as the parties realigned geographically, the north-south splits within each party that had marked voting behavior in the 1960s, 1970s, and 1980s largely disappeared. Using data from Nolan McCarty, Keith Poole, and Howard Rosenthal's DW-NOMINATE database—which estimates legislators' ideological positions based on their roll-call voting behavior—the intensifying polarization of the parties in both chambers on this dimension of conflict is illustrated in figure 2.[66] The figure plots the mean ideological positions of Republicans and Democrats, respectively, between 1965 and 2005. (Note that, in the figure, negative values represent more liberal voting patterns, whereas positive values indicate more conservative patterns of voting.) These developments provided empirical evidence that—as Jackson alleged—many Republicans may well have preferred a significantly reduced role for the federal government in safeguarding minority voting rights by 2005.

To prevent partisan polarization on racial issues from undermining reauthorization of the VRA, the major civil rights organizations, led by the LCCR, Jackson's Rainbow-PUSH Coalition, and the CBC, committed in March 2005 to a major legislative campaign to renew the law.[67] Their main legislative objectives were to reauthorize the preclearance, minority-language, and election-observer provisions of the Act and to "clarify [legislative] language that [had] been muddied" by *Bossier II* and *Ashcroft*.[68]

The emphasis of the campaign on preserving the preclearance and minority-language provisions of the Act put the civil rights community at odds with many academic lawyers in the voting rights community, who argued that these measures should be significantly revised both to reflect

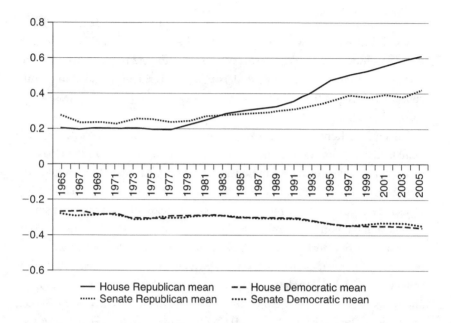

FIGURE 2. Partisan polarization in the House and Senate (based on DW-NOMINATE scores, 1st dimension), 1965–2005.

SOURCE: "The Polarization of the Congressional Parties," accessed August 23, 2016, available from VoteView.com, http://voteview.com/political_polarization_2015.html.

changing political and racial circumstances and to head off adverse rulings by an increasingly unsympathetic Supreme Court. Indeed, prominent academic lawyers, including Richard L. Hasen of the University of California, Irvine, Samuel Issacharoff of NYU, and Heather Gerken of Yale University, suggested that targeted reforms to the VRA—such as an update to the coverage formula to incorporate more recent information about discrimination in elections, alterations that would make it easier for states with histories of good behavior to "bail out" of coverage, and new measures that would empower minority communities and local governments to negotiate plans to "opt-in" to preclearance coverage—would make the Act more constitutionally defensible and thus better able to withstand inevitable challenges by conservative legal organizations.[69]

But civil rights leaders strenuously disagreed, insisting that the Act be reauthorized without major changes. In the political context of the day, this approach was understandable. Given unified control of the federal government

by a staunchly conservative Republican Party, civil rights activists believed it was necessary to devote limited resources to preserving past gains rather than attempt to make significant alterations to the text of the statute. Otherwise, they risked completely losing control of the legislative process in a Congress in which their genuine supporters represented a distinct minority.[70]

The legislative strategy drew directly on the experiences and lessons of previous campaigns, especially the massive 1982 effort to "Save the VRA." The Rainbow-PUSH Coalition took the lead, drumming up public and media interest in the reauthorization. Beginning with a ceremonial walk across Selma's Edmund Pettus Bridge on March 10, 2005, that was attended by three dozen members of Congress, Rainbow-PUSH organized a series of public forums, rallies, and marches that celebrated the fortieth anniversary of the VRA and highlighted the importance of renewing the preclearance and minority-language provisions of the Act.[71] These efforts culminated in an August 6, 2005, march in Atlanta to demonstrate against the state's strict voter identification law. The march was attended by many members of the CBC, dignitaries from civil rights organizations and the AME Church, and between ten and twenty thousand more people.[72]

Meanwhile, other "Renew the VRA" coalition members coordinated a behind-the-scenes lobbying strategy aimed at influencing congressional deliberations. Recognizing that the conservative majority on the Supreme Court had, with *Boerne v. Flores*, raised the evidentiary bar required to justify congressional assertions of power under the Fourteenth and Fifteenth Amendments, the "Renew the VRA" campaign members labored to establish a compelling basis of evidence that might mollify conservative justices.[73] The LCCR, Lawyers' Committee for Civil Rights Under Law, and ACLU all conducted comprehensive tallies of voting rights violations in states covered by Section 4, documenting ongoing discrimination against African Americans, Latinos, and other racial minority groups. "We hope and expect that at the end of [congressional consideration] Congress will have a strong record of discrimination before it and will vote to reauthorize the expiring provisions," explained Barbara Arnwine, executive director of the Lawyers' Committee for Civil Rights Under Law.[74]

At the same time, "Renew the VRA" coalition members organized grassroots training workshops "around the country . . . giving community leaders opportunity to gain media training, [to] hear status reports on congressional activity, and to develop local public education campaigns around the re-

authorization of the expiring provisions of the [Act]."[75] Over the course of the campaign, thousands of local voting rights activists made their voices heard in the halls of Congress. According to the Human Rights Campaign,

> The Leadership Conference on Civil Rights, along with its coalition members, which include the Human Rights Campaign, signed more than 100,000 reauthorization petitions and made 15,000 calls to congressional offices urging renewal of the Voting Rights Act. An aggressive grassroots education and organization effort was waged across the country by thousands of volunteers in their local communities.[76]

Within Congress, members of the CBC harnessed the energy generated by grassroots activists in the service of legislative initiative. Selected as the chief negotiator on behalf of civil rights forces, Democratic representative Mel Watt of North Carolina reached out to Republican congressman and House Judiciary chairman James Sensenbrenner of Wisconsin in late spring 2005 to commence renewal of the Act.[77] A vocal Republican advocate of the 1982 reauthorization of the VRA, Sensenbrenner remained personally committed to the cause, vowing in a July 2005 speech before the NAACP that he would work to renew the law "during this session of Congress and in its current form [that is, without weakening amendments]."[78] The Wisconsin Republican made full use of his prerogatives as Judiciary chairman to structure House deliberations so this promise could be fulfilled. A very large proportion of the witnesses invited to testify before Sensenbrenner's Subcommittee on the Constitution, which enjoyed primary jurisdiction over the legislation, represented civil rights organizations affiliated with the LCCR, ensuring that the preponderance of testimony would support the objectives of the "Renew the VRA" coalition. Sensenbrenner did the cause a further service by entering the evidence, compiled by coalition members, of ongoing racial discrimination in elections into the congressional record, thereby rendering "official" statistical data pointing to the need for the continuation of the coverage formula, preclearance provisions, and minority-language provisions of the Act.[79]

Desire to Avoid Racial Controversy and
Initial Republican Acquiescence to Expansive Legislation

The publicity campaign and fact-finding efforts orchestrated by civil rights groups and abetted by Sensenbrenner's cooperation fostered a political climate in which most members of Congress anticipated that—despite extreme polarization between the parties on both economic and racial issues—the

VRA would be renewed in a bipartisan vote prior to the 2006 midterm elections.[80] In no small part, this was due to the effective framing by the civil rights movement of the renewal as a fundamental civil rights issue, which mobilized Democratic support and—much more important in a Congress dominated by the GOP—discouraged Republicans from voicing vigorous opposition to the legislation despite their generally conservative positions on racial issues and dubiousness toward the 2006 reauthorization. (The underlying skepticism of many Republicans toward renewal of the VRA was palpable: of 152 cosponsors of the legislation ultimately introduced in the House, only 27 were Republicans.)[81]

Indeed, contemporary reports suggest that many Republicans were fearful that publicly opposing the Act would subject them to charges of racial insensitivity from Democrats, the media, and moderate white voters and thereby undermine the party's brand. Roger Clegg, a vocal critic of the VRA from the conservative Center for Equal Opportunity, bitterly complained that "the Republicans know that if they question the wisdom of reauthorization the Democrats will relentlessly demagogue them on the issue. . . . They'll be called racist and accused of wanting to turn back the clock on civil rights. The Republicans would really like to have this off the table."[82] Edward Blum agreed, arguing that

> Apart from a few courageous members of Congress, the Republican congressional leadership, cheered on by the Bush administration, is hell-bent on keeping [the preclearance] system in place. Why? . . . Republicans don't want to be branded as hostile to minorities, especially just months from an election. After all, every American knows how important the VRA was in securing voting rights for Southern blacks. And even though only Section 5 is up for reauthorization, Democrats will claim Republicans want to "turn back the clock" if they voice any doubts. Who wants to rebut that charge?[83]

As Blum's comments intimated, the desire of congressional Republicans to appear sympathetic to minority voters, which was especially strong among those in the leadership charged with framing the party's national campaign, was greatly heightened in the political context of the day. As the *Washington Post* reported, with the Iraq and Hurricane Katrina debacles steadily eroding the popularity of the party, "Republican leaders . . . hoped that early action [on the VRA renewal] would earn goodwill from minority voters as members of Congress head into a brutally competitive fall [2006] campaign season."[84]

Republican desire to forestall political controversy over the VRA can also be inferred from actions by party leaders that appeared intended get the Act "off the table" (to use Clegg's phrase) as quickly as possible. In a highly unusual move, GOP leaders joined hands with their Democratic counterparts to simultaneously introduce the Sensenbrenner-Watt legislation in both chambers of Congress. Leaders from both parties then participated in a rare bipartisan press event on the Capitol steps, vowing "to move quickly to complete work on the two versions [of the VRA renewal] before the close of the 109th Congress," *Roll Call* reported.[85] (The press event effectively committed the leadership of both parties to the Sensenbrenner-Watt legislation brokered in the House.)[86] House Republican Majority Leader John Boehner of Ohio went so far as to attempt to put the bill on the "suspension calendar"—an expedited legislative track that bars all amendments and requires a two-thirds majority to pass—a maneuver not typically undertaken with legislation as far-reaching and important as the VRA.[87]

Notably, the bill closely tracked the priorities of the "Renew the VRA" coalition, reauthorizing for twenty-five years the provisions pertaining to preclearance, language-minority protections, and federal election observers while fine-tuning some of the details of each.[88] Crucially, however, Section 4, which established the formula determining which jurisdictions were obligated to submit proposed voting changes for preclearance, was to be continued, using elections data from 1964, 1968, and 1972, for another twenty-five years in a form identical to that determined in the 1982 reauthorization. This decision was notable because it effectively "froze" in place the existing coverage formula and its underlying assumptions about racial dynamics in covered (and noncovered) jurisdictions. For some observers, the continuation of the existing formula without amendments heightened the risk that the conservative justices would strike it down and thereby render the preclearance regime inoperative.[89] Nevertheless, given the apparently strong support of the leadership from both parties for the reauthorization, the legislation seemed on its way to easy passage.

Republican Rebellion—and Backtracking— over Minority Voting Rights in the House

Without warning, however, House Speaker Dennis Hastert pulled the bill from the legislative calendar on June 21, 2006, effectively halting progress on the renewal.[90] The delay stemmed from fierce opposition by Republican backbenchers—expressed to the leadership at a private party caucus—to the con-

tinuation of the preclearance and minority-language provisions of the Act.[91] According to the *Washington Post*, southern Republican representatives, led by Lynn Westmoreland of Georgia, claimed that the preclearance provisions had "achieved [their] purpose and become more nuisance than necessity."[92] At least eighty Republicans also passionately opposed extension of the minority-language rules on the grounds that these provisions "divide our country, increase the risk of voter error and fraud, and burden local taxpayers," in the words of Iowa representative Steve King, the leader of the group.[93] Republican representatives demanded floor votes on amendments to weaken or strip the preclearance and minority-language provisions as the price of the reinstatement of the Sensenbrenner-Watt bill on the House legislative calendar.[94]

The delay highlighted the underlying hostility of many House Republicans to vigorous federal voting rights enforcement as well as their disenchantment with efforts by the Republican leadership to reauthorize the VRA swiftly in the name of party brand maintenance. "Most of us felt we had been cut out [of negotiations over extensions of the law]," seethed conservative California Republican Dana Rohrabacher, who criticized the "heavy-handed way [the reauthorization] had been pushed through and rammed down everyone's throats as though it were a fait accompli."[95] Ironically, efforts by the Republican leadership to forestall political embarrassment by shutting the rank-and-file out of negotiations produced exactly the type of high-profile controversy that party leaders had hoped to avoid.

Indeed, even as Republican Speaker Dennis Hastert attempted to reassure the public that the Republican leadership was "[still] committed to passing the Voting Rights Act legislation as soon as possible," civil rights activists worked aggressively to portray the postponement as a betrayal by the Republican Party of the nation's fundamental commitment to civil rights.[96] "Those members who held up today's vote represent retrogressive forces that America hasn't seen at this level since the 1960s," Wade Henderson exclaimed. "We expect the leadership to move this bill past this small group of saboteurs. The nation's continued progress toward equality demands it."[97] Meanwhile, congressional Democrats "seized the chance to spotlight the rare public dissension in Republican ranks," the *Baltimore Sun* reported, gleefully pointing to the failure of Republican leaders to win rank-and-file backing for the reauthorization as evidence of their hypocritical positioning on civil rights matters.[98] "You have [Republican Party Chairman Ken Mehlman] stand up one day and say, 'We're going to make a major outreach to African American

voters,' and the next day, you pull the Voting Rights Act from the floor," Mel Watt caustically remarked.[99]

All told, "the rebellion was an embarrassment for the Republican leadership," as the *New York Times* concluded.[100] Specifically highlighting the adverse electoral implications of the delay, the *Los Angeles Times* declared that "the rare public display of GOP dissension was a blow to strategists at the White House who had hoped an election-year renewal of the act would boost Republicans' appeal to minority voters in the fall elections." The *Washington Post* noted, meanwhile, that the dissension threatened to "delay [President] Bush's goal of drawing millions of Latino voters to the Republican Party and helping realign ethnic politics for decades to come."[101] More generally, polls from the period suggested that Americans favored Democratic candidates over Republicans in the 2006 elections by a 51–42 margin, indicating that Republicans had serious work to do to reclaim the allegiance of moderate and swing voters going into the fall campaigns and thus could ill afford to allow such an embarrassment to fester.[102]

Electoral pressure to maintain a moderate public image on voting rights matters helps explain the subsequent actions of both Republican leaders and the rank and file to advance the VRA despite their generally very conservative views. Hoping to forestall further damage to the party's reputation, House GOP leaders again banished conservatives from negotiations over the bill. Both Westmoreland and King complained that they had been cut out of the primary negotiations: Westmoreland groused that "I don't know who's talking, but it's not us."[103] Although party leaders ultimately accepted demands by Republican backbenchers for up-or-down votes on weakening amendments, they scheduled votes only on proposals that were generally expected to fail due to unanimous Democratic opposition and a split Republican vote.[104] In effect, the leadership permitted individual Republican representatives to take positions that would please racially conservative constituents within their districts but not to make alterations to the Sensenbrenner-Watt bill that would further tarnish the national brand of the Republican Party.[105] All four amendments failed, but three received majority support within the House Republican caucus, providing a strong indication of the intensity of rank-and-file Republican enmity to the extension of the preclearance and minority-language provisions of the Act.[106]

Nonetheless, following the failure of these amendments House Republicans overwhelmingly backed passage of the Sensenbrenner-Watt bill. (In-

deed, the measure passed on a 390–33 vote.) As the final vote tally indicated, a substantial fraction of House Republicans who voted in favor of the weakening amendments nonetheless voted for passage of the VRA. Despite previously supporting an amendment to shorten the VRA reauthorization period from twenty-five to ten years, 99 Republicans (or 44 percent of Republicans voting "yea" or "nay" on both measures) voted for reauthorization. And even though they previously voted to strike the bilingual ballot protections from the Act, 149 Republicans (or 66 percent of those voting "yea" or "nay" on both measures) supported renewal of the VRA. Finally, after votes favoring an amendment to expedite bailout by jurisdictions from coverage under Section 4 of the Act, 84 Republicans (or 38 percent of those voting on both measures) voted for passage. (Democratic support for each of the proposed amendments was miniscule—varying between one and four votes—so the degree of strategic voting on the Democratic side was also trivial.)[107] In the end, the chain of legislative events—coupled with the dramatic reversal in Republican voting between the amendment votes and the vote on final passage—strongly suggested that many House Republicans believed that voting to approve the VRA was necessary from an electoral perspective even though doing so required abandonment of their preferred policy positions.

Republican Obstruction in the Senate and Bush's Belated Intervention on Behalf of the VRA

In the Senate, it was "déjà vu all over again," The Hill reported, as legislative consideration of the VRA was repeatedly delayed by cancellations and postponements of committee hearings and markup sessions. Reports suggested that the delays were due to Republicans' ongoing dissatisfaction with the legislation. (Indeed, pointing to the pervasiveness of this displeasure, only twelve of fifty-five Republican senators signed on as cosponsors of the bill, compared with forty-three of forty-four Democrats.)[108] Conservative Republican senators argued that the preclearance process imposed an excessive burden on southern states. "Our part of the country, no matter how good we do, we're going to be treated differently than the rest of the country," complained Republican senator Trent Lott of Mississippi.[109] Led by Republican Tom Coburn of Oklahoma, Republicans also sought to weaken the minority-language requirements in the bill.[110] The continued delay of the reauthorization thus threatened to prove an ongoing embarrassment to the GOP, especially as the impending annual national convention of the NAACP—fortuitously scheduled to begin in Washington, DC, in late July 2006—promised to draw even

greater media attention (as well as the lobbying pressure of one thousand NAACP delegates) to the matter.[111]

Anxiety about the electoral repercussions of continuing Republican delay of the reauthorization provides a compelling explanation of President Bush's otherwise-puzzling decision to agree to speak on July 20, 2006, at the NAACP convention in strong support of passage of the Sensenbrenner-Watt bill in the Senate.[112] Indeed, it is quite doubtful that Bush would have addressed the NAACP in support of the legislation in the absence of the specific electoral pressures faced by the GOP at the time. Due to his anger with the organization's harsh criticism of his presidency, Bush had never previously accepted an invitation from the NAACP to speak at its annual conference—a record that, until 2006, had made him the first president in decades not to speak to the group.[113] Furthermore, in light of the fact that the president's appointments and administrative decisions had repeatedly undermined voting rights enforcement within the Department of Justice, it is doubtful that Bush supported the substance of the legislation. In short, given the considerations otherwise weighing against such a move, Bush's actions make sense only in the context of the election-year imperative "to strengthen ties between Republicans and black voters and . . . to reassure moderate white voters with a message of reconciliation," as the *New York Times* perceptively reported.[114] Even so, the address electrified Senate Republicans: the legislation was brought to a floor vote later the same day and passed the chamber 98–0. Bush signed the legislation "amid midterm election season fanfare" in an elaborate Rose Garden ceremony a week later.[115]

The impression that Republican leaders endorsed the reauthorization largely for reasons of party brand maintenance was further bolstered by the immediate efforts by party leaders to make political hay out of the renewal with voters of color. On the same day that Bush signed the reauthorization into law, Republican National Committee chairman Ken Mehlman touted the party's voting rights achievements at an Atlanta gathering of the National Urban League. In his address, Mehlman pled for "a fair hearing, the chance to make our case, the opportunity to work together on important issues where we can agree, like the Voting Rights Act."[116] But since the president and many congressional Republicans had approved the renewal only belatedly and after the revolt by Republican backbenchers threatened to turn the matter into a serious political liability for the party's national brand, Mehlman's statement arguably represented a creative reconstruction of the legislative history.

The politics of the 2006 renewal thus bore some resemblance to that of previous reauthorizations of the preclearance and minority-language provisions of the Act. As in those past legislative struggles, leading conservative politicians initially expressed skepticism about, if not outright opposition to, renewal of these requirements. This inspired civil rights activists to mount a massive grassroots and lobbying campaign to preserve the core features of the law; their efforts clarified and publicized the racial stakes surrounding the reauthorization. Loath to face public disapproval for diluting the Act and thereby alienating both moderate whites and people of color in an election year, most Republicans ultimately acquiesced to the demands of the civil rights organizations despite their transparent opposition to these provisions.

On closer inspection, however, the 2006 reauthorization was a more ambiguous victory for civil rights activists. Although civil rights leaders achieved their immediate programmatic objectives, their decision not to make adjustments to Sections 4 and 5 of the Act rendered the VRA increasingly vulnerable to constitutional challenge before a Court that was becoming ever more unsympathetic to robust voting rights enforcement by the federal government. In fact, a controversial Senate Judiciary Committee report written exclusively by Republicans and issued only a day before Bush signed the bill into law (that is, *after* the Senate had already passed the measure) provided grist for an inevitable constitutional challenge by conservative legal organizations by alleging that Congress failed to engage in "the kind of thorough debate that would have produced a superior product" because of an "unnecessarily heightened political environment" and the "expedited nature of the process."[117] Before the ink on Bush's signature had even dried, conservative legal organizations, led by the Project on Fair Representation and lavishly funded by conservative foundations such as Charles Koch's Knowledge and Prosperity Fund, began planning legal challenges to the constitutionality of the preclearance provisions of the Act. "See you in court," Edward Blum vowed.[118] Although the 2006 legislation renewed the most powerful provisions of the VRA, it reestablished them on very shaky foundations.

Bush's Judicial Appointments and the Demise of the Preclearance Regime

With the conclusion of the legislative struggle, conflict over voting rights again shifted to the tightly linked arenas of judicial appointments and judicial

adjudication of voting rights disputes. Following in the footsteps of his Republican predecessors, President Bush exploited his appointment powers to advance the long-standing Republican project of weakening the commitment of the federal government to voters of color while simultaneously shielding the GOP from public censure. His appointees also accelerated the enduring Republican objective of enhancing the powers of the Court so as to rein in the authority of Congress to protect vulnerable citizens under the Fourteenth and Fifteenth Amendments.

George W. Bush's View of Voting Rights Matters

Bush's statements about the Constitution and the Supreme Court and his endorsement of figures whose conservative views on voting rights matters were well known provided clear indications that he believed the Court should limit the powers of the federal government to safeguard minority voting rights. Bush subscribed to the prevailing conservative perspective—articulated most clearly and consistently by his Republican forebears Richard Nixon and Ronald Reagan—that judges should interpret the Constitution narrowly, in accordance with the putative understanding of the framers of the document. As he argued in an important address,

> I made a promise to the American people during the campaign that if I was fortunate enough to be elected, my administration would seek out judicial nominees who follow that philosophy [of strict construction of the Constitution]. . . . We would seek judges who would faithfully interpret the Constitution, and not use the courts to invent laws or dictate social policy.[119]

In the context of voting rights policy making, however, this mode of constitutional and statutory interpretation had very specific connotations. Both Nixon and Reagan, along with their appointees to the Court, had consistently construed this method to require a very narrow understanding of the Voting Rights Act. The embrace by President Bush of a "strict constructionist" methodology thus implied that he favored a similarly conservative resolution of voting rights controversies by the Court.

More to the point, on both the 2000 and 2004 campaign trails Bush expressed admiration for the jurisprudence of justices Antonin Scalia and Clarence Thomas, which, he suggested, best reflected his own constitutional philosophy.[120] These remarks, which were widely interpreted as pointing to the judicial philosophy desired by Bush in potential Supreme Court nominees, were telling, because these justices held an especially narrow view of

the scope of federal voting rights enforcement. Scalia and Thomas amassed very conservative voting records in voting rights cases before the Court, casting liberal votes in 35 and 21 percent of the voting rights cases they considered, respectively.[121] Moreover, the duo adopted a particularly extreme position on the scope of Section 5 of the Act. In a concurring opinion on *Holder v. Hall* (1994) not joined by Kennedy, O'Connor, or Rehnquist, the duo contended that Section 5 of the VRA addressed only government actions that directly limited citizens' access to the ballot and not measures that diluted the voting strength of nonwhite racial groups. Hewing to the position laid out by the Reagan administration during the 1980s, they asserted that

> the statute was originally perceived as a remedial provision directed specifically at eradicating discriminatory practices that restricted blacks' ability to register and vote in the segregated South. Now, the Act has grown into something entirely different. In construing the Act to cover claims of vote dilution, we have converted the Act into a device for regulating, rationing, and apportioning political power among racial and ethnic groups.[122]

The retrenchment envisioned by these justices would have rendered Section 5 inapplicable to vote dilution claims, imperiling the ability of nonwhite voters to elect candidates of choice and threatening their capacity to exercise substantive influence in the electoral process in jurisdictions with racially polarized voting and histories of discrimination.[123] Bush's expression of respect for these justices thus implied that the president favored both a sharply limited understanding of minority voting rights and a substantially reduced role for the elective branches of the federal government in protecting them.

A final clue to Bush's view of how the Supreme Court should treat the Voting Rights Act can be found in his appointment in 2004 of Abigail Thernstrom to the vice-chairwomanship of the United States Commission on Civil Rights, the independent body charged with recommending civil rights measures to Congress. Author of a major conservative treatise on voting rights politics and a frequent editorialist for the *Wall Street Journal*, *National Review*, *Commentary*, and other conservative outlets, Thernstrom was a prominent critic both of majority-minority districting and of the Court's post-*Allen* jurisprudence requiring federal preclearance of election regulations that threatened to dilute minority voting power.[124] Thernstrom also forcefully advocated the repeal of Section 5 during the 2005–2006 struggle over renewal of the VRA, proclaiming in the *Wall Street Journal* that "preclearance is no lon-

ger defensible."[125] The elevation of Thernstrom to a position of authority on civil rights matters arguably signaled Bush's endorsement of her well-known voting rights views.

Bush's Supreme Court Appointments and the Entrenchment of Conservative Voting Rights Views

During his tenure in office, Bush enjoyed the opportunity to appoint two justices to the Supreme Court due to the retirement of associate justice Sandra Day O'Connor and the passing of chief justice William H. Rehnquist. The president took significant steps to ensure that these opportunities were harnessed in service of advancing his conservative judicial agenda. According to Associate White House Counsel Dabney Friedrich, appointment of ideological conservatives to the Court (and to the lower federal courts) was "one of the President's most important domestic priorities," and thus secured "a great deal of [Bush's] attention."[126] Bush adopted Reagan's famously rigorous screening process in order to maximize the likelihood that his appointees would remain true to his conservative agenda.[127] Potential nominees were subjected to lengthy background checks, reviews of published opinions and articles, and extensive in-person interviews.[128] Although the process produced one major misfire—the nomination to the Court of the underqualified (and, in the view of Republican activists, insufficiently conservative) Harriet Miers—it was widely perceived that Bush succeeded in selecting nominees that would advance conservative objectives in many areas of policy.

For proponents of strong federal voting rights enforcement, Bush's nominees—federal judges John Roberts (as chief justice) and Samuel Alito (as associate justice)—were causes for serious concern. Although both Roberts and Alito were respected jurists, both were also viewed as profoundly skeptical of federal efforts to promote civil and voting rights. Roberts, whose confirmation hearings overlapped with the early legislative deliberations over the 2006 extension of the VRA, elicited the greatest anxiety among civil rights activists.[129] Roberts had played an important role on the legal team assembled by the Bush campaign to challenge the recount of Florida ballots during the disputed 2000 election, a fact that raised important questions about his commitment to the principle that the votes of all Americans should be counted.[130] More worrisomely—as documents from Roberts's tenure in the Reagan Justice Department revealed—Roberts had stridently objected during legislative debate over the 1982 reauthorization to proposals to protect the voting rights of racial and language minorities from election regulations with dis-

criminatory effects.[131] Roberts's memos characterized these measures as rad-
ical reforms that would "throw into litigation existing electoral systems at ev-
ery level of government" and "lead to a quota system in electoral politics." The
young aide also repeatedly exhorted high-ranking Justice officials to rebut the
legal and political arguments of civil rights activists, and he drafted model
statements along these lines for use by his superiors.[132]

Since Bush had full knowledge of Roberts's record at the time of his ap-
pointment it seems reasonable to conclude—especially given the president's
own ideological commitments and administrative record on voting rights is-
sues—that the president endorsed these views and anticipated Roberts would
advance them on the Court. Indeed, Bush's selection of Roberts distinctly
echoed both Richard Nixon's appointment of William Rehnquist and Ronald
Reagan's elevation of Rehnquist to the chief justiceship despite considerable
evidence suggesting that Rehnquist opposed vigorous federal enforcement
of civil and voting rights. A significant motivation in all these appointments
seemed to be to use them to secure conservative voting rights objectives that
the president had cherished but declined to advance legislatively so as to
maintain the party's standing both with citizens of color and with moder-
ate whites.

Bush's nomination of Roberts also echoed Reagan's nomination of Rehn-
quist insofar as it represented—perhaps surprisingly—a relatively low-pro-
file means of advancing conservative positions on voting rights (and other)
matters. As was the case with Rehnquist's confirmation, Roberts's was largely
ignored by a substantial fraction of the public. According to contemporary
polls, between 39 and 41 percent of Americans reported having followed the
story of Roberts's confirmation hearings "not too closely" or "not closely at
all."[133] Moreover, just after Roberts's confirmation, surveys indicated that a
majority of Americans either had no opinion of the new chief justice (25 per-
cent) or had never heard of him (27 percent).[134] Americans' modest attention
to and lack of knowledge of Roberts's confirmation meant that his conserva-
tive voting rights views very likely escaped the attention of a significant seg-
ment of the public. This fact, in turn, provided Bush with a considerable op-
portunity to use the Roberts appointment to advance his conservative voting
rights views without exposing himself or the GOP to disapprobation from
many Americans.

Indeed, if—as the foregoing suggests—Bush selected Supreme Court jus-
tices in part with an eye toward judicial diminution of the scope of federal

voting rights enforcement, the subsequent voting records of his appointees suggest he was strikingly effective in accomplishing this task. Data from the Supreme Court Database indicates that out of five cases on voting rights issues through the end of the 2015 Supreme Court term, both Roberts and Alito registered a liberal vote in only a single case (that is, in 20 percent of cases). Thus, Roberts and Alito cast liberal votes in voting rights cases even less frequently than Scalia or Thomas, the next most conservative justices on voting rights issues.[135]

Conservative Justices Carry on Republican Resistance to Preclearance by Judicial Means

Bolstered by Bush's appointments, the conservative justices appear to have set their sights on the further diminution of the protections afforded by the Act to minority voters—a task that, strikingly, remained impervious to the election and reelection of liberal Democrat Barack Obama to the White House in 2008 and 2012. After threatening to strike down Section 5 directly in *NAMUDNO v. Holder* (2009), Roberts marshaled support from the other conservative justices to overturn the Section 4 coverage formula in *Shelby County v. Holder*, a suit funded by Edward Blum's Project on Fair Representation.[136] The ruling wove together ideological themes advocated by Republican presidents and members of Congress, pointing to the important links between the justices' arguments and the positions of the elected Republican officials that played the predominant role in appointing them.

The core argument offered in the majority opinion was that racial conditions in southern states had improved to such an extent that in 2013 it was "irrational to base coverage on the use of voting tests 40 years ago, when such tests have been illegal since that time."[137] Under contemporary circumstances, the majority opinion claimed, the coverage formula represented an unconstitutional imposition on the principle of "equal state sovereignty," because it unjustifiably targeted some states for harsher treatment than others:

> In 1965, the States could be divided into two groups: those with a recent history of voting tests and lower voter registration and turnout, and those without these characteristics. Congress based its coverage formula on that distinction. Today the Nation is no longer divided along those lines, yet the Voting Rights Act continues to treat it as if it were. . . . Congress, if it is to divide the States—must identify those jurisdictions to be singled out on a basis that makes sense in light of current conditions. It cannot rely simply on the past.[138]

Although the decision avoided striking down Section 5 directly, *Shelby County* had the practical consequence of rendering preclearance inoperative.[139] Released from coverage under Section 4, previously covered jurisdictions were freed to institute restrictive voting policies without having to submit them for evaluation by the DOJ or the federal courts.

The decision greatly accelerated the judicialization of voting rights policy making, initiated by Nixon's appointees and elaborated by the appointees of Reagan and George H. W. Bush, by further limiting congressional enforcement powers under the Fifteenth Amendment. The majority opinion built on the Rehnquist Court's work in *Boerne v. Flores*, further ratcheting up the standard of evidence required to warrant congressional efforts to protect minority voters. Although Congress asserted that the evidentiary record provided a compelling basis for the retention of the coverage formula, the majority opinion flatly rejected this contention, claiming instead that "no one can fairly say that [the record] shows anything approaching the 'pervasive,' 'flagrant,' 'widespread,' and 'rampant' discrimination that faced Congress in 1965, and that clearly distinguished the covered jurisdictions from the rest of the Nation at that time."[140] As an empirical matter, the characterization of the facts offered by the majority was debatable, as empirical research suggested both that negative racial attitudes among whites were significantly more prevalent in areas covered by the formula struck down by the Court and that successful voting rights suits, consent decrees, and legal settlements occurred overwhelmingly in jurisdictions that had been covered by Section 4.[141] Even setting aside this crucial point, the ruling asserted the right of the Court to substitute for that of Congress its own judgment of the evidence used to justify congressional decisions in the realm of voting rights enforcement and of the content of the choices themselves.[142] In this sense, the Court's judgment both reflected and advanced the vision of the Court as a "bulwark of a limited Constitution" articulated by the Reagan administration and reaffirmed by the Bushes.

Other features of the majority opinion similarly echoed the ideological and programmatic commitments of the administrations that appointed the justices comprising the majority. The majority opinion announced a markedly expanded understanding of the doctrine of "equal state sovereignty" that departed from past precedent and substantially circumscribed the authority of the legislative branch. Generally speaking, equal-state sovereignty is the principle that the relationship between the federal government and each state

should be essentially the same in terms of benefits provided and obligations imposed. Traditionally, however, this principle applied only to the terms on which states were admitted to the union, not to congressional remedies for violations of constitutional rights that occurred after admission. Nonetheless, the majority opinion in *Shelby County* invoked this doctrine as a rationale for striking down Section 4, extending this principle well beyond its original ambit. Given the modest support for this principle either in the text of the Constitution or in existing judicial doctrine, this aspect of the decision also pointed to the allegiance of the conservative justices to the principle of the limited Constitution asserted by recent Republican administrations.[143]

In truth, it is fair to say that with *Shelby County* the Roberts Court finally achieved the controversial purposes that Republican elected officials had cherished for more than four decades but had been unable to accomplish by legislative or administrative means. A major benefit of the Court's striking of the coverage formula was that it granted Republican Party leaders and elected officials "plausible deniability" of political culpability, even though Republican officials were in fact responsible for the choices that made *Shelby County* possible. Indeed, there is evidence pointing to significant popular discomfort with the *Shelby County* ruling, which in turn explains why Republican elected officials would have been motivated to delegate to the Court the task of terminating the preclearance regime. Immediately following the Court's ruling, a majority of Americans either "disapproved somewhat" (16 percent) or "disapproved strongly" (35 percent) of the decision.[144] Furthermore, polls tapping Americans' attitudes in the aftermath of the ruling showed that 53 percent of respondents believed that "discrimination in voting remains a problem and should be addressed by Congress" and that 54 percent thought that strengthening the Voting Rights Act should be "an immediate priority" or "priority over the next couple of years" for the president and Congress.[145]

But the strongest indication that *Shelby County* represented the realization of the long-term political strategy on the part of Republican officials to weaken the VRA while avoiding blame for doing so was the enthusiasm of prominent congressional Republicans for the ruling, *despite the fact that the decision struck down legislation for which these members had previously voted*. Republican senator Charles Grassley of Iowa—who voted in favor of final passage of the reauthorization of the VRA in 2006—praised the *Shelby County* decision, declaring, "What [the ruling] tells me is after 45 years, the Voting Rights Act worked, and that's the best I can say. It just proves that

it worked."[146] Republican senator Jeff Sessions of Alabama—another "yes" voter on final passage in 2006—applauded the Court's decision. "The world has changed since 1965," Sessions announced. "It was raw discrimination in 1965. . . . That's why the act passed, and it has been pretty darn successful."[147] Yet another Republican senator who voted to reauthorize preclearance in 2006, Lindsey Graham of South Carolina, responded to news of the ruling by exclaiming, "As a South Carolinian, I'm glad we will no longer be singled out and treated differently than our sister states."[148] On the House side, Republican Bob Goodlatte of Virginia claimed in early 2015 that it was not "necessary" to reinstate preclearance following the *Shelby County* decision— even though he had voted in 2006 to reauthorize Sections 4 and 5 for twenty-five years, until 2031.[149] The embrace by high-profile Republicans of a Court ruling that undermined the very legislation for which they had previously voted provided compelling evidence that the GOP had deliberately empowered the Court to accomplish racially conservative purposes that they desired but could not achieve in Congress.

Conclusion

The striking of Section 4 of the Voting Rights Act by the Court's five conservative justices represented the culmination of political efforts that had been underway for more than four decades. As in previous chapters of the development of the Act, legislative, administrative, and judicial policy making proceeded according to very different logics, with legislative processes advancing an expansive approach to federal voting rights enforcement even as administrative and judicial machinations institutionalized a much more circumscribed understanding. As in previous episodes, these patterns were attributable to partisan maneuvering and in particular to a politics of partisan blame avoidance for racially conservative decisions practiced by Republican elected officials. During the 2006 reauthorization cycle, many Republicans swallowed their staunch opposition to major provisions of the VRA, acquiescing to an expansion of the Act in a bid to maintain a positive civil rights reputation during a difficult election campaign. Yet, even as they nominally embraced the enhancement of the provisions of the Act, Republicans worked quietly behind the scenes to undermine the very legislation they had publicly endorsed. Within the Department of Justice, political appointees and like-minded civil servants pursued a deliberately destructive policy that eroded

the capacity of the Civil Rights Division to accomplish its core objectives. Meanwhile, President George W. Bush appears to have consciously selected Supreme Court nominees whose records strongly indicated that they would view inevitable challenges to the constitutionality of the Act with great sympathy. Soon after their appointments, these justices delivered decisions that Republicans had long desired but had been unwilling to advocate too loudly in the halls of Congress.

These developments profoundly altered the character of federal voting rights politics, shifting the political and institutional advantage to opponents of robust voting rights enforcement. Indeed, while states previously covered by preclearance raced to institute stringent new voting requirements, Republicans in Congress worked diligently to block efforts to instate a new coverage formula. Meanwhile—as the next chapter shows—the Obama administration faced the formidable task of revitalizing a Civil Rights Division crippled by the troubling legacies of the Bush years. Between 2014 and 2016, already vulnerable voters—people of color, language-minority citizens, poor people, and the young—bore the primary burden of overcoming new obstacles to casting ballots.

5 Voting Rights Politics in the Age of Obama, 2009–2016

T HE ELECTION IN NOVEMBER 2008 OF DEMOCRATIC CANDI-
date Barack Obama as the first African American president
in American history elicited a tidal wave of commentary about the appar-
ent transformation of racial politics in the United States. "The election . . .
amounted to a national catharsis," gushed the *New York Times* in an election
review titled "Obama Elected President as Racial Barrier Falls." Indeed, the
Times asserted, the election was "a strikingly symbolic moment in the evo-
lution of the nation's fraught racial history, a breakthrough that would have
seemed unthinkable just two years ago."[1] "Obama Makes History," read the
headline of the *Washington Post* in a similar report. That article claimed that
Obama "[rode] a reformist message of change, an inspirational exhortation of
hope to become the first African American to ascend to the White House."[2]
Taking the celebration of Obama's historic victory to an absurd extreme,
Forbes proclaimed that the election demonstrated conclusively that "racism
in America is over."[3]

Even as Americans pondered the implications of Obama's striking
achievement, some conservative legal commentators and political analysts
wondered aloud whether the 2008 election pointed to the irrelevance of the
Voting Rights Act. After all, if an African American presidential candidate
could win a majority of the national vote and achieve notable success in tra-
ditional Republican bastions such as Indiana, North Carolina, and Virginia,
were the assumptions underlying the VRA still valid?[4] With her husband Ste-

phen Thernstrom, US Civil Rights commissioner and perennial VRA critic Abigail Thernstrom pronounced a week after the election that "the myth of racist white voters was destroyed by this year's presidential election. . . . [T]he doors of electoral opportunity in America are open to all."[5]

Sadly, the events of the following years belied the optimism attending the election of the first black president in American history. In states around the nation, legislatures adopted an avalanche of stringent voting laws that weighed heaviest on poor, youthful, and minority voters. In a pattern that critics derided as "Jim Crow 2.0," such measures were most likely to be adopted in Republican-controlled states with significant nonwhite populations and competitive elections, bolstering the impression that they were, in fact, instituted to demobilize nonwhite (and likely Democratic) voters and thereby help engineer Republican victories at the polls.[6] These developments sharply polarized Democrats and Republicans, with Democrats charging their opponents with deliberately suppressing the vote among Democrat-leaning groups and Republicans defending the new policies as necessary to ensure the integrity of elections.[7] Efforts by the Obama Justice Department to combat restrictive voter legislation only antagonized conflicts within an ideologically divided CRD and exacerbated partisan disagreement on voting rights matters in Congress.

Ironically, the very fact of Obama's election—which the president candidly attributed in part to the Voting Rights Act—made voting rights politics even more fraught.[8] His election and presidency were attended by an intensifying relationship between racial attitudes and partisan preferences among white Americans.[9] Even more worrisomely, public opinion polls showed that the most enthusiastic supporters of restrictive voting rules and regulations were white Republicans with uncharitable views toward people of color.[10]

But the increasingly bitter politics surrounding minority voting rights was also partly attributable to the changed institutional environment. With its ruling in *Shelby County*, the conservative justices on the Supreme Court had swept aside the provision Republicans most vigorously opposed. This new state of affairs relieved Republicans of the politically fraught burden of justifying departures from existing voting rights law and allowed them to exploit their majority status in Congress to obstruct "divisive" legislation proposed by Democrats. For their part, given the infeasibility of reestablishing preclearance in a Congress in which Republicans controlled the House of Representatives—and, after 2014, the Senate as well—Democrats made the strategic

choice to highlight Republican intransigence as a campaign issue in order to rally support among African American and Latino constituents. All told, this partisan maneuvering worsened an already toxic political climate, rendering voting rights reforms nearly impossible prior to the 2016 elections and, given Republican Donald Trump's election in 2016, improbable thereafter.

Poor and minority voters bore the brunt of the failure of Congress to enact stronger voting protections in the wake of *Shelby County*. Assessments of the 2014 elections indicated that restrictive state voting laws passed after the ruling may have depressed turnout in ways that altered outcomes in key contests in several states.[11] In 2015, more than one hundred new bills restricting voter access were put forward in state legislatures around the nation, raising the specter of further constraints on the right to vote.[12] Although there are some indications of backlash against such policies—indeed, evidence suggests that emotional debates about stringent election rules may serve to mobilize Democratic voters in elections—only time will tell whether the tide of restrictive voting rules is still gaining strength or at last receding.[13]

The Obama Administration's Implementation of the VRA before *Shelby County*

President Obama entered office in January 2009 determined to implement a much more expansive vision of civil rights enforcement than that adopted during the presidency of George W. Bush. Drawing on biblical allusions characteristic to the civil rights movement, the president explained that

> Today we stand on the shoulders of all the Moses generation that made the Voting Rights Act possible, that made the Civil Rights Act possible, that made the civil rights movement possible. Yet with all of the progress that has been made since that terrible day in Selma, we also know that there is still much work to be done by us, the Joshua generation.[14]

But the accomplishment of the president's objectives faced long odds. Standing in the way of the revitalization of federal voting rights enforcement were the administrative dysfunction and political discord within the Civil Rights Division unleashed during Bush's presidency. Restoring the historic mission of the Division thus required restructuring its internal operations—a task of monumental proportions. Refurbishing the Division also entailed repudiating Bush's administrative legacy, which was bound to engender staunch

opposition among congressional Republicans and conservative activists. Iron-
ically, Obama's efforts to reinvigorate the CRD involved adoption of aggres-
sive administrative tactics that were the mirror image of those used by Repub-
lican skeptics of voting rights enforcement in the 1970s, 1980s, and 2000s to
limit implementation of the Act. Obama's efforts—although only partly suc-
cessful—pointed to the centrality of administrative combat in the contempo-
rary politics of voting rights enforcement.

Administrative Conflict within CRD

The resolve of President Obama to reestablish the credibility of the CRD
was revealed in the selection of Eric Holder to serve as attorney general. Al-
though Holder's previous service in the Department of Justice focused pri-
marily on anticorruption matters, there was little doubt that the new attorney
general embraced an expansive understanding of civil and voting rights. "We
must resist the temptation to conclude that our nation has fulfilled its prom-
ise of full equality based on one moment or on one election," Holder pro-
claimed in an important address. "We know better than that. . . . We still have
work to do."[15]

The Attorney General moved quickly to "reshap[e] the Justice Depart-
ment's Civil Rights Division" by "pushing it back into some of the most im-
portant areas of American political life, including voting rights, housing, em-
ployment, bank lending practices and redistricting after the 2010 census."[16]
But Holder encountered a Division that was both thoroughly demoralized
by the conflicts of the Bush years and lacking in knowledgeable and experi-
enced civil rights attorneys. Accomplishing the ambitious objectives set by the
new attorney general necessitated both a dramatic expansion of the number
of qualified civil rights attorneys and a comprehensive effort to ease tensions
between staff loyal to Holder's vision and the much more conservative lawyers
hired between 2001 and 2008.[17] Holder clearly recognized the difficulties in-
volved, declaring early in his tenure that although the Division was "getting
back to doing what it has traditionally done . . . the wounds that were inflicted
on this Division were deep, and it will take some time for them to fully heal."[18]

As CRD prepared to hire dozens of new attorneys in order to strengthen
its enforcement capabilities, Holder and other Justice officials acknowledged
the imperative not to replicate the unscrupulous practices that had distorted
personnel policy between 2001 and 2008. At the same time, however, Obama's
team sought to ensure that new hires shared its commitment to vigorous fed-
eral civil and voting rights enforcement. Under Division chief Thomas E. Pe-

rez, hiring decisions were placed "once more in the hands of career lawyers rather than political appointees," the *Washington Post* reported.[19] Ostensibly, the devolution of authority was intended to preclude the politicization of hiring by presidential appointees that had occurred on Bush's watch. But it also inevitably institutionalized liberal preferences in the hiring process. As administration officials knew, most senior career attorneys remained dedicated to a vision of energetic civil rights enforcement. Consequently, delegation of hiring authority to careerists effectively empowered them to reinforce this commitment. Subsequent analyses showed that "the lawyers hired . . . have been far more likely [than those newly employed during Bush's tenure] to have civil rights backgrounds—and to have ties to traditional civil rights organizations with liberal reputations, like the American Civil Liberties Union or the Lawyers' Committee for Civil Rights Under Law."[20] Indeed, a 2013 report of the Office of Inspector General found that eight of nine new hires made in 2011 had "one or more liberal affiliations" and none had conservative associations, although this was in no small part due to the fact that qualified applicants overwhelmingly hailed from liberal interest groups and law firms.[21]

More significantly, and in a distinct echo of the Bush years, Obama administration officials occasionally intervened in personnel matters in an aggressive fashion to ensure that CRD staff conformed to the vision of the president. Most notably, in January 2010, the administration reached an agreement with Chris Coates, the conservative leader of the Voting Section who had taken over after the departure of disgraced former chief John Tanner, in which Coates would transfer to the US Attorneys' Office in South Carolina so that Perez's team could replace him with Chris Herren, a longtime career attorney with extensive experience on voting rights issues.[22] As the Office of Inspector General documented, there were valid grounds for the reassignment of Coates, including his poor management skills, questionable decision-making, and divisive leadership approach.[23] But the transfer was still problematic insofar as it appeared to be "based in part on the unsupported belief that Coates could not be trusted to faithfully implement the new administration's policies and that he would not do so if he was allowed to remain in his position."[24]

The reassignment of Coates was bound up with another controversial administrative decision, involving the erstwhile Voting Section chief, that underscored the determination of the Obama administration to refocus enforcement activities on the protection of minority voting rights. The de-

cision in question was the dismissal of an investigation of alleged intimidation of white Philadelphia voters by members of the New Black Panther Party (NBPP).[25] During the 2008 elections, two members of the NBPP (one a certified poll watcher), dressed in paramilitary uniforms, stood near a Philadelphia polling station in what some Republican poll watchers perceived as a "menacing" fashion. Neither police investigations nor subsequent Criminal Section inquiries yielded identifiable victims of discrimination or intimidation.[26] Over the following weeks, however, video footage of the NBPP poll watchers taken by a Republican activist found its way onto Fox News, where it became a staple of reports alleging intimidation of white voters.

During the waning weeks of Bush's presidency, Coates began his own investigation of the matter. Based on accounts by Republican Party poll watchers and attorneys, Coates and a small team of similar-minded lawyers requested authorization to file suit against the two NBPP members on the scene as well as two alleged accomplices for intimidating or conspiring to intimidate white voters.[27] Acting Assistant Attorney General Grace Chung Becker approved the lawsuit in the final days of Bush's tenure in office without following the normal procedure of issuing a notice letter to the defendants prior to filing. The departure from protocol was provocative because "absent this decision [to forgo issuing notice letters], the case would not have been filed prior to the change in administrations." As it was, however, this deviation from the norm "created the perception that the decision was made in order to deprive the new administration of the opportunity to make its own assessment of the proposed litigation."[28]

As the Obama administration transitioned into office, the suit against the NBPP members advanced through the federal court system.[29] Within the Department of Justice, however, Acting Assistant Attorney General for Civil Rights Loretta King and Acting Deputy Assistant Attorney General for Civil Rights Steven Rosenbaum raised serious questions about the quality of evidence used to support the charges assembled by Coates and his team.[30] Consequently, in early May 2009 the Division leadership "ordered that three of the original four defendants be dismissed from the case . . . and that the proposed injunction against the fourth be significantly narrowed."[31] Both the Office of Professional Responsibility within the Department of Justice and the Office of the Inspector General determined that Division leaders made the appropriate judgment based on the facts and the relevant case law. But the matter became a major source of grievance among congressional Republi-

cans in 2010, when Coates and colleague J. Christian Adams claimed before the conservative-dominated US Commission on Civil Rights that Obama appointees had blocked the investigation because the suspects were black and the alleged victims were white.[32]

The bitterness exemplified in the allegations of Coates and Adams pointed to deeper ideological and partisan conflicts within the Division "over whether the agency should focus on protecting historically oppressed minorities or enforce laws without regard to race."[33] These tensions posed serious and ongoing obstacles to Obama's ambition to revitalize federal voting rights enforcement. The 2013 Office of Inspector General report documented numerous instances of ideology-based harassment and inappropriate disclosure of confidential information on the part of both liberal and conservative attorneys and staff. Much more troublingly, it identified a pervasive "politically charged atmosphere and polarization within the Voting Section" that obstructed effective enforcement of federal voting rights law.[34] As the report concluded,

> We believe that the high partisan stakes associated with some of the statutes that the Voting Section enforces have contributed to polarization and mistrust within the Section. . . . We found that people on different sides of internal disputes about particular cases in the Voting Section have been quick to suspect those on the other side of partisan motivations, heightening the sense of polarization in the Section.[35]

The political polarization of staff charged with enforcing the VRA helps explain the otherwise surprisingly lethargic pace of enforcement during Obama's first term in office. Although data on enforcement actions between 2009 and 2012 are hard to come by, available measures of Division activities are underwhelming.[36] The Division issued only sixteen Section 5 objections (out of more than eighteen thousand submissions received) between 2009 and 2012, with most of those coming in 2011 and 2012. This objection rate was virtually identical to that observed between 2001 and 2005—the most politicized period during George W. Bush's tenure in office. Additionally, the Division reported "litigat[ing] four cases during this period opposing voting changes filed for judicial review" and "fil[ing] seven lawsuits to enforce the minority language protections of the Act."[37] Law professor Michael Selmi noted in 2013 that voting rights litigation activity during Obama's first term was "roughly the same as was filed by the second [George W.] Bush administration and far below the activity of Bush's first administration."[38] Although this lackluster

record was attributable, at least in part, to problems that preceded Obama's presidency, it also belied his pledge to restore rigor to federal enforcement of minority voting rights.

Justice's Stand against Voter ID

Beginning in late 2011, however, the attorney general and the CRD began to adopt a more proactive posture, taking a prominent, if belated, stand against the wave of stringent voting laws that were being enacted primarily in Republican-controlled states. In a December 2011 address at the Lyndon B. Johnson Presidential Library in Austin, Texas, Holder urged "political parties to resist the temptation to suppress certain votes in the hope of attaining electoral success" and warned that discriminatory laws would face Department objections.[39] Coming in the midst of CRD review of laws in South Carolina and Texas requiring voters to produce photo identification before casting ballots and of provisions in Florida shortening the early-voting period and tightening regulations on voter registration organizations, the speech appeared to signal "tough review of state laws on voting rights."[40]

Soon after Holder's address, the DOJ issued objections to both the South Carolina and the Texas laws, placing the administration squarely on the side of liberals and civil rights activists in the "escalating national legal battle over voter ID laws," the *Washington Post* reported. Indeed, as the first departmental objections to state voter identification laws since 1994, the objections represented a major expansion of federal enforcement under the VRA as well as a clear repudiation of the approach adopted by the Bush administration.[41] Further indications of the reinvigoration of voting rights enforcement appeared in June 2012, when a federal court agreed with the objection by the Division to Florida's proposed election rules.[42]

These developments—coupled with increasingly outspoken criticism of restrictive voting regulations by the attorney general and other administration officials—outraged Republican elected officials throughout the South, who maintained that voter ID laws and other stringent rules were necessary to prevent voter fraud by impersonation.[43] Republicans in Congress charged that the true purpose of the administration's intensified scrutiny of voter ID laws was to "help [Obama] win a second term" in office.[44] The ensuing election season was marked by a flurry of suits and countersuits by political campaigns to either challenge or defend controversial voter-access rules, crowding the federal court system with voting rights litigation that would continue to play out after the election had concluded.[45]

The Obama Administration's Implementation
of the VRA after *Shelby County*

The 2012 presidential election returned Obama to the White House—just in time to confront the voting rights fallout over *Shelby County v. Holder*. Indeed, hurried efforts by southern states to institute stringent voter rules in the wake of the ruling created a heightened sense of urgency within Obama's Department of Justice and forced administrative officials to adopt new legal strategies to counter these measures.[46] All told, the administration's experience illustrated the myriad difficulties involved in fighting voting rights violations via litigation *after* potentially discriminatory laws had already been implemented. This in turn highlighted the severity of the impact of *Shelby County v. Holder* on the scope of voting rights enforcement.

Responding to the June 2013 announcement by Texas attorney general Greg Abbott that the state would immediately implement its voter ID law, Holder declared that the Division would urge a federal judge to enjoin the rules and require the state to continue to submit its election-law changes to the federal courts for preapproval.[47] The gambit relied in part on Section 3 of the Act—a seldom-used provision that allows federal courts to "bail in" jurisdictions to preclearance coverage if they are found to engage in intentional voting discrimination that violates the Constitution. Holder's actions indicated that Section 3 might enjoy a renaissance as a weapon in the Division's post–*Shelby County* struggle against state voter ID laws.[48] In fact, just months later the DOJ filed an almost identical suit to block implementation of a suite of stringent new voting rules by the state of North Carolina.[49]

In truth, however, Holder's new initiatives attested to the Department's weakened legal position in the post–*Shelby County* era. The DOJ's efforts to block implementation of stringent voting rules in the two states relied on Section 2 of the VRA. Unlike Section 5, which places the burden on covered jurisdictions to demonstrate that proposed changes in voting rules or regulations do not have the intent or effect of reducing minority political power, Section 2 puts the onus on critics of new rules to prove that such changes leave vulnerable groups with fewer opportunities to participate in the political process. Furthermore, whereas preclearance is an administrative procedure that is largely dominated by the Department of Justice, Section 2 enforcement is based on litigation, with ultimate decision-making authority residing in the federal courts. Because the success rate of Section 2 litigation in areas formerly covered by Section 4 has been approximately 40 percent over the last

thirty years, plaintiffs faced an uphill battle in efforts to challenge stringent election rules (which previously might have been denied preclearance, at least by the Obama administration) through Section 2 suits.[50]

Indeed, the parallel sagas of the DOJ's challenges to the North Carolina and Texas rules highlighted the considerable costs and protracted time frames associated with Section 2 litigation—even when such litigation ends in success. In the North Carolina case, federal judge Thomas Schroeder (a George W. Bush appointee) denied the Obama administration's request for a preliminary injunction in August 2014, ensuring that the measures—widely viewed as the most draconian in the nation—would be on the books for the 2014 midterm elections.[51] Following the elections, both the administration and private civil rights organizations continued their suits against the state.[52] Finally, in July 2016, a federal appeals court struck down the North Carolina law, noting that it targeted African American voters "with almost surgical precision."[53] But North Carolina appealed the decision to the US Supreme Court in August 2016, setting the stage for further legal proceedings.[54]

In the Texas case, a federal court initially enjoined the state's strict voter identification law. The US Supreme Court reversed in October 2014, however, allowing the state to go through with enforcement of the law in the 2014 elections.[55] After the election the Obama administration resumed its legal challenge, receiving a favorable ruling from a three-judge panel of the Fifth Circuit Court of Appeals in August 2015. But the state immediately requested, and received, a rare en banc review of the panel ruling by the fifth circuit's entire fifteen-judge bench.[56] In late July 2016, the fifth circuit again sided with the administration and civil rights plaintiffs, upholding the panel ruling and remanding the case to the US District Court for the Southern District of Texas to create a remedy for voters burdened by the state's voter identification requirement.[57]

Prior to the death of associate justice Antonin Scalia, it is likely that a majority of the Court would have sided with each of the states in question, paving the way to implementation of their stringent voting rules in the 2016 elections. With Scalia's passing, however, the Court was equally divided between liberals and conservatives, leaving open the possibility that it would split 4–4 and thereby leave the lower court rulings in place. On August 30, 2016, the Court divided in just this fashion on the matter of North Carolina's appeal, with the practical result of leaving the lower court's ruling in place. This represented a major legal victory for the Obama administration and civil rights

organizations.[58] (As of March 2017, the Texas case is still being litigated at the district-court level.)[59] Even so, the difficult and protracted histories of both cases underscore the challenges attending the use of Section 2 litigation as a primary mode of voting rights enforcement.

The chronicle of voting rights enforcement during the Obama administration indicated that the politics surrounding implementation of the VRA had come full circle. For much of the previous forty years, Republican presidents had exploited bureaucratic politics as a less visible and traceable means to limit the enforcement of the Act. This had allowed them to limit the scope of federal voting rights enforcement while largely avoiding high-profile and politically embarrassing struggles over minority voting rights. Determined to reestablish the CRD as a guardian of minority voting rights, Barack Obama adopted some of the very same administrative tactics employed by his conservative predecessors. Yet, even as this restructuring allowed the Division to reassert itself as an important player in struggles over the scope of minority voting rights, it heightened tensions within the CRD and exacerbated voting rights conflicts between Democrats and Republicans in Congress. These struggles undermined prospects for a legislative response to the Court's decision in *Shelby County*.

Legislative Struggle over the VRA and the 2016 Presidential Campaign

The *Shelby County* decision invited Congress to develop a new—and, in the view of the conservative justices, constitutionally permissible—coverage formula under Section 4 of the Act. But accomplishing this end was a tall order, despite the staunch support of President Obama and many congressional Democrats. The intensity of partisan polarization on economic and racial matters between 2013 and 2016—reinforced by partisan skirmishing in advance of the 2016 elections—rendered the chances of bipartisan cooperation on voting rights legislation remote. Indeed, roll-call-based measures of partisan polarization in Congress indicated that party divisions reached unprecedented heights during Obama's second term in office, further eroding the already limited common ground on which a voting rights compromise could be constructed.[60]

The changed policy circumstances resulting from the *Shelby County* decision reinforced the partisan obstacles to reinstatement of Section 4, primar-

ily by removing the institutional and electoral constraints that had previously
dissuaded Republicans from vigorously contesting renewal of the Act in Con-
gress. Prior to *Shelby County*, the high visibility, traceability, and openness of
the legislative process strongly encouraged Republicans to acquiesce to con-
tinuation of the coverage formula and preclearance despite the staunch oppo-
sition of many in the GOP to these provisions (and the general conservatism
of many Republicans on civil rights issues, especially after 1980). This imper-
ative explained overwhelming GOP support for the reauthorization in 2006
despite the extreme conservatism of the party caucus at the time. In stark con-
trast, because the conservative position—the absence of preclearance—repre-
sented the status quo in the post–*Shelby County* era, Republicans were spared
the burden of explaining and justifying departures from the prevailing state
of affairs. Indeed, to maintain their preferred status quo, Republicans sim-
ply had to exploit the characteristic institutional conservatism of Congress
(rendered easier by their control of both chambers after 2014) and raise ques-
tions about Democrats' untested policy proposals. The *Shelby County* ruling
thus granted congressional Republicans the ability to sustain—perhaps per-
manently, given their capacity to filibuster in the Senate—a political decision
that many Republican legislators had long desired but could never have ac-
complished by legislative means.

Frustrated in the legislative domain, Democrats, led by presidential nom-
inee Hillary Clinton, sought to make minority vote suppression a major issue
on the campaign trail. This strategy—though effective as a means to mobi-
lize Democratic voters—further eroded prospects for reinstatement of pre-
clearance prior to the 2016 elections by placing even more emphasis on the
partisan implications of the revitalization of the Act and thereby encouraging
Republicans to double down on their opposition.[61]

Congressional Politics After Shelby County

Shelby County "put a dagger in the heart of the Voting Rights Act of 1965,"
exclaimed civil rights luminary and Georgia congressman John Lewis.[62] In
the wake of the ruling, the major civil rights organizations scrambled to de-
velop remedial legislation and win support among influential members of
Congress. A long-planned August 2013 commemoration of the 1963 March
on Washington, organized by the NAACP, National Urban League, National
Action Network, and other civil rights organizations and attended by tens of
thousands of marchers, served as the effective kickoff for this effort. Speaker
after speaker at the event "cited [the] recent Supreme Court ruling that effec-

tively erased a key anti-discrimination provision of the 1965 Voting Rights Act," and they called for new legislation to restore the coverage formula and reinstate the preclearance process.[63]

But while civil rights activists reached out to virtually all major Republican politicians, "not a single Republican elected official stood on the steps of the Lincoln memorial . . . with activists, actors, lawmakers and former presidents invited to mark the 50th anniversary of the March on Washington."[64] The absenteeism of rank-and-file Republican officeholders seemed to provide a clear indication that voting rights did not rate highly among the legislative priorities of the GOP, which boded ill for efforts to revitalize the VRA.

Nonetheless, working closely with Democratic representatives John Lewis of Georgia and John Conyers of Michigan, Republican representative James Sensenbrenner of Wisconsin, and Democratic senator Patrick Leahy of Vermont, civil rights organizations hammered out a proposal to renew the VRA over the winter of 2013–2014. The centerpiece of the legislation, introduced in January 2014 and dubbed the Voting Rights Amendment Act (VRAA), was a new coverage formula that would have reinstated federal preclearance of proposed voting changes in covered jurisdictions. Under the new formula, only jurisdictions with documented voting rights violations within the past fifteen years would be subject to preclearance, but new jurisdictions could be bailed in to the coverage formula if they committed the requisite number of violations within a fifteen-year period.[65] The VRAA also strengthened other provisions of the Act. It enhanced Section 3 by dropping the requirement that only intentional voting discrimination could be used as grounds for a bail-in. (The loosened rules would have substantially aided the Obama administration's ongoing efforts to bail states into preclearance coverage under Section 3.) The language of the VRAA also made it easier for plaintiffs to obtain preliminary injunctions against potentially discriminatory voting laws, enhanced the authority of the attorney general to send election monitors to jurisdictions with histories of discrimination against language-minority voters, and required subdivisions in all fifty states to publicize certain changes to election rules and regulations.[66]

Nonetheless, in an acknowledgement of just how much the *Shelby County* decision had shifted the legislative advantage in favor of Republican opponents of preclearance, the VRAA coverage formula represented a significant retreat from the pre–*Shelby County* status quo. Whereas the VRA had previously required federal preclearance of proposed voting changes in all or part

of fifteen states, the coverage formula featured in the VRAA extended only to Georgia, Louisiana, Mississippi, and Texas. As the price of maintaining Sensenbrenner's cooperation, previous DOJ objections against state voter ID laws could not be counted against states as voting rights violations for purposes of coverage under the new formula.[67]

Even with these concessions, advocates of the VRAA faced great difficulty in eliciting Republican support. "Right now, the hurdle is getting Republican votes," Florida Democrat Alcee Hastings emphasized.[68] Hastings's observation was, if anything, an understatement. In stark contrast with the behavior of their predecessors during the 2005–2006 reauthorization process, both Republican Speaker of the House John Boehner of Ohio and Republican Senate minority leader Mitch McConnell of Kentucky declined to endorse the VRAA in 2014.[69] Moreover, the legislation drew miniscule cosponsorship support from Republicans in either the House (only 11 of 166 cosponsors were Republicans) or the Senate (0 of 12 cosponsors were Republicans).[70] The behavior of both Republican leaders and rank-and-file legislators pointed both to growing partisan polarization over minority voting rights and to rising awareness in the GOP caucus that the *Shelby County* decision had finally freed Republicans to fully express their opposition to the coverage formula and preclearance.

Republican resistance only hardened following the shocking defeat of House majority leader Eric Cantor of Virginia by Tea Party candidate David Bratt in a June 2014 Republican primary election. The rout of Cantor—who had expressed tentative support for a legislative "fix" for the *Shelby County* decision—seemed to point to widespread antipathy toward the VRA among Republican activists and primary election voters and thus reinforced unwillingness to consider the bill among Republican legislators.[71]

In the House, Republican representative Bob Goodlatte of Virginia, chairman of the House Judiciary Committee and a noted critic of preclearance, declined to schedule a markup of the legislation, and Republican leaders refused even to discuss scheduling a floor vote.[72] Meanwhile, during a June 2014 Senate hearing on the VRAA, top Republicans voiced incredulity about the continued focus of the legislation on southern states.[73] The hearing marked the end of the road for the VRAA in that chamber.

Voting Rights Reform as a 2016 Campaign Issue

The 2014 elections strengthened Republican dominance in the House and turned over control of the Senate to the GOP. The apparent electoral mandate encouraged Republicans to double down on opposition to the reinstatement

of the coverage formula and preclearance. House Judiciary Committee chairman Bill Goodlatte announced that Republicans had concluded that "[they had] not seen a process forward that is necessary [to restore Section 4 of the VRA] because [they] believe[d] the Voting Rights Act provided substantial protection in this area."[74] Because any bill would have to clear his committee in order to be enacted into law, the statement amounted to a pronouncement by the House Republican Caucus that there would be no voting rights legislation during the 114th Congress. This further underscored Republican determination to maintain the new—and in their view, favorable—programmatic status quo established by the conservative majority on the Supreme Court.

Nonetheless, buoyed by President Obama's January 2015 State of the Union request that "on this 50th anniversary of the great march from Selma to Montgomery and the passage of the Voting Rights Act, we . . . come together, Democrats and Republicans, to make voting easier for every single American," Conyers and Sensenbrenner gamely resubmitted their bill in the House.[75] As in the previous Congress, however, few Republicans moved to support the legislation: of 107 House cosponsors of the bill, only 15 were Republicans.[76] Realizing that the majority of Republicans were unlikely to accept even a mild version of preclearance, Democratic lawmakers changed tactics in June 2015, advancing symbolic legislation that could not be enacted in the GOP-controlled Congress but embodied the programmatic objectives of liberals and civil rights activists. Although the "Voting Rights Advancement Act of 2015" (VRAA2) incorporated the VRAA's muscular provisions pertaining to bail-in, injunction authority, and transparency, the new legislation proposed a much more expansive, "rolling" coverage formula that would have initially covered thirteen states. The VRAA2 also provided for nationwide preclearance coverage for "a limited universe of voting changes that have historically been found to be discriminatory"—including changes to methods of election, jurisdiction boundaries, the contours of minority districts, and rules governing voting qualifications—in political subdivisions with substantial nonwhite or minority-language populations.[77] The legislation was clearly a Democratic project; indeed, 100 percent of the bill's 178 House cosponsors and 93 percent of its 45 Senate cosponsors were Democrats.[78]

Because the sweeping provisions of the VRAA2 had no chance of becoming law, it was evident that Democrats introduced the measure to reaffirm their commitment to minority voting rights, create a favorable contrast with the Republican Party, and fire up civil rights leaders and liberal constituents

going into the pivotal 2016 campaign season. As Vermont senator Patrick Leahy frankly admitted,

> The previous bill [the VRAA] we did in a way to try and get bipartisan support—which we did. We had the Republican Majority Leader of the House [Eric Cantor] promise us that if we kept it like that it would come up for a vote. It never did. We made compromises to get [Republican] support and they didn't keep their word. So this time I decided to listen to the voters who had their right to vote blocked and they asked for strong legislation that fully restores the protections of the VRA.[79]

As might be expected given the partisan politics surrounding voting rights, both bills languished in Congress. Indeed, a Democrat-backed discharge petition to force the VRAA2 out of Goodlatte's committee and bring it to a vote on the House floor, supported by 181 Democrats (out of 186) and 0 Republicans (out of 247), failed due to the universality of Republican opposition.[80]

Obstruction of renewal of the coverage formula and preclearance by the GOP became a galvanizing political theme for Democrats beginning in the summer of 2015.[81] Hillary Clinton, the eventual winner of the 2016 Democratic presidential nomination, made criticism of stringent voting rules and calls for rejuvenation of the VRA central campaign themes.[82] "Forty years after Barbara Jordan [the first African American woman elected to Congress from Texas] fought to extend the Voting Rights Act, its heart has been ripped out," Clinton declared in a major June 2015 speech at Jordan's alma mater, the historically black Texas Southern University. Using especially pointed language, Clinton characterized voter ID laws as "nakedly partisan" attempts by Republicans to "limit the electorate" and criticized Republican presidential aspirants for supporting these measures.[83] During the fall of 2015 and spring of 2016, Clinton continued to highlight voting rights issues, "criticizing Republican leaders . . . for ID laws that she said have made voting harder for people of color and young people."[84]

Meanwhile, Democratic operatives, led by Marc Elias, a prominent elections lawyer and counsel to Clinton's campaign, mounted a nationwide legal struggle funded by liberal billionaire George Soros to roll back restrictive voting rights laws.[85] "[Restrictive voting rules are], right now, the big fight in politics," Elias argued, "and will be one of the defining fights I think for the next five to 10 years."[86] Elias's team brought major lawsuits challenging conservative-backed election rules in Ohio, Michigan, Virginia, and Wisconsin to,

in Elias's words, "ensure that every eligible voter has an opportunity to vote and have their vote counted without unreasonable hurdles being put in their way."[87] They also joined the DOJ's fight against restrictive rules in North Carolina and Texas.

By the end of September 2016, Elias's team had participated in important legal victories in North Carolina and Texas, as noted above; in Wisconsin, where a federal judge began overseeing efforts to "make it easier for those lacking the state's required ID to cast ballots"; and in Michigan, where a federal court enjoined the state's ban on straight-ticket ballots on the grounds that it would increase wait times at polls and thereby discriminate against African American voters. But the team also suffered a defeat in Ohio, where a federal appeals court declined to overturn the state's recently enacted rules shortening the time period in which individuals could register and vote at the same time.[88] Although the outcomes of other suits were unpredictable, the litigation had important political ramifications that dovetailed with the broader electoral interests of the Democratic Party. As voting rights expert Richard L. Hasen cogently argued, "These lawsuits serve a political purpose even if they are not successful legally. They keep the issue of voter suppression in the minds of Democratic constituencies and help galvanize Democratic voters. It puts Democrats on the offensive rather than the defensive."[89] Elias himself made the linkage between his litigation efforts and Democratic campaigning explicit, frankly stating that "the way to reauthorize the Voting Rights Act is to make Nancy Pelosi the speaker of the House and Chuck Schumer the [Senate] majority leader and put Hillary Clinton in the White House."[90]

Predictably, efforts by Democrats to transform the struggle over the VRA into a major campaign issue elicited harsh criticism from top Republican and conservative operatives. The contenders for the Republican presidential nomination universally panned Clinton's proposals, even as they generally ignored voting rights matters.[91] Indeed, after winning the Republican presidential nomination, Donald Trump disregarded voting rights issues, instead focusing on the specter of alleged voter fraud. Contrary to all available evidence, Trump claimed that the 2016 election was likely to be marked by systematic fraud, going so far as to suggest that "the only way we can lose, in my opinion . . . is if cheating goes on."[92] These warnings—broadcast in "increasingly urgent and racially suggestive language"—appeared intended to cast doubt on the legitimacy of the election if the result favored Hillary Clinton.[93] Trump's statements represented a particularly ugly escalation of the rhetoric

surrounding the subject of voter fraud and further undermined prospects for political compromise on voting rights matters.

Conclusion

"What's left of the Voting Rights Act?," the *New York Times Magazine* asked rhetorically in August 2015.[94] The answer is clear: while the Act is not irreparably broken, it is battered and at clear risk of further diminution. Even before the Supreme Court's ruling in *Shelby County*, the ability of President Obama to implement the Act had been weakened by the reduced staff capacity and bureaucratic infighting within the CRD deriving from the politicization of hiring and administrative procedures during the Bush administration. Efforts by Obama to rehabilitate the Division ensnared the president and his political appointees in bureaucratic intrigue while also further eroding the standing of the president with congressional Republicans, whose support was necessary if the VRA was to remain robust over the long run. After *Shelby County*, the Obama administration and civil rights organizations gamely continued efforts to combat restrictive state voting rules. Although these exertions scored notable legal victories in North Carolina, Texas, Wisconsin, and Michigan between 2013 and 2016, they also highlighted the tremendous costs and uncertainty associated with voting rights enforcement in the post–*Shelby County* era.

Shelby County also transformed the legislative politics surrounding the VRA, establishing a new status quo in which conservatives enjoyed an advantaged strategic position. By effectively terminating preclearance, the decision freed Republican critics of the VRA from the burden of having to justify legislative attacks on Section 5 themselves. The ruling also enabled Republicans to exploit the characteristic institutional conservatism of Congress to maintain a relatively narrow federal voting rights paradigm that they could never have enacted by legislative means. The combination of conservative judicial activism and Republican legislative obstructionism has fostered a new status quo that in important respects resembles the situation prior to enactment of the VRA in 1965. In that atmosphere, civil rights advocates and federal officials were forced to rely on litigation as the primary mode of enforcement.

Conclusion

Partisan Interests, Institutional Conflict, and
the Future of the Voting Rights Struggle

URING THE 2016 PRESIDENTIAL CAMPAIGN, THE DEPART-
ment of Justice, civil rights activists, conservative legal organiza-
tions, and Republican state-election officials waged intense legal battles over
restrictive voting laws in states throughout the nation. In Texas—where a fed-
eral court had ruled that the state's voter ID law discriminated against mi-
nority voters—Department of Justice officials filed a new legal complaint in
mid-September charging that state election officials were implementing the
order to publicize the court's decision and accept a wider array of identifica-
tion at the polls in bad faith.[1] (Finally, in late September 2016 the court issued
an extraordinary order requiring the state to publish new materials that ac-
curately explain the relaxed rules for voter ID and furnish federal attorneys
and voting rights plaintiffs with copies of all relevant documents.)[2] Mean-
while, in dozens of North Carolina counties, Republican-controlled county
election boards were reportedly attempting to limit early voting in spite of a
federal appeals court ruling that such measures intentionally discriminated
against African American voters. Predictably, these maneuvers spurred civil
rights organizations to prepare new suits to enjoin these activities.[3] In Ne-
vada, tribal leaders filed suit against two counties and the state secretary of
state on the grounds that the counties' failure to establish accessible sites for
in-person voter registration and in-person early voting by tribal members
discriminated on the basis of race.[4]

While voting rights litigation pitting the federal government and civil

rights plaintiffs against state officials garnered headlines, local governments throughout the nation—but especially in jurisdictions previously covered by Sections 4 and 5 of the VRA—were quietly altering election rules in ways that may disproportionately burden people of color and language-minority citizens. Indeed, between June 2013 and September 2016 the NAACP Legal Defense Fund tallied dozens of subtle alterations in election rules—such as changes in methods of election, middecade redistricting, purges of voter rolls, relocation of polling places, reductions in the number of polling places, and so forth—in counties and municipalities previously covered by Sections 4 and 5. These alterations may make it more difficult for members of historically disadvantaged communities to vote and wield political influence.[5] While civil rights organizations prepared to challenge some of these initiatives in court, the sheer number of alterations overwhelmed the availability of legal resources.

Republican candidate Donald Trump's shocking victory in the 2016 presidential election undoubtedly reinforced escalating conflict over federal voting rights enforcement. Indeed, coming on the heels of his repeated claims that the presidential election would probably be characterized by extensive voter fraud, Trump's election likely paved the way for renewed executive efforts to circumscribe federal voting rights enforcement. Even though Trump won the election (despite losing the popular vote), the president-elect continued to claim that the election was marred by extensive voter fraud, suggesting that he views fraud prevention rather than voting rights enforcement as his top priority.[6] The impression that Trump was hostile to robust federal voting rights enforcement was reinforced with his announcement of his pick for the attorney generalship. Trump's nominee to lead the Department of Justice, Republican Alabama senator Jeff Sessions, who unsuccessfully prosecuted black voting rights activists on trumped-up voter fraud charges during his stint as a US attorney during the Reagan era, is a fierce critic of the VRA.[7] More generally, Sessions's history of racially insensitive remarks—including allegations that he referred to a black attorney as "boy" and attacked the NAACP and ACLU as "un-American" for "forcing civil rights down the throats of people"—is so explosive that it once led a Senate committee to deem him unfit for a federal judgeship.[8] Given Trump's general willingness to bend or break the rules to achieve his political objectives, a major diminution of federal voting rights enforcement—and even a return to the egregious politicization of the George W. Bush years—seems likely. Indeed, in one of the most prominent

decisions of his early tenure as attorney general, Sessions dropped the DOJ's legal charge that the state of Texas adopted its voter ID law with discriminatory intent, signaling a retreat from the more vigorous enforcement activities of the Obama administration.[9]

Considered together, these developments represented the culmination of more fundamental trends in voting rights policy making—specifically, the gradual supplanting of a legislative politics that generally favored the expansion of minority voting rights with an administrative and judicial politics that rendered these rights more vulnerable to contestation and retrenchment—that had been underway since 1968. As I have argued in this book, while the legislative process has consistently expanded federal voting rights safeguards, administrative developments and judicial rulings have increasingly chipped away at these protections. Over time, this dynamic has rendered the right to vote ever more precarious; at the same time, it has eroded the authority of the most democratic branch of the federal government to safeguard the rights of minority voters. Today, this dynamic is encapsulated in the stark contrast between the proliferation of legal struggles over minority voting rights in jurisdictions previously covered by Sections 4 and 5 and the complete absence of serious legislative work to respond to the *Shelby County* decision in Congress.

This characteristic developmental pattern is attributable in turn to the political dynamics traced throughout this book. I argue that this pattern emanated from efforts by critics (affiliated primarily but not exclusively with the Republican Party) of robust federal voting rights enforcement to narrow the scope of federal intervention while at the same time maintaining the electorally valuable reputation of party support for minority voting rights. Throughout the 1965–2016 period, conservatives faced cross-cutting political pressures. On one hand, ideological commitments and constituency demands pushed them toward a narrow understanding of federal voting rights enforcement. On the other hand, electoral pressures to cater to moderate whites and people of color discouraged them from seeking to limit the federal role in a too obvious or aggressive fashion. For these figures, the political challenge was to find a way to reduce the scope of federal voting rights enforcement without alienating moderate whites and people of color and thereby diminishing their electoral prospects.

Over time, Republicans learned that this objective could be furthered through a strategy that exploited the varying visibility, traceability, and accessibility of decision-making processes on voting rights matters within the

various branches of the federal government. In Congress, where decision-making on voting rights matters is extremely visible, easily traceable to the choices of elected officials, and broadly accessible to a range of interests, Republican elected officials repeatedly acquiesced to expansive reauthorizations of the Voting Rights Act—despite the clear opposition of many within the GOP caucus to robust federal voting rights enforcement—in order to safeguard the party's reputation. Yet Republicans worked in a consistent fashion to weaken federal voting rights protections when granted the opportunity through administrative maneuvers and judicial appointments—two channels that, at least on voting rights matters, have been characterized by lower visibility, lesser traceability for controversial decisions, and limited responsiveness to demands from outside groups. Over time, these dynamics fostered the divergence of legislative policy making from administrative and (especially) judicial policy making and the eventual ascendance of conservative jurisprudence in delimiting the scope of voting rights enforcement.

Across the many varied observations of voting rights politics presented in the preceding chapters, I found extensive evidence in favor of this argument. First and foremost were the internal memos and other archival documents prepared by presidential aides, members of Congress, and political activists pointing to electoral imperatives as a core motivation for Republicans' acquiescence to expansive voting rights bills despite their skepticism of these initiatives. But more subtle clues could be discerned in the patterns of behavior of Republican officials. For example, the fact that many Republican (and some Democratic) members of Congress repeatedly voted for final passage of expansive voting rights proposals despite previously supporting failed amendments that would have seriously weakened the VRA provided indications that they felt politically constrained to appear supportive of minority voting rights when it counted—that is, when the question was whether there would be an extension of the VRA.

Or consider the fact that Republican presidents repeatedly adopted administrative strategies—appointments, staffing practices, and bureaucratic routines—that served to undermine the expansive legislation they ostensibly endorsed. Although puzzling if one takes Republican presidential support for voting rights legislation at face value, these actions make sense if we take a broader view of Republican incentives and electoral strategies. From this perspective, we can appreciate that these administrative practices enabled Republican presidents to accomplish an objective consistent with conservative

ideology and core constituency preferences (limiting the scope of federal voting rights enforcement) while at the same time advancing a critical electoral interest (maintaining a positive reputation on voting rights matters). In this way, the recurrence of these divergent patterns of behavior provides strong support for my central argument.

Similarly, the peculiar patterns surrounding Republican presidents' Supreme Court nominations—in particular, the repeated articulation of judicial philosophies and selection of judicial nominees whose principles seemed in serious conflict with the spirit of the voting rights legislation these presidents signed into law—make sense once electoral imperatives and institutional politics are taken into account. Republican presidents' judicial nominations did not contradict their legislative decisions. Rather, both played a distinct part in Republicans' overarching strategy of limiting the scope of federal voting rights enforcement by means that would obscure instead of underscore GOP culpability. Thus, repeated observation of this pattern across several Republican presidential administrations—especially the Nixon, Reagan, and Bush II administrations—lends greater credence to my argument. On the whole, close inspection of the evidence accumulated in this book provides many convergent observable implications.

In addition to providing a satisfying explanation of the striking development of federal voting rights policy making, this book enriches our understanding of the politics surrounding efforts by partisan coalitions to entrench their ideological and political commitments in law and policy making. My in-depth study provides strong confirmation for the provocative claim that elected officials may invite—in fact, empower—unelected political allies to challenge and even countermand legislative choices these same elected officials deplored but were unwilling to block. Indeed, under circumstances such as those faced by conservative Republicans between 1969 and 2013, this counterintuitive strategy makes perfect political sense, despite its troubling normative implications.

At the same time, my work points to the possibility that this politics of institutional retrenchment may proceed in an incremental—rather than wholesale—fashion. Much previous research on efforts to advance controversial programmatic objectives through institutional entrenchment in the bureaucracy or federal courts focuses on the efforts of "lawmaking majorities" of "dominant national coalitions" enjoying preponderant (if transitory) control of the federal government. Under such conditions, these dominant co-

alitions work in authoritative fashion, exploiting their majorities to institutionalize their preferences against challenges by their political rivals. Yet, as I show in this book, Republican critics of expansive voting rights enforcement achieved considerable—if gradual—success in institutionalizing their voting rights preferences in the bureaucracy and federal courts between 1969 and 2016 despite lacking a dominant national coalition during this period (except, perhaps, briefly between 2001 and 2006). Importantly, though, this success did not come all at once or even during a relatively short period of time. Rather, Republican presidents exploited moments—sometimes fleeting—of control of one or more of the elective branches of the federal government to incrementally advance a narrower vision of federal voting rights enforcement through the bureaucracy or courts. Furthermore, both because Democrats remained a potent force in Congress throughout the period and because Republicans were constrained to appear publicly supportive of minority voting rights, their efforts to entrench a more conservative approach via administration and jurisprudence were always complicated by their acquiescence to more expansive voting rights legislation. Thus, the overarching trajectory toward a more fragmented system of federal voting rights enforcement—and ultimately a more conservative one, insofar as it limits federal authority and places minority voting rights at greater risk of diminution—was halting and protracted rather than authoritative and swift.

Finally, this book takes a pragmatic view of both the promise and limitations of each of the branches of the federal government in relation to the rights of vulnerable groups in society. Rather than arguing that this or that branch holds out the most hope for progress in the realm of civil rights as a general matter, I emphasize the flexibility and capacity of each branch to serve as a protagonist (or antagonist) in the civil rights struggle. Indeed, this book illustrates how all three branches have been strategically utilized and manipulated by both proponents and opponents of racial equality in specific consequential struggles over federal voting rights enforcement. From 1965 to 2015, Congress best served the cause of expanding voting rights while the executive branch and especially the Supreme Court frequently advanced a narrower view of federal voting rights enforcement. This reflected a particular configuration of political and institutional forces—most notably, the authoritative institutionalization of robust federal voting rights enforcement with the enactment of the VRA in 1965, an enduring pattern of strong Democratic influence in Congress between 1965 and 2016, and an emergent pattern of Republican dominance of the presidency (especially between 1968 and 2008).

Under different political and institutional conditions, however, it is possible that either the executive branch or the federal courts could supersede Congress as the most effective guarantor of minority voting rights. Even then, though, the underlying premise of this book—that partisan and racial coalitions manipulate the unique characteristics of the various branches of the federal government to advance preferred racial agendas while simultaneously cultivating favorable public reputations—would continue to illuminate our understanding of voting rights politics.

Trump's presidential victory and nomination of the controversial Sessions to lead the Department of Justice indicate that, rather than fading into the annals of American history, partisan and racial struggle over access to the ballot will only intensify in the coming years. Indeed, civil rights activists anticipate a difficult—and quite possibly desperate—conflict to maintain existing federal voting rights protections and head off new restrictive state legislation.[10] For American politics in general, and for the Republican Party in particular, this represents a tragic missed opportunity. Although political parties in the United States have often served as agents of exclusion, American democracy would be much better served if they operated as engines of political incorporation.[11] Yet, if the regular workings of party politics obstruct the expansion of suffrage, other vehicles must be found through which thwarted citizens can realize their aspirations. As President Obama recently observed, the VRA "didn't come to pass because folks suddenly decided it was the right thing to do"; rather, the legislation was enacted because civil rights activists created political conditions in which elected officials felt compelled as a matter of electoral necessity—despite underlying ideological preferences or the demands of core constituencies—to adopt federal safeguards to protect vulnerable voters.[12] Thus, just as the Voting Rights Act of 1965 was brought into existence through the struggles of civil rights activists on the Edmund Pettus Bridge in Selma, Alabama, so too may the next chapter of America's voting rights history be written on the streets of cities and towns throughout the nation.

Notes

Introduction

1. Grassley quoted in Jackie Calmes, "On Voting Case, Reaction from 'Deeply Disappointed' to 'It's About Time," *New York Times*, June 26, 2013; Sessions quoted in Richard Wolf and Brad Heath, "Ruling Resets Voting Rights Fight," *USA Today*, June 26, 2013.

2. Quoted in Meena Ganesan, "Supreme Court Decisions: Voting Rights Act Reaction Live," *PBS NewsHour*, June 25, 2013, accessed October 23, 2015, available at http://www.pbs.org/newshour/rundown/supreme-court-decisions-voting-rights-act -gay-marriage-reaction/. See also David Weigel, "Southern Republican Senators Happy That Supreme Court Designated Their States Not-Racist," *Slate*, June 25, 2013, http:// www.slate.com/blogs/weigel/2013/06/25/southern_republican_senators_happy_that _supreme_court_designated_their_states.html.

3. Transcript of Oral Arguments in the Supreme Court of the United States, Shelby County, Alabama v. Eric H. Holder Jr., Attorney General, et al., Washington, DC, February 23, 2013, accessed October 2, 2015, available from the Supreme Court website, http://www.supremecourt.gov/oral_arguments/argument_transcripts/12-96 .pdf, at 46–48.

4. Transcript of Oral Arguments, US Supreme Court, *Shelby County*, at 48.

5. For reviews, see, for example, J. Mitchell Pickerill and Cornell W. Clayton, "The Rehnquist Court and the Political Dynamics of Federalism," *Perspectives on Politics* 2, no. 2 (2004): 233–48; and Thomas M. Keck, "Party Politics or Judicial Independence? The Regime Politics Literature Hits the Law Schools," *Law & Social Inquiry* 32, no. 2 (2007): 511–44.

6. Mark Graber, "The Nonmajoritarian Difficulty: Legislative Deference to the Judiciary," *Studies in American Political Development* 7, no. 1 (1993): 35–73; Terri Jen-

189

nings Peretti, *In Defense of a Political Court* (Princeton, NJ: Princeton University Press, 1999); Howard Gillman, "How Political Parties Can Use the Courts to Advance Their Agendas: Federal Courts in the United States, 1875–1891," *American Political Science Review* 96, no. 3 (2002): 511–24; Howard Gillman, "Party Politics and Constitutional Change: The Political Origins of Liberal Judicial Activism," in *The Supreme Court and American Political Development*, eds. Ronald Kahn and Ken I Kersch (Lawrence: University Press of Kansas, 2006); George I. Lovell, *Legislative Deferrals: Statutory Ambiguity, Judicial Power, and American Democracy* (Cambridge, UK: Cambridge University Press, 2003).

7. Keith E. Whittington, "'Interpose Your Friendly Hand': Political Supports for the Exercise of Judicial Review by the United States Supreme Court," *American Political Science Review* 99, no. 4 (2005): 583–96; Whittington, *The Political Foundations of Judicial Supremacy* (Princeton, NJ: Princeton University Press, 2007).

8. See, for example, Matthew E. K. Hall, "Rethinking Regime Politics," *Law & Social Inquiry*, 37, no. 4 (2012): 878–907.

9. For example, Robert A. Dahl, "Decision-Making in a Democracy: The Supreme Court as a National Policy-Maker," *Journal of Public Policy* 6, no. 1 (1957): 279–95; and Graber, "Nonmajoritarian Difficulty." These ends may be controversial within the dominant coalition, between the national parties, or at the state and local levels.

10. I thank an anonymous reviewer for this important point.

11. See, for example, the vigorous debate on the question of whether the federal courts can have a significant impact on civil rights struggles by themselves or are ultimately dependent on the president and Congress (and the activism of minority advocates) to advance civil rights agendas. See Gerald Rosenberg, *The Hollow Hope: Can the Courts Bring about Social Change?* (Chicago: University of Chicago Press, 1991); David J. Garrow, "Hopelessly Hollow History: Revisionist Devaluing of *Brown v. Board of Education*," *Virginia Law Review* 80, no. 1 (1994): 151–60; and Michael J. Klarman, "How *Brown* Changed Race Relations: The Backlash Thesis," *Journal of American History* 81, no. 1 (1994): 81–118.

12. Adam Sheingate, "Political Entrepreneurship, Institutional Change, and American Political Development," *Studies in American Political Development* 17, no. 2 (2003): 185–203; Jacob Hacker, "Privatizing Risk without Privatizing the Welfare State: The Hidden Politics of Social Policy Retrenchment in the United States," *American Political Science Review* 98, no. 2 (2004): 243–60.

13. See also James Mahoney and Kathleen Thelen, "A Theory of Gradual Institutional Change," in *Explaining Institutional Change: Ambiguity, Agency, and Power*, ed. James Mahoney and Kathleen Thelen (Cambridge, UK: Cambridge University Press, 2010), 1–37.

14. Colin D. Moore, "Extensions of the Voting Rights Act," in *The Voting Rights Act: Securing the Ballot*, ed. Richard M. Valelly (Washington, DC: CQ Press, 2006). Moore declares that the repeated reauthorization of the VRA reflects "the happy logic of democracy" (at 108).

15. David Garrow, *Protest at Selma: Martin Luther King, Jr., and the Voting Rights*

Act of 1965 (New Haven, CT: Yale University Press, 1978), at xi; and Hugh Davis Graham, "Voting Rights and the American Regulatory State," in *Controversies in Minority Voting*, ed. Bernard Grofman and Chandler Davidson (Cambridge, UK: Cambridge University Press, 1992), 177.

16. Victor Andres Rodriguez, "Section 5 of the Voting Rights Act of 1965 after *Boerne*: The Beginning of the End of Preclearance?," *California Law Review* 91, no. 3 (2003): 769–826; Samuel Issacharoff, "Is Section 5 of the Voting Rights Act a Victim of Its Own Success?," *Columbia Law Review* 104, no. 6 (2004): 1710–31; Nathaniel Persily, "The Promise and Pitfalls of the Voting Rights Act," *Yale Law Journal* 117, no. 2 (2007): 174–254; Daniel P. Tokaji, "If It's Broke, Fix It: Improving Voting Rights Act Preclearance," *Howard Law Journal* 49, no. 3 (2005): 785–842; Richard L. Hasen, "Constitutional Avoidance and Anti-Avoidance by the Roberts Court," *Supreme Court Review* 1, no. 1 (2009): 181–223.

17. Supreme Court watchers recognized, however, that the Court's 2009 decision in *NAMUDNO v. Holder*, in which the majority raised questions about the continued constitutionality of preclearance, made it all but certain that the Court would issue a decisive ruling on the matter in short order. See Richard L. Engstrom, "*NAMUDNO*: A Curveball on Voting Rights," *Justice System Journal* 30, no. 3 (2009): 351–60.

18. The minority language provisions of the Act were also renewed in a separate legislative action in 1992.

19. Alexander Keyssar, *The Right to Vote: The Contested History of Democracy in the United States*, rev. ed. (New York: Basic Books, 2009).

20. Most historical work focuses on enactment of the VRA in 1965. See, for example, Douglas McAdam, *Political Process and the Development of Black Insurgency, 1930–1970* (Chicago: University of Chicago Press, 1982); Garrow, *Protest at Selma*; Taylor Branch, *At Canaan's Edge: America in the King Years 1965–68* (New York: Simon and Schuster, 2007); Nick Kotz, *Judgment Days: Lyndon Baines Johnson, Martin Luther King, Jr., and the Laws That Changed America* (New York: Houghton Mifflin Harcourt, 2005); Brian K. Landsburg, *Free at Last to Vote: The Alabama Origins of the 1965 Voting Rights Act* (Lawrence: University Press of Kansas, 2007); and Gary May, *Bending Toward Justice: The Voting Rights Act and the Transformation of American Democracy*, New York: Basic Books, 2013).

21. See, for example, Ellen D. Katz, "Federalism, Preclearance, and the Rehnquist Court," *Villanova Law Review* 46, no. 5 (2005): 1179–218; Ellen D. Katz, "Reinforcing Representation: Congressional Power to Enforce the Fourteenth and Fifteenth Amendments in the Rehnquist and Waite Courts," *Michigan Law Review* 101, no. 7 (2003): 2341–408; J. Morgan Kousser, "The Strange, Ironic Career of Section 5 of the Voting Rights Act, 1965–2007," *Texas Law Review* 86, no. 4 (2008): 669–775; J. Morgan Kousser, *Colorblind Injustice: Minority Voting Rights and the Undoing of the Second Reconstruction* (Chapel Hill: University of North Carolina Press, 1999); Pamela Karlan, "Section 5 Squared: Congressional Power to Extend and Amend the Voting Rights Act," *Houston Law Review* 44, no. 1 (2007): 1–32; Christian Rivers, *The Congressional Black Caucus, Minority Voting Rights, and the U.S. Supreme Court* (Ann

Arbor: University of Michigan Press, 2012); Laughlin McDonald, "The Counterrevolution in Minority Voting Rights," *Mississippi Law Journal* 65, no. 1 (1995): 271–313; Peyton McCrary, "Bringing Equality to Power: How the Federal Courts Transformed the Electoral Structure of Southern Politics, 1960–1990," *Journal of Constitutional Law* 5, no. 4 (2002): 665–708.

22. See, for example, David Canon, *Race, Redistricting, and Representation: The Unintended Consequences of Black Majority Districts* (Chicago: University of Chicago Press, 1999); David Lublin, *The Paradox of Representation: Racial Gerrymandering and Minority Interests in Congress* (Princeton, NJ: Princeton University Press, 1999); Charles Cameron, David Epstein, and Sharyn O'Halloran, "Do Majority-Minority Districts Maximize Substantive Black Representation in Congress?," *American Political Science Review* 90, no. 4 (1996): 794–812; David Epstein and Sharyn O'Halloran, "Measuring the Electoral and Policy Impact of Majority-Minority Voting," *American Journal of Political Science* 43, no. 2 (1999): 367–95; Katherine Tate, *Black Faces in the Mirror: African Americans and Their Representatives in the US Congress* (Princeton, NJ: Princeton University Press, 2003); Kenny Whitby, *The Color of Representation: Congressional Behavior and Black Interests* (Ann Arbor: University of Michigan Press, 2000); Christian Grose, *Congress in Black and White: Race and Representation in Washington and at Home* (Cambridge, UK: Cambridge University Press, 2011); Paru Shah, Melissa Marschall, and Anirudh V. S. Ruhil, "Are We There Yet? The Voting Rights Act and Black Representation on City Councils, 1981–2006," *Journal of Politics* 75, no. 4 (2013): 993–1008; David Lublin, Thomas Brunell, Bernard Grofman, and Lisa Handley, "Has the Voting Rights Act Outlived Its Usefulness? In a Word, 'No,'" *Legislative Studies Quarterly* 34, no. 4 (2006): 525–53; Matt A. Barreto, Gary M. Segura, and Nathan D. Woods, "The Mobilizing Effect of Majority-Minority Districts on Latino Turnout," *American Political Science Review* 98, no. 1 (2004): 65–75; John D. Griffin and Michael Keane, "Descriptive Representation and the Composition of African American Turnout," *American Journal of Political Science* 50, no. 4 (2006): 998–1012; and Rene R. Rocha, Caroline J. Tolbert, Daniel C. Bowen, and Christopher J. Clark, "Race and Turnout: Does Descriptive Representation in State Legislatures Increase Minority Voting?," *Political Research Quarterly* 63, no. 4 (2010): 890–907.

23. Kousser, "Strange, Ironic Career of Section 5"; Ari Berman, *Give Us the Ballot: The Modern Struggle for Voting Rights in America* (New York: Farrar, Straus, and Giroux, 2015).

24. Kousser, "Strange, Ironic Career of Section 5," 673.

25. Ibid., at 673–74.

26. Ibid., at 775.

27. Ari Berman, "Republicans Used to Support Voting Rights—What Happened?," *The Nation*, April 14, 2014. This theme pervades Berman's popular writing on the subject. See also Berman, "Why Are Conservatives Trying to Destroy the Voting Rights Act?," *The Nation*, February 6, 2013; Berman, "Where are the GOP Supporters of Voting Rights?," *The Nation*, June 25, 2014; and Berman as quoted in Samantha Lachman, "Why the Historic Bipartisan Consensus on Voting Rights Has

Disappeared," *Huffington Post*, September 11, 2015, accessed September 17, 2015, available at http://www.huffingtonpost.com/entry/ari-berman_55f1fc09e4b093be51be527a.

28. The first quote is from Ari Berman, "LBJ's Voting Rights Law Is Being Gutted," *Austin-American Statesman*, October 16, 2015, available at http://www.press display.com/pressdisplay/mobile/articleview.aspx?articleId=2b50b6bd-e114-4690 -8d75-b5fb7ac95cef&bookmarkid=; the second is from Berman, "Why Are Conservatives Trying to Destroy the Voting Rights Act?"

29. Ari Berman, "Inside John Roberts' Decades-Long Crusade Against the Voting Rights Act," *Politico*, August 10, 2015; Ari Berman, "The Conservatives Who Gutted the Voting Rights Act Are Now Challenging 'One Person, One Vote,'" *The Nation*, May 28, 2015. Other journalistic coverage has similarly focused on Roberts's personal role in attacking the VRA, as though Roberts were an individual ideologue rather than the judicial instrument of a broader partisan and racial order. See, for example, Adam Serwer, "Chief Justice Roberts' Long War Against the Voting Rights Act," *Mother Jones*, February 27, 2013; and Emily Bazelon, "John Roberts' Stealthy Plan to Destroy the Voting Rights Act," *Slate*, June 25, 2013.

30. Desmond S. King and Rogers M. Smith, *Still a House Divided: Race and Politics in Obama's America* (Princeton, NJ: Princeton University Press, 2011); Desmond S. King and Rogers M. Smith, "Racial Orders in American Political Development," *American Political Science Review* 99, no. 1 (2005): 75–92; Philip Klinkner and Rogers M. Smith, *The Unsteady March: The Rise and Decline of Racial Equality in America* (Chicago: University of Chicago Press, 1999); Paul Frymer, *Uneasy Alliances: Race and Party Competition in America*, 2nd ed. (Princeton, NJ: Princeton University Press, 2010); Richard Valelly, *The Two Reconstructions: The Struggle for Black Enfranchisement* (Chicago, IL: University of Chicago Press, 2004).

31. Edward G. Carmines and James A. Stimson, *Issue Evolution: Race and the Transformation of American Politics* (Princeton, NJ: Princeton University Press, 1989); Keith T. Poole and Howard Rosenthal, *Congress: A Political-Economic History of Roll Call Voting* (Oxford, UK: Oxford University Press, 2000).

32. See, for example, Daniel DiSalvo, *Engines of Change: Party Factions in American Politics, 1868–2010* (Oxford, UK: Oxford University Press, 2012); Geoffrey Kabaservice, *Rule and Ruin: The Downfall of Moderation and the Destruction of the Republican Party, from Eisenhower to the Tea Party* (Oxford, UK: Oxford University Press, 2012).

33. As Keith Poole and Howard Rosenthal show, in Congress, at least, economic and racial issues have collapsed onto a single dimension of partisan conflict, and the parties have polarized sharply on this dimension since the 1970s. See Poole and Rosenthal, *Congress: A Political-Economic History*.

34. Eric Schickler, *Racial Realignment: The Transformation of American Liberalism, 1932–1965* (Princeton, NJ: Princeton University Press, 2016).

35. John Gerring, *Party Ideologies in America, 1828–1996* (Cambridge, UK: Cambridge University Press, 2001); Hans Noel, "The Coalition Merchants: The Ideological Roots of the Civil Rights Realignment," *Journal of Politics* 74, no. 1 (2012): 156–73.

36. Schickler, *Racial Realignment*; David Karol, *Party Position Change in American Politics: Coalition Management* (Cambridge, UK: Cambridge University Press, 2009), chap. 4; Christopher A. Baylor, "First to the Party: The Group Origins of the Partisan Transformation on Civil Rights, 1940–1960," *Studies in American Political Development* 27, no. 1 (2013): 1–31.

37. Sean Farhang and Ira Katznelson, "The Southern Imposition: Congress and Labor Law in the New Deal and Fair Deal," *Studies in American Political Development* 19, no. 1 (2005): 1–30.

38. Jeffrey A. Jenkins, Justin Peck, and Vesla Weaver, "Between Reconstructions: Congressional Action on Civil Rights, 1891–1940," *Studies in American Political Development* 24, no. 1 (2010): 57–89.

39. Anthony S. Chen, *The Fifth Freedom: Jobs, Politics, and Civil Rights in the United States, 1941–1972* (Princeton, NJ: Princeton University Press, 2009).

40. Schickler, *Racial Realignment*, chap. 5.

41. Gerring, *Party Ideologies in America*.

42. Carmines and Stimson, *Issue Evolution*; Gary Miller and Norman Schofield, "Activists and Partisan Realignment in the United States," *American Political Science Review* 97, no. 2 (2003): 245–60.

43. See, for example, Geoffrey Layman and Thomas Carsey, "Party Polarization and 'Conflict Extension' in the American Electorate," *American Journal of Political Science* 46, no. 4 (2002): 786–802; and Matthew Levendusky, *The Partisan Sort: How Liberals Became Democrats and Conservatives Became Republicans* (Chicago: University of Chicago Press, 2009).

44. See, for example, Jeffrey Stonecash and Howard Reiter, *Counter-Realignment: Political Change in the Northeast* (Cambridge, UK: Cambridge University Press, 2011); and Earl Black and Merle Black, *The Rise of Southern Republicans* (Cambridge, MA: Harvard University Press, 2002).

45. Tali Mendelberg, *The Race Card: Campaign Strategy, Implicit Messages, and the Norm of Racial Equality* (Princeton, NJ: Princeton University Press, 2001), 8.

46. Mendelberg, *The Race Card*, chap. 3; Jon Hurwitz and Mark Peffley, "Playing the Race Card in the Post–Willie Horton Era: The Impact of Racialized Code Words on Support for Punitive Crime Policy," *Public Opinion Quarterly* 69, no. 1 (2005): 99–112.

47. But the presidency of Barack Obama appears to have primed old-fashioned racism as an important factor in American politics. For a review, see, for example, Tali Mendelberg, "Racial Priming Revived," *Perspectives on Politics* 6, no. 1 (2008): 109–23; Lawrence D. Bobo and Camille Z. Charles, "Race in the American Mind: From the Moynihan Report to the Obama Candidacy," *Annals of the American Academy of Political and Social Science* 621 (2009): 243–59; Jonathan Knuckey and Myunghee Kim, "Racial Resentment, Old-Fashioned Racism, and the Vote Choice of Southern and Nonsouthern Whites in the 2012 U.S. Presidential Election," *Social Science Quarterly* 96, no. 4 (2015): 905–22.

48. William N. Eskridge and John Ferejohn, *A Republic of Statutes: The New American Constitution* (New Haven, CT: Yale University Press, 2011), chaps. 1–2.

49. On the link between the ideology of "color-blind" civil rights enforcement

and the interests of middle- and upper-class white suburbanites, see, for example, Matthew Lassiter, *The Silent Majority: Suburban Politics in the Sunbelt South* (Princeton, NJ: Princeton University Press, 2006).

50. Indeed, recent empirical research at both the state and the individual-legislator level provides strong evidence that support for restrictive state voting rules and regulations is driven by the Republican partisan objective of strategically demobilizing minority voters. See, for example, Keith G. Bentele and Erin E. O'Brien, "Jim Crow 2.0? Why States Consider and Adopt Restrictive Voter Access Policies," *Perspectives on Politics* 11, no. 4 (2013): 1088–116; William D. Hicks, Seth C. McKee, Mitchell D. Sellers, and Daniel A. Smith, "A Principle or a Strategy? Voter Identification Laws and Partisan Competition in the American States," *Political Research Quarterly* 68, no. 1 (2015): 18–33; Seth C. McKee, "Politics Is Local: State Legislator Voting on Restrictive Voter Identification Legislation," *Research & Politics*, July 2015, doi: 10.1177/2053168015589804; William D. Hicks, Seth C. McKee, and Daniel A. Smith, "The Determinants of State Legislator Support for Restrictive Voter ID Laws," *State Politics & Policy Quarterly* 2016: 1–21.

51. Eric Schickler, *Disjointed Pluralism: Institutional Innovation and the Development of the U.S. Congress* (Princeton, NJ: Princeton University Press, 2001).

52. On this dynamic, see, for example, Joseph Crespino, *Strom Thurmond's America* (New York: Hill and Wang, 2012).

53. Although voters typically know relatively little about the positions of individual candidates, they do a fairly good job differentiating between the parties based on their overarching policy reputations. For reviews, see, for example, James M. Snyder Jr. and Michael M. Ting, "An Informational Rationale for Political Parties," *American Journal of Political Science* 46, no. 1 (2002): 90–110; and Noam Lupu, "Party Brands and Partisanship: Theory with Evidence from a Survey Experiment in Argentina," *American Journal of Political Science* 57, no. 1 (2013): 49–64.

54. Gary Cox and Mathew McCubbins, *Setting the Agenda: Responsible Party Government in the U.S. House of Representatives* (Cambridge, UK: Cambridge University Press, 2003), at 21.

55. See, for example, R. Douglas Arnold, *The Logic of Congressional Action* (New Haven, CT: Yale University Press, 1990); E. E. Schattschneider, *The Semisovereign People: A Realist's View of Democracy* (New York: Holt, Reinhart and Winston, 1960); and Frank Baumgartner and Bryan D. Jones, *Agendas and Instability in American Politics* (Chicago: University of Chicago Press, 1993).

56. Since the mass media provide the primary means of transmission of political information to citizens, mass-media attention is a good measure of the extent to which an issue is prominent in "public debate." Additionally, because media coverage provides information about what elected officials are doing, it enables (at least in principle) citizens to trace responsibility for outcomes to their decisions. Baumgartner and Jones pioneered the use of mass media coverage as a measure of attention to political issues in *Agendas and Instability in American Politics*. See also the Policy Agendas Project online, accessed March 30, 2016, at policyagendas.org.

57. To generate the plots, I searched for "Voting Rights Act" in the full text of

front-page newspaper articles between January 1, 1965, and December 31, 2015, in the ProQuest Historical *New York Times* and ProQuest Historical *Washington Post* databases. The Historical *New York Times* database archives articles only through 2012, whereas the *Washington Post* series ends in 1999.

58. More detailed empirical investigation also supports this conclusion. The correlations between the number of front-page articles mentioning the VRA and an indicator variable for legislative consideration of renewal of the VRA were quite strong: .54 and .51 for the *New York Times* and *Washington Post* series, respectively. In striking contrast, the correlations between the number of front-page articles and the number of Supreme Court judgments or opinions pertaining to voting rights were very small (.11 and .03 for the *New York Times* and *Washington Post* series, respectively). Major changes in administrative policy on voting rights matters—as opposed to routine enforcement actions—are much more difficult to quantify and thus match with media-attention data. As a proxy for "major changes in administrative policy," I used a dummy variable differentiating Democratic and Republican administrations. The correlations between the number of front-page articles mentioning the VRA and this dummy variable were a very modest .14 for the *New York Times* series and a somewhat larger .46 for the *Washington Post* series.

59. Arnold, *Logic of Congressional Action*; see also Jacob S. Hacker, *The Divided Welfare State: The Battle Over Public and Private Social Benefits in the United States* (Cambridge, UK: Cambridge University Press, 2002).

60. On the strategy of "venue shifting," see, for example, Baumgartner and Jones, *Agendas and Instability in American Politics*.

61. Timothy Groseclose and Nolan McCarty, "The Politics of Blame: Bargaining before an Audience," *American Journal of Political Science* 45, no. 1 (2001): 100–119.

62. See, for example, Sidney M. Milkis, Jesse H. Rhodes, and Emily J. Charnock, "What Happened to Post-Partisanship? Barack Obama and the New American Party System," *Perspectives on Politics* 10, no. 1 (2012): 57–76; Sidney M. Milkis and Jesse H. Rhodes, "George W. Bush, the Republican Party, and the 'New' American Party System," *Perspectives on Politics* 5, no. 3 (2007): 461–88; Terry M. Moe and William G. Howell, "The Presidential Power of Unilateral Action," *Journal of Law, Economics, and Organization* 15, no. 1 (1999): 132–79.

63. Mathew D. McCubbins and Thomas Schwartz, "Congressional Oversight Overlooked: Police Patrols Versus Fire Alarms," *American Journal of Political Science* 28, no. 1 (1984): 165–79.

64. Arnold, *Logic of Congressional Action*, 27; David Epstein and Sharyn O'Halloran, *Delegating Powers: A Transaction Cost Politics Approach to Policy Making Under Separate Powers* (Cambridge, UK: Cambridge University Press, 1999).

65. Gillman, "How Political Parties Can Use the Courts," 524; Jack Balkin and Sanford Levinson, "Understanding the Constitutional Revolution," *Virginia Law Review* 87, no. 6 (2001): 1045–109.

66. Whittington, "Interpose Your Friendly Hand," 592.

67. Although it is true that the voting behavior of some justices changed significantly during their tenures on the Court, the behavior of Republican appointees to

the Court over the last five decades (with the important exceptions of Justices Blackmun, Stevens, and Souter) has remained reliably conservative. See Lee Epstein, Andrew D. Martin, Kevin M. Quinn, and Jeffrey A. Segal, "Ideological Drift among Supreme Court Justices: Who, When, and How Important?," *Northwestern University Law Review* 101, no. 4 (2007): 1483–542.

68. On the importance of this dynamic, see Balkin and Levinson, "Understanding the Constitutional Revolution," 1075–76.

69. On process tracing, see, for example, Alexander L. George and Andrew Bennett, *Case Studies and Theory Development in the Social Sciences* (Cambridge, MA: MIT Press, 2004).

70. Adrian Kay and Phillip Baker, "What Can Causal Process Tracing Offer to Policy Studies? A Review of the Literature," *Policy Studies Journal* 43, no. 1 (2015): 1–20.

71. Andrew Bennett and Jeffrey T. Checkel, "Process Tracing: From Philosophical Roots to Best Practices," *Simons Papers in Security and Development*, no. 21/2012 (June 2012), accessed July 13, 2016, available at http://webcache.googleusercontent.com/search?q=cache:EuPlzrDQ8HwJ:summit.sfu.ca/system/files/iritems1/14884/SimonsWorkingPaper21.pdf+&cd=1&hl=en&ct=clnk&gl=us.

72. On smoking-gun evidence, see, for example, James Mahoney, "The Logic of Process Tracing Tests in the Social Sciences," *Sociological Methods & Research* 41, no. 4 (2012): 570–97.

73. Barbara Geddes, *Paradigms and Sandcastles: Theory Building and Research Design in Comparative Politics* (Ann Arbor: University of Michigan Press, 2000), 38–40.

74. Timothy McKeown, "Case Studies and the Limits of the Quantitative Worldview," in *Rethinking Social Inquiry: Diverse Tools, Shared Standards*, ed. Henry E. Brady and David Collier (Lanham, MD: Rowman and Littlefield, 2004), 149–50.

75. Timothy J. McKeown, "Case Studies and the Statistical Worldview: Review of King, Keohane, and Verba's *Designing Social Inquiry: Scientific Inference in Qualitative Research*," *International Organization* 53, no. 1 (1999): 161–90.

Chapter 1

1. Editorial, "Southern Winds of Change," *Boston Globe*, August 12, 1965.

2. Schickler, *Racial Realignment*, chap. 9.

3. Dorsey Edward Lane, "The Civil Rights Act of 1957," *Howard Law Journal* 4, no. 1 (1958): 36–49; Thomas R. Winquist, "Civil Rights: Legislation: The Civil Rights Act of 1957," *Michigan Law Review* 56, no. 4 (1958): 619–30.

4. Nicole L. Gueron, "An Idea Whose Time Has Come: A Comparative Procedural History of the Civil Rights Acts of 1960, 1964, and 1991," *Yale Law Journal* 104, no. 5 (1995): 1201–34.

5. Allan Lichtman, "The Federal Assault against Voting Discrimination in the Deep South, 1957–1967," *Journal of Negro History* 54, no. 4 (1969): 346–67.

6. Roy Wilkins, recorded interview by Berl Bernhard, August 13, 1964, transcript, John F. Kennedy Library Oral History Program, at 3.

7. James Farmer, recorded interview by John F. Stewart, March 10, 1967, transcript, John F. Kennedy Library Oral History Program, at 5.

8. Bruce Ackerman and Jennifer Nou, "Canonizing the Civil Rights Revolution: The People and the Poll Tax," *Northwestern Law Review* 103, no. 1 (2009): 63–148, at 84–85.

9. United States Department of Justice, "Report of the Attorney General to the President on the Department of Justice's Activities in the Field of Civil Rights," December 29, 1961, Papers of John F. Kennedy, Presidential Papers, President's Office Files, Subject, Civil Rights: General, 1961, John F. Kennedy Presidential Library, Boston, Massachusetts.

10. Roy Wilkins to Harris Wofford, April 5, 1961, Papers of John F. Kennedy, Presidential Papers, White House Staff Files, Harris Wofford, Alphabetical Files, 1956–1962, Wilkins, Roy, 1 December 1960–15 March 1962, John F. Kennedy Presidential Library, Boston, Massachusetts.

11. Nicholas Katzenbach, recorded interview by Larry J. Hackman, November 16, 1964, John F. Kennedy Presidential Library Oral History Program, at 19.

12. Steven F. Lawson, "Prelude to the Voting Rights Act: The Suffrage Crusade, 1962–1965," *South Carolina Law Review* 57, no. 4 (2006): 889–921, at 890–91.

13. Southern Christian Leadership Conference, "Southwide Voter Registration Prospectus," undated 1961, Burke Marshall Personal Papers, Assistant Attorney General Files, 1958–1965 (bulk 1961–1964), Series 1, Subject File, 1961–1964, Voter Registration: Miscellaneous and Undated, John F. Kennedy Presidential Library, Boston, Massachusetts.

14. Quoted in "Regional Council to Study Cause of Low Voter Registration," *Memphis Tri-State Defender*, April 7, 1962.

15. Robert Bird, "Student Tells of Registration Drive," *Boston Globe*, May 5, 1963.

16. James Forman, interview by Blackside Inc., December 11, 1985, for *Eyes on the Prize: America's Civil Rights Years (1954–1965)*, Washington University Libraries, Film and Media Archive, Henry Hampton College.

17. "National Drives Push Race Vote Beyond Historic 5.5 Million Mark," *Baltimore Afro-American*, October 24, 1964.

18. Harvard Sitkoff, *The Struggle for Black Equality, 1954–1980* (New York: Hill and Wang, 1981), at 121; Garrow, *Protest at Selma*, at 16.

19. United States Commission on Civil Rights, *Voting* (Washington, DC: United States Commission on Civil Rights, 1961), at 133.

20. See, for example, United States Commission on Civil Rights, *Voting in Mississippi* (Washington, DC: United States Commission on Civil Rights, 1965), chap. 4.

21. Council of Federated Organizations, "Case Studies of Intimidation," 1964, available from the *Civil Rights Movement Veterans* project (Tougaloo College), accessed April 30, 2015, available at http://www.crmvet.org/docs/64_cofo_intimidation .pdf.

22. Voter Education Project, "News Release," March 31, 1963, Joseph Rauh Papers, Box 24, "Civil Rights—1963," United States Library of Congress, Washington, DC.

23. James Farmer, *Louisiana Story, 1963* (New York: Congress of Racial Equality, 1963), available from the *Civil Rights Movement Veterans* project (Tougaloo College), accessed April 30, 2015, available at http://www.crmvet.org/docs/6311_core_la-r.pdf.

24. May, *Bending Toward Justice*, at 20–21.

25. Courtney Evans, recorded interview by James A. Oesterle, December 18, 1970, Robert F. Kennedy Oral History Program, John F. Kennedy Presidential Library Oral History Program, at 52.

26. Burke Marshall, recorded interview by Larry J. Hackman, January 19–20, 1970, John F. Kennedy Presidential Library Oral History Program, at 45.

27. Nicholas D. Katzenbach, interview by Paige E. Mulhollan, Oral History Interview I, November 12, 1968, Transcript, Internet Copy, Lyndon B. Johnson Presidential Library, at 21, available at http://www.lbjlibrary.net/assets/documents/archives/oral_histories/katzenbach/KATZENB1.PDF.

28. Garrow, *Protest at Selma*, at 16.

29. Burke Marshall, recorded interview by Anthony Lewis, June 14, 1964, John F. Kennedy Presidential Library Oral History Program, at 90.

30. United States Department of Justice, "A Review of the Activities of the Department of Justice in Civil Rights, 1963," at 7.

31. "Meeting on Birmingham," September 23, 1963, John F. Kennedy Presidential Recordings, *Kennedy, Johnson, and the Quest for Justice: The Civil Rights Tapes*, ed. Jonathan Rosenberg and Zachary Karabell (New York: Norton, 2003), at 151.

32. J. Francis Pohlhaus, "The Civil Rights Bill of 1963: A Comparative Analysis of Three Versions of the Civil Rights Bill H.R. 7152," Leadership Conference on Civil Rights, undated 1963, Alicia Kaplow Papers, 1964–1968, Archives Main Stacks, MSS 507, Box 1, Folder 4, Wisconsin Historical Society, Madison, Wisconsin.

33. Diane Nash and James Bevel, "Proposal for Action in Montgomery," September 17, 1963, available from the *Civil Rights Movement Veterans* project (Tougaloo College), accessed May 6, 2015, available at http://www.crmvet.org/docs/nashplan.htm. See also Diane Nash, interview by Blackside Inc., November 12, 1985, for *Eyes on the Prize: America's Civil Rights Years (1954–1965)*, Washington University Libraries, Film and Media Archive, Henry Hampton College.

34. C. T. Vivian, interview by Taylor Branch, March 29, 2011, Smithsonian Institute National Museum of African American History and Culture and the United States Library of Congress.

35. Johnson narrates his own growing concern with civil rights in *Vantage Point: Perspectives of the Presidency, 1963–1969* (New York: Holt, Rinehart, and Winston, 1971), 154–57. See also Sidney M. Milkis, Daniel J. Tichenor, and Laura Blessing, "'Rallying Force': The Modern Presidency, Social Movements, and the Transformation of American Politics," *Presidential Studies Quarterly* 43, no. 3 (2013): 641–70.

36. Transcript of telephone conversation between Lyndon B. Johnson and Theodore Sorenson, June 3, 1963, Theodore C. Sorensen Personal Papers, Subject Files,

1961–1964, Civil Rights: Legislation, 1963: Sorensen-LBJ phone conversation, 3 June 1963, TCSPP-030-013, John F. Kennedy Presidential Library, Boston, Massachusetts.

37. Rustin quote is from Bayard Rustin, interview by Blackside Inc., 1979, for *Eyes on the Prize: America's Civil Rights Years (1954–1965)*, Washington University Libraries, Film and Media Archive, Henry Hampton College.

38. Martin Luther King Jr., *Why We Can't Wait* (New York: Signet Classics, 2000).

39. Harry McPherson, interview by T. H. Baker, Oral History Interview IV, March 24, 1969, Transcript, Internet Copy, Lyndon B. Johnson Presidential Library, accessed May 26, 2015, available from the Miller Center of Public Affairs online, at http://web2.millercenter.org/lbj/oralhistory/mcpherson_harry_1969_0324.pdf.

40. Sidney M. Milkis, *Political Parties and Constitutional Government: Remaking American Democracy* (Baltimore, MD: Johns Hopkins University Press, 1999), at 107–16.

41. Quote is from Student Nonviolent Coordinating Committee, *Mississippi Freedom Project* (Atlanta: Student Nonviolent Coordinating Committee, 1964), Alicia Kaplow Papers, Friends of SNCC—General, 1964–1967, undated, Archives Main Stacks, MSS 507, Box 1, Folder 9, Wisconsin Historical Society, Madison, Wisconsin.

42. Kotz, *Judgment Days*, 189–221.

43. On the MFDP's history, see, for example, Leslie Burle McLemore, "The Mississippi Freedom Democratic Party: A Case Study of Grass-Roots Politics," PhD diss., University of Massachusetts, Amherst, 1971.

44. Martin Luther King Jr., "Annual Report of Martin Luther King Jr., President, Southern Christian Leadership Conference—Eighth Annual Convention," Savannah, Georgia, September 28–October 2, 1964, available from the *Civil Rights Movement Veterans* project (Tougaloo College), accessed May 6, 2015, available at http://www.crmvet.org/docs/6409_sclc_mlk_rpt.pdf,.

45. Rev. Andrew Young, interview by Blackside Inc., October 11, 1985, for *Eyes on the Prize: America's Civil Rights Years (1954–1965)*, Washington University Libraries, Film and Media Archive, Henry Hampton College.

46. In February 1965, a plurality of Americans (42 percent) reported their belief that the federal government was moving "too fast" to enforce the Civil Rights Act. Gallup poll, "America's Mood in the Mid-Sixties," February 1965, available via subscription to the iPoll Database, Roper Center for Public Opinion Research, University of Connecticut.

47. Telephone conversation between Lyndon B. Johnson and Nicholas Katzenbach, December 14, 1964, Lyndon B. Johnson Presidential Recordings, as housed at the Miller Center of Public Affairs online, accessed May 7, 2015, available at http://web2.millercenter.org/lbj/audiovisual/whrecordings/telephone/conversations/1964/lbj_wh6412_02_6611.wav.

48. *The Department of Justice during the Administration of President Lyndon B. Johnson, November 1963–January 1969*, n.d., especially pp. 15–27, Administrative History of the Department of Justice, Part Vi1; Volume VI, Volume VII, Part X, Box 5, Administrative History of the Department of Justice, Lyndon B. Johnson Presiden-

tial Library, Austin, Texas; "Memorandum on Voting Legislation," March 5, 1965, Office Files of Lee White, Box 3, Voting Rights 1965, Lyndon B. Johnson Presidential Library, Austin, Texas.

49. Nicholas Katzenbach to Lyndon B. Johnson, December 29, 1964, White House Central Files, Human Rights 2-7, Box 55, HU 2-7 Voting, 11/22/63–8/19/65, Lyndon B. Johnson Presidential Library, Austin, Texas.

50. Telephone conversation between Lyndon B. Johnson and Martin Luther King Jr., January 15, 1965, Lyndon B. Johnson Presidential Recordings, as housed at the Miller Center of Public Affairs online, accessed May 11, 2015, available at http://web2.millercenter.org/lbj/audiovisual/whrecordings/telephone/conversations/1965/lbj_wh6501_04_6736.wav.

51. King quoted in Charles E. Fager, *Selma 1965: The March That Changed the South* (Boston: Beacon Press, 1985), at 9–10.

52. Indeed, a mid-February 1965 survey found that 63 percent of Americans believed that the federal government should leave the matter of African American enfranchisement to local communities. Gallup poll, "America's Mood in the Mid-Sixties," February 1965, available via subscription to the iPoll Database, Roper Center for Public Opinion Research, University of Connecticut.

53. Andrew Young, *An Easy Burden: The Civil Rights Movement and the Transformation of America* (New York: HarperCollins, 1996), at 352.

54. Bevel quoted in Branch, *At Canaan's Edge*, at 9. See also James Bevel, interview by Blackside Inc., November 13, 1985, for *Eyes on the Prize: America's Civil Rights Years (1954–1965)*, Washington University Libraries, Film and Media Archive, Henry Hampton Collection.

55. John Lewis, *Walking with the Wind: A Memoir of the Movement* (New York: Harvest Books, 1999), at 318; Anne Pearl Avery, interview by Joseph Mosnier, May 31, 2011, for the Southern Oral History Program under contract with the Smithsonian Institution's National Museum of African American History and Culture and the United States Library of Congress, at 31.

56. "Brutality Stops Ala. Vote March," *Chicago Defender*, March 8, 1965.

57. "SNCC Report on Bloody Sunday," March 7, 1965, available from the *Civil Rights Movement Veterans* project (Tougaloo College), accessed October 9, 2015, available at http://www.crmvet.org/docs/6503_sncc_bloodysunday_rpt.pdf.

58. Branch, *At Canaan's Edge*, at 56.

59. Harry McPherson to Lyndon B. Johnson, memorandum, March 12, 1965, Legislative Background Files, Voting Rights Act of 1965, Box 1, March 12, 1965—Fauntroy et al., Lyndon B. Johnson Presidential Library, Austin, Texas.

60. The quote is from Nan Robertson, "Johnson Pressed for a Voting Law," *New York Times*, March 9, 1965. The data on demonstrations is from Federal Bureau of Investigation, "Demonstration Protesting the Racial Situation in Selma, Alabama—Racial Matters," March 15, 1965, Office Files of Mildred Stegall, Box 71B[1 of 2], Race Relations and Related Matters, January to April 1965 [1 of 2], Lyndon B. Johnson Presidential Library, Austin, Texas.

61. Telephone conversation between Lyndon B. Johnson and Bill Moyers, March 8, 1965, Lyndon B. Johnson Presidential Recordings, as housed at the Miller Center of Public Affairs online, accessed May 13, 2015, available at http://web2.millercenter.org /lbj/audiovisual/whrecordings/telephone/conversations/1965/lbj_wh6503_04_7044 .wav.

62. Lyndon B. Johnson, "Statement by the President on the Situation in Selma, Alabama," March 9, 1965, Public Papers of the President of the United States, available from the American Presidency Project Online, accessed March 14, 2016, available at http://www.presidency.ucsb.edu/ws/index.php?pid=26802&st=&st1=.

63. Some details on these negotiations are provided in Tom Wicker, "President and Congress: Shaping Voting Bill," *New York Times*, March 21, 1965.

64. Nicholas Katzenbach to Bill D. Moyers and Lee C. White, "RE: Voting Rights Message—Horace Busby's Comments," memorandum, March 1, 1965, Office Files of Bill Moyers, Box 6, Voting Rights Message [1 of 2], Lyndon B. Johnson Presidential Library, Austin, Texas.

65. "Mr. Valenti's Notes, March 14, 1965—Cabinet Meeting," Legislative Background Files, Voting Rights Act of 1965, Box 1, Drafting of the Voting Rights Message and Reports on March 1965 Activities in Alabama, Lyndon B. Johnson Presidential Library, Austin, Texas.

66. Quotes are from Lyndon B. Johnson, "Speech before Congress on Voting Rights," March 15, 1965, accessed June 10, 2015, available from the Miller Center of Public Affairs website, http://millercenter.org/president/speeches/speech-3386.

67. JRJ to Marvin Watson, memorandum, March 17, 1965, White House Central Files, Human Rights, Box 66, LE/HU 2-7 11/22/63–5/31/65, Lyndon B. Johnson Presidential Library, Austin, Texas; Marvin Watson to Lyndon B. Johnson, memorandum, March 17, 1965, White House Central Files, Human Rights, Box 66, LE/HU 2-7 11/22/63–5/31/65, Lyndon B. Johnson Presidential Library, Austin, Texas; Gallup poll, March 18–23, 1965, accessed June 10, 2015, available via subscription to the iPoll Database, Roper Center for Public Opinion Research, University of Connecticut.

68. Nicholas Katzenbach to Lyndon B. Johnson, memorandum, May 21, 1965, White House Central Files, Human Rights, Box 66, LE/HU 2-7, 11/22/63–5/31/65, Lyndon B. Johnson Presidential Library, Austin, Texas.

69. The motion was supported by 63 percent of Democrats and 78 percent of Republicans. Senate vote 32, March 18, 1965, accessed July 19, 2016, available from GovTrack.us, https://www.govtrack.us/congress/votes/89-1965/s32.

70. E. W. Kenworthy, "Senate Defeats Southern Move to Delay Bill on Voting, 67–13," *New York Times*, March 19, 1965; Robert C. Albright, "Vote Bill Hits Snag, Substitute Is Considered," *Washington Post*, April 27, 1965; E. W. Kenworthy, "Southern Attack on Vote Bill Fails," *New York Times*, May 7, 1965.

71. The first quote is from Robert C. Albright, "Voting Bill Is Sent to Senate," *Washington Post*, April 10, 1965; the second is from May, *Bending Toward Justice*, at 156.

72. Larry O'Brien to Lyndon B. Johnson, "RE: Voting Rights Legislation," April 26, 1965, White House Central Files, Legislation, Human Rights, Box 66, LE/ HU 2-7 11/22/63–5/31/65, Lyndon B. Johnson Presidential Library, Austin, Texas.

73. E. W. Kenworthy, "Senate Reaches Poll Tax Accord," *New York Times*, May 20, 1965.

74. Author's analysis of Senate vote 52, 89th Cong., 1st Sess., from "Democrat and Republican Party Voting Splits Congress 35–113 (31 May 2015)," accessed July 19, 2016, available at VoteView.com, http://voteview.com/partycount.html.

75. Kenworthy, "Southern Attack."

76. Note that the number of southern Republicans voting on these bills was very small—typically four.

77. Robert C. Albright, "Cloture Move Seen as Senate Liberals Reshape Vote Bill," *Washington Post*, May 15, 1965.

78. Branch, *At Canaan's Edge*, at 226. See also E. W. Kenworthy, "Senate, 70 to 30, Invokes Closure on Voting Rights," *New York Times*, May 26, 1965.

79. Quote is from Arnold Aronson to Cooperating Organizations, "The Conference Protests House Delay on Voting Rights Bill," June 24, 1965, Leadership Conference on Civil Rights, Office Files of Lee White, Box 3, Voting Rights Act 1965, Lyndon B. Johnson Presidential Library, Austin, Texas.

80. "Joint Statement of Honorable Gerald H. Ford, and Honorable William M. McCulloch," April 5, 1965, Emanuel Celler Papers, Part II: Special Legislative File 1955–1972, Box 473, Civil Rights—Voting Rights, 1965, Executive Committee Meeting, United States Library of Congress, Washington, DC.

81. Robert C. Albright, "New Delays Seen as Senate, House Conflict on Poll Tax," *Washington Post*, June 2, 1965; Dan Day, "House-Senate Fight Seen on Vote Bill," *Baltimore Afro-American*, June 5, 1965.

82. "The Voting Rights Bill and the Poll Tax," *Hartford Courant*, July 1, 1965.

83. Telephone conversation between Lyndon B. Johnson and Martin Luther King Jr., July 7, 1965, Lyndon B. Johnson Presidential Recordings, as housed at the Miller Center of Public Affairs online, accessed June 17, 2015, available at http://web2 .millercenter.org/lbj/audiovisual/whrecordings/telephone/conversations/1965/lbj _wh6507_02_8311.mp3.

84. Tuck quoted in "Rights Foes Back GOP Voting Bill," *New York Times*, July 8, 1965. See also Morton Mintz, "Southerners Swing Reluctantly to GOP Voting Bill in House," *Washington Post*, July 8, 1965; E. W. Kenworthy, "GOP Voting Bill Falters in House," *New York Times*, July 9, 1965.

85. Author's analysis of House vote 86, 89th Cong., 1st Sess., July 9, 1965, accessed July 19, 2016, available from GovTrack.us, https://www.govtrack.us/congress /votes/89-1965/h86.

86. "House Passes Voting Rights Bill," *Boston Globe*, July 10, 1965.

87. Telephone conversation between Johnson and King, July 7, 1965.

88. Leadership Conference on Civil Rights, "Leadership Conference Position on Senate-House Bill," Emanuel Celler Papers, Part II: Special Legislative File, 1955–1972, Box 472, Civil Rights—Voting Rights, 1965, Working Papers for HR 6400, United States Library of Congress, Washington, DC.

89. Garrow, *Protest at Selma*, at 131. See also Richard L. Lyons, "Voting Rights Bill Passed by House after GOP Attack," *Washington Post*, August 4, 1965.

90. E. W. Kenworthy, "Conferees Agree on Voting Rights," *New York Times*, July 30, 1965.

91. Quoted in Carroll Kilpatrick, "No Room for Injustice," *Boston Globe*, August 7, 1965.

92. Of course, implementation also depended on the capacity and cooperation of state and local election officials, which varied substantially across covered jurisdictions.

93. Quoted in "A New Day for Dixie," *Baltimore Afro-American*, August 21, 1965.

94. Ramsey Clark, interview by Harri Baker, Oral History Interview IV, April 16, 1969, Transcript, Internet Copy, Lyndon B. Johnson Presidential Library, at 2.

95. Stephen Pollak, interview by Thomas H. Baker, Oral History Interview III, January 30, 1969, Transcript, Internet Copy, Lyndon B. Johnson Presidential Library, at 19.

96. Morris Abram, interview by Michael L. Gillette, Oral History Interview II, May 3, 1984, Typescript, Internet Copy, Lyndon B. Johnson Presidential Library.

97. See, for example, Nicholas Katzenbach, "A Review of the Activities of the Department of Justice in Civil Rights in 1965 and 1966," May 1, 1966, Office Files of Ceil Bellinger, Box 18, Voting—Registration, Lyndon B. Johnson Presidential Library, Austin, Texas.

98. United States Commission on Civil Rights, *Political Participation* (Washington, DC: United States Commission on Civil Rights, 1968), at 154.

99. Voter Education Project, *The Effects of Federal Examiners and Organized Registration Campaigns on Negro Voter Registration* (Atlanta: Voter Education Project, July 1966). On the early effects of the VRA, see also L. Thorne McCarty and Russell B. Stevenson, "The Voting Rights Act of 1965: An Evaluation," *Harvard Civil Rights—Civil Liberties Law Review* 3, no. 2 (1968): 357–422.

100. Hubert Humphrey to Lyndon B. Johnson, February 2, 1966, White House Central Files, Human Rights, EX/HU 2-7 11/22/63–1/20/69, Voting, Box 55, HU 2-7 10/16/65–2/2/66, Lyndon B. Johnson Presidential Library, Austin, Texas.

101. Telephone conversation between Lyndon B. Johnson and Roy Wilkins, November 20, 1965, Lyndon B. Johnson Presidential Recordings, as housed at the Miller Center of Public Affairs online, accessed June 2, 2015, available at http://web2 .millercenter.org/lbj/audiovisual/whrecordings/telephone/conversations/1965/lbj _wh6511_07_9185.wav. See also *Political Participation*, at 156; "Justice Dept. Disappointed with Vote Registration Pace," *Baltimore Afro-American*, December 25, 1965. The call for "affirmative" programs is from the United States Civil Rights Commission, quoted in John Herbers, "Rights Unit Asks More Examiners," *New York Times*, December 5, 1965.

102. See, for example, Wiley Branton to Ramsey Clark, "Report on Recent Georgia Field Trip," memorandum, August 30, 1966, Personal Papers of Ramsey Clark, Civil Rights Division, Box 63, 1966, Lyndon B. Johnson Presidential Library, Austin, Texas.

103. "Vote Aides Sent to Polls in South," *New York Times*, November 9, 1966.

104. *Political Participation*, at 157; John W. Macy to Lyndon B. Johnson, "Commission Action Under the Voting Rights Act," memorandum, November 8, 1968, White House Central Files, Human Rights, Box 55, HU 2-7, Voting, 2/26/66–, Lyndon B. Johnson Presidential Library, Austin, Texas.

105. "Vote Aides Sent to Polls in South"; "Southern Negro Vote Boost Pleases US Officials," *Norfolk New Journal and Guide*, November 19, 1966; Macy to Johnson, November 8, 1968.

106. Quote is from *Political Participation*, at 160.

107. Lucy Benson and Sue Jeshel to Judy Campbell, April 9, 1971, League of Women Voters Records, Legislative Action File—Voting Rights, Part IV, Box 507, 1971–1975, United States Library of Congress, Washington, DC.

108. Gayle Binion, "The Implementation of Section 5 of the 1965 Voting Rights Act: A Retrospective on the Role of the Courts," *Western Political Quarterly* 32, no. 2 (1979): 154–73, at 157–58.

109. Luis Fuentes-Rohwer and Guy-Uriel E. Charles, "The Politics of Preclearance," *Michigan Journal of Race and Law* 12, no. 4 (2007): 514–35.

110. John W. Gardner to William McCulloch, July 1, 1969, Records of the Leadership Conference on Civil Rights, LCCR Subject File, Box 139, Folder 20, United States Library of Congress, Washington, DC; *Political Participation*, especially pp. 21–132.

111. Garrow, *Protest at Selma*, at 189. As Garrow notes, these figures represent estimates, not precise tabulations.

112. Khalilah Brown-Dean, Zoltan Hajnal, Christina Rivers, and Ismail White, *50 Years of the Voting Rights Act: The State of Race in Politics*, Joint Center for Political and Economic Studies report, accessed July 19, 2016, available at http://jointcenter.org/sites/default/files/VRA%20report,%203.5.15%20(1130%20am)(updated).pdf.

113. NAACP, "A Legislative and Enforcement Program for the 91st Congress and the Administration, 1969–70," at 6, Records of the NAACP, Part VI, Box A25, Folder 2, "Ninety-First Congress, 1969–1972," United States Library of Congress, Washington, DC.

114. Lucas A. Powe, *The Warren Court and American Politics* (Cambridge, MA: Harvard University Press, 2000); Bruce Ackerman, *We the People, Volume 3: The Civil Rights Revolution* (Cambridge, MA: Harvard University Press, 2014).

115. Alexander M. Bickel, "The Voting Rights Cases," *Supreme Court Review* 79, no. 1 (1966): 79–102.

116. Luis Fuentes-Rohwer, "Understanding the Paradoxical Case of the Voting Rights Act," *Florida State University Law Review* 36, no. 4 (2009): 698–763, at 706.

117. On the "patronage" appointments model frequently employed by Democratic presidents, see especially Henry Abraham, *Justices, Presidents, and Senators: A History of the US Supreme Court Appointments from Washington to Bush II*, 5th ed. (Baltimore: Rowman and Littlefield, 2007).

118. Arthur J. Goldberg, interview by Ted Gittinger, Oral History Interview I, March 23, 1983, Transcript, Internet Copy, Lyndon B. Johnson Presidential Library.

119. Telephone conversation between Lyndon B. Johnson and Richard Russell,

July 19, 1965, in *Reaching for Glory: Lyndon Johnson's Secret White House Tapes*, ed. Michael Beschloss (New York: Simon and Schuster, 2001), at 396.

120. Questions about Fortas's finances had already forced President Johnson to withdraw his nomination of Fortas to the chief justiceship following Earl Warren's announcement of his plans to retire from the Court. John Massaro, "LBJ and the Fortas Nomination for Chief Justice," *Presidential Studies Quarterly* 97, no. 4 (1983): 603–21, at 603.

121. See, for example, Trevor Parry-Giles, "Character, the Constitution, and the Ideological Embodiment of 'Civil Rights' in the 1967 Nomination of Thurgood Marshall to the Supreme Court," *Quarterly Journal of Speech* 82, no. 4 (1996): 364–82.

122. Quote is from Mark Tushnet, "Thurgood Marshall and the Brethren," *Georgia Law Review* 80, no. 6 (1991): 2109–30, at 2109; see also Lucius J. Barker, "Thurgood Marshall, The Law, and the System: Tenets of an Enduring Legacy," *Stanford Law Review* 44, no. 5 (1992): 1237–47; Alfred A. Slocum, "'I Dissent': A Tribute to Justice Thurgood Marshall," *Rutgers Law Review* 45, no. 4 (1991): 889–902.

123. Author's analysis of data from the Supreme Court Database, accessed July 19, 2016, available at http://scdb.wustl.edu/about.php.

124. Opinion of Chief Justice Earl Warren, South Carolina v. Katzenbach, 383 U.S. 301 (1966), at 323.

125. Archibald Cox, "The Supreme Court, 1965 Term," *Harvard Law Review* 80, no. 1 (1966): 91–272, at 101.

126. Fuentes-Rohwer, "Paradoxical Case"; Luis Fuentes-Rohwer, "Judicial Activism and the Interpretation of the Voting Rights Act," *Cardozo Law Review* 32, no. 3 (2011): 857–83.

127. Warren, *South Carolina*, 383 U.S. at 308–15.

128. Ibid., at 324.

129. Luis Fuentes-Rohwer, "Legislative Findings, Congressional Powers, and the Future of the Voting Rights Act," *Indiana Law Journal* 82, no. 1 (2007): 100–130, at 108.

130. Warren, *South Carolina*, 383 U.S. at 329.

131. Ibid., at 331.

132. Ibid., at 335.

133. The relevant section of the VRA is Section 4(e), which provided that no person who had completed a sixth-grade education in a school accredited by the commonwealth of Puerto Rico shall be denied the right to vote on account of an inability to read or write in English. Eskridge's quote is from his article, "Some Effects of Identity-Based Social Movements on Constitutional Law in the Twentieth Century," *Michigan Law Review* 100, no. 8 (2002): 2062–407, at 2314.

134. Fuentes-Rohwer, "Paradoxical Case," at 715.

135. Opinion of Justice William Brennan, Katzenbach v. Morgan, 384 U.S. 641 (1966), at 649.

136. William Cohen, "Congressional Power to Interpret Due Process and Equal Protection," *Stanford Law Review* 27, no. 3 (1975): 603–20, at 605. See also Edward V. Heck, "Justice Brennan and the Heyday of Warren Court Liberalism," *Santa Clara Law Review* 20, no. 3 (1980): 841–87, at 861.

137. Brennan, *Katzenbach*, 384 U.S. at 649.

138. Ibid., at 651.

139. Ibid., at 653.

140. Ibid., at 652. The language is intentionally speculative; the opinion did not cite direct evidence that Congress did in fact make this judgment.

141. Brennan, *Katzenbach*, 384 U.S. at 652.

142. Section 4(e) extended voting rights only to non-English speakers educated to the sixth-grade level in so-called American-flag schools, that is, schools within the United States or its territories. Brennan, *Katzenbach*, 384 U.S. at 657.

143. See, for example, *The Shameful Blight: The Survival of Racial Discrimination in Voting in the South* (Washington, DC: Washington Research Project, 1972).

144. Chandler Davidson, "The Voting Rights Act: A Brief History," in *Controversies in Minority Voting: The Voting Rights Act in Perspective*, ed. Bernard Grofman and Chandler Davidson (Washington, DC: Brookings Institution Press, 1992), 7–34, at 22–23.

145. The fact that African American plaintiffs were bringing the suits raised the subsidiary questions of whether the VRA contemplated a private right of action to enforce the Act's provisions (the text of the statute was not explicit on this point) and whether private litigants might bring suit in local federal district courts rather than in the District Court for the District of Columbia. In *Allen*, the Court held that "private parties had standing under the Voting Rights Act to seek both a declaratory judgment that a new voting change was subject to the federal review required by Section 5 and an injunction prohibiting the enforcement of a voting change which had not been submitted for federal approval." It also allowed private litigants to bring suit in local courts as a way to ease the financial burden of litigation. These rulings were extremely important, because "the success of the VRA would be greatly inhibited if citizens were solely dependent upon the limited resources of the Attorney General's office to protect their voting rights." The first quote is from John J. Roman, "Section 5 of the Voting Rights Act: The Formation of an Extraordinary Federal Remedy," *American University Law Review* 22, no. 1 (1973): 111–33, at 116; the second is from Susan Gluck Mezey, "Judicial Interpretation of Legislative Intent: The Role of the Supreme Court in the Implication of Private Rights of Action," *Rutgers Law Review* 36, no. 1 (1984): 53–90, at 61.

146. McCrary, "Bringing Equality to Power."

147. Chief Justice Warren, Allen v. State Board of Elections, 393 U.S. 544 (1969), at 565–66.

148. The reapportionment cases, for example, Baker v. Carr (369 U.S. 186, 1962) and Reynolds v. Sims (377 U.S. 533, 1964), overturned efforts by localities to effectively disenfranchise people of color through discriminatory districting and apportionment schemes. See especially *Reynolds*, 377 U.S. at 555–56. The idea that the understanding of "effectiveness" in *Allen* is imported from the reapportionment cases comes from Lani Guinier, "[E]Racing Democracy: The Voting Rights Cases," *Harvard Law Review* 108, no. 1 (1995): 109–38, at 119–20.

149. Warren, *Allen*, 393 U.S. at 566.

150. Ibid., at 567.

151. Ibid., at 567.

152. Ibid., 568.

153. Ibid., at 569.

154. Pamela Karlan and Peyton McCrary, "Without Fear and Without Research: Abigail Thernstrom on the Voting Rights Act," *Journal of Law and Politics* 4, no. 4 (1988), 751–77, at 757.

155. Ibid., at 757.

156. See Dissenting Opinion of John Marshall Harlan, Allen v. State Board of Elections, 393 U.S. 544 (1969), at 590–91.

157. Marshall quoted in Warren, *Allen*, 393 U.S. at 564.

158. It may well be that the Court's presentation of the legislative history is defective but that a more thorough analysis of that history provides a more compelling case for the majority's interpretation of the statute. For example, in "Without Fear and Without Research," Karlan and McCrary provide evidence (not cited in the majority opinion) that at least some members of Congress perceived vote dilution as a potential problem that should be addressed by Section 5 of the Act.

159. J. Morgan Kousser, "Do the Facts of Voting Rights Support Chief Justice Roberts's Opinion in *Shelby County*?," *TransAtlantica* 1 (2015), text and figure 5, accessed March 30, 2016, available at https://transatlantica.revues.org/7462.

160. Adam Fairclough, *To Redeem the Soul of America: The Southern Christian Leadership Conference and Martin Luther King Jr.* (Athens: University of Georgia Press, 1987), at 253.

161. See, especially, Lassiter, *The Silent Majority*, introduction.

162. Vesla M. Weaver, "Frontlash: Race and the Development of Punitive Crime Policy," *Studies in American Political Development* 21, no. 2 (2007): 230–65.

163. Quoted in Steven R. Goldzwig, "LBJ, the Rhetoric of Transcendence, and the Civil Rights Act of 1968," *Rhetoric and Public Affairs* 6, no. 1 (2003): 25–53, at 30.

164. Herbert Shapiro, "The Vietnam War and the American Civil Rights Movement," *Journal of Ethnic Studies* 16, no. 4 (1989): 117–41.

165. Louis Harris and Associates, Harris survey, April 1967, accessed June 15, 2015, available from the iPoll Database, Roper Center for Public Opinion Research, University of Connecticut.

Chapter 2

1. "Thanks to LBJ, Dixie Bloc Buried by Congress," *Chicago Defender*, October 25, 1965.

2. Tom Wicker, "The South: The Second Secession Ends," *New York Times*, September 5, 1965.

3. Lyndon B. Johnson, "Address to the Nation Announcing Steps to Limit the War in Vietnam and Reporting His Decision Not to Seek Reelection," March 31, 1968, Lyndon B. Johnson Presidential Library, accessed December 7, 2015, available online at http://www.lbjlib.utexas.edu/johnson/archives.hom/speeches.hom/680331.asp.

4. Federal efforts to repress civil rights and black liberation activists are summarized in Natsu Taylor Saito, "Whose Liberty? Whose Security? The USA PATRIOT Act in the Context of COINTELPRO and the Unlawful Repression of Political Dissent," *Oregon Law Review* 81, no. 4 (2002): 1051–131. COINTELPRO activities are extensively documented in Ward Churchill and Jim Vander Wall, *The COINTELPRO Papers: Documents from the FBI's Secret Wars Against Dissent in the United States* (Boston: Southend Press, 2002).

5. See, for example, Alan Brinkley, "1968 and the Unraveling of Liberal America," in *1968: The World Transformed*, ed. Carole Fink, Philipp Gassert, and Detlef Junker (Cambridge, UK: Cambridge University Press, 1998), pp. 219–36; and Lewis L. Gould, *1968: The Election That Changed America* (Chicago: Ivan R. Dee, 1993).

6. Warren Weaver Jr., "Democratic Split Buoys GOP," *New York Times*, August 30, 1968.

7. Richard Nixon, campaign address in Anaheim, California, September 16, 1968, available from the Annenberg/Pew Presidential Election Discourse Dataset, CD-ROM, http://www.library.upenn.edu/collections/communication/presidential_cam paign.html.

8. Raymond Price, *With Nixon* (New York: Viking Press, 1977), at 200.

9. Quoted in Gareth Davies, "Richard Nixon and the Desegregation of Southern Schools," *Journal of Policy History* 19, no. 4 (2007): 276–94, at 368.

10. Quoted in "Celler Introduces Voting Rights Bill," *New York Times*, January 24, 1969.

11. Gloster B. Current to Roy Wilkins, "Points for Conference with Nixon," memorandum, February 6, 1969, Records of the NAACP, Part VI: Administrative File, Box A25, Folder 3, Nixon, Richard M., 1968–1970, 1 of 3, United States Library of Congress, Washington, DC.

12. Daniel P. Moynihan, "Memorandum for Honorable John N. Mitchell, the Attorney General," February 7, 1969, Daniel Patrick Moynihan Papers, White House Central Files, Staff Member Office Files, Series III: Subject File, Sub-Series B: Subject File #2, Box 42, "Civil Rights 4: Groups (2 of 3)," Richard M. Nixon Presidential Library, Yorba Linda, California.

13. Roy Reed, "Nixon Aides Pressing Opposing Views on Extension of the Voting Rights Act," *New York Times*, June 11, 1969; David S. Broder, "Mitchell Postpones Testimony," *Washington Post*, May 28, 1969.

14. Leadership Conference on Civil Rights, "Voting Rights Act Extension (H.R. 4249)," Records of the Leadership Conference on Civil Rights, Part I: Subject File, 1951–1980, Box 139, Folder 20, "Voting Rights Act of 1965, Department of Justice," United States Library of Congress, Washington, DC.

15. Bill Timmons "Report of a Republican Leadership Meeting in the House," June 2, 1969, White House Central Files, Subject Files: HU(Human Rights), Box 19, "Voting Begin 12/31/1969," Richard M. Nixon Presidential Library, Yorba Linda, California.

16. Dean Kotlowski, *Nixon's Civil Rights: Politics, Principle, and Policy* (Cambridge, MA: Harvard University Press, 2001), at 81; Hugh Davis Graham, *The Civil*

Rights Era: Origins and Development of National Policy, 1960–1972 (Oxford, UK: Oxford University Press, 1990), at 354.

17. John N. Mitchell, "Statement before Subcommittee No. 5 of the House Judiciary Committee on H.R. 4249, Voting Rights Act of 1965," June 26, 1969, Records of the Leadership Conference on Civil Rights, Part I: LCCR Subject File, Box 139, Folder 20, United States Library of Congress, Washington, DC.

18. Quoted in Warren Weaver Jr., "Vote Act Scored by Southerners," *New York Times*, July 10, 1969.

19. Bryce Harlow to John Dean, July 1, 1969, John W. Dean Subject File, 1969–73, White House Special Files, Staff Member Office Files, Box 78, "Voting Rights Act [1 of 4]," Richard M. Nixon Presidential Library, Yorba Linda, California.

20. Althea T. L. Simmons to Benjamin Hooks, memorandum, December 1, 1980, Records of the NAACP, Part IX: Washington Bureau, Box 517, Folder "Voting Rights Extension, Jan.–Mar. 1981," United States Library of Congress, Washington, DC.

21. Leadership Conference on Civil Rights, "Voting Rights Act Extension (H.R. 4249)." See also J. Francis Pohlhaus to the Executive Director, Washington Bureau, and General Counsel, NAACP, "Voting Rights Bill," February 3, 1981, Records of the NAACP, Part IX: Washington Bureau, Box 517, Folder "Voting Rights Extension, Jan.–Mar. 1981," United States Library of Congress, Washington, DC.

22. Quoted in William L. Vaughn, "NAACP Pledges to Fight Nixon on Voting Rights," *Chicago Defender*, July 3, 1969.

23. Warren Weaver Jr., "Scott Disputing Nixon on Rights," *New York Times*, June 28, 1969; John P. MacKenzie, "Key Republican Balks at Change in Voting Act," *Washington Post*, June 20, 1969.

24. Lamar Alexander to Bill Timmons, May 28, 1969, White House Central Files, Human Rights, Box 19, "Voting Begin 12/31/1969," Richard M. Nixon Presidential Library, Yorba Linda, California.

25. The first quote is from Warren Weaver Jr., "House Rules Unit May Lift Voting Rights Blockade," *New York Times*, October 29, 1969; the second is from Richard L. Lyons, "Voting Rights Bill Cleared by Hill Unit," *Washington Post*, November 19, 1969.

26. Lyons, "Voting Rights Bill Cleared."

27. Quoted in "NAACP Angry over Defeat of Voting Rights Law," *San Francisco Sun Reporter*, December 20, 1969. Administration officials employed "intensive last-minute lobbying" to "keep its Republican ranks in the House virtually intact" in support of the Nixon bill. John F. Finney, "House Approves Nixon Bill to End Voting Rights Act," *New York Times*, December 12, 1969.

28. Author's analysis of House Vote 151, 91st Cong., accessed July 19, 2016, available at GovTrack.us, https://www.govtrack.us/congress/votes/91-1969/h151; author's analysis of "Democratic and Republican Party Voting Splits Congresses 35–113," accessed July 20, 2016, available at Voteview.com, http://voteview.com/partycount.html.

29. "House OKs Nixon's Voting-Rights Bill," *Boston Globe*, December 12, 1969.

30. Patrick J. Buchanan, "Notes from Legislative Leadership Meeting," memoranda for the President, March 8, 1970, President's Office Files, White House Special

Files, Staff Member and Office Files, Box 80, "Beginning March 1, 1970," Richard M. Nixon Presidential Library, Yorba Linda, California.

31. Arnold Aronson to Participating Organizations, "Behind the Carswell and Voting Rights Victories," April 20, 1970, Records of the NAACP, Part VI, Box A25, Folder 18, "Supreme Court, Carswell, Harrold G., Mar.–May 1970, 3 of 3," United States Library of Congress, Washington, DC.

32. Spencer Rich, "Rights Bill to Delay Vote on Carswell," *Washington Post*, February 18, 1970.

33. Pohlhaus to the Ex. Dir., Dir., and GC, NAACP, February 3, 1981; see also John W. Finney, "Fights Loom on Rights and Education," *New York Times*, February 16, 1970; and Fred P. Graham, "Senate Delay on Carswell Likely Until After Vote Rights Action," *New York Times*, February 18, 1970.

34. "Senate Backs, 47–32, Proposal to Extend Voting Rights Law," *New York Times*, March 6, 1970; "Senate Approves Use of Voting Act in Areas of North," *New York Times*, March 11, 1970; Spencer Rich, "Vote Act Extension to North is Backed," *Washington Post*, March 11, 1970.

35. Edward Kennedy, "Memorandum of Senator Kennedy on Lowering the Voting Age to 18," Emanuel Celler Papers, Part II: General Legislative File, 1957–1972, Box 438, "Extend Voting Rights Act of 1965 (1)," United States Library of Congress, Washington, DC.

36. According to a March 1970 Gallup poll, 56 percent of Americans believed that "18, 19, and 20 year olds should be permitted to vote." Gallup Organization, Gallup poll, March 1970, accessed June 15, 2015, available via subscription to the iPoll Database, Roper Center for Public Opinion Research, University of Connecticut.

37. Richard Nixon to John W. McCormack, April 27, 1970, White House Central Files, Subject Files: HU(Human Rights), Box 19, "Voting 1/1/70–4/30/70," Richard M. Nixon Presidential Library, Yorba Linda, California.

38. Leadership Conference on Civil Rights, "Voting Rights Act (H.R. 4249)."

39. In addition to the March 1970 poll cited above, a survey from July 1970 showed that a strong majority of Americans supported the expansion of the franchise to eighteen- to twenty-one-year-olds and rejected common arguments made against voting by younger people. Louis Harris and Associates, Harris survey, July 1970, accessed June 23, 2015, available via subscription to the iPoll Database, Roper Center for Public Opinion Research, University of Connecticut.

40. Author's analysis of civil rights "most important problem" data, accessed July 21, 2016, available from the Comparative Policy Agendas Project, http://www.comparativeagendas.net.

41. Richard K. Cook to Dwight Chapin, "Request for Meeting of the President with Emanuel Celler and Bill McCulloch, Chairman and Ranking Minority Member of the House Committee on the Judiciary," April 7, 1970, William E. Timmons, White House Central Files, Staff Member Office Files, Series H: Legislation Files, 2 of 3, Folder "Voting Rights Act," Richard M. Nixon Presidential Library, Yorba Linda, California.

42. Leadership Conference on Civil Rights, "Annual Report, July 1970," Records

of the Leadership Conference on Civil Rights, Part I: Subject File, Box 123, Folder 8, United States Library of Congress, Washington, DC.

43. Quote is from "LCCR Urges Support for Voting Bill," *Baltimore Afro-American*, May 2, 1970; See also Clarence Mitchell to Black Elected Officials, May 28, 1970, Records of the Leadership Conference on Civil Rights, Part I: Subject File, 1951–1980, Box 139, Folder 16, "Voting Rights Act of 1965 Emergency Meeting, June 8–9, 1970," United States Library of Congress, Washington, DC.

44. In May, the margin in favor of Democratic candidates was 45 to 32 percent, whereas in June it was 46 to 33. See Gallup Organization, Gallup poll, May 1970, and Gallup poll, June 1970, accessed June 15, 2015, both available via subscription to the iPoll Database, Roper Center for Public Opinion Research, University of Connecticut. Public favorability toward Nixon's civil rights stands is measured in Louis Harris and Associates, Harris survey, May 1970, accessed June 23, 2015, available via subscription to the iPoll Database, Roper Center for Public Opinion Research, University of Connecticut.

45. Samuel G. Jackson to Leonard Garment, June 8, 1970, Leonard Garment Papers, White House Central Files, Staff Member and Office Files, Alpha-Subject Files, Box 157, "Voting Rights [2 of 3]," Richard M. Nixon Presidential Library, Yorba Linda, California.

46. "Black Leaders Map Wash. 'Last Stand' on Voting Rights," *New Pittsburgh Courier*, June 6, 1970; "Lobbyists Push Hard for Voting Rights Extension," *Baltimore Afro-American*, June 13, 1970.

47. There was much less vote-shifting on the Democratic side. Of 221 Democrats who voted on both bills, 131 voted only for the Scott/Hart bill, 36 voted for both, 41 voted only for the Nixon plan, and 13 opposed both measures. Author's analysis of House Roll Calls 151 and 274, "91st House Roll Call Data," accessed July 20, 2016, available at VoteView.com, http://voteview.com/HOUSE91.html.

48. Len Garment, "Memorandum on Voting Rights," June 18, 1970, and Raymond Price, "Voting Rights Act—to sign or veto," June 18, 1970, both in White House Central Files, Subject File: HU(Human Rights), Box 20, "Voting 6/1/70–7/31/70," Richard M. Nixon Presidential Library, Yorba Linda, California.

49. Harry Dent to John Ehrlichman, "Recommendation on 18-Year-Old Vote Legislation," June 19, 1970, White House Central Files, Subject Files: HU(Human Rights), Box 20, "Voting 6/1/70–7/31/70," Richard M. Nixon Presidential Library, Yorba Linda, California.

50. John Price, "Voting Rights Legislation," March 5, 1970, White House Central Files, Subject Files: HU(Human Rights), Box 19, "Voting 1/1/70–4/30/70," Richard M. Nixon Presidential Library, Yorba Linda, California.

51. Clarence Mitchell, "Suggested Amendments to the Voting Rights Act of 1965," February 5, 1974, Bradley H. Patterson Jr. Papers, White House Central Files, Staff Member and Office Files, Box 71, "Voting Rights Amendment," Richard M. Nixon Presidential Library, Yorba Linda, California.

52. See, for example, Marvin Caplan to Pat Shakow, December 16, 1974, Records of the Leadership Conference on Civil Rights, Part II: Issues File, 1957–1991, Box 65,

Folder 5, "Voting Rights Act Extension 1975 and Correspondence 1975–1979," United States Library of Congress, Washington, DC.

53. Quoted in William Raspberry, "We Still Need the Voting Rights Act," *Washington Post*, March 10, 1975.

54. National Association for the Advancement of Colored People, "Quarterly Report of the Washington Bureau, NAACP," March 31, 1975, Records of the Leadership Conference on Civil Rights, Box 65, Folder 8, "Voting Rights Act Extension, 1975, Miscellaneous Background Materials, 1965, 1974–1975, n.d.," United States Library of Congress, Washington, DC.

55. Quoted in Pam Banks, "Voting Act Outlook Favorable, Mitchell Tells Rights Leaders," *Baltimore Afro-American*, February 8, 1975.

56. Pohlhaus to the Ex. Dir., Dir., and GC, NAACP, February 3, 1981.

57. "House Unit Moves to Add Areas to Voting Rights Act Coverage," *New York Times*, April 18, 1975; see also "Inclusion of Latins Urged for Voting Act," *Washington Post*, January 24, 1975.

58. Lawrence Meyer, "Shift Debated in Voting Rights," *Washington Post*, December 26, 1974.

59. Pohlhaus to the Ex. Dir., Dir., and GC, NAACP, February 3, 1981.

60. Quoted in William Raspberry, "Expanding the Voting Rights Act," *Washington Post*, March 21, 1975.

61. Perez quoted in Raspberry, "Expanding the Voting Rights Act."

62. "Voting Act Extension May Be in Trouble," *Baltimore Afro-American*, May 24, 1975.

63. Democratic Study Group, "Voting Rights Act Extension," June 1, 1975, No. 94-10, Patsy Mink Papers, Congressional File I, 1883–2005, Box 76, Folder 1, "Voting Rights Act of 1965, Extensions Background Information General," United States Library of Congress, Washington, DC.

64. Quoted in "Voting Rights Act Wins Two Rounds," *New York Times*, June 4, 1975.

65. Don Edwards, "Dear Colleague" letter, May 29, 1975, Patsy Mink Papers, Congressional File I, 1883–2005, Box 76, Folder 5, "Voting Rights Act of 1965, Extensions Correspondence," United States Library of Congress, Washington, DC. See also "House Unit Rejects Voting Rights Shift," *New York Times*, May 1, 1975.

66. "Efforts to Ease Voting Rights Bill Rejected," *Washington Post*, June 4, 1975.

67. Ernest Holsendolph, "Senators Defeat Attempts to Dilute Vote Rights Bill," *New York Times*, July 18, 1975; "Senate Considering Voting Bill," *Hartford Courant*, July 19, 1975.

68. "Senate Calls Up Voting Rights Bill," *New York Times*, July 19, 1975; Spencer Rich, "Voting Act Extension Is Pressed," *Washington Post*, July 19, 1975.

69. Quoted in Spencer Rich, "Voting Rights Bill Modified in Senate," *Washington Post*, July 24, 1975.

70. Carl McCall, "An Extension of Justice," *New York Amsterdam News*, August 20, 1975.

71. James A. Baker, interview by Richard Norton Smith, November 2, 2010,

Gerald R. Ford Oral History Project, accessed August 20, 2015, http://geraldrford foundation.org/centennial/oralhistory/james-a-baker/.

72. Rowland Evans and Robert Novak, "The Incompetency Factor," *Washington Post*, July 31, 1975.

73. Richard L. Madden, "Senate Modifies Voting Act Plan: Backs a Seven-Year Extension After Rejecting Ford Plea to Cover All States," *New York Times*, July 24, 1975.

74. Quoted in Madden, "Senate Modifies Voting Act Plan."

75. Author's analysis of civil rights "policy mood" data, accessed July 21, 2016, available from the Comparative Policy Agendas Project, http://www.comparative agendas.net.

76. Roper Organization, survey, June 14–21, 1975, accessed July 19, 2016, available via subscription to the iPoll Database, Roper Center for Public Opinion Research, University of Connecticut.

77. Louis Harris and Associates, Harris survey, July 1975, accessed June 23, 2015, available via subscription to the iPoll Database, Roper Center for Public Opinion Research, University of Connecticut; Gallup Organization, Gallup poll (AIPO), June 1975, accessed June 23, 2015, available via subscription to the iPoll Database, Roper Center for Public Opinion Research, University of Connecticut; George Gallup, "Ford Support Up as 1976 Hopeful," *Hartford Courant*, July 14, 1975.

78. Rich, "Voting Rights Bill Modified in Senate."

79. McCall, "An Extension of Justice."

80. As a technical matter, the vote was on a measure to table Stennis's amendment, so a "yea" vote represented a vote against the amendment. Author's analysis of Senate vote 312, 94th Cong., July 23, 1975, accessed July 21, 2016, available at GovTrack. us, https://www.govtrack.us/congress/votes/94-1975/s312.

81. Author's analysis of Senate votes 308 and 309 (July 22); 311 (July 23); and 315, 316, 317, 318, 319, 320, 325, 326, 327, and 328 (July 24); 94th Cong., Senate Roll Calls, accessed July 22, 2016, available at VoteView.com, http://voteview.com/SENATE94 .html.

82. Additional roll calls—Senate votes 314, 321, and 324—involved votes on weakening amendments (as opposed to votes to table such amendments) to narrow the bilingual elections provisions, grant district courts within states jurisdiction over matters arising from the Act, and raise the trigger for coverage under the minority-language section from 5 to 10 percent. These amendments all failed. Notably, however, they received an average support of 51 percent of voting Republicans as compared with an average of 21 percent of voting Democrats.

83. Author's analysis of Senate votes 312 (July 23) and 329 (July 24), 94th Cong., Senate Roll Calls, accessed July 21, 2016, available at VoteView.com, http://voteview .com/SENATE94.html.

84. Author's analysis of Senate votes 317 and 329 (both on July 24), 94th Cong., Senate Roll Calls, accessed July 21, 2016, available at VoteView.com, http://voteview .com/SENATE94.html.

85. Author's analysis of Senate votes 321 and 329 (both on July 24), 94th Cong.,

Senate Roll Calls, accessed July 21, 2016, available at VoteView.com, http://voteview
.com/SENATE94.html.

86. Richard L. Madden, "Congress Passes 7-Year Extension of Voting Rights Act,"
New York Times, July 29, 1975.

87. Quoted in "Ford Signs Bill on Voting Rights," *New York Times*, August 7, 1975.

88. See, for example, Joel D. Aberbach and Bert A. Rockman, "Clashing Beliefs
within the Executive Branch: The Nixon Administration Bureaucracy," *American Po-
litical Science Review* 70, no. 2 (1976): 456–68; Richard P. Nathan, *The Plot That Failed:
Nixon and the Administrative Presidency* (New York: Wiley and Sons, 1975).

89. Richard W. Waterman, "The Administrative Presidency, Unilateral Power,
and the Unitary Executive Theory," *Presidential Studies Quarterly* 39, no. 1 (2009):
5–9, at 5; Nathan, *The Plot That Failed*, at 8.

90. Richard Harris, *Justice: The Crisis of Law, Order, and Freedom in America*
(New York: Dutton, 1970).

91. James Rosen, *The Strong Man: John Mitchell and the Secrets of Watergate*
(New York: Doubleday, 2008), chap. 4.

92. James M. Naughton, "Justice Department's New Image: Nixon's Right Arm,"
New York Times, December 25, 1969.

93. John Carmody, "Jerry Leonard—A Team Man in Justice's Civil Rights,"
Washington Post, March 8, 1970.

94. *The Voting Rights Act: Ten Years Later* (Washington, DC: United States Com-
mission on Civil Rights, 1975), at 338. See also *The Shameful Blight*, at 51–59.

95. James E. Alt, "The Impact of the Voting Rights Act on Black and White Voter
Registration in the South," in *Quiet Revolution in the South: The Impact of the Voting
Rights Act, 1965–1990*, ed. Chandler Davidson and Bernard Grofman (Princeton, NJ:
Princeton University Press, 1994), at 351–77.

96. "Is Mitchell Crippling Vote Law?" *Baltimore Afro-American*, October 3, 1970.

97. Fred P. Graham, "Mitchell Assailed on a Rights Stand," *New York Times*, Sep-
tember 24, 1970.

98. John Conyers to Jerris Leonard, July 21, 1971, Leonard Garment Files, White
House Central Files, Staff Member and Office Files, Alpha-Subject Files, Box 156, "Vot-
ing Rights [1 of 3]," Richard M. Nixon Presidential Library, Yorba Linda, California.

99. Arnold Aronson to Heads of National Organizations and Washington Repre-
sentatives, "Help Head Off a Threat to the Voting Rights Act," April 13, 1971, Records
of the Leadership Conference on Civil Rights, Part I: Subject File, Box 139, Folder 19,
United States Library of Congress, Washington, DC.

100. Jerris Leonard to Howard Glickstein, November 12, 1970, Leonard Garment
Files, White House Central Files, Staff Member and Office Files, Alpha-Subject Files,
Box 156, "Voting Rights [1 of 3]," Richard M. Nixon Presidential Library, Yorba Linda,
California.

101. John P. MacKenzie, "Voting Right Switch Asked of Mitchell," *Washington
Post*, March 29, 1971; Larry Lipman, "Policy Switch on Election Changes," *Baltimore
Afro-American*, June 5, 1971.

102. Leonard Garment to Tom Stoel, March 12, 1971, Leonard Garment Papers,

White House Central Files, Staff Member and Office Files, Alpha-Subject Files, Box 156, "Voting Rights [1 of 3]," Richard M. Nixon Presidential Library, Yorba Linda, California.

103. Kotlowski, *Nixon's Civil Rights*, at 95.

104. Stanley A. Halpin and Richard L. Engstrom, "Racial Gerrymandering and Southern State Legislative Redistricting: Attorney General Determinations Under the Voting Rights Act," *Journal of Public Law* 22, no. 1 (1973): 37–66; Kousser, "Strange, Ironic Career of Section 5," at 689.

105. John P. MacKenzie, "U.S. Is Rebuked on Vote Rights," *Washington Post*, May 21, 1973. The administration's position was ultimately rejected by the federal court of appeals for the DC circuit in Harper v. Levi, 520 F.2d 53 (D.C. Cir. 1975).

106. Kousser, "Strange, Ironic Career of Section 5," at 688.

107. *Voting Rights Act: Enforcement Needs Strengthening* (Washington, DC: General Accounting Office, February 6, 1978), at 16.

108. Author's analysis of front-page newspaper articles on the Voting Rights Act (contained in table I.1) and "most important problem" (civil rights) public-opinion data from the Comparative Agendas Project, accessed July 25, 2016, available at http://www.comparativeagendas.net/us.

109. Howard Ball, "Confronting Institutional Schizophrenia: The Effort to Depoliticize the U.S. Department of Justice, 1974–1976," in *Gerald R. Ford and the Politics of Post-Watergate America*, vol. 1, ed. Bernard J. Firestone and Alexej Ugrinsky (Westport, CT: Greenwood Press, 1993), pp. 97–110.

110. Quoted in Nancy V. Baker, "Rebuilding Confidence: Ford's Choice of Attorney General," in *Gerald R. Ford and the Politics of Post-Watergate America*, vol. 1, ed. Bernard J. Firestone and Alexej Ugrinsky (Westport, CT: Greenwood Press, 1993), at 84.

111. Victor S. Navasky, "The Attorney General as Scholar, Not Enforcer," *New York Times*, September 7, 1975.

112. "Rights Violators Facing U.S. Action," *New York Times*, March 9, 1975.

113. "Crackdown on VR Violators," *Memphis Tri-State Defender*, March 15, 1975; Ed Rogers, "Feds Checking Election Law Changes," *Baltimore Afro-American*, March 15, 1975.

114. "U.S. Justice Dept. Challenges Ga.'s Election Policies," *Atlanta Daily World*, September 18, 1976; "U.S. Suit Charges Georgia Failed to Comply with Law in Commissioners Election," *Atlanta Daily World*, September 26, 1976.

115. "Bilingual Elections Due in 464 Counties Under Voting Act," *New York Times*, August 28, 1975; "Officials in 27 States Told to Conduct Bilingual Balloting," *Hartford Courant*, August 28, 1975; "Voting Act Extended by New Guidelines," *Hartford Courant*, April 22, 1976; John M. Crewdson, "U.S. to Oversee Texas Bilingual Votes," *New York Times*, May 1, 1976.

116. Victor L. Lowe, statement before the Subcommittee on Civil and Constitutional Rights, House Committee on the Judiciary on the Department of Justice's Enforcement Activities Regarding the Voting Rights Act of 1965 as Amended, February 6, 1978, accessed July 25, 2016, available at http://gao.gov/assets/100/98649.pdf.

117. General Accounting Office, *Voting Rights Act: Enforcement Needs Strengthening* (Washington, DC: February 6, 1978), at 11–16, 26–28.

118. Richard Nixon, campaign speech in Salt Lake City, Utah, September 18, 1968, Pew/Annenberg Presidential Election Discourse Dataset, CD-ROM.

119. Richard Nixon, campaign speech in St. Louis, Missouri, September 26, 1968, Pew/Annenberg Presidential Election Discourse Dataset, CD-ROM.

120. John Ehrlichman, *Witness to Power: The Nixon Years* (New York: Simon and Schuster, 1982), at 115.

121. William H. Rehnquist to John Ehrlichman, "RE: Judicial Selection," May 29, 1969, John D. Ehrlichman Papers, White House Special Files, Staff Member and Office Files, Alpha-Subject Files 1963 (1968–1973), Box 39, Folder 510B [Supreme Court, Haynsworth Nomination] [II] [3 of 3], Richard M. Nixon Presidential Library, Yorba Linda, California.

122. Bruce H. Kalk, "The Carswell Affair: The Politics of a Supreme Court Nomination in the Nixon Administration," *American Journal of Legal History* 42, no. 3 (1998): 261–87.

123. On Nixon's role in the Burger appointment, see Abraham, *Justices, Presidents, and Senators*, at 254–55; and David A. Yalof, *Pursuit of Justices: Presidential Politics and the Selection of Supreme Court Justices* (Chicago: University of Chicago Press, 2001), at 99–104.

124. William Safire, *Before the Fall: An Inside View of the Pre-Watergate White House* (New York: Da Capo Press, 1975), at 267.

125. Robert Mason, *Richard Nixon and the Quest for a New Majority* (Chapel Hill: University of North Carolina Press, 2004), at 54–55.

126. Note that since Nixon's appointees did not vote on exactly the same issues as the justices they replaced, these are by necessity rough comparisons. The dataset used was "Justice-Centered Data: Cases Organized by Supreme Court Citation," which includes one set of justice votes for each dispute. This data is available from the Supreme Court Database, accessed March 2, 2017, available online at http://scdb.wustl.edu/data.php.

127. John Ehrlichman, "On the Bills We Are Considering Vetoing," notes, June 18, 1970, White House Central Files, Subject Files: HU(Human Rights), Box 20, "Voting 6/1/1970–7/31/70," Richard M. Nixon Presidential Library, Yorba Linda, California.

128. Chandler Davidson, Tanya Dunlap, Gale Kenny, and Benjamin Wise, "Vote Caging as a Republican Ballot Security Technique," *William Mitchell Law Review* 34, no. 2 (2008): 533–62; Tova Andrea Wang, *The Politics of Voter Suppression: Defending and Expanding Americans' Right to Vote* (Ithaca, NY: Cornell University Press, 2012), at 45–49.

129. David M. O'Brien, "The Politics of Professionalism: President Gerald R. Ford's Appointment of Justice John Paul Stevens," *Presidential Studies Quarterly* 21, no. 1 (1991): 103–26.

130. Quotes are from Lesley Oelsner, "Factors in Court Choice," *New York Times*, November 30, 1975; and James Kidney, "John Paul Stevens—A Moderate Conservative," *Boston Globe*, November 29, 1975.

131. Richard L. Engstrom, "Racial Vote Dilution: Supreme Court Interpretations of Section 5 of the Voting Rights Act," *Southern University Law Review* 4, no. 1 (1977): 139–64, at 140.

132. See especially *Voting Rights Act: Ten Years Later.*

133. Although blacks had constituted a population majority prior to the annexation, a lower voter registration rate relative to whites had prevented them from exercising influence consistent with their numbers. But everyone involved anticipated that the growing African American population would provide black voters with a working majority in Richmond in the near future.

134. Howard Ball, "Racial Vote Dilution: Impact of the Reagan DOJ and the Burger Court on the Voting Rights Act," *Publius: The Journal of Federalism* 16, no. 4 (1986): 29–48, at 36.

135. Opinion of Justice Byron White, City of Richmond v. United States, 422 U.S. 358 (1975), at 371.

136. Ibid., at 371.

137. Peyton McCrary, "The Interaction of Policy and Law: How the Courts Came to Treat Annexations under the Voting Rights Act," *Journal of Policy History* 26, no. 4 (2014): 429–58.

138. Warren Weaver Jr., "High Court Backs Richmond's Annexation of White Suburb That Altered Racial Balance," *New York Times*, June 25, 1975.

139. Amanda K. Baumle, Mark Fossett, and Warren Waren, "Strategic Annexation under the Voting Rights Act: Racial Dimensions of Annexation Practices," *Harvard BlackLetter Law Journal* 24, no. 1 (2008): 83–115; McCrary, "Interaction of Policy and Law," at 447.

140. Richard L. Engstrom, "Racial Discrimination in the Electoral Process: The Voting Rights Act and the Vote Dilution Issue," in *Party Politics in the South*, ed. Robert P. Steed, Laurence W. Moreland, and Tod A. Baker (New York: Praeger, 1980), 197–212, at 207.

141. In that case, in explaining why annexations were covered by Section 5 requirements, the Court noted, "Clearly, revision of boundary lines has an effect on voting [and thus falls subject to preclearance]. . . . It dilutes the weight of the votes of the voters to whom the franchise was limited *before the annexation*, and 'the right of suffrage can be denied by a debasement or dilution of the weight of a citizen's vote just as effectively as by wholly prohibiting the free exercise of the franchise'" (emphasis added; internal quote is from *Reynolds*, 377 U.S.). Perkins v. Matthews, 400 U.S. 379 (1971), at 388.

142. At the time of *Beer*, Justice John Paul Stevens had been appointed to the Court, but he did not participate in the case.

143. Under conditions of racially polarized voting with a white plurality, at-large seats grant whites exaggerated political influence.

144. Opinion of Justice Potter Stewart, Beer v. United States, 425 U.S. 130 (1976), at 138–39.

145. Ibid., at 141.

146. Ibid., at 141.

147. Karlan, "Section 5 Squared," at 8.

148. Leadership Conference on Civil Rights, "Statement on Supreme Court's Voting Rights Act Decision," April 23, 1975, Records of the Leadership Conference on Civil Rights, Part II: Issues File, 1957–1991, Box 65, Folder 2, "Voting Rights Act Enforcement, 1976–1986," United States Library of Congress, Washington, DC.

149. Kousser, "Roberts's Opinion in *Shelby County*," fig. 4.

150. As quoted in Stewart, *Beer*, 425 U.S. at 141.

151. Warren, *South Carolina*, 383 U.S. at 316.

152. Committee on the Judiciary, United States Senate, "Voting Rights Act Extension," S. Rep. No. 94-295, at 19 (July 22, 1975).

153. Richard L. Madden, "Fighter for Civil Rights," *New York Times*, December 27, 1976; "The Death of Sen. Hart," *Boston Globe*, December 28, 1976; "Sen. Philip Hart Dies at Age 64," *Hartford Courant*, December 27, 1976.

Chapter 3

1. Quoted in Herbert H. Denton, "Reagan Signs Voting Rights Extension," *Washington Post*, June 30, 1982.

2. Julian Bond, "Civil Rights Priority," *The Portland Skanner*, October 20, 1982.

3. Robert Pear, "Major Fight Expected over Efforts to Extend Voting Rights Measure," *New York Times*, March 9, 1981.

4. James U. Blacksher and Larry T. Menefee, "From *Reynolds v. Sims* to *City of Mobile v. Bolden*: Have the White Suburbs Commandeered the Fifteenth Amendment?" *Hastings Law Journal* 34, no. 1 (1982–1983): 1–59.

5. Opinion of Justice Stewart, Mobile v. Bolden, 446 U.S. 55 (1980), at 55. As a technical matter, the plurality held that Section 2 of the VRA merely brought into operation the Fifteenth Amendment's prohibition against the denial or abridgement of the right to vote on the basis of race, and thus it added no additional weight to the plaintiff's suit.

6. Stewart, *Mobile*, 446 U.S. at 62.

7. This history is brilliantly covered in Kousser, *Colorblind Injustice*.

8. David A. Koenigsberg, "The Standard of Proof in At-Large Vote Dilution Discrimination Cases after *City of Mobile v. Bolden*," *Fordham Urban Law Journal* 10, no. 1 (1981–82): 103–46. See also Harold Wolfson, "*City of Mobile v. Bolden*: A Setback in the Fight against Discrimination," *Brooklyn Law Review* 47, no. 1 (1980): 169–201.

9. Desiree M. Franklin, "The 'Changing' Standard of Proof in Vote Dilution Claims," *Memphis State University Law Review* 13, no. 1 (1982–1983): 249–63.

10. Fred Barbash, "Justices Limit Court Powers Under Voting Rights Act," *Washington Post*, April 23, 1980.

11. Opinion of Justice White, Mobile v. Bolden, 446 U.S. 55 (1980), at 94–95.

12. As White pointedly noted in his dissent, "The Court's cryptic rejection of [the

conclusions of the lower courts] ignores the principles that an invidious discriminatory purpose can be inferred from objective factors of the kind relied on in *White v. Regester*, and that the trial courts are in a special position to make such intensely local appraisals." White, *Mobile*, 446 U.S. at 95.

13. The quote is from Franklin, "'Changing' Standard of Proof in Vote Dilution Claims," at 258.

14. Ronald Reagan, "Remarks at Neshoba County Fair," August 3, 1980, accessed February 18, 2016, available from the *Neshoba County Democrat*, http://neshoba democrat.com/Content/NEWS/News/Article/Transcript-of-Ronald-Reagan-s-1980 -Neshoba-County-Fair-speech/2/297/15599.

15. David E. Rosenbaum, "Black Leaders Declare Differences Remain after a Talk with Reagan," *New York Times*, December 12, 1980.

16. Howell Raines, "Reagan and States' Rights," *New York Times*, March 4, 1981.

17. Morton C. Blackwell to Diana Lozano, "Administration Initiative on Voting Rights Act," memorandum, January 13, 1981, Elizabeth Dole Files, Series I Subject File, Box 60, "Voting Rights Act—January 1982–June 1982," Ronald Reagan Presidential Library, Simi Valley, California.

18. Walter E. Fauntroy, Chairman of the Congressional Black Caucus, Letter to Supporters, April 28, 1981, Records of the Leadership Conference on Civil Rights, LCCR Issues File, Box 67, Folder 3, United States Library of Congress, Washington, DC.

19. Quoted in Bernard Weinraub, "Liberal Groups Are Joining Forces to Defend Their Goals and Gains," *New York Times*, March 9, 1981. On earlier meetings, see, for example, "Attendance—Voting Rights Meeting, January 7, 1981," Records of the Leadership Conference on Civil Rights, LCCR Issues File, Box 68, Folder 7, United States Library of Congress, Washington, DC.

20. Ralph G. Neas to Participating Organizations, "Fight to Extend Voting Rights Act Underway," June 22, 1981, Records of the Leadership Conference on Civil Rights, LCCR Issues File, Box 66, Folder 4, United States Library of Congress, Washington, DC.

21. Quoted in "Jackson to Combat 'US Swing to Right,'" *Boston Globe*, November 2, 1980.

22. NAACP Washington Bureau, "Dear NAACP Leader," June 10, 1981, Records of the Leadership Conference on Civil Rights, LCCR Issues File, Box 66, Folder 4, United States Library of Congress, Washington, DC.

23. Ralph G. Neas, "Ralph G. Neas Draft Outline for Legislative Campaign on VRA Extension," n.d. 1982, Records of the Leadership Conference on Civil Rights, LCCR Issue Files, Box 68, Folder 5, United States Library of Congress, Washington, DC. Discussion of civil rights groups' strategy can be found in Pear, "Major Fight."

24. William L. Taylor, interview, January 2007, Edward M. Kennedy Oral History Project, Miller Center of Public Affairs, University of Virginia, accessed October 13, 2015, available at http://millercenter.org/oralhistory/interview/william_taylor _01-2007.

25. Robert Pear, "Campaign to Extend Voting Rights Act Gains Support," *New York Times*, July 2, 1981; William Raspberry, "Henry Hyde's Second Thoughts," *Washington Post*, June 12, 1981.

26. "Marches Across the US Mark Memory of King," *Boston Globe*, April 5, 1981; Kendal Weaver, "Thousands March for Voting Act," *Boston Globe*, April 6, 1981; "Voting Rights," *Seattle Skanner*, May 6, 1981; "Marchers Re-Enact Start of a 1965 Rights Effort," *New York Times*, April 6, 1981.

27. NAACP Washington Bureau, "Dear NAACP Leader."

28. "Statement of Ralph G. Neas, Executive Director, LCCR," July 15, 1982, Records of the Leadership Conference on Civil Rights, LCCR Issue Files, Box 67, Folder 2, United States Library of Congress, Washington, DC; "Key Organizations in the V.R.A. Extension Fight," June 23, 1982, Records of the Leadership Conference on Civil Rights, LCCR Issue Files, Box 68, Folder 6, United States Library of Congress, Washington, DC.

29. "Media Report," June 12, 1981, Records of the Leadership Conference on Civil Rights, LCCR Issue Files, Box 67, Folder 5, United States Library of Congress, Washington, DC.

30. Hill aide and administration official both quoted in Charles R. Babcock, "White House Delays Taking Stand on Voting Rights Act Extension," *Washington Post*, June 30, 1981.

31. Michael Uhlmann to Martin Anderson, "Preliminary Observations on Extension of the Voting Rights Act," April 17, 1981, at 8, Edwin Meese III Papers, Box 37, "1965 Voting Rights Act (2)," Ronald Reagan Presidential Library, Simi Valley, California.

32. Ed Thomas to Ed Meese, "Extension of Voting Rights Act," August 27, 1981, Edwin Meese III Papers, Box 20, "Voting Rights Act Materials (3)," Ronald Reagan Presidential Library, Simi Valley, California.

33. Bill Peterson, "Southern Republicans Back Voting Rights Act," *Washington Post*, June 13, 1981.

34. Author's analysis of "The Polarization of the Congressional Parties—House Polarization 46th–114th Congresses," accessed July 28, 2016, available at VoteView.com, http://voteview.com/political_polarization_2015.html.

35. Henry J. Hyde, "Updating the Voting Rights Act," *Boston Globe*, June 8, 1981.

36. Thelma Duggin to Elizabeth Dole, "Voting Rights Act," June 11, 1981, Elizabeth Dole Files, Series I Subject File, Box 60, "Voting Rights Act—1981 (2 of 8)," Ronald Reagan Presidential Library, Simi Valley, California.

37. "Voting Rights Extension—Should the President Include Remarks Concerning This Issue in Speech at NAACP, 29 June 1981," minutes of meeting, June 11, 1981, Edwin Meese III Papers, Box 20, "Voting Rights Act Materials (3)," Ronald Reagan Presidential Library, Simi Valley, California.

38. Richard B. Wirthlin to James Baker III, Michael Deaver, and Edwin Meese III, "Voting Rights Act," July 17, 1981, Edwin Meese III Papers, Box 20, "Voting Rights Act Materials (4)," Ronald Reagan Presidential Library, Simi Valley, California.

39. Reagan quoted in "President Seeks Assessment of Voting Rights Act," *New York Times*, June 16, 1981.

40. Bill Peterson, "House Backs Vote Rights Extension," *Washington Post*, October 6, 1981.

41. Mel Bradley to Martin Anderson, "Voting Rights Act—Discussion Points (Detailed)," n.d., at 3, Melvin L. Bradley Files (OPL), Series II, Box 15, "A64-Voting Rights II(6)," Ronald Reagan Presidential Library, Simi Valley, California.

42. Author's analysis of House Roll Call votes 224, 226, 227, and 228, "97th House Roll Call Data," accessed August 15, 2016, available at VoteView.com, http://voteview.com/HOUSE97.html.

43. Thomas M. Boyd and Stephen J. Markman, "The 1982 Amendments to the Voting Rights Act: A Legislative History," *Washington and Lee Law Review* 40, no. 4 (1983): 1347–1428, at 1377–78.

44. Elizabeth Dole to Richard Darman, "Voting Rights Act," October 7, 1981, Elizabeth Dole Files, Series I Subject File, Box 60, "Voting Rights Act—1981 (7 of 8)," Ronald Reagan Presidential Library, Simi Valley, California.

45. Trent Lott to Ronald Reagan, October 13, 1981, WHORM: Human Rights 015, Box 2, "HU015(Voting Rights) 049000-059999," Ronald Reagan Presidential Library, Simi Valley, California.

46. Ed Rogers, "Senators Claim 60 Votes for Voting Rights Bill," *Baltimore Afro-American*, December 26, 1981.

47. Author's analysis of 97th Congress Senate Roll Call votes 679, 680, 681, 682, 683, 684, 685, and 686, "Democratic and Republican Party Voting Splits, Congresses 35–113," May 31, 2015, accessed August 22, 2016, available from VoteView.com, http://voteview.com/partycount.html. Among other things, the amendments sought to repeal the bilingual election requirements, extend preclearance to the entire nation, limit the time allocated to the DOJ for preclearance review, loosen preclearance "bailout" requirements, and shorten the preclearance renewal period.

48. Sherrie Cooksey to Ken Duberstein, "Voting Rights Act Legislation," February 17, 1982, Kenneth Duberstein Files, OLA, Series IV, Box 28, "Voting Rights (2)," Ronald Reagan Presidential Library, Simi Valley, California.

49. Quoted in Mary Thornton, "Justice Official Cautions Senate Panel on Voting Changes," *Washington Post*, March 2, 1982.

50. Elizabeth H. Dole to James A. Baker III, "Black Strategy," January 30, 1982, Elizabeth Dole Files, Series I Subject File, Box 5, "Black Strategy 1982 (2 of 4)," Ronald Reagan Presidential Library, Simi Valley, California.

51. Herbert H. Denton, "Administration in Mighty Effort to Avoid Offense on Civil Rights," *Washington Post*, May 6, 1982.

52. NBC News/Associated Press, NBC News/Associated Press poll, January 1982, accessed June 15, 2015, available via subscription to the iPoll Database, Roper Center for Public Opinion Research, University of Connecticut. Reports from midyear indicated that fully 50 percent of Americans agreed with the statement that Reagan "doesn't really care about the needs and problems of black people." Gallup Organiza-

tion, Gallup report, May 1982, accessed June 15, 2015, available via subscription to the iPoll Database, Roper Center for Public Opinion Research, University of Connecticut.

53. "Senate Stops Voting Rights Filibuster," *Washington Post*, June 16, 1982; "Hill Clears Voting Law," *Washington Post*, June 24, 1982; Herbert H. Denton, "Reagan Signs Voting Rights Extension," *Washington Post*, June 30, 1982.

54. The best extended discussion of the minority-language provisions is James T. Tucker, *The Battle Over Bilingual Ballots: Language Minorities and Political Access Under the Voting Rights Act* (London: Ashgate, 2009).

55. Ellen D. Katz et al., "Documenting Discrimination in Voting: Judicial Findings Under Section 2 of the Voting Rights Act Since 1982," *University of Michigan Journal of Law Reform* 39, no. 4 (2005): 643–772, at 665. As Katz and her colleagues note, these data likely underestimate the effectiveness of Section 2 because they included only *published* cases; in fact, based on corroborating evidence from the ACLU, they estimate that as many as 1,600 Section 2 suits were filed between 1982 and 2005.

56. Edward Kennedy, interview, February 12, 2007, Edward Kennedy Oral History Project, Miller Center of Public Affairs, University of Virginia, accessed October 13, 2015, available at http://millercenter.org/oralhistory/interview/edward_m_kennedy_02-12-2007.

57. Charles R. Babcock, "Justice Officials Move to Control Sensitive Civil Rights Division," *Washington Post*, June 4, 1981.

58. Quote is from Washington Council of Lawyers, "Reagan Civil Rights: The First Twenty Months," *Black Law Journal* 8, no. 1 (1983): 68–94, at 68; See also Robert Pear, "Reagan Choice for Civil Rights Post," *New York Times*, June 8, 1981.

59. William Bradford Reynolds, "Individualism vs. Group Rights: The Legacy of *Brown*," *Yale Law Journal* 93, no. 6 (1984): 995–1005, at 995.

60. Both quotes are from Stuart Taylor Jr., "When Goals of Boss and His Staff Lawyers Clash," *New York Times*, June 22, 1984.

61. Marissa Martino Golden, *What Motivates Bureaucrats? Politics and Administration During the Reagan Years* (New York: Columbia University Press, 2000), at 88–89.

62. Lani Guinier, "Keeping the Faith: Black Voters in the Post-Reagan Era," *Harvard Civil Rights–Civil Liberties Review* 24, no. 1 (1989): 393–435, at 407–8. See also Statement of William Bradford Reynolds, Hearing before the Senate Committee on the Judiciary, Nomination of William Bradford Reynolds to be Associate Attorney General of the United States, 99th Cong., 1st Sess., June 4, 5, and 18, 1985, accessed March 2, 2017, available from the Haitha Trust online, https://babel.hathitrust.org/cgi/pt?id=pst.000012017447;view=1up;seq=5.

63. Marissa Martino Golden, "Exit, Voice, Loyalty, and Neglect: Bureaucratic Responsiveness to Presidential Control During the Reagan Administration," *Journal of Public Administration, Research, and Theory* 2, no. 1 (1992): 29–62, at 45.

64. Stuart Taylor Jr., "Justice Dept. Says Dissidents 'Are Welcome to Leave' Jobs," *New York Times*, February 2, 1982.

65. Quoted in Stuart Taylor Jr., "Rights Chief Holds 'Tense Meeting' with Lawyers," *New York Times*, February 18, 1982.

66. Brian K. Landsberg, "The Role of Civil Service Attorneys and Political Appointees in Making Policy in the Civil Rights Division of the U.S. Department of Justice," *Journal of Law and Policy* 9, no. 1 (1992–1993): 275–88, at 287.

67. Days's quote is from Drew S. Days III, "Holding the Line," *Creighton Law Review* 20, no. 1 (1986–1987): 1–10, at 7; Golden, *What Motivates Bureaucrats?*, 97.

68. *Voting Rights Enforcement and Reauthorization: The Department of Justice's Record of Enforcing the Temporary Voting Rights Act Provisions* (Washington, DC: United States Commission on Civil Rights, 2006), at 24–27, accessed March 2, 2017, available from the University of Maryland Law School, https://www.law.umaryland.edu/marshall/usccr/documents/051006VRAStatReport.pdf; National Commission on the Voting Rights Act, *Protecting Minority Voters: The Voting Rights Act at Work, 1982–2005* (Washington, DC: National Commission on the Voting Rights Act, 2006), at 185–86.

69. Laughlin McDonald, "The Quiet Revolution in Minority Voting Rights," *Vanderbilt Law Review* 42, no. 4 (1989): 1249–97, at 1285; Pamela S. Karlan, "Two Section Twos and Two Section Fives: Voting Rights and Remedies after *Flores*," *William & Mary Law Review* 39, no. 3 (1998): 725–41, at 734; Norman Amaker, *Civil Rights and the Reagan Administration* (Washington, DC: Urban Institute Press, 1988).

70. Testimony of Frank Parker, Hearing before the Senate Committee on the Judiciary, Nomination of William Bradford Reynolds to be Associate Attorney General of the United States, 99th Cong., 1st Sess., 1985, at 452.

71. Frank Parker, *Black Votes Count: Political Empowerment in Mississippi After 1965* (Chapel Hill: University of North Carolina Press, 1990), at 188.

72. Al Kamen, "Grounds to Sue on Voter Rights are Broadened," *Washington Post*, July 1, 1986.

73. On Bush's view of voting rights matters, see Neal Devins, "Reagan Redux: Civil Rights Under Bush," *Notre Dame Law Review* 68, no. 5 (1993): 955–1001.

74. Richard Thornburgh, interview, October 23–24, 2001, George H. W. Bush Oral History Project, Miller Center of Public Affairs, University of Virginia, available at http://millercenter.org/oralhistory/interview/richard-thornburgh, accessed October 13, 2015.

75. Ibid.

76. Michael Wines, "Shaking Up Justice," *New York Times*, May 21, 1989.

77. Michael Isikoff, "Civil Rights Nominee Defuses Criticism," *Washington Post*, March 8, 1990.

78. National Commission on the Voting Rights Act, *Protecting Minority Voters*, figures 1–2; Robert Pear, "Under the Voting Law, Citizens' Rights Get More than Lip Service," *New York Times*, July 21, 1991.

79. Linda Greenhouse, "In Retreat, Supreme Court Limits Scope of '65 Voting Rights Act," *New York Times*, January 28, 1992.

80. David Johnston, "In Justice Dept. of the 90's, Focus Shifts from Rights," *New York Times*, March 26, 1991.

81. Michael Oreskes, "Seeking Seats, Republicans Find Ally in Rights Act," *New York Times,* August 20, 1990; Richard L. Berke, "G.O.P. Tries a Gambit with Voting Rights," *New York Times,* April 14, 1991; Richard E. Cohen, "Voting Rights Act Could Haunt Democrats," *National Journal,* January 4, 1992; "Unlikely Allies on Civil Rights," *US News and World Report,* February 10, 1992.

82. David Lublin, *The Paradox of Representation: Racial Gerrymandering and Minority Interests in Congress* (Princeton, NJ: Princeton University Press, 1999).

83. David Lublin and D. Stephen Voss, "The Missing Middle: Why Median-Voter Theory Can't Save Democrats from Singing the Boll-Weevil Blues," *Journal of Politics* 65, no. 1 (2003): 227–37.

84. Richard Fleisher and John R. Bond, "The Shrinking Middle in the US Congress," *British Journal of Political Science* 34, no. 2 (2004): 429–51.

85. Debra Cassens Moss, "The Policy and the Rhetoric of Ed Meese," *ABA Journal* (February 1, 1987): 64–69.

86. Office of Legal Policy, *Report to the Attorney General: Redefining Discrimination—"Disparate Impact" and the Institutionalization of Affirmative Action* (Washington, DC: United States Department of Justice, 1988), at 145.

87. Ibid., at 148.

88. Office of Legal Policy, *Guidelines on Constitutional Litigation* (Washington, DC: United States Department of Justice, 1988), at 56.

89. Edwin Meese III, "The Supreme Court of the United States: Bulwark of a Limited Constitution," *South Texas Law Review* 27, no. 1 (1986): 455–66.

90. Quoted in Andrew E. Busch, *Ronald Reagan and the Politics of Freedom* (Lawrence: University Press of Kansas, 2001), at 41.

91. Peter J. Wallison, "Memorandum for the File," August 29, 1986, Peter Wallison Papers, OA 14287, Box 5, "Supreme Court/Rehnquist/Scalia General Selection Scenario [1 of 3]," Ronald Reagan Presidential Library, Simi Valley, California.

92. Busch, *Ronald Reagan and the Politics of Freedom,* at 41.

93. "Fact Sheet on Alleged Harassment of Voters by Justice William H. Rehnquist in the Early 1960's," n.d., 1986, Peter Wallison Papers, OA 14287, Box 6, "Supreme Court Nominations—Rehnquist [5 of 5]," Ronald Reagan Presidential Library, Simi Valley, California.

94. These data come from the Supreme Court Database, accessed March 2, 2017, available at http://scdb.wustl.edu/analysis.php. The cases were Georgia v. United States (1973), NAACP v. New York (1973), Connor v. Waller (1975), City of Richmond v. United States (1975), Beer v. United States (1976), United States v. Board of Supervisors of Warren County, Texas (1977), Briscoe v. Bell (1977), Morris v. Gressette (1977), United States v. Board of Commissioners of Sheffield, Mississippi (1978), Berry v. Doles (1978), Dougherty County, Georgia v. White (1978), City of Rome v. United States (1980), McDaniel v. Sanchez (1981), Hathorn v. Lovorn (1982), City of Port Arthur, Texas v. United States (1982), and City of Lockhart v. United States (1983).

95. Dawn Johnson argues that the Reagan administration's views on voting rights matters (and other civil rights concerns) may have been influenced by Rehnquist's opinions. See Johnson, "Ronald Reagan and the Rehnquist Court on Congressional

Power: Presidential Influences on Constitutional Change," *Indiana Law Review* 78, no. 1 (2003): 363–412.

96. Arthur Culvahouse, "Justice William Rehnquist," n.d., Arthur Culvahouse Papers, OA 15065, Box 4, "Supreme Court—Robert Bork—Copy of Candidate Notebook—Rehnquist/Scalia [2 of 2]," Ronald Reagan Presidential Library, Simi Valley, California.

97. ABC News/Washington Post poll, June 19–24, 1986, accessed August 18, 2016, available via subscription to the iPoll Database, Roper Center for Public Opinion Research, University of Connecticut. Several weeks later, public knowledge of Rehnquist had barely improved. People for the American Way, Judicial Nominations poll, July 10–14, 1986, Peter D. Hart Research Associates, accessed August 18, 2016, available via subscription to the iPoll Database, Roper Center for Public Opinion Research, University of Connecticut.

98. See, for example, Louis Harris and Associates, Harris survey, August 5–11, 1986, accessed August 18, 2016, available via subscription to the iPoll Database, Roper Center for Public Opinion Research, University of Connecticut; NBC News/Wall Street Journal Survey, August 11–12, 1986, accessed August 18, 2016. available via subscription to the iPoll Database, Roper Center for Public Opinion Research, University of Connecticut.

99. Note that since Reagan's appointees did not vote on exactly the same issues as the justices they replaced, these are by necessity rough comparisons. Additionally, the data for Rehnquist include both his tenure as associate justice as well as his subsequent service as chief justice. The data set used, "Justice-Centered Data: Cases Organized by Supreme Court Citation," is from the Supreme Court Database, accessed March 2, 2017, available at http://scdb.wustl.edu/data.php.

100. Empirical evidence for this characterization can be found in measures of Thomas's (and other justices') ideologies as estimated based on their judicial voting behavior. Arguably the most popular measures of judicial ideology are the "Martin-Quinn" scores, accessed September 20, 2016, available at http://mqscores.berkeley.edu/.

101. Bush's other appointee to the Court, Justice David Souter, turned out to be a profound disappointment for conservatives. Once installed in office, Souter often (though not always) voted with the Court's liberal wing.

102. This ambition was facilitated by a dramatic increase in funding for CRD spearheaded by congressional Democrats. The increase began during the George H. W. Bush years and continued until the Republican capture of Congress after the 1994 elections, after which Republicans choked off funding to the Division. United States Commission on Civil Rights, *Funding Federal Civil Rights Enforcement* (Washington, DC: United States Commission on Civil Rights, June 1995), at 29; United States Commission on Civil Rights, *Funding Federal Civil Rights Enforcement: 2000–2003* (Washington, DC: United States Commission on Civil Rights, April 2002), accessed October 15, 2015, available at http://www.usccr.gov/pubs/crfund02/report.htm.

103. Deval Patrick, "Swearing-In Ceremony Remarks," April 14, 1994, Office of

Communications and Don Baer, "Long Range Planning," William J. Clinton Digital Library, accessed October 15, 2015, available at http://clinton.presidentiallibraries.us/items/show/34812.

104. "Department of Justice Defends Rights of Minority Voters, Takes Action in North Carolina, Georgia, and Texas," February 22, 1994, Domestic Policy Council, Steven Warnath, and Civil Rights Series, "[Civil Rights Working Group][1]," William J. Clinton Digital Library, accessed October 14, 2015, available at http://clinton.presidentiallibraries.us/items/show/7131. In the later years of his administration, Clinton also allocated additional funding to the CRD for civil rights enforcement. See, for example, Josh Gottheimer to Michael Waldman, "Thursday Race Initiative Budget Meeting," January 7, 1999, Office of Speechwriting and Michael Waldman, "Race 1/7/99," William J. Clinton Presidential Library, accessed October 15, 2015, available at http://clinton.presidentiallibraries.us/items/show/45254.

105. See, for example, Christina Rivers, "'Conquered Provinces'? The Voting Rights Act and State Power," *Publius: The Journal of Federalism* 36, no. 3 (2006): 421–42. Ginsburg and Breyer replaced moderate-to-liberal justices Byron White and Harry Blackmun, respectively, and thus did not drastically alter the Court's ideological balance.

106. E. Walter Terrie, "Several Recent Supreme Court Decisions and Their Implications for Political Redistricting in Voting Rights Act Context," *Population Research and Policy Review* 15, no. 6 (1996): 565–78, at 569.

107. Justice Sandra Day O'Connor, Shaw v. Reno, 509 U.S. 630 (1993), at 647. But the majority opinion also declined to address the question of whether "the intentional creation of majority-minority districts, without more, always gives rise to an equal protection claim." O'Connor, *Shaw*, 509 U.S. at 649.

108. Yet, as J. Morgan Kousser correctly notes, since skin color *is* closely associated with political interest as an empirical matter, it is hard to see how this is a negative stereotype. See Kousser, *Colorblind Injustice*. The fact of extensive racial-bloc voting was well known at the time of the *Shaw* ruling. See, for example, Samuel Issacharoff, "Polarized Voting and the Political Process: The Transformation of Voting Rights Jurisprudence," *Michigan Law Review* 90, no. 7 (1991): 1833–91.

109. The term "expressive harms" comes from Richard Pildes and Richard Niemi's influential analysis of the majority opinion in Shaw. See Pildes and Niemi, "Expressive Harms, 'Bizarre Districts,' and Voting Rights: Evaluating Election-District Appearances after *Shaw v. Reno*," *Michigan Law Review* 92, no. 4 (1993): 483–587; see also Samuel Issacharoff and Thomas C. Goldstein, "Identifying the Harm in Racial Gerrymandering Claims," *Michigan Journal of Race and Law* 1, no. 1 (1996): 47–68.

110. David R. Dow, "The Equal Protection Clause and the Legislative Redistricting Cases—Some Notes Concerning the Standing of White Plaintiffs," *Minnesota Law Review* 81, no. 5 (1997): 1123–48. Desmond S. King and Rogers M. Smith have argued persuasively that the primary opponents of majority-minority districts have been white proponents of a "color-blind" interpretation of the Constitution. See King and Smith, *Still a House Divided*.

111. Peter Applebome, "Suits Challenging Redrawn Districts That Help Blacks," *New York Times*, February 14, 1994.

112. Joan Biskupic, "Behind U.S. Race Cases, a Little-Known Recruiter," *Reuters*, December 4, 2012; Jim Rutenberg, "A Dream Undone: Inside the 50-Year Campaign to Roll Back the Voting Rights Act," *New York Times Magazine*, July 29, 2015.

113. "Accomplishments of the Civil Rights Division in the Clinton Administration," Domestic Policy Council, Steven Warnath, and Civil Rights Series, "[Civil Rights Working Group]," William J. Clinton Digital Library, accessed October 14, 2015, available at http://clinton.presidentiallibraries.us/items/show/7130.

114. The DOJ twice refused Georgia's redistricting proposals because it believed that the state failed to provide adequate opportunities for African American voters. Opinion of Justice Anthony Kennedy, Miller v. Johnson, 515 U.S. 900 (1995), at 906–7.

115. Ibid., at 915.

116. Ibid., at 916.

117. Pamela S. Karlan, "Exit Strategies in Constitutional Law: Lessons for Getting the Least Dangerous Branch Out of the Political Thicket," *Boston University Law Review* 82, no. 1 (2002): 667–98, at 688.

118. Kennedy, *Miller*, 515 U.S. at 917.

119. Rivers, *Congressional Black Caucus*, at 140.

120. As Justice Kennedy wrote for the majority, "There is no indication that Congress intended such a far-reaching application of Section 5 [so as to incorporate majority-minority districting], so we reject the Justice Department's interpretation of the statute." Kennedy, *Miller*, 515 U.S. at 927.

121. Ibid., at 927.

122. Ibid., at 927.

123. Quotes are from Hillary Clinton, Remarks at the NAACP 86th Annual Convention, Minneapolis, Minnesota, July 13, 1995, Office of Speechwriting and James (Terry) Edmonds, "7/13/96 NAACP-HRC[1]," William J. Clinton Digital Library, accessed October 14, 2015, available at http://clinton.presidentiallibraries.us/items/show/33735.

124. John E. Yang, "Remapping the Politics of the South," *Washington Post*, April 16, 1996.

125. Pamela S. Karlan, "The Fire Next Time: Reapportionment after the 2000 Census," *Stanford Law Review* 50, no. 3 (1998): 731–63, at 749.

126. See, for example, Charles Gregory Warren, "Towards Proportional Representation? The Strange Bedfellows of Racial Gerrymandering and Equal Protection in *Easley v. Cromartie*," *Mercer University Law Review* 53, no. 2 (2002): 945–66.

127. Linda Greenhouse, "High Court Takes Case on Districts and Rights," *New York Times*, January 23, 1999.

128. Opinion of Justice Sandra Day O'Connor, Reno, Attorney General v. Bossier Parish School Board et al., 520 U.S. 471 (1997), at 475.

129. Ibid., at 478.

130. This paragraph draws heavily on Katz, "Federalism, Preclearance, and the Rehnquist Court"; and Luis Fuentes-Rohwer, "Paradoxical Case."

131. In effect, Congress adopted the Court's standard in White v. Regester (1975) as its statutory standard. See Justice John Paul Stevens, Opinion Dissenting in Part and Concurring in Part from Reno, Attorney General v. Bossier Parish School Board et al., 520 U.S. 471 (1997), at 505.

132. Katz, "Federalism, Preclearance, and the Rehnquist Court," at 1194.

133. O'Connor, *Reno v. Bossier*, 520 U.S. at 483.

134. Quoted in Stevens, *Reno v. Bossier*, 520 U.S. at 505–6.

135. Ellen D. Katz, "Reinforcing Representation: Enforcing the Fourteenth and Fifteenth Amendments in the Rehnquist and Waite Courts," *Michigan Law Review* 101, no. 7 (2003): 2341–408, at 2380, n.225.

136. Quoted in "The Supreme Court Made It More Difficult Monday for Federal Officials," *St. Louis Post-Dispatch*, May 13, 1997.

137. Breyer and Ginsburg argued that the question should have been decided in *Bossier I* and took the expansive view that "the 'purpose' inquiry does extend beyond the search for retrogressive intent. It includes the purpose of unconstitutionally diluting minority voting strength." See Concurring Opinion of Justice Stephen Breyer, Reno, Attorney General v. Bossier Parish School Board et al., 520 U.S. 471 (1997), at 493.

138. Peyton McCrary, Christopher Seaman, and Richard Valelly, "The End of Preclearance as We Knew It: How the Supreme Court Transformed Section 5 of the Voting Rights Act," *Michigan Journal of Race and Law* 11, no. 1 (2006): 275–323, at 302–3.

139. Justice Antonin Scalia, Reno v. Bossier Parish School Board et al. II, 528 U.S. 320 (2000), at 329–30.

140. This paragraph draws heavily on Alaina C. Beverly, "Lowering the Preclearance Hurdle: *Reno v. Bossier Parish School Board*, 120 S. Ct. 866 (2000)," *Michigan Journal of Race and Law* 5, no. 2 (2000): 695–710.

141. White, *City of Richmond*, 422 U.S. at 378. See also "The Supreme Court, 1999 Term: Leading Cases," *Harvard Law Review* 114, no. 1 (2000): 179–390, at 382.

142. City of Pleasant Grove v. United States, 479 U.S. 462 (1987).

143. Linda Greenhouse, "Justices Say Redistricting Need Only Prevent Backsliding," *New York Times*, January 2, 2000.

144. Justice David Souter, Opinion Dissenting from Reno v. Bossier Parish School Board et al. II, 528 U.S. 320 (2000), at 358–59, n.10; See also "The Supreme Court, 1999 Term," at 380.

145. National Commission on the Voting Rights Act, *Protecting Minority Voters*, at 77–80.

146. "Talking Points: Religious Freedom Restoration Act Supreme Court Decision, *City of Boerne v. Flores et al.*," Office of Speechwriting and James (Terry) Edmonds, "Supreme Court Decisions," William J. Clinton Digital Library, accessed October 14, 2015, available at http://clinton.presidentiallibraries.us/items/show/34030.

147. Justice Anthony Kennedy, majority opinion in City of Boerne v. Flores, 521 U.S. 507 (1997), at 519.

148. See, for example, Karlan, "Two Section Twos and Two Section Fives," at 725–41; and Rodriguez, "Section 5 of the Voting Rights Act of 1965 after *Boerne*."

149. Kennedy, *Boerne*, 521 U.S. at 533.

150. Victor Andres Rodriguez, "Section 5 of the Voting Rights Act of 1965 after *Boerne*: The Beginning of the End of Preclearance?," *California Law Review* 91, no. 3 (2003): 769–826, at 792–94; Ellen D. Katz, "Dismissing Deterrence," *Harvard Law Review Forum*, April 14, 2014, accessed November 25, 2014, available at http://harvard lawreview.org/2014/04/dismissing-deterrence/.

151. Quoted in Denton, "Reagan Signs."

152. Katz et al., "Documenting Discrimination in Voting"; Matt A. Barreto, Gary M. Segura, and Nathan D. Woods, "The Mobilizing Effect of Majority-Minority Districts on Latino Turnout," *American Political Science Review* 98, no. 1 (2004): 65–75; Griffin and Keane, "Descriptive Representation"; Rene R. Rocha, Caroline J. Tolbert, Daniel C. Bowen, and Christopher J. Clark, "Race and Turnout: Does Descriptive Representation in State Legislatures Increase Minority Voting?" *Political Research Quarterly* 63, no. 4 (2010): 890–907.

153. "Inside the Voting Rights Act: On the Endangered List," *Atlanta Journal-Constitution*, June 8, 1997.

Chapter 4

1. Quoted in Renew the VRA Campaign, "Civil Rights Coalition Celebrates Renewal of Landmark Voting Rights Act," press release, July 27, 2006, accessed January 27, 2014, available online from the Internet Archive, https://web.archive.org/web /20060920191326/http://renewthevra.civilrights.org/vra_news/details.cfm?id=45845.

2. Quoted in "Bush Extends Voting Rights Act; Civil Rights Leaders on Hand. President Also Signs Bill Targeting Pedophiles," *Akron Beacon Journal*, July 28, 2006.

3. Goodwin Liu, "The Bush Administration and Civil Rights: Lessons Learned," *Duke Journal of Constitutional Law and Public Policy* 4, no. 1 (2009): 77–105; Karlan, "Lessons Learned."

4. Jo Becker and Amy Argetsinger, "The Nominee as a Young Pragmatist," *Washington Post*, July 22, 2005; R. Jeffrey Smith, Amy Goldstein, and Jo Becker, "A Charter Member of the Reagan Vanguard," *Washington Post*, August 1, 2005.

5. Office of the Inspector General, US Department of Justice, *A Review of the Operations of the Voting Section of the Civil Rights Division*, (Washington, DC: Office of the Inspector General, Oversight and Review Division, March 2013), chap. 4.

6. Shelby County, Alabama v. Holder, Attorney General, et al., 570 U.S. _____ (2013). Decided June 25, 2013.

7. George W. Bush, "Remarks on Receiving the Report of the National Commission on Federal Election Reform," July 31, 2001, Public Papers of the Presidents of the United States, accessed January 28, 2014, available from the American Presidency Project, http://www.presidency.ucsb.edu/ws/index.php?pid=73369&st=voting+rights &st1=.

8. Empirical analyses detailing the discarding of minority ballots in the 2000 election can be found in, for example, Minority Staff, Special Investigations Division,

Committee on Government Reform, US House of Representatives, *Income and Racial Disparities in the Undercount in the 2000 Presidential Election*, July 9, 2001, accessed March 3, 2017, available from the Stanford Law School, http://election2000 .law.stanford.edu/wp-content/uploads/2013/02/house.study_.dem_.pdf; United States Civil Rights Commission, *Voting Irregularities in Florida during the 2000 Presidential Election* (Washington, DC: United States Commission on Civil Rights, 2001); Walter Mebane, "The Wrong Man is President! Overvotes in the 2000 Presidential Election in Florida," *Perspectives on Politics* 2, no. 3 (2004): 525–35; Michael C. Herron and Jasjeet S. Sekhon, "Overvoting and Representation: An Examination of Overvoted Presidential Ballots in Broward and Miami-Dade Counties," *Electoral Studies* 22, no. 1 (2003): 21–47.

9. Robert Pear, "Overhauling Elections: Bush Signs Legislation Intended to End Voting Disputes," *New York Times*, October 30, 2002.

10. Ashcroft's opponent, former Missouri governor Mel Carnahan, had been killed in a plane crash shortly before the election. Carnahan's widow, Jean, ran in his stead and ultimately defeated Ashcroft by a 50–48 margin. The unusual circumstances of Jean Carnahan's victory reinforced Republicans' inclination to claim that the election had been tainted by fraud. John W. Fountain, "Senator Refuses to Challenge Loss," *New York Times*, November 9, 2000.

11. Eric Lipton and Ian Urbina, "In 5-Year Effort, Scant Evidence of Voter Fraud," *New York Times*, April 12, 2007.

12. John Ashcroft, "Prepared Remarks at the Voting Integrity Symposium," United States Department of Justice, October 8, 2002, accessed October 16, 2015, available at http://www.justice.gov/archive/ag/speeches/2002/100802ballotintegrity .htm; see also "Fact Sheet: Protecting Voting Rights and Preventing Election Fraud," United States Department of Justice, accessed October 17, 2015, available at http:// www.justice.gov/archive/opa/pr/2002/November/02_at_641.htm.

13. Leadership Conference on Civil Rights, "LCCR Letter to Attorney General John Ashcroft re: 'Voting Access and Integrity Initiative,'" November 1, 2002, accessed October 17, 2015, available at http://www.civilrights.org/advocacy/letters /2002/lccr-letter-to-attorney-general-john-ashcroft-re-voting-access-and-integrity -initiative.html.

14. Carol D. Leonnig, "Political Hiring in Justice Division Probed," *Washington Post*, June 21, 2007.

15. Matthew Murray, "DOJ Vets Hit von Spakovsky," *Roll Call*, June 20, 2007.

16. Quoted in Jane Mayer, "The Voter-Fraud Myth," *The New Yorker*, October 29, 2012.

17. Von Spakovsky quoted in Rutenberg, "A Dream Undone."

18. Dan Eggen, "Civil Rights Focus Shift Roils Staff at Justice," *Washington Post*, November 13, 2005; Charlie Savage, "In Shift, Justice Department Is Hiring Lawyers with Civil Rights Backgrounds," *New York Times*, May 31, 2011.

19. Schlozman quoted in David G. Savage, "Bush Appointee Saw Justice Lawyers as 'Commies,' 'Crazy Libs,' Report Says," *Los Angeles Times*, January 14, 2009.

20. Rich likely exacerbated matters, however, by "testing" new, and in his view

objectionable, rules issued by Bush's political appointees. See Office of the Inspector General, US Department of Justice, *A Review of the Operations*, at 149–54.

21. Adam Serwer, "The Battle for Voting Rights," *American Prospect*, January 8, 2010.

22. William Yeomans, "Rebuilding Civil Rights Enforcement," *Human Rights Magazine* 37, no. 4 (2010), accessed April 7, 2016, available at http://www.american bar.org/publications/human_rights_magazine_home/human_rights_vol37_2010 /fall2010/rebuilding_civil_rights_enforcement.html.

23. Rachel Morris, "Tipping Back the Scales," *Washington Monthly*, September 9, 2009; Gilda R. Daniels, "Office Politics: Hiring and Firing Government Lawyers," *Public Law* 18 (Winter 2010): 7–9.

24. Leonnig, "Political Hiring."

25. First quote in Morris, "Tipping Back the Scales"; second quote in Savage, "Bush Appointee."

26. Office of the Inspector General, US Department of Justice, and Office of Professional Responsibility, *An Investigation of Allegations of Politicized Hiring and Other Improper Personnel Actions in the Civil Rights Division* (Washington, DC: US Department of Justice, Office of the Inspector General and Office of Professional Responsibility, July 2, 2008), accessed December 21, 2015, available at https://oig.justice .gov/special/s0901/final.pdf, at 14–35.

27. See, for example, Adam Serwer, "John Tanner's Ghost Still Haunts the Justice Department," *American Prospect*, July 29, 2009; and Donovan Slack, "Department of Justice Investigates Attorney in Boston Voting Lawsuit," *Boston Herald*, November 5, 2007.

28. Matt Corley, "Tanner Apologizes for Saying He Liked His Coffee 'Mary Frances Berry Style—Black and Bitter,'" *ThinkProgress*, January 15, 2009, accessed December 21, 2015, available at http://thinkprogress.org/politics/2009/01/15/34872/tanner -apology/.

29. Quoted in Dan Abrams, "Changes in the Civil Rights Division," NBC News, December 14, 2007, accessed October 15, 2015, available at http://www.nbcnews.com /id/22265419/ns/msnbc-verdict_with_dan_abrams/t/changes-civil-rights-division /#.ViAKfekoGXo.

30. Office of the Inspector General, US Department of Justice, and Office of Professional Responsibility, *An Investigation of Allegations*, at 43–45; Eggen, "Civil Rights Focus Shift."

31. Edward M. Kennedy, "Restoring the Civil Rights Division," *Harvard Law and Policy Review* 2, no. 1 (2008): 211–36, at 215.

32. Office of the Inspector General, US Department of Justice, *A Review of the Operations*, at 156.

33. Office of the Inspector General and US Department of Justice, Office of Professional Responsibility, *An Investigation of Allegations*, at 35–43.

34. William R. Yeomans, "The Politics of Civil Rights Enforcement," *Washburn Law Journal* 53, no. 3 (2014): 509–45, at 528.

35. Peter Margulies, *Law's Detour: Justice Displaced in the Bush Administration* (New York: NYU Press, 2010), at 94.

36. Liu, "Bush Administration and Civil Rights," at 83.

37. Ibid., at 85.

38. Karlan, "Lessons Learned," at 22; Marc Posner, *The Politicization of Justice Department Decision-Making Under Section 5 of the Voting Rights Act: Is It a Problem and What Should Congress Do?* (Washington, DC: American Constitution Society for Law and Policy, January 2006), at 14.

39. Dan Eggen, "Official's Article on Voting Law Spurs Outcry," *Washington Post*, April 13, 2006; Richard L. Hasen, "Who is Publius? The Answer Might Surprise You," *Election Law Blog*, March 29, 2006, accessed December 21, 2015, available at http://electionlawblog.org/archives/005295.html; Richard L. Hasen, "Implausible Deniability," *Slate*, June 13, 2007.

40. Dan Eggen, "Staff Opinions Banned in Voting Rights Cases; Criticism of Justice Dept.'s Rights Division Grows," *Washington Post*, December 10, 2005.

41. Office of the Inspector General, US Department of Justice, *A Review of the Operations*, chap. 4.

42. *Information on Employment Litigation, Housing and Civil Rights Enforcement, Voting, and Special Litigation Sections' Enforcement Efforts from Fiscal Years 2001 through 2007*, (Washington, DC: Government Accountability Office, October 2009), at 68.

43. Fuentes-Rohwer and Charles, "The Politics of Preclearance," at 517. The data presented by Fuentes-Rohwer and Charles includes the final year of Clinton's tenure in office, 2000.

44. Scott Horton, "The US Attorneys Scandal Enters the Criminal Prosecutions Phase," *Harper's*, June 16, 2008. Another important factor in Graves's firing was his refusal to intervene in a dispute between the staff of Senator Kit Bond of Missouri and Sam Graves, a congressman from the state, which led Bond to demand Todd Graves's removal from office. Todd and Sam Graves are brothers. Richard L. Hasen, *The Fraudulent Fraud Squad: Understanding the Battle over Voter I.D.* (New Haven, CT: Yale University Press, 2012).

45. Sam Hananel, "Justice Office Defends Filing Voter Fraud Case Before Election," *Associated Press*, June 6, 2007; Terry Frieden, "Justice Official Revises Testimony in Voter-Fraud Case," *CNN*, June 13, 2007, accessed January 3, 2016, available at http://www.cnn.com/2007/POLITICS/06/13/us.attorneys/. Graves was one of nine US attorneys fired for political reasons in the "Attorney-Gate" scandal that eventually forced the resignation of Attorney General Alberto Gonzales.

46. Greg Gordon, "2006 Missouri's Election Was Ground Zero for GOP," *McClatchy Newspapers*, May 3, 2007. Called to testify before the Senate Judiciary Committee to explain the departure from established practices, Schlozman initially claimed that he brought the suit "at the direction" of the Department's Public Integrity Section, but he later recanted in the face of contrary statements from officials within that Section. Schlozman's retraction raised the question of why he attempted

to hide behind the Public Integrity Section if the case to bring charges against the ACORN activists before the election was strong on the merits.

47. Scott Horton, "Brad Schlozman's 'Good Americans,'" *Harper's*, June 22, 2007.

48. Thomas B. Edsall and Dan Eggen, "Bush Picks Controversial Nominees for FEC," *Washington Post*, December 17, 2005.

49. Richard L. Hasen, *The Voting Wars: From Florida 2000 to the Next Election Meltdown* (New Haven: Yale University Press, 2012), at 126–30. The draft report is still available online through the *New York Times* website, accessed January 4, 2016, available at http://graphics8.nytimes.com/packages/pdf/national/20070411voters_draft_report.pdf.

50. The quotes are from *Report of Investigation: Preparation of the Voter Fraud and Voter Intimidation Report* (Washington, DC: US Election Assistance Commission, Office of Inspector General, March 2008), at 15. See also Tova Andrea Wang, "A Rigged Report on US Voting?" *Washington Post*, August 30, 2007.

51. *Report of Investigation*, at 16.

52. John Bresnahan, "Han von Spakovsky Withdraws FEC Nomination," *Politico*, May 16, 2008.

53. Jacelyn Benson, "Turning Lemons into Lemonade: Making *Georgia v. Ashcroft* the *Mobile v. Bolden* of 2007," *Harvard Civil Rights–Civil Liberties Review* 39, no. 4 (2005): 485–511.

54. David J. Becker, "Saving Section 5: Reflections on *Georgia v. Ashcroft*, and Its Impact on the Reauthorization of the Voting Rights Act," in *Voting Rights Act Reauthorization of 2006: Perspectives on Democracy, Participation, and Power*, ed. Ana Henderson (Berkeley: University of California Press, 2007), at 223.

55. Justice Sandra Day O'Connor, opinion for the Court, Georgia v. Ashcroft, 539 U.S. 461 (2003), at 479.

56. Justice David Souter, dissent from Georgia v. Ashcroft, 539 U.S. 461 (2003), at 493, 495.

57. O'Connor, *Georgia*, 539 U.S. at 480, 482.

58. Katz, "Reinforcing Representation," 2381; Pamela S. Karlan, "*Georgia v. Ashcroft* and the Retrogression of Retrogression," *Election Law Journal* 3, no. 1 (2004): 21–36.

59. Henderson quoted in "Conference Launches Drive to Re-Authorize Voting Act," *New York Beacon*, March 10, 2005.

60. Edward Blum and Abigail Thernstrom, "After 40 Years, It's Time for Virginia to Move On," *Richmond Times-Dispatch*, August 1, 2005.

61. Bush quoted in Roland S. Martin, "Bush Tells CBC He's 'Unfamiliar' with Voting Rights Act," *Chicago Defender*, January 27, 2005, at 4.

62. Rove quote is from Keli Goff, "Rove: Bush Was Skeptical of Voting Rights Act," *The Root*, June 27, 2013. See also Alberto Gonzales, "Voting Rights for All Americans," *Fox News Latino*, July 8, 2013, accessed October 21, 2015, available at http://latino.foxnews.com/latino/opinion/2013/07/08/alberto-gonzales-voting-rights-for-all-americans/.

63. Quoted in Clarence Page, "Bush on Voting Rights: Clueless or Cagey?" *Philadelphia Tribune*, February 4, 2005.

64. Jesse L. Jackson Sr. "Selma 40 Years Later," *Los Angeles Sentinel*, March 3, 2005.

65. This dynamic is summarized in Christopher Hare and Keith T. Poole, "The Polarization of Contemporary American Politics," *Polity* 46, no. 3 (2014): 411–25.

66. NOMINATE polarization data based on member of Congress's roll call votes is available at Keith Poole and Howard Rosenthal's VoteView website, accessed March 3, 2017, http://voteview.com/political_polarization_2015.htm.

67. "Conference Launches Drive"; David Stokes, "Activist against Black Vote's 'Assault,'" *Atlanta Inquirer*, March 12, 2005; La Risa Lynch, "Rev. Jackson Demands Renewal of Voting Rights Act," *Chicago Weekend*, March 16, 2005; "The Black Caucus Plan: Elected Officials Present Political Positions Needed to Overcome and Eliminate Disparities That Exist between African Americans and White Americans," *Sacramento Observer*, March 3, 2005.

68. The quote about the Supreme Court decisions is from Scott Westbrook Simpson, "Congress Praised for Moving Forward on Reauthorization of Voting Rights Act: Passage Critical to Protect the Rights of All Americans to Vote," Leadership Conference on Civil Rights, October 18, 2005, accessed February 3, 2014, available at http://www.civilrights.org/press/2005/congress-praised-for-moving-forward-on-reauthorization-of-voting-rights-act-passage-critical-to-protect-the-rights-of-all-americans-to-vote.html.

69. These differences are summarized in Daniel Tokaji, "Two Perspectives on the Voting Rights Act," *Election Law Blog*, May 6, 2006, accessed February 6, 2014, available at http://electionlawblog.org/archives/005582.html.

70. Nathaniel Persily, "Options and Strategies for Renewal of Section 5 of the Voting Rights Act," *Howard Law Journal* 49, no. 4 (2005–2006): 717–39.

71. "1965 'Bloody Sunday' Selma March Remembered: Civil Rights Act Will Be Up for Renewal in 2007," *Miami Times*, March 9, 2005; Stokes, "Activist Against Black Vote's 'Assault'"; Lesley R. Chinn, "Voting Rights to Highlight 34th Annual PUSH Convention," *Chicago Citizen*, June 8, 2005; Tanangachi Mfuni, "Jackson, Sharpton Rally to Protect the Voting Rights Act," *New York Amsterdam News*, July 14, 2005.

72. Roland S. Martin, "Voting Rights Supporters Must Go on the 'Offensive,'" *Chicago Defender*, August 8, 2005; Jamal E. Watson, "Marching to Vote: Thousands Gather in Atlanta to Urge Congress to Renew Voting Rights Act," *New York Amsterdam News*, August 11, 2005; Denise Rolark Barnes, "It's Time to Put on Your Marching Shoes," *Washington Informer*, August 11, 2005; Shaila Dewan, "In Georgia, Thousands March in Support of Voting Rights," *New York Times*, August 7, 2005.

73. On the Court's increasing expectations for evidence justifying congressional intervention, see, for example, Richard L. Hasen, "Congressional Power to Renew the Preclearance Provisions of the Voting Rights Act after *Tennessee v. Lane*," *Ohio State Law Journal* 66, no. 6 (2005): 177–207.

74. Arnwine quoted in Tyler Lewis, "House Begins Hearings on Voting Discrim-

ination and Reauthorization of the VRA," Leadership Conference on Civil Rights, October 18, 2005, accessed February 3, 2014, available at http://www.civilrights.org /voting-rights/vra/2006/house-begins-hearings-on-voting-discrimination-and -reauthorization-of-the-vra.html.

75. Tyler Lewis, "Regional 'Train-the-Trainer' Conferences Commemorate Voting Rights Act," available at the archived RenewtheVRA.org website at the Internet Archive, accessed February 3, 2014, available at http://web.archive.org/web /20060920220544/http://renewthevra.civilrights.org/vra_news/details.cfm?id=41444.

76. Human Rights Campaign, "Human Rights Campaign Applauds Civil Rights Coalition on Voting Rights Act Renewal," July 28, 2006, accessed March 10, 2014, available at http://www.hrc.org/press-releases/entry/human-rights-campaign -applauds-civil-rights-coalition-on-renewal-of-landmar.

77. See, for example, James Thomas Tucker, "The Politics of Persuasion: Passage of the Voting Rights Reauthorization Act of 2006," *Journal of Legislation* 33, no. 2 (2007), 214–15.

78. Quoted in Sam Manuel, "NAACP Holds National Convention," *The Militant* 69, no. 30 (August 8, 2005), accessed March 10, 2014, available online at http://www .themilitant.com/2005/6930/693058.html. See also Mike Allen, "A Push to Extend Voting Rights Act: Rep. Sensenbrenner Tells NAACP He Will Work to Renew Provisions of Law," *Washington Post*, July 10, 2005. On Sensenbrenner's support for the VRA, see David Nather, "Sensenbrenner Hailed for the Rights Stuff," *CQ Weekly*, October 3, 2005.

79. Tucker, "Politics of Persuasion," at 217–18.

80. See, for example, Teddy Davis, "Parties Strategize on Renewing Voting Rights Act," *Roll Call*, August 1, 2005; Brian DeBose, "Congress Likely to Renew Vote Act: Hearing Weighs Key Provisions," *Washington Times*, October 26, 2005; Brian DeBose, "Congress Plans to Renew Voting-Act Provisions," *Washington Times*, November 11, 2005; Rick Lyman, "Extension of Voting Act Is Likely Despite Criticism," *New York Times*, March 29, 2006.

81. "Co-Sponsors: H.R. 9—109th Congress (2005–2006)," Congress.gov, accessed September 9, 2016, available at https://www.congress.gov/bill/109th-congress /house-bill/9/cosponsors.

82. Quoted in Lyman, "Extension of Voting Act."

83. Edward Blum, "An Insulting Provision," *National Review*, May 2, 2006.

84. Shailagh Murray, "Voting Rights Act Extensions Pass House Despite GOP Infighting," *Washington Post*, July 14, 2006.

85. Jennifer Yachnin, "Parties Show Unity on VRA," *Roll Call*, May 3, 2006.

86. Tucker, "Politics of Persuasion," at 234–35.

87. "Amendment to Voting Rights Act Extension Has Dim Prospects on House Floor," *CQ Today*, June 16, 2006.

88. "H.R. 9(109th): Fannie Lou Hamer, Rosa Parks, and Coretta Scott King Voting Rights Reauthorization and Amendments of 2006," accessed February 7, 2014, available at *GovTrack.us* at https://www.govtrack.us/congress/bills/109/hr9/text;

"Summary of the Voting Rights Act Reauthorization and Amendments Act of 2006 (the VRARA)(H.R.9/S.2703)," Leadership Conference on Civil Rights, June 20, 2006, accessed February 7, 2014, available at http://www.civilrights.org/voting-rights/vra /2006/vrara-summary.html.

89. Hasen, "*Shelby County* and the Illusion of Minimalism," at 11.

90. Jennifer Yachnin, "GOP Delays Vote on VRA," *Roll Call*, June 22, 2006; Keith Perine and Susan Ferrichio, "Voting Rights Act Extension Postponed," *CQ Weekly*, June 26, 2006.

91. Johanna Neuman, "GOP Halts Extension of Voting Rights Act," *Los Angeles Times*, June 22, 2006.

92. Charles Babington, "GOP Rebellion Stops Voting Rights Act; Complaints Include Bilingual Ballots and Scope of Justice Dept. Role in South," *Washington Post*, June 22, 2006.

93. Quoted in "King Applauds Decision to Give Americans Another Chance to End Bilingual Voting," Press Release, June 21, 2006, Office of Steve King, available at https://steveking.house.gov/media-center/press-releases/king-applauds-decision-to -give-americans-another-chance-to-end-bilingual, accessed October 20, 2015.

94. Brian DeBose, "Language Rules Impede Extension of Voter Rights Act," *Washington Times*, May 5, 2006; Carl Hulse, "Rebellion Stalls Extension of Voting Act," *New York Times*, June 22, 2006; David Mikhail, "GOP Splits but Dem Deal on VRA Holds," *The Hill*, June 27, 2006.

95. Quoted in Yachnin, "GOP Delays Vote on VRA."

96. Quoted in Babington, "GOP Rebellion Stops Voting Rights Act."

97. Quoted in Tyler Lewis, "Important Vote on the Voting Rights Reauthorization Hijacked," Leadership Conference on Civil Rights, June 21, 2006, accessed April 7, 2016, available at http://www.civilrights.org/voting-rights/vra/2006/important-vote -on-the-voting-rights-act-reauthorization-hijacked.html?referrer=https://www .google.com/.

98. Johanna Neuman, "Renewal of Voting Rights Act is Delayed," *Baltimore Sun*, June 22, 2006.

99. Quoted in Adam Nagourney, "Republicans Coming Up Short in Effort to Reach Out to African-American Voters," *New York Times*, July 18, 2006.

100. Raymond Hernandez, "After Challenges, House Approves Renew of Voting Rights Act," *New York Times*, July 14, 2006.

101. Charles Babington, "House May Chill Bush's Wooing of Latino Voters," *Washington Post*, June 30, 2006.

102. Democracy Corps survey, fielded by Greenberg Quinlan Rosner Research, June 25–29, 2006, accessed September 21, 2016, available from the Roper Center for Public Opinion Research, University of Connecticut.

103. Quoted in Jennifer Yachnin, "Rank and File Cut Out of VRA Talks," *Roll Call*, June 28, 2006.

104. Ben Pershing, "For VRA, This Week Is Finally Prime Time," *Roll Call*, July 11, 2006.

105. The strongest support for each of the Republican-offered amendments came from representatives in jurisdictions covered by Section 4 of the Act. See, for example, Sarah Binder, "Reading Congressional Tea Leaves from the 2006 Renewal of the Voting Rights Act," *The Monkey Cage*, June 27, 2013, accessed October 20, 2015, available at http://themonkeycage.org/2013/06/reading-congressional-tea-leaves-from-the-2006-renewal-of-the-voting-rights-act/.

106. Seth Stern, "Voting Rights Extension's Four Rejected Amendments," *CQ Weekly*, July 17, 2006; Seth Stern, "Voting Rights Extension Passed," *CQ Weekly*, July 17, 2006.

107. Author's analysis of House votes 370, 371, 372, 373, and 374, 109th Cong., 2nd Sess., accessed August 24, 2016, data available from GovTrack.us, https://www.govtrack.us/congress/votes#session=290&chamber[]=2.

108. "Co-Sponsors: S.2703—109th Congress (2005–2006)," accessed September 9, 2016, available at Congress.gov, https://www.congress.gov/bill/109th-congress/senate-bill/2703/cosponsors.

109. Quoted in Jonathan Allen, "In Senate, It's Déjà Vu All Over Again on Voting Rights Act Extension," *The Hill*, June 28, 2006.

110. Tucker, "Politics of Persuasion," at 259.

111. Mary Otto, "NAACP Says 1,000 Will Press Senators on Voting Rights Act," *Washington Post*, July 16, 2006.

112. Quotes are from "Bush Invokes Civil Rights in NAACP Speech," *NBC News*, July 21, 2006, accessed February 11, 2014, available at http://www.nbcnews.com/id/13949974/#.UvphmoJdVgo.

113. "Bond Criticizes, Invites Bush," *Washington Post*, July 17, 2006.

114. Sheryl Gay Stolberg, "In Speech to N.A.A.C.P., Bush Offers Reconciliation," *New York Times*, July 21, 2006.

115. Jennifer Loven, "Bush Signs Voting Rights Act Extension Amid Midterm Election Season Fanfare," *Eagle-Tribune*, July 28, 2006.

116. Quoted in Tom Baxter, "GOP Renews Pitch to Blacks," *Atlanta Journal-Constitution*, July 28, 2006.

117. On the report and its status as "legislative history," see Erica Lai, "Appended Post-Passage Senate Judiciary Committee Report: Unlikely 'Legislative History' for Interpreting Section 5 of the Reauthorized Voting Rights Act," *University of Pennsylvania Law Review* 156, no. 2 (2007): 453–90.

118. Edward Blum, "See You in Court," *National Review Online*, July 6, 2006, accessed November 21, 2014, available from the Project on Fair Representation, http://www.projectonfairrepresentation.org/see-you-in-court/.

119. President George W. Bush, "Remarks to the Cincinnati Chapter of the Federalist Society," Cincinnati, Ohio, October 6, 2008, Public Papers of President George W. Bush, 2008, Book II (Government Printing Office, 2009), accessed March 3, 2017, available online at https://www.gpo.gov/fdsys/pkg/PPP-2008-book2/html/PPP-2008-book2-doc-pg1272.htm.

120. Fred Barnes, "Bush Scalia," *Weekly Standard*, July 5, 1999; Jamison Foser,

"Did Bush Promise to Appoint a Justice Like Scalia?" *Media Matters for America*, October 15, 2005, accessed January 5, 2016, available at http://mediamatters .org/research/2005/10/13/did-bush-promise-to-appoint-a-justice-like-scal/134001; Christopher L. Eisgruber, *The Next Justice: Repairing the Supreme Court Appointments Process* (Princeton, NJ: Princeton University Press, 2008), at 5.

121. Author's analysis of data from the Supreme Court Database, accessed September 9, 2016, available at http://scdb.wustl.edu/. This analysis used the dataset organized by Supreme Court citation.

122. Justice Clarence Thomas, Concurring Opinion to Holder v. Hall, 512 U.S. 874 (1994), at 893–94.

123. Pamela S. Karlan, "Our Separatism? Voting Rights as an American Nationalities Policy," *University of Chicago Legal Forum* 83, no. 1 (1995): 83–110.

124. Thernstrom's major work on voting rights issues is *Whose Votes Count? Affirmative Action and Minority Voting Rights* (Cambridge, MA: Harvard University Press, 1987).

125. Abigail Thernstrom and Edward Blum, "Do the Right Thing," *Wall Street Journal*, July 15, 2005.

126. Friedrich quoted in David W. Neubauer and Stephen S. Meinhold, *Judicial Process: Law, Courts, and Politics in the United States* (New York: Cengage Learning, 2010), at 179.

127. Sheldon Goldman et al., "W. Bush Remaking the Judiciary: Like Father Like Son?" *Judicature* 86, no. 6 (May/June 2003): 282–311.

128. On Bush's appointment process and appointees, see, for example, Yalof, "In Search of a Means to an End"; Sheldon Goldman, Sara Schiavoni, and Elliot Slotnick, "W. Bush's Judicial Legacy: Mission Accomplished," *Judicature* 92, no. 6 (2009): 258–88; Thomas Keck, "Bush's Greatest Legacy? The Federal Courts and the Republican Regime," in *Testing the Limits: George W. Bush and the Imperial Presidency*, ed. Mark J. Rozell and Gleaves Whitney (New York: Rowman and Littlefield, 2009), 219–42.

129. See, for example, Dorothy I. Height and Wade Henderson, Leadership Conference on Civil Rights, Arlen Spector and Patrick Leahy, Chairman and Ranking Member of the Senate Judiciary Committee, September 15, 2005, appended to Hearings on the Nomination of John G. Roberts Jr. to be Chief Justice of the Supreme Court of the United States, September 12–15, 2005, accessed February 14, 2014, available at the Government Printing Office, http://www.gpo.gov/fdsys/search/pagedetails .action?granuleId=&packageId=GPO-CHRG-ROBERTS&fromBrowse=true.

130. Ari Berman, "How the 2000 Election in Florida Led to a New Wave of Voter Disenfranchisement," *The Nation*, July 28, 2015.

131. William L. Taylor, "John Roberts: The Nominee," *New York Review of Books*, October 6, 2005.

132. John Roberts to the attorney general, "Talking Points for White House Meeting on Voting Rights Act," memorandum, January 26, 1982, National Archives and Records Administration, Record Group 60, Department of Justice, Accession #60-89-372, Box 30, Folder "John G. Roberts, Jr. Misc."; John Roberts to Brad Reyn-

olds, assistant attorney general, Civil Rights Division, "Voting Rights Act," memorandum, February 8, 1982, National Archives and Records Administration, Record Group 60, Department of Justice, Accession #60-89-0172, Files of William Bradford Reynolds, 1981–88, Box 14, Folder "387-AAG Civil Rights Division; Voting Rights Act; Internal Memos"; See also John Roberts to the attorney general and others, "Regional Op-Ed Piece on Consequences of an Effects Test in Section 2 of the Voting Rights Act," memorandum, March 1, 1982, National Archives and Records Administration, Records Group 60, Department of Justice, Accession #60-88-0495, General Correspondence Files, 1981–84, Box 4, "Civil Rights Division."

133. See, for example, Henry J. Kaiser Family Foundation Health Poll report, October 4–9, 2005, and Pew Research Center for the People and the Press News Interest Index Survey, October 6–10, 2005, both accessed August 18, 2016, both available via subscription to the iPoll Database, Roper Center for Public Opinion Research, University of Connecticut.

134. FOX News/Opinion Dynamics poll, December 13–14, 2005, accessed August 18, 2016, available via subscription to the iPoll Database, Roper Center for Public Opinion Research, University of Connecticut. This survey question was especially useful as a means to gain insight about respondents' attitudes about and knowledge of Roberts, because it was not biased by references to George W. Bush or the Republican Party.

135. Author's analysis of data from the Supreme Court Database, accessed August 25, 2016, available at http://supremecourtdatabase.org/data.php. Note again that such comparisons between justices are necessarily rough, because the justices did not all vote on all of the same cases.

136. "Two Suits Challenge Heart of Voting Rights Act," *Legal Times Blog (BLT)*, April 30, 2010, accessed November 21, 2014, available at *the BLT*, http://legaltimes.typepad.com/blt/2010/04/two-suits-challenge-heart-of-voting-rights-act.html.

137. Opinion of Chief Justice John Roberts, Shelby County, Alabama v. Holder, 570 U.S. _____ (2013), at 23.

138. Opinion of Chief Justice John Roberts, Shelby County, Alabama v. Holder (Slip Opinion), June 25, 2013, 18, 20.

139. Nicholas Stephanopoulos, "The South after *Shelby County*," (working paper no. 451, University of Chicago Public Law and Legal Theory, October 2013, at 2).

140. Roberts, *Shelby County*, 570 U.S. at 21.

141. See, for example, Anita Earls and Allison Riggs, "Brief of Political Science and Law Professors as Amici Curiae in Support of Respondents," Shelby County, Alabama, v. Eric Holder Jr., accessed January 5, 2016, available at http://www.americanbar.org/content/dam/aba/publications/supreme_court_preview/briefs-v2/12-96_resp_amcu_pslp.authcheckdam.pdf; Christopher S. Elmendorf and Douglas M. Spencer, "Are the Covered States 'More Racist' than Other States?" *Election Law Blog*, March 4, 2013, accessed January 5, 2016, available at https://electionlawblog.org/?p=48009; and Kousser, "Roberts' Opinion in Shelby County."

142. Ellen D. Katz, "What Was Wrong with the Record?," *Election Law Journal* 12, no. 3 (2013): 329–31.

143. Constitutional scholars from both the left and the right have sharply criticized the "equal-state sovereignty" arguments contained in *Shelby County*. See, for example, Edward Cantu, "The Separation-of-Powers and the Least Dangerous Branch," *Georgetown Journal of Law and Public Policy* 1, no. 13 (2015): 1–58; Joseph Fishkin, "The Dignity of the South," *Yale Law Journal Forum* 123 (June 2013), accessed March 23, 2016, available at http://www.yalelawjournal.org/forum/the-dignity-of-the-south; John Greenbaum, Alan Martinson, and Sonia Gill, "*Shelby County v. Holder*: When the Rational Becomes Irrational," *Howard Law Journal* 57, no. 3 (2014): 811–67; and Hasen, "*Shelby County* and the Illusion of Minimalism." See also quotes in Thomas B. Colby, "In Defense of the Equal Sovereignty Principle," *Duke Law Journal* 65, no. 1 (2016): 1–80, at 2.

144. ABC News/Washington Post survey, June 26–30, 2013, accessed August 26, 2016, available via subscription to the iPoll Database, Roper Center for Public Opinion Research, University of Connecticut.

145. McClatchy/Marist poll, July 15–18, 2013, accessed January 6, 2016, available via subscription to the iPoll Database, Roper Center for Public Opinion Research, University of Connecticut.

146. Quoted in Jackie Calmes, "On Voting Case, Reaction from 'Deeply Disappointed' to 'It's About Time,'" *New York Times*, June 26, 2013.

147. Quoted in Richard Wolf and Brad Heath, "Ruling Resets Voting Rights Fight," *USA Today*, June 26, 2013.

148. Quoted in Meena Ganesan, "Supreme Court Decisions: Voting Rights Act Reaction Live," *CBS News Hour*, June 25, 2013, accessed October 23, 2015, available at http://www.pbs.org/newshour/rundown/supreme-court-decisions-voting-rights-act -gay-marriage-reaction/. See also David Weigel, "Southern Republican Senators Happy That Supreme Court Designated Their States Not-Racist," *Slate*, June 25, 2013.

149. Quoted in Jennifer Bendery, "It's Not 'Necessary' to Restore Key Part of Voting Rights Act, Top Republican Says," *Huffington Post*, January 14, 2015.

Chapter 5

1. Adam Nagourney, "Obama Elected President as Racial Barrier Falls," *New York Times*, November 4, 2008.

2. Robert Barnes and Michael D. Shear, "Obama Makes History," *Washington Post*, November 5, 2008.

3. John McWhorter, "Racism in America Is Over," *Forbes*, December 30, 2008.

4. The formulation of this question paraphrases Stephen Ansolabehere, Nathaniel Persily, and Charles Stewart III, "Race, Region, and Vote Choice in the 2008 Election: Implications for the Future of the Voting Rights Act," *Harvard Law Review* 126, no. 6 (2010): 1385–436, at 1387. Ansolabehere, Persily, and Stewart argue that the assumptions of the VRA largely retained their validity even in light of Obama's election.

5. Abigail Thernstrom and Stephen Thernstrom, "Racial Gerrymandering Is Unnecessary," *Wall Street Journal*, November 11, 2008. In reality, evidence for the per-

sistence of racially polarized voting—in which citizens of color prefer candidates who descriptively represent them while whites prefer to be represented by whites—is overwhelming. See, for example, Richard L. Engstrom, "The Elephant in the Room: *NAMUDNO, Shelby County,* and Racially Polarized Voting," *TransAtlantica* 1 (2015), accessed April 19, 2016, available at https://transatlantica.revues.org/7427?lang=fr.

6. See, for example, Keith G. Bentele and Erin E. O'Brien, "Jim Crow 2.0? Why States Consider and Adopt Restrictive Voter Access Policies," *Perspectives on Politics* 11, no. 4 (2013): 1088–116; and William D. Hicks, Seth C. McKee, Mitchell D. Sellers, and Daniel A. Smith, "A Principle or a Strategy? Voter Identification Laws and Partisan Competition in the American States," *Political Research Quarterly* 68, no. 1 (2015): 18–33. At the individual level, state legislators were more likely to support restrictive voting rules if they were Republicans and representing districts with substantial black populations. See Seth McKee, "Politics Is Local: State Legislator Voting on Restrictive Voter Identification Legislation," *Research and Politics* July–September (2015): 1–7; and William D. Hicks, Seth C. McKee, and Daniel A. Smith, "The Determinants of State Legislator Support for Restrictive Voter ID Laws," *State Politics and Policy Quarterly* (2016): 1–21.

7. Empirical studies suggest that restrictive voting policies—and discriminatory implementation of these policies—can in fact pose obstacles to voting. See, for example, R. Michael Alvarez, Delia Bailey, and Jonathan N. Katz, "The Effect of Voter Identification Laws on Turnout" (social science working paper 1267R, California Institute of Technology, January 2008); Lonna Rae Atkeson, Lisa Ann Bryant, Thad E. Hall, Kyle Saunders, and Michael Alvarez, "A New Barrier to Participation: Heterogeneous Application of Voter Identification Policies," *Electoral Studies* 29, no. 1 (2010): 66–73; Rachel V. Cobb, D. James Greiner, and Kevin M. Quinn, "Can Voter ID Laws Be Administered in a Race-Neutral Manner? Evidence from the City of Boston in 2008," *Quarterly Journal of Political Science* 7, no. 1 (2012): 1–33; and M. V. Hood III and Charles S. Bullock III, "Much Ado about Nothing? An Empirical Assessment of the Georgia Voter Identification Statute," *State Politics and Policy Quarterly* 12, no. 4 (2012): 394–414.

8. Barack Obama, "50 Years After the Voting Rights Act, We Still Have Work to Do," *Medium,* August 6, 2015, accessed February 9, 2016, available at https://medium.com/@PresidentObama/50-years-after-the-voting-rights-act-we-still-have-work-to-do-fcee728c54d0#.v4s6ly7i8.

9. See, for example. Spencer Piston, "How Explicit Racial Prejudice Hurt Obama in the 2008 Election," *Political Behavior* 32, no. 4 (2010): 431–51; Michael Tesler, "The Spillover of Racialization into Health Care: How President Obama Polarized Public Opinion by Racial Attitudes and Race," *American Journal of Political Science* 56, no. 3 (2012): 690–704; Michael Tesler, "The Return of Old-Fashioned Racism to White Americans' Partisan Preferences in the Early Obama Era," *Journal of Politics* 75, no. 1 (2013): 110–23; and Jonathan Knuckey and Myunghee Kim, "Racial Resentment, Old-Fashioned Racism, and the Vote Choice of Southern and Nonsouthern Whites in the 2012 U.S. Presidential Election," *Social Science Quarterly* (2015), doi: 10.1111/ssqu.12184.

10. See, for example, David C. Wilson and Paul R. Brewer, "The Foundations of

Public Opinion on Voter ID Laws: Political Predispositions, Racial Resentment, and Information Effects," *Public Opinion Quarterly* 77, no. 4 (2013): 962–84; and Shaun Bowler and Todd Donovan, "A Partisan Model of Electoral Reform: Voter Identification Laws and Confidence in State Elections," *State Politics and Policy Quarterly* (2016): 1–22, doi: 10.1177/1532440015624102.

11. Wendy R. Weiser, "How Much of a Difference Did New Voting Restrictions Make in Yesterday's Close Races?," November 5, 2014, Brennan Center for Justice, New York University School of Law, accessed November 25, 2014, available at http://www.brennancenter.org/print/12822; Ari Berman, "Did Voting Restrictions Determine the Outcomes of Key Midterm Races?," *The Nation*, November 6, 2014. Early reports also indicated serious voting problems in other states, such as Georgia and Texas, that had recently implemented restrictive voting requirements. Dana Liebelson and Ryan J. Reilly, "This Is What Happened Because Congress Didn't Fix the Voting Rights Act," *Huffington Post*, November 11, 2014; Erik Eckholm and Richard Fausset, "As New Rules Take Effect, Voters Report Problems in Some States," *New York Times*, November 4, 2014; Ed Pilkington, "Unusual Level of Glitches at US Polling Stations Reported on Election Day," *The Guardian*, November 5, 2014.

12. "Voting Laws Roundup 2015," Brennan Center for Justice, June 3, 2015, accessed September 7, 2015, available at http://www.brennancenter.org/analysis/voting-laws-roundup-2015.

13. Nicholas A. Valentino and Fabian G. Neuner, "Why the Sky Didn't Fall: Mobilizing Anger in Reaction to Voter ID Laws," *Political Psychology* (2016), doi: 10.1111/pops.12332.

14. Barack Obama, "Statement on the 45th Anniversary of the 1965 Voting Rights March," March 7, 2010, Public Papers of the Presidents of the United States, accessed August 27, 2015, available from the American Presidency Project at http://www.presidency.ucsb.edu/ws/index.php?pid=87616&st=civil+rights&st1=Department+of+Justice.

15. Quoted in Austin Fenner and Leonard Greene, "And Justice for All—AG Makes Equal Rights Priority," *New York Post*, July 14, 2009. See also Holder comments in Jonathan Martin, "Holder Vows to Restore DOJ Civil Rights," *Politico*, March 8, 2009.

16. Charlie Savage, "White House to Shift Efforts on Civil Rights," *New York Times*, September 1, 2009.

17. Charlie Savage, "Justice Dept. Refocuses on Civil Rights Enforcement," *International Herald Tribune*, September 2, 2009; Krissah Thompson, "Civil Rights Office Returns to Old Role," *Washington Post*, September 27, 2009.

18. Quoted in Savage, "White House to Shift Efforts."

19. Jerry Markon, "Justice Department's Civil Rights Division Steps Up Enforcement," *Washington Post*, June 4, 2010.

20. Charlie Savage, "In Shift, Justice Department Is Hiring Lawyers with Civil Rights Backgrounds," *New York Times*, May 31, 2011; see also Office of the Inspector General, US Department of Justice, *A Review of the Operations*, at 213–16.

21. Office of the Inspector General, US Department of Justice, *A Review of the*

Operations, at 209. The evidence considered in the report, however, "did *not* reveal that [the Division] staff allowed political or ideological bias to influence their hiring decisions" (at 214, emphasis added).

22. Yeomans, "The Politics of Civil Rights Enforcement," at 532. See also Adam Serwer, "The Battle for Voting Rights," *The American Prospect*, January 8, 2010; and "Voting Section Chief Out Amid Controversy," *Main Justice*, December 27, 2009, accessed January 12, 2016, available at http://www.mainjustice.com/tag/christopher -coates/.

23. Todd Gregory and Jeremy Holden, "'A True Member of the Team': Coates' Testimony Used to Revive Phony DOJ Scandal," *Media Matters for America*, September 23, 2010, accessed January 12, 2016, available at http://mediamatters.org /research/2010/09/23/a-true-member-of-the-team-coates-testimony-used/171071.

24. The Coates affair is exhaustively documented in Office of the Inspector General, US Department of Justice, *A Review of the Operations*, at 156–80. The quote is from page 179.

25. The NBPP saga is thoroughly documented in *Investigation of Dismissal of Defendants in United States v. New Black Panther Party for Self-Defense, Inc.* (Washington, DC: Department of Justice, Office of Professional Responsibility, March 17, 2011); and Office of the Inspector General, US Department of Justice, *A Review of the Operations*. What follows in this and the next paragraph is drawn in large part from these reports.

26. *Investigation of Dismissal of Defendants*, at 13–14.

27. Ibid., at 20–22.

28. Office of the Inspector General, US Department of Justice, *A Review of the Operations*, at 66.

29. Ibid., at 1.

30. See ibid., at 58.

31. Ibid., at 45. For details, see 60–63.

32. Josh Gerstein, "Prosecutor: DOJ Bias against Whites," *Politico*, September 24, 2010; Krissah Thompson, "Voter-Intimidation Case Riles the Right; Justice Dept. Criticized Over Suit Against New Black Panthers," *Washington Post*, July 15, 2010; Krissah Thompson, "DOJ Cleared in Black Panther Case," *Washington Post*, March 30, 2011.

33. Jerry Markon and Krissah Thompson, "Black Panther Case Reveals Schism," *Washington Post*, October 23, 2010.

34. Office of the Inspector General, US Department of Justice, *A Review of the Operations*, at 255.

35. Ibid., at 251–52.

36. See *Civil Rights Division, 2009–2012* (Washington, DC: United States Department of Justice, 2013), accessed September 1, 2015, available at http://www.justice.gov /sites/default/files/crt/legacy/2013/03/27/crtaccomplishment09_12.pdf.

37. Ibid., at 54.

38. Michael L. Selmi, "The Obama Administration's Civil Rights Record: The Dif-

ference an Administration Makes," *Journal of Law and Social Equality* 2, no. 1 (2013): 108–36, at 120.

39. Eric Holder, "Address at the LBJ Library on Voter Registration and Rights," *American Rhetoric Online Speech Bank*, December 13, 2011, accessed August 31, 2015, available at http://www.americanrhetoric.com/speeches/ericholderlbjlibrary voterrights.htm.

40. The quote is from Charlie Savage, "Holder Signals Tough Review of State Laws on Voting Rights," *New York Times*, December 14, 2011. See also Jerry Markon and Krissah Thompson, "Holder Joins Debate on Voting Laws' Turnout Effects," *Washington Post*, December 13, 2011; Charlie Savage, "A Lightning Rod Undeterred by G.O.P. Thunder," *New York Times*, December 18, 2011; and "Holder Vows to Enforce Voting Rights Laws," *Washington Post*, December 14, 2011.

41. Charlie Savage, "U.S. Cites Race in Halting Law over Voter ID," *New York Times*, December 24, 2011; Sari Horwitz, "Administration Blocks Texas's New Voter ID Law," *Washington Post*, March 13, 2012. See also Patrik Jonsson, "Partisan Feud Escalates over Voter ID Laws in South Carolina, Other States," *Christian Science Monitor*, January 11, 2012.

42. Information on the Florida suit is from *Civil Rights Division, 2009–2012*, at 54; and Jerry Markon, "Federal Judge Blocks Parts of Florida Voting Law," *Washington Post*, June 1, 2012.

43. Chris McGreal, "Minority Voting Rights Under Threat from ID Laws, Attorney General Warns," *The Guardian*, May 30, 2012; Sari Horowitz, "Holder Vows to Aggressively Fight Voter-ID Laws," *Washington Post*, July 11, 2012.

44. Quoted in Justin Sink, "Justice Blocks Texas Voter ID Law," *The Hill*, March 13, 2012.

45. Ethan Bronner, "A Tight Election May Be Tangled in Legal Battles," *New York Times*, September 10, 2012; Warren Richey, "Early Voting," *Christian Science Monitor*, September 13, 2012.

46. Immediately following the decision, Alabama, Florida, Mississippi, North Carolina, and Texas all moved to implement more stringent rules and regulations pertaining to voting. Lizette Alvarez, "Ruling Revives Florida Efforts to Police Voters," *New York Times*, August 8, 2013.

47. "Feds Seek to Restore Voting Law Restrictions on Texas," *Legal Monitor Worldwide*, July 26, 2013.

48. Warren Richey, "Voting Rights Act Fallout," *Christian Science Monitor*, July 25, 2013; Charlie Savage and Adam Liptak, "New Tack Taken on U.S. Voting Rights," *International Herald Tribune*, July 26, 2013.

49. Josh Gerstein, "DOJ Challenges N.C. Voter ID Law," *Politico*, September 30, 2013; Ryan J. Reilly, "DOJ to Sue North Carolina Over Voter ID Law, Voting Restrictions," *Huffington Post*, September 30, 2013; Ari Berman, "North Carolina Will Determine the Future of the Voting Rights Act," *The Nation*, July 11, 2014.

50. Nicholas Stephanopoulos, "The South After *Shelby County*," *Supreme Court Review* 1 (2013): 55–134.

51. Ari Berman, "North Carolina Becomes the Latest Casualty of the Supreme Court's Voting Rights Act Decision," *The Nation*, August 9, 2014.

52. Robert Barnes, "N.C. Case Represents Pivotal Point of Voting Debate," *Washington Post*, July 30, 2015; Greg Sargent, "The Voting Rights Act Is 50 Years Old. In North Carolina, Its Legacy Hangs in the Balance," *Washington Post*, August 7, 2015.

53. Quoted in "North Carolina Voter ID Law Targeted African Americans, Appeals Court Rules," *Reuters*, July 29, 2016.

54. Josh Gerstein, "North Carolina Asks Supreme Court to Reinstate Voter ID Law," *Politico*, August 16, 2016.

55. Michael Waldman, "How the Supreme Court Made a Mess of Our Voting System," October 20, 2014, Brennan Center for Justice, New York University School of Law, accessed November 25, 2014, available at http://www.brennancenter.org/analysis /how-supreme-court-made-mess-our-voting-system; Adam Liptak, "Supreme Court Allows Texas to Use Strict Voter ID Law in Coming Election," *New York Times*, October 18, 2014.

56. Matt Ford, "A Voter-ID Battle in Texas," *The Atlantic*, March 10, 2016.

57. Jim Malewitz, "Texas Voter ID Law Violates Voting Rights Act, Court Rules," *Texas Tribune*, July 20, 2016.

58. Adam Liptak, "Supreme Court Blocks North Carolina from Restoring Strict Voting Law," *New York Times*, August 31, 2016.

59. Michael Wines, "Court Filing Accuses Texas of Misleading Voters without IDs," *New York Times*, September 7, 2016; Ian Millhiser, "Texas Defied a Court's Voting Rights Order, and the Court's Not Happy," *ThinkProgress*, September 20, 2016, accessed September 21, 2016, available at https://thinkprogress.org/texas-defied-a -courts-voting-rights-order-and-the-court-s-not-happy-f9e6427dbb42#.5m8rpemwa; *Texas NAACP v. Steen (Consolidated with Veasey v. Abbott)* (Washington, DC: Brennan Center for Justice, March 1, 2017), accessed March 6, 2017, available at https:// www.brennancenter.org/legal-work/naacp-v-steen.

60. See Keith Poole and Howard Rosenthal, "The Polarization of the Congressional Parties," updated January 2016, accessed August 29, 2016, available at http:// voteview.com/political_polarization_2015.html.

61. Richard L. Hasen, "Is Hillary Clinton Dooming Real Election Reform?," *Slate*, June 8, 2015; David A. Graham, "The Double Bind of Voting Rights," *The Atlantic*, June 5, 2015.

62. Quoted in Catherine Paden, "Voting Rights and the Personal Politics of U.S. Rep. John Lewis," *Boston Banner* 49, no. 2 (2013): 7.

63. "Thousands Gather to Mark Anniversary of March on Washington," *Wall Street Journal*, August 24, 2013. See also Jennifer Bihm, "March on Washington," *The Sentinel* 79, no. 35 (2013): A1–2.

64. Ed O'Keefe, "Republicans Absent from March on Washington," *Washington Post*, August 28, 2013. See also Patrick O'Connor, "At 50th Anniversary of March, No GOP Speakers," *Wall Street Journal*, August 28, 2013.

65. NAACP Legal Defense Fund, "The Voting Rights Amendment Act of 2014,"

accessed August 19, 2015, available from the NAACP LDF website, http://www.naacp ldf.org/case-issue/voting-rights-amendment-act-2014.

66. William Yeomans et al., "The Voting Rights Amendment Act of 2014: A Constitutional Response to *Shelby County*," May 2014, American Constitution Society for Law and Policy Issue Brief, accessed April 19, 2016, available at http://www.acslaw .org/sites/default/files/Yeomans_Stephanopoulos_Chin_Bagenstos_and_Daniels _-_VRAA_1.pdf.

67. Ari Berman, "Members of Congress Introduce a New Fix for the Voting Rights Act," *The Nation*, January 24, 2014; Ari Melber, "Major Hole in New Voting Rights Bill," *MSNBC*, January 20, 2014, accessed August 21, 2015, available at http:// www.msnbc.com/msnbc/major-hole-new-voting-rights-bill.

68. Quoted in Billy House, "New Voting-Rights Bill Splits Lawmakers—Even Before It Is Unveiled," *National Journal*, January 15, 2014.

69. Jim Rutenberg, "Nine Years Ago, Republicans Favored Voting Rights. What Happened?" *New York Times Magazine*, August 12, 2015.

70. "Cosponsors: H.R. 3899—113th Congress (2013–2014)," accessed August 26, 2016, available at Congress.gov, https://www.congress.gov/bill/113th-congress/house -bill/3899/cosponsors; "Cosponsors: S. 1945—113th Congress (2013–2014)," accessed August 26, 2016, available at Congress.gov, https://www.congress.gov/bill/113th -congress/senate-bill/1945/cosponsors.

71. See, for example, Emma Dumain, "Can Cantor Deliver on Voting Rights Act?" *Roll Call*, March 12, 2014; and Ari Berman, "Eric Cantor's Defeat Is Bad News for the Voting Rights Act," *The Nation*, June 11, 2014.

72. Cameron Joseph, "Clock Ticking on 2014 Fix to the Voting Rights Act," *The Hill*, April 16, 2014; Lauren French, "CBC Plots Path Forward," *Politico*, May 6, 2014; Naureen Kahn, "Stalled Voting Rights Act Amendment Leaves Voters Vulnerable, Critics Say," *Al Jazeera America*, June 5, 2014.

73. Quoted in Jaime Fuller, "Republicans Used to Unanimously Back the Voting Rights Act. Not Anymore," *Washington Post*, June 26, 2014.

74. Quoted in Jennifer Bendery, "It's Not 'Necessary' to Restore Key Part of Voting Rights Act, Top Republican Says," *Huffington Post*, January 14, 2015. See also Zachary Roth, "Top GOPer Confirms Congress Won't Strengthen Voting Rights Act," *MSNBC*, January 17, 2015, accessed August 24, 2015, available at http://www.msnbc .com/msnbc/top-goper-confirms-congress-wont-strengthen-voting-rights-act.

75. Barack Obama, "Remarks by the President in State of the Union Address," January 20, 2015, accessed August 24, 2015, available at WhiteHouse.gov, https://www .whitehouse.gov/the-press-office/2015/01/20/remarks-president-state-union-address -january-20-2015; Ben Kamisar, "Bipartisan Duo Pushes to Restore the Voting Rights Act," *The Hill*, February 11, 2015; Jennifer Bendery, "Bill to Restore Voting Rights Act Gets Another Bipartisan Push," *Huffington Post*, February 11, 2015.

76. "Cosponsors: H.R. 885—114th Congress (2015–2016)," accessed August 26, 2016, available from Congress.gov, https://www.congress.gov/bill/114th-congress /house-bill/885/cosponsors.

77. See "Voting Rights Advancement Act of 2015—Section by Section," accessed August 24, 2015, available from Senator Patrick Leahy's website, http://www.leahy .senate.gov/imo/media/doc/Voting%20Rights%20Advancement%20Act%20-%20 Section%20by%20Section%20%286-24-15%29.pdf.

78. "Cosponsors: H.R. 2867—114th Congress (2015–2016)," accessed August 26, 2016, available at Congress.gov, https://www.congress.gov/bill/114th-congress/house -bill/2867/cosponsors; "Cosponsors: S 1659—114th Congress (2015–2016)," accessed August 26, 2016, available at Congress.gov, https://www.congress.gov/bill/114th -congress/senate-bill/1659/cosponsors.

79. Quoted in Westerly Lowery, "Congressional Democrats to Introduce New Voting Rights Act Fix," *Washington Post*, June 23, 2015.

80. Discharge Petition 0004, United States House of Representatives, June 15, 2016, accessed August 29, 2016, available at http://clerk.house.gov/114/lrc/pd/petitions /DisPet0004.xml.

81. Sarah Wheaton, "Democrats Galvanize Around Voting Rights," *Politico*, August 6, 2015.

82. Zachary Roth, "Hillary Clinton Lays Out Sweeping Voting Rights Vision," *MSNBC*, June 4, 2015, accessed August 26, 2015, available at http://www.msnbc.com /msnbc/hillary-clinton-early-voting-nationwide; Jamelle Bouie, "Hillary Clinton Hits the GOP on Voter Suppression," *Slate*, June 4, 2015; Annie Karni, "Hillary Clinton Names and Shames Republicans for Voting Restrictions," *Politico*, June 4, 2015.

83. Quoted in Dan Mercia and Eric Bradner, "Clinton Calls Out GOP Opponents by Name on Voting Rights," *CNN*, June 5, 2015, accessed August 26, 2015, available at http://www.cnn.com/2015/06/04/politics/hillary-clinton-voting-rights-texas/. The Clinton quote characterizing stringent voter rules as "nakedly partisan" comes from Jordan Fablan, "Obama: Voting Law 'Has to Be a Priority,'" *The Hill*, August 6, 2015.

84. Vanessa Williams, "In Alabama, Clinton Rebukes Governor on Voting Rights for Black Americans," *Washington Post*, October 18, 2015; Gabrielle Levy, "Clinton, Dems Sue Arizona for Voting Rights Violations," *U.S. News & World Report*, April 14, 2016.

85. Maggie Haberman, "George Soros Bankrolls Democrats' Fight in Voting Rights Cases," *New York Times*, June 5, 2015; Samantha Lachman, "As Hillary Clinton Pitches Voting Rights on the Trail, Her Counsel Looks to Fight for Them in Court," *Huffington Post*, June 16, 2015; Sam Frizell, "Democrats Play Hardball on Voting Laws Ahead of 2016," *Time*, May 14, 2015.

86. Elias quoted in "Senate Democrats' Super Lawyer Preps for Overtime," *Roll Call*, October 31, 2014.

87. Elias quoted in "Virginia Voter ID Lawsuit Is Part of National Push by Democrats," *Washington Post*, January 1, 2016.

88. Quote is from Robert Barnes, "Without Conservative Supreme Court Majority, Voter-Law Challengers Make Gains," *Washington Post*, September 5, 2016.

89. Richard L. Hasen, "Clinton Lawyer Marc Elias among Those Behind Major New Voting Rights Lawsuit in Wisconsin," *Election Law Blog*, May 29, 2015, accessed August 26, 2015, available at https://electionlawblog.org/?p=72945.

90. Quoted in Robert Barnes, "The Crusade of a Democratic Super-Lawyer with Multimillion-Dollar Backing," *Washington Post*, August 7, 2016.

91. Quoted in Maggie Haberman, "Republican Candidates Assail Hillary Clinton on Voting Rights," *New York Times*, June 5, 2015. See also "'Dividing Americans': Potential GOP Rivals Assail Clinton over Fiery Voting Law Speech," *Fox News*, June 5, 2015, accessed August 26, 2015, available at http://www.foxnews.com/politics/2015/06/05/dividing-americans-potential-gop-rivals-assail-clinton-over-fiery-voting-law/.

92. Eli Watkins and Rachel Chason, "Trump Campaign Doubles Down on Fraud Claims," *CNN*, August 13, 2016, accessed August 26, 2016, available at http://www.cnn.com/2016/08/12/politics/donald-trump-pennsylvania-cheating/.

93. Maggie Haberman and Matt Flegenheimer, "Donald Trump, a 'Rigged' Election and the Politics of Race," *New York Times*, August 21, 2016.

94. Jim Rutenberg, "What's Left of the Voting Rights Act?," *New York Times Magazine*, August 5, 2015.

Conclusion

1. "Texas Heading Back to Court over Voter ID Law," *Austin American-Statesman*, September 13, 2016.

2. Cristian Farias, "Texas Got Caught Flouting a Court Order on Voter ID, and Now It's under Supervision," *Huffington Post*, September 20, 2016.

3. Tierney Sneed, "North Carolina May End Up Back in Court over Its Foot Dragging on Early Voting," *Talking Points Memo*, September 2, 2016.

4. Melissa Matheney, "Nevada Tribal Leaders File Lawsuit Claiming Voting Rights Violations," *Fox News 4*, September 7, 2016, accessed September 13, 2016, available at http://mynews4.com/news/local/nevada-tribal-leaders-file-lawsuit-claiming-unequal-access-to-voting.

5. NAACP Legal Defense and Educational Fund, *Democracy Diminished: State and Local Threats to Voting Post–Shelby County, Alabama v. Holder* (Washington, DC, 2016), accessed March 6, 2017, available at http://www.naacpldf.org/publication/democracy-diminished-state-and-local-threats-voting-post-shelby-county-alabama-v-holder. The NAACP-LDEF is continually updating its data set.

6. Tom LoBianco, "Trump Falsely Claims 'Millions of People Who Voted Illegally' Cost Him Popular Vote," *CNN.com*, November 28, 2016.

7. Ari Berman, "Jeff Sessions, Trump's Pick for Attorney General, Is a Fierce Opponent of Civil Rights," *The Nation*, November 18, 2016.

8. Quoted in Adam Serwer, "Will Jeff Sessions Roll Back Civil-Rights Protections?," *The Atlantic*, November 18, 2016.

9. The administration remains a party in the case but is leaving assertion of the discriminatory-intent charge to private civil rights litigants. Manny Fernandez and

Eric Lichtblau, "Justice Dept. Drops a Key Objection to a Texas Voter ID Law," *New York Times*, February 27, 2017.

10. A. J. Vicens, "Roberts Gutted the Voting Rights Act. Jeff Sessions Is Poised to Finish It Off," *Mother Jones*, November 28, 2016.

11. Paul Frymer, *Uneasy Alliances: Race and Party Competition in America* (Princeton, NJ: Princeton University Press, 1999).

12. Barack Obama, "50 Years After the Voting Rights Act, We Still Have Work to Do," *Medium*, August 6, 2015, accessed February 9, 2016, available at https://medium .com/@PresidentObama/50-years-after-the-voting-rights-act-we-still-have-work-to -do-fcee728c54d0#.v4s6ly7i8.

Index

Page numbers followed by f or t indicate material in figures or tables.

(G. H. W.) and, 111; Bush (G. W.) and, 136–37, 153–56; challenges to, 50; *City of Richmond v. United States*, 87–89, 91–92, 125; Clinton and, 118; Congress' intent re Section 2 violations, 124; coverage formula changes (2013), 130–31; failures to comply with, 46, 80, 82; FBI investigation of, 50; Ford and, 69–74, 82; *Georgia v. Ashcroft*, 139–40; Hillary Clinton campaign and, 174, 178; Hyde amendment, 102; initial passage of (1965), 38t, 40–42; Johnson and, 79; *Miller v. Johnson*, 120; *Mobile v. Bolden*, 100; *NAMUDNO*, 158; negotiations on, 36; Nixon and, 61–62, 65, 79–81, 91–92; as no longer necessary, 161; Obama and, 171–72; "opt-in" to, 144; Reagan and, 99, 102–3, 114; Republicans evading responsibility regarding, 96, 141, 180; Reynolds and CRD, 109; in Scott/Hart bill, 66t; *Shaw v. Reno*, 118; *Shelby County v. Holder*, 130–31, 158–62, 164, 174; in VRAA, 175–76; in VRAA2, 177–78. See also *Reno v. Bossier Parish II*
presidential elections: discarded ballots in 2000 election, 132, 142; economic/racial sorting in, 12; VRA and 2016 campaign, 173–74, 176–82
Pressley v. Etowah County, 111
Price, John, 69
Price, Raymond K., 68
private property rights, 12
private right of action, 207n145
process tracing, 20
Project on Fair Representation, 142, 153, 158
proportionality, 89, 106
public opinion/knowledge, 195n56; awareness of voting rights issues, 81; belief in existence of discrimination, 160; of Bush's civil rights performance, 131–32, 142, 153–54; on

civil rights, 67, 75, 77, 92, 106, 147; continuing support for civil rights, 41, 59, 65, 67–69, 75, 77, 160; on CRD abdication of duties, 46; cynicism about government, 81; following Hurricane Katrina, 141; growing awareness of white violence, 26; on local control in race matters, 201n52; mobilizing of, 32, 145–46; partisan attitudes toward civil rights, 164; of party public brand, 14–19, 21; of public dissension among Republicans, 149–50; racial conservatism of Republican voters, 12; on Reagan and civil rights, 99–100, 102, 106; on Rehnquist, 116–17; response to Bloody Sunday, 35–36; response to *Shelby County v. Holder*, 1–2, 131, 160–61, 164–65, 174–76; on Roberts, 157; uproar over Tanner statement, 135; use of administrative bureaucracy to evade, 18–19, 78, 81, 83, 92, 107; voter knowledge of parties, 195n53; VRA extensions a response to, 59, 95, 101–2, 106, 131. See also moderate white voters
Puerto Rican voters, 52

qualification or procedure, meaning of, 54

race in politics: 95, 103; and New Deal realignment, 11–12; racist rhetoric redefined as unacceptable, 12–13; Republican fear of racism charges, 10, 102, 105. See also partisan coalitions
"racial gerrymander" claims, 119–20
Rainbow-PUSH Coalition, 101, 129, 143, 145
Randolph, A. Philip, 63
Reagan, Ronald: and 1982 VRA renewal, 7, 102–3, 106, 113; and "affirmative action," 114, 119, 124; bureaucratic obstructionism, 83; challenging Ford,

STANFORD STUDIES IN LAW AND POLITICS
Edited by Keith J. Bybee

Wayne Batchis, *The Right's First Amendment: The Politics of Free Speech and the Return of Conservative Libertarianism*
2016

Melinda Gann Hall, *Attacking Judges: How Campaign Advertising Influences State Supreme Court Elections*
2014

G. Alan Tarr, *Without Fear or Favor: Judicial Independence and Judicial Accountability in the States*
2012

Charles Gardner Geyh, editor, *What's Law Got to Do with It? What Judges Do, Why They Do It, and What's at Stake*
2011

Keith J. Bybee, editor, *Bench Press: The Collision of Courts, Politics, and the Media*
2007